Why Architecture Matters

BLAIR KAMIN

WHY ARCHITECTURE MATTERS

Lessons from Chicago

THE UNIVERSITY OF CHICAGO PRESS · CHICAGO AND LONDON

BLAIR KAMIN has been the *Chicago Tribune's* architecture critic
since 1992. His work has been recognized with the Pulitzer
Prize for Criticism (1999), the George Polk Award for
Criticism (1996), and the American Institute of Architects'
Institute Honor for Collaborative Achievement (1999).

The University of Chicago Press, Chicago 60637
The University of Chicago Press, Ltd., London
Copyright © 2001 by Chicago Tribune Company
All rights reserved. Published 2001
Printed in the United States of America

10 09 08 07 06 05 04 03 02 2 3 4 5
ISBN: 0-226-42321-2 (cloth)

Library of Congress Cataloging-in-Publication Data
Kamin, Blair.
 Why architecture matters : lessons from Chicago / Blair Kamin.
 p. cm.
 Includes index.
 ISBN 0-226-42321-2 (cloth)
 1. Architecture—Illinois—Chicago. 2. Chicago (Ill.)—Buildings,
structures, etc. I. Title.
NA735.C4 K36 2001
720'.9773'11—dc21 2001027407

⊗ The paper used in this publication meets the minimum
requirements of the American National Standard for
Information Sciences—Permanence of Paper for Printed
Library Materials, ANSI Z39.48–1992.

To Barbara, Willie, and Teddy, and to my parents

CONTENTS

PART TWO
The Art of Architecture 99

PART FOUR
The Lakefront: Democratic Vistas 279

INTRODUCTION

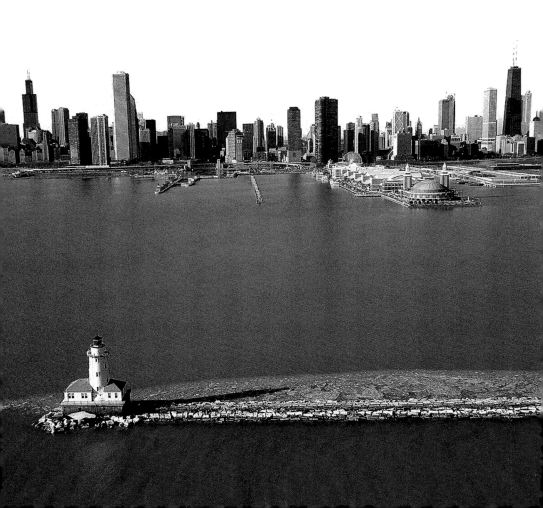

T he tale may seem hard to believe today, especially if you happen to be glancing at the forest of construction cranes on the Chicago skyline. But back in 1992, there actually were rumblings in the newsroom that the Chicago Tribune might no longer need an architecture critic. This was the situation: an overheated commercial real-estate market had just collapsed. Brand-new skyscrapers in Chicago and other cities sat empty, with acres of vacant office space. As thousands of architects were thrown out of work, a new form of gallows humor arose. "How do you find an architect?" the joke went. "Hail a cab." What newspaper in its right mind would ask one of its writers to muse on a skyline that had stopped growing?

Yet architecture is much more than a parade of skyscrapers, to be ogled like models strutting down a runway. From highways to high-rises, schools to subways, bridges to baseball parks, architecture reflects our values and our visions, and, in turn, it shapes just about everything we do. It is not a frill. It is essential to the quality of life. That was the thrust of the memo I sent to the Tribune's then-editor, Jack Fuller, on September 2, 1992. It set out to explain why the Tribune—the preeminent newspaper in the preeminent city of American architecture—should carry on the tradition established by its late, Pulitzer Prize–winning architecture critic, Paul Gapp.

"You can ignore a piece of sculpture or a painting hung on the walls of the Art Institute," the memo began, "but architecture is the inescapable art. Despite the recession in commercial real estate, new structures continue to rise in both the city and suburbs that demonstrate the profound daily impact architecture has on the lives of our readers."

As things turned out, Fuller, now the president of Tribune Publishing,

CHICAGO FROM LAKE MICHIGAN: The great American city, a mirror of architecture and urban design trends around the nation.

dismissed the argument that when the skyscraper died, architecture died with it. He and Howard Tyner, then the *Tribune*'s features editor and now vice president for editorial at Tribune Publishing, gave one of the best jobs in journalism to a 35-year-old reporter who had gone to architecture school but who was frighteningly unschooled in the practical art of how Chicago works. And so, nearly 10 years, more than a thousand bylines, and innumerable design wars later, here we are—with a chance to look back on what has turned out to be an extraordinary decade of building in an extraordinary city of architecture.

Even now, Chicago never fails to take my breath away. As I drive my son to school, heading south on Lake Shore Drive, I am dazzled by the cliff of condominiums along Lake Michigan—a body of water that is sometimes as angry as a gray winter sky, and alternately as peaceful as an aquamarine Caribbean sea. When the Drive curves at Oak Street Beach, and the X-braces of the mighty John Hancock Center loom into view, I am astounded by the presence of sand so close to the heart of a big city. Is this Rio? We speed past Ludwig Mies van der Rohe's steel and glass high-rises at 860 and 880 North Lake Shore Drive, as elegant as two men in black tie, and the curvaceous Lake Point Tower, whose undulating glass walls seem as liquid as the lake. And then, the squared-off towers of downtown rise like medieval battlements and Grant Park unfolds in front of them, a great green carpet that could be the gardens of Versailles. If you're not impressed by that tableau, then I suggest you check your pulse.

Of course, cities need to be livable as well as impressive. That quality is what distinguishes Chicago from its counterparts in the Sun Belt, where clusters of mirror-glass towers rise like Oz from the prairie, promising an urban experience that their downtowns—pockmarked by parking lots and lacking a vibrant mix of activities—fail to deliver. But downtown Chicago pulses with chock-a-block action. It is compact and walkable, not only on Michigan Avenue and State Street but also on Dearborn Street, where you can take a 20-minute stroll and get a short course in the history of the skyscraper. And all this is simply the gateway to a city that promises the wonders of Frank Lloyd Wright, Louis Sullivan, and legions of other architects who have never received their proper due.

Little wonder, then, that Chicagoans are far more conversant about architecture than the denizens of other American cities. Take a cab in from O'Hare and you're likely to get a minilecture on the driver's top 10 buildings. Here, at least, architecture is firmly entrenched in the civic dialogue.

But that hardly means that I am about to declare victory on a broader scale. Nationwide, the battle to show that architecture matters is ongoing

and, in many respects, more difficult to wage than ever. Read the vast majority of American newspapers and you will find that architecture—if it appears at all—is covered not as art or as urban planning, but as real estate. And then there is the academy, where, all too frequently, architecture is taught only as art—and then, in a theory-laden, mumbo-jumbo that those of us who speak normal English call "Archi-babble."

Whether it appears in newspapers or trade journals, too much of architecture criticism today focuses exclusively on those eye-catching, high-style essays by Frank Gehry, Rem Koolhaas, and the profession's other stars. We ignore their stunning structures at our peril, of course. But does it also make sense to neglect the far more pervasive buildings that aren't destined to be displayed on museum walls—the subway stations, the beach houses, the parking garages? It is far wiser, I believe, to open our eyes to the entirety of the built environment, including the seemingly natural landscapes of public parks, many of which, in reality, are man-made.

In contrast to the critic who is addressing an audience of professionals or academics, then, the newspaper critic has a special role to play: to be the indispensable link, as the *Wall Street Journal*'s Ada Louise Huxtable has so cogently stated, between the public and the public realm. Indeed, the very term "architecture critic" may be a misnomer. We are urban critics as much as architecture critics. (A more fitting, all-inclusive title might be "built environment critic," but that one doesn't exactly roll off the tongue.)

So the articles collected in this book reject a narrow, formal approach and instead follow one pioneered at the *San Francisco Chronicle* by Allan Temko. It is called "activist criticism." Does that mean I walk around Chicago with a picket sign? No, though some of the schlock buildings that have been going up lately sorely tempt me.

Activist criticism is based on the idea that architecture affects everyone and therefore should be understandable to everyone. It analyzes architecture as a fine art and as a social art, placing buildings in the context of the politics, the economics, and the cultural forces that shape them. Activist criticism invites readers to be more than consumers who passively accept the buildings that are handed to them. It bids them, instead, to become citizens who take a leading role in shaping their surroundings. Its fundamental purposes are these: to stop hideous buildings and urban spaces from disfiguring the landscape, and to introduce constructive alternatives into the public debate.

When you are an activist critic, you do not wait for mistakes to happen and then bemoan the results after the fact. You whack at the offending party with the journalistic equivalent of a two-by-four. In addition to hammering away at bad plans, however, an activist critic is obliged

to point the way toward good ones. Besides the two-by-four, in other words, the tools of the trade include a searchlight.

Sometimes, these tools get used in tandem, good-cop, bad-cop style, as in the six-part series on Chicago's lakefront that concludes this book. It castigates Chicago mayor Richard M. Daley for failing to plan the future of his city's greatest public space, but it also takes pains to navigate a better course—one that looks at the lakefront holistically rather than seeing it piecemeal. Subsequently, the mayor and his people commissioned plans for four of the shoreline's seven parks.

Does activist criticism always produce such satisfying results? Hardly, as the postscripts to these essays show; you lose as many battles as you win. Yet far more important than any individual outcome, as Huxtable has written, is what transpires in the ongoing dialogue between the critic and the reader—the standards that are formed, the sights that are raised, the way that a critic's observations enter and then alter the public discourse. In that sense, every review—not just the preemptive strike—is a form of activist criticism. For it is only by analyzing what we have built today that we can better grasp what to design tomorrow.

It helps to come to this task with a set of consistent but flexible principles rather than a rigid ideology and a desire to impose it on everyone else. I believe in quality, so that buildings are well-crafted as well as well-designed; in utility, so that buildings serve their inhabitants both functionally and spiritually; in authenticity, so that buildings are rooted in reality, not fantasy; and in continuity, so that buildings engage in civilized dialogue rather than ignoring (or, almost as bad, mimicking) one another. Above all, I believe in the power of architecture to make genuine places rather than generic cityscapes and that architecture should adorn human activity rather than direct it.

If architecture matters in a school in Chicago's gang-plagued Back of the Yards neighborhood, for example, then that sends the message that education matters, too. That's why I place a premium on architectural innovation—not only because it has the capacity to elevate construction to the level of art, but also because it can enrich and expand human possibilities. While it is naive to expect that better buildings will make better people, it is equally foolish to ignore the subtle yet significant impact that the built environment has on our visions and, thus, our actions. The choices we make in creating that external world speak volumes about our inner values.

No city better illustrates the consequences of such choices than Chicago. As the historian Perry Duis has suggested, Chicago often serves as the great American exaggeration, expressing at larger scale—and often

in excruciating contrast—design trends evident elsewhere in the country. For years, it could claim to be the home of both the world's tallest building, Sears Tower, and the world's largest public-housing project, the Robert Taylor Homes. Even though Sears Tower lost its world's-tallest crown to Malaysia's Petronas Twin Towers in 1996, the city and its suburbs remain an astonishingly accurate barometer of the fortunes and the misfortunes of American architecture and urban planning. Both were very much on display in Chicago during the 1990s.

These essays, which originally appeared in the *Tribune* and have been adapted for this book, span a period in which architecture went from bust to boom and architects stopped driving cabs and started drafting condos. Yet for all these years did to enlarge bank accounts, they hardly swelled self-confidence, either among architects or in the culture at large. Instead, this era presented the unlikely combination of unparalleled affluence and underlying anxiety, the latter visible in everything from the fear spawned by corporate downsizing to the loathing expressed by antiglobalization riots. The Internet epitomized the decade's double edge, enabling us to shoot e-mails across the ocean with the flick of a keystroke but speeding up life to a breakneck pace—24 hours a day, 7 days a week, or, as it became known, "24/7." So much for the Extravagant Eighties. Welcome to the Nervous Nineties. Little in this tumultuous 10 years seemed anchored to old patterns of living, least of all our buildings and urban spaces.

Americans who thought they were immune from terrorist violence were jolted on February 26, 1993, when a bomb-laden van exploded at the World Trade Center in New York City, killing six people and injuring more than 1,000. A little more than two years later, on April 19, 1995, a truck bomb detonated at the Alfred P. Murrah Federal Building in Oklahoma City, killing another 168 people, including 19 children, in the worst terrorist attack on American soil. The explosions did violence to more than their intended targets; they spawned a fortress mentality that trampled upon the nation's tradition of accessibility and openness. The most visible change came in a three-block stretch of Pennsylvania Avenue in front of the White House, which then-President Bill Clinton closed to traffic shortly after the Oklahoma City bombing. Yet the bunkering of America extended from newly fortified Capitol Hill to New York's cordoned-off City Hall, and from guarded and gated subdivisions to older neighborhoods that were outfitted with new shields. In Chicago, responding to a crime wave, Daley barricaded city side streets with cul-de-sacs, creating safe residential enclaves, but severing the social connections once forged by Chicago's ubiquitous street grid. Almost everywhere, it seemed,

the profoundly democratic notion of a public realm—where people and ideas both moved freely—was under siege.

There was more to jangle the nerves of stressed-out Americans; the very landscape beneath them was shifting, altering habits and habitats alike. As part of the frenzied "24/7" way of life, the computer modem turned the home into an extension of the office rather than a refuge from it. Yards shrank in size, yet houses got ever larger, with oversize "McMansions" looming above modest ranch houses and throwing the once-serene landscape of countless suburbs into disarray. Suburbs, sporting new skylines but choking on traffic, came to look more and more like cities, while cities, suffering an outbreak of strip malls and theme parks, increasingly resembled suburbs. Even that familiar icon of twentieth-century America, the skyscraper, assumed a strange new identity, at least in Chicago. In the past, skyscrapers were built largely to contain offices and apartments while the broadcast antennas atop them were an economic afterthought. But in a new world's-tallest-building plan for Chicago's Loop, antennas became the building's chief reason for being; offices and condos would simply stretch into the sky to meet these giant rabbit ears. Or so, at least, it was thought. The newfangled arrangement ultimately collapsed, the victim of a very old-fashioned problem: the developer couldn't come up with enough cash to finance his dream.

Chicago's skyline thus lost an opportunity to establish a clear focus—"the center of the tent," as Adrian Smith, the architect of the foiled plan, called it. Much the same could be said about architecture in the nineties: the field was without a discernable core. In contrast to the dominance of International Style modernism in the postwar era or the pervasive postmodernism that followed, no single style held sway. Nor did any architect stake out a broadly agreed-upon direction, Gehry's triumph at the Guggenheim Museum in Bilbao, Spain, notwithstanding. Indeed, for all the hype that this was "the age of the architect," architects often were shoved to the margins of the very process they once controlled, their authority usurped by "value engineers" whose chief role, it seemed, was to squeeze all the love out of buildings.

Still, the nervousness of the time managed to lace itself through almost every aspect of the built environment. There were, first, the nervous buildings, their designers deliberately making architecture off-kilter in an attempt to evoke the chaotic quality of modern life. "The real world today," Gehry said, "comes hurtling at you like a runaway truck. . . . That's the energy I try to harness in my work." With its spectacular, sculpted walls of titanium, his Guggenheim was the prime example—the secular cathedral of the age, a place to which people from around the world made pilgrimages. In an apt

bit of symbolism that perfectly summed up the period, its climactic interior space had no clearly defined center.

The Guggenheim, whose complex curves were made possible by the same software system used to design French Mirage jet fighters, also revealed the singular importance of the computer and the shift, as Koolhaas cleverly termed it, from brick and mortar to "click and mortar." For even as the computer intensified the widespread feeling of convulsive change in everyday life, it allowed architects to express that change by freeing them, as no technology had done before, from the bonds of orthodox, right-angled geometry. Buildings no longer had to play it straight, as they did in traditional post-and-beam construction, because the computer could work out the structural problems posed by endless complex angles. Now they could tilt. They could curve. They could warp. Even among mainstream modernists whose projects were less radical than Gehry's, "dynamism" became a buzzword, diagonal forms a cliche.

Then there were the retro buildings: retro skyscrapers, retro ballparks, retro condominiums, and retro libraries that looked as if they had been designed at the turn of the century—the last one. There even was retro modernism, evident in the new but old-in-spirit Arts Club of Chicago, which yearned for the aesthetic certainty of the mid-twentieth century. To be sure, there always is a tension between tradition and innovation, a conflict exemplified in the Chicago of the 1890s by the neoclassical World's Columbian Exposition of 1893 and its reaction against the city of soot-covered skyscrapers then taking shape in the Loop. But the 1990s ushered in a new variation of this theme—the soothing retro building, or as one designer of a very-determined-to-be-old-fashioned condo tower put it, "comfort architecture." If globalization and the explosion of communications technology ratcheted up the tension in everyday life, then comfort architecture presented buildings that sought, by virtue of their go-down-easy familiarity, to tamp down the very stress that architects like Gehry were so intent upon expressing.

Finally, there were buildings that were neither nervous nor comforting, but painfully plain. They served up a reminder of what the 1990s were really about—"It's the economy, stupid," as the Clintonites were fond of saying. This was a new Gilded Age, but it did not gild its major commercial buildings, as the princes of prosperity had done in decades past. Instead, it delivered a new, stripped-down architecture—not the austere, elegant modernism of Mies, but designs that aspired only to contain the most possible space for the least possible cost. Developers always have conceived of buildings as three-dimensional investments, of course. Yet in the 1990s, marching to Wall Street's tune as never before, they were far

more likely to value short-term profits over long-term quality—and thus to put their money in private amenities rather than architecture's public face. This trend was evident in Chicago's new condominium towers, the worst of which were like public housing for the rich, and in the city's new North Bridge district, an architecturally lifeless, nine-block tourist zone just west of Michigan Avenue. In the eighties, when real-estate developers erected postmodern trophy buildings to lure law firms and other tenants, it was an insult to call a building plain. In the nineties, that was precisely the outcome desired by cost-conscious business leaders.

Between the late nineteenth century and the middle years of the twentieth, Chicago made its reputation as a city that fearlessly embraced the future, transforming everyday uses into extraordinary architecture. From the Reliance Building to the Hancock Center, many of those masterpieces are covered in these pages. Yet in the nineties, Chicago simultaneously found itself as a city and lost its architectural nerve, reveling in an unprecedented wave of construction in its downtown and in many neighborhoods, but muffing chance after chance to live up to its legacy of risk-taking innovation. If the newly bustling State Street symbolized the renaissance of urban America, then backward-looking buildings like the Harold Washington Library Center spoke to what Robert Campbell of the *Boston Globe* has dubbed "the boldness gap"—a failure to live up to the standards set by adventurous architecture in Europe and Japan.

Today, we have blandness, not boldness. Retailers from the suburbs and national chains want cookie-cutter buildings in the city; shopping choices expand as architectural possibilities contract. Just look at the destruction of the once-great, Beaux-Arts ensemble of North Michigan Avenue. The issue that underlies the tawdry new storefronts there is how planners and the private sector respond to the drive for standardization—by caving in or by working aggressively to maintain a sense of place. On Michigan Avenue, they've caved. On State Street, for the most part, they've held their ground. Ain't Chicago great? It's one city, with two schools of urban planning.

There are other ironies at work here. To his great credit, Daley has rushed to save old landmarks from the wrecker's ball. But the aesthetically conservative mayor and his subordinates have hindered the making of new landmarks by quashing forward-looking designs. Also under Daley, Chicago has been in the forefront of a national trend that has upgraded the design of streets, bridges, and other infrastructure. Yet even as Chicago rightly emphasizes the spaces that connect buildings, it has only begun to link those who live in the isolated clusters of public housing with the rest of society. Closed-off streets remain closed. Far too little low-income housing has been built.

Recently, federal and local officials have started to tear down crumbling high-rises. But the demolitions simply raise another question: how do we weave the poorest of the poor into the fabric of American life rather than simply replace vertical ghettoes with new horizontal ones?

More challenges loom, from reigning in suburban sprawl to coming to grips with the impact of the Internet. Perhaps they're related. The vehicle-oriented landscape of sprawl separates us in all those cars, pickups, and SUVs; the World Wide Web, despite its popular chat rooms, threatens to make us even more atomized—alone and anonymous in a world of intangible pixels. But if newly thriving suburban business districts and the astounding popularity of Chicago's Cows on Parade public art program offer reliable signs, then sprawl and the Web actually are whetting our appetite for the tangible, the tactile, and the social. Technology comes and goes; the need to gather stays.

As ever, the quality of the built world depends on the choices we make; increasingly, the impact of those decisions spans the borders of city wards, individual municipalities, and even states. The sweeping regional plans now being drawn up for Chicago and other cities attest to that.

But it is probably unrealistic to put too much stock in the regulatory role of government; in the end, the marketplace and the marketplace of ideas are far more positive—and powerful—agents of change. We look to the art of architecture to clarify the human condition and to express the spirit of the times. Yet it is equally important that architecture engage contemporary problems and processes rather than merely comment on them or on itself.

Every building is a new piece of the evolving metropolis, a new layer of the ever-changing urban collage. This collective work of art forms an unflinching record of who we are and what we do. It connects us in time and space to those who went before us even as it represents our legacy—for better or for worse—to those who come after.

That is why architecture matters.

That is the story of what follows.

Part One

The Evolving Metropolis

As a new millennium was born, Chicago, once on the ropes with the rest of the Rust Belt, bounded back—not as strong as it once was, but still an urban powerhouse. Construction cranes filled the skyline. Thousands of old houses were torn down and replaced by new ones. The city even learned that its population had grown for the first time since the 1950s, rising to nearly 2.9 million during the 1990s, a gain of more than 100,000 people. The most visible sign of recovery was a surge of building that recalled the words of the poet Carl Sandburg: "Put the city up / tear the city down / put it up again / let us find a city."

Yet this was a very different city from the old Chicago—more apt to sip a Starbucks than to down a shot and a beer, just as likely to play as it was to work. Necessity, it was clear, had been the mother of this reinvention.

Former bedroom suburbs now dominated the region, so the city—which no longer claimed the majority of the area's jobs—was forced to remake itself into a tourist-friendly shopping and entertainment mecca. Ideally, as a push to preserve historic buildings showed, the new emphasis on tourism meant reinforcing Chicago's matchless urban character. Yet in reality, as glitzy, theme

park attractions suggested, the city often wound up copying the very suburbs with which it was competing.

The issue was how to respond to change: by letting real-estate developers shape the city or by guiding growth through planning. Two very different answers emerged on Chicago's showcase streets, State Street and North Michigan Avenue. The results were an object lesson in the art of city-making.

An urban wasteland when the decade began, its 1970s transit mall bleak and unappealing, State Street began an astonishing recovery—not just commercially, but aesthetically, with renovated storefronts and subway stations, and a new but old-fashioned streetscape. None of these projects was architecturally adventurous, yet they enhanced the street's special sense of place and went a long way toward making "that great street" great again. A notable exception was the botched, city-backed plan for the biggest vacant lot along State Street, a property known as Block 37. Overall, however, State's fortunes were on the rise.

"The Magnificent Mile," as North Michigan Avenue was dubbed by real-estate magnate Arthur Rubloff, presented another, sadder story. Once an extraordinary collection of Beaux-Arts buildings, a Paris on the Prairie that emerged from Daniel Burnham's great 1909 Chicago Plan, the Mag Mile continued its postwar path of unbridled growth. City officials professed that they saw nothing wrong with the street's development; they stuck to their policy of laissez-faire. The outcome, as represented by a new Disney store and a renovated Marriott Hotel, was predictable: an acceleration of the descent into design mediocrity that began in the 1970s with Water Tower Place. Daley's plan for a piece of public art at the gateway to North Michigan symbolized the depths to which the street had sunk.

THE MEDIOCRE MILE

The Mayor's Maypole

Boul Mich Pylon Plan Reason to Hoist Warning Flags

MAY 1, 1997

With no public hearings, one of Chicago's great public spaces is about to be defiled by an overscaled, overwrought, absolutely unnecessary piece of decoration—a flag-draped, cast-aluminum pylon, taller than a seven-story building, that will be stuck like a maypole in the middle of Michigan Avenue.

Let's call it the Mayor's Maypole, since Mayor Richard M. Daley has seen and approved it.

When it is erected at Michigan and Wacker Drive as part of the rebuilding of Michigan Avenue south of the Chicago River, this florid excrescence will be 75 feet tall, with a stylized version of the four-star Chicago flag draped from its crossbar. The pylon will rise from a 12- to 15-foot-wide median, a few feet broader than the one that existed before the reconstruction began this year.

City engineers assure that the new median will not disrupt the flow of traffic. But it surely will disturb the delicate balance between buildings and open space, solids and voids, that makes the area around the Michigan Avenue Bridge a district of extraordinary dignity and drama.

Built in 1920, the bridge is much more than a way to get from point A to point B. It is a place as much as a passageway, a civic gateway to both the Magnificent Mile and the Loop. That is due not only to its four Beaux-Arts bridge-tender houses, but also to the soaring '20s skyscrapers that roughly correspond to each of its four corners.

To the north are the Spanish Revival Wrigley Building and the neo-

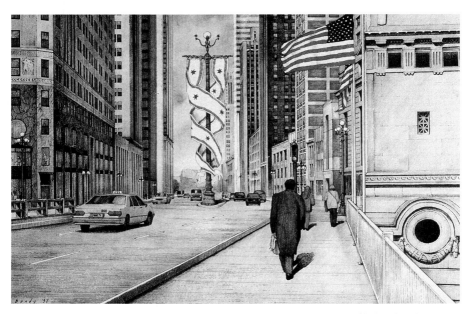

THE PLAN FOR A PYLON SOUTH OF THE MICHIGAN AVENUE BRIDGE: Not knowing when to leave well enough alone.

Gothic Tribune Tower. To the south are the stepped-back Art Deco sliver of the 333 North Michigan Avenue Building and the bowed, neoclassical 360 North Michigan Avenue Building, with its crowning belvedere.

What is remarkable is the way these four buildings, all designed by different architects over the course of a decade, are perfectly attuned to one another, at once formidable individual presences and part of a coherent urban ensemble.

Together, their walls frame an outdoor space that is comparable to a room. And what a room it is—an expanse of water and sky that cracks open the tightly defined corridors of office buildings that mark the approaches to the bridge.

Even those approaches are spectacular. Both the Wrigley and 333 North Michigan Buildings take advantage of a slight diagonal jog the Michigan Avenue Bridge makes, seemingly looming up from the middle of the street and drawing the traveler onward. Once the bridge is crossed, the facades of the four towers imperceptibly reorient you, making what could have been a jarring interruption seem so well orchestrated as to be inevitable.

The area around the bridge, in short, is as close to perfect an urban space as one can get. No one has ever complained about it. Yet, officials in

the city's transportation department, who have done exemplary work renovating bridges elsewhere in the city, have managed to persuade themselves—and the mayor—that a better gateway to the stretch of Michigan Avenue south of the bridge is needed.

Voila!

There will be not one pylon, but two, as part of a $5 to $6 million expansion of the Michigan Avenue rebuilding, originally priced at $16 million. Pylon number 2 will be located at the southern entrance to downtown, at Michigan Avenue and Roosevelt Road. The idea, according to Howard Decker of DLK Architecture, the firm shaping the changes, is to have three vertical markers (the third being the historic Water Tower) at key points along Michigan Avenue. The pylon at Wacker, he says, will complement what the buildings and the bridge pylons already do, acting like a hinge that turns the traveler to the south.

There is a curiously circular logic to all this. The real city works just fine as a gateway. But we supposedly need a piece of decoration that will reinforce and represent the gateway that already exists. Such redundant symbolism does not come cheap. The total cost for the pylons will be about $350,000. And there will be additional costs to the public realm.

The city has yet to commission a study, by either DLK or an independent source, to assess whether the pylon will block the view of the Wrigley Building as one looks from the south to the north. That, simply put, is an astounding omission, nothing less than a breach of public trust. Given how thousands of people enjoy that vista every day, there is no way this project should have moved forward without such a study.

Little thought also seems to have been given to the materials that will be used for the pylon and the impact they will have on the character of the bridge district. Those banners, for example, actually won't be banners. They will be made of perforated metal, allowing the wind to pass through them. But the metal, no matter how well it is built, invariably will bring a certain tinniness to a district recognized for built-for-the-ages solidity. How will it withstand the weather? Will it rust? A gutter, ripped off a house by a hurricane and wrapped around a light pole, already comes to mind.

So do ancient, tattered pictures of State Street's retail palaces, draped in red, white, and blue bunting to celebrate some patriotic occasion. That is because the pylon's architecture, as much as its banners, will be a throwback to the Victorian era. Its decorative froufrou is to include, atop the pylon, a globe and four stars that will light up at night.

In fairness to Decker, the architectural details of the pylon are a work in progress. But architecture really is beside the point here. The pylon is a

major urban design mistake. Worse, it is progressing with no input from the public that will have to live with it. Instead of running the idea up the flagpole, so to speak, the city shopped it to so-called stakeholders like the Central Michigan Avenue Association. Its members are said to have approved—perhaps because they want to draw attention to their frumpy, easily ignored business district, making it more like the Mag Mile.

The trouble is, we all have a stake in the area around the Michigan Avenue Bridge. As much as the lakefront or Daley Plaza, it is sacred turf, meant to be treated with great reverence and respect. Instead, it is being killed with kindness.

There is a time to tinker and a time to leave well enough alone. Every generation faces the question of whether it should improve upon the achievements of its ancestors or act as selfless stewards of the past. This is one instance in which adding to an urban space definitely will subtract from it.

How about if Hizzoner marks May Day by canning the Mayor's Maypole?

Postscript

Daley abandoned the pylon plan in June 1997. The median space that would have been devoted to the maypole was instead given over to a less intrusive, more appropriate use—planter boxes comparable to those on Michigan Avenue north of the bridge.

Twice Cursed

Rehabbed Marriott Is Miles and Miles from Magnificent

DECEMBER 29, 1998

It's too bad that our urban eyesores can't be exchanged as easily as unwanted Christmas gifts. They seem to stick around forever, like that holiday guest you can't wait to usher out the door. In the process, they give new and distressing meaning to the notion that architecture is the inescapable art.

For 20 years, no building more painfully exemplified this idea than the Chicago Marriott Hotel at 540 North Michigan Avenue, a concrete monstrosity that blighted the Magnificent Mile. Even its designers, the otherwise talented firm of Harry Weese & Associates, deigned not to put a picture of this faceless clunker on their office walls lest the building scare off potential clients.

Yet now that the base of the Marriott has been given a long-awaited,

THE MICHIGAN AVENUE MARRIOTT: Originally a concrete monstrosity; hardly any better after a flashy makeover.

$20 million makeover, it seems fair to ask whether there's a curse—a design curse—on this block, like the hex the owner of the Billy Goat Tavern once put on the Cubs. For in its own flashy way, the new Marriott is nearly as bad as its brutishly stolid predecessor—the most garish, ill-composed addition to North Michigan Avenue in years.

At least the old Marriott was quietly ugly.

Its top didn't poke at you with shiny blades that resemble Cadillac tail fins. Its walls weren't covered with green glass that creates distorted reflections of the buildings around it. It didn't have scores of silly-looking steel buttons protruding from its facade. It didn't look like it belonged in a Dallas shopping mall.

And that is the real trouble with this building—that it could be anywhere, not just Dallas, but Denver, or Seattle, or Boston.

We live in an age of interchangeable architecture that is eroding the regional differences that once lent a distinctive flavor to American cities. Lots of things account for this blurring of public places—computers, jet travel, architects copying their peers. But the profusion of megastores, those temples to consumption that depend upon cast-in-chromium images to move merchandise, is the latest engine driving this trend. The

new Marriott, which has been reshaped to make room for a Virgin mega-store that fairly bursts with Sun Belt glitz, is no exception.

Nothing could be more different from the unpretentious Art Deco building that graced the site before the old Marriott muscled in in 1978. Its jewel was a semicircular interior courtyard surrounded by shops on two levels. Diana Court, it was called, for its fountain of Diana, the goddess of hunting, by the sculptor Carl Milles.

Old-timers still rue its loss, and for good reason: this was the kind of architecture that let you know that you were on North Michigan Avenue, and nowhere else.

High Expectations

When the Marriott renovation was announced as part of John Buck's $1.5 billion North Bridge development, which will include Chicago's first Nordstrom store, a Walt Disney Co. indoor theme park, and three hotels, the conventional wisdom was that putting a new face on the building would be a plus.

The architects, Chicago's DeStefano and Partners, planned to cover most of the nearly windowless, concrete base of the Marriott with different shades of a green granite that was supposed to harmonize with North Michigan's few remaining prewar limestone buildings. It sounded promising, even if the Marriott's 46-story hotel tower would go largely untouched.

But a change in materials alone does not a handsome building make, just as a single ingredient doesn't guarantee a perfect meal. The recipe for delectable design nearly always calls for good proportions, pleasing rhythms, finely honed details, and a creative intelligence skilled at fusing the disparate parts of a building into a satisfying whole. The latter quality, in particular, is absent here.

The Marriott used to have too little richness of detail. Now it has far too much, like a starving man who gorges at a smorgasbord. To call this overdesigned mess "an improvement," as some charitable sidewalk critics are doing, is to acknowledge just how far expectations have fallen for a street that once was the most handsome boulevard this side of the Champs-Elysées. It's like saying that the Chicago City Council is having a pretty good year because you can count the number of aldermen sent to prison on a single hand.

To be fair, DeStefano and Partners were up against severe constraints. First, they could only paper over the exterior of the building rather than fundamentally alter it. So while the new, dark-green granite base of the Marriott is reasonably dignified, the main entrance to the hotel and its arched hallway remain pitifully small.

In addition, the architects could not punch real windows into the Marriott's concrete facade because the ballrooms and conference rooms behind it are supposed to be illuminated only by artificial light. So they had to trick up fake windows to lighten the Marriott's blocky mass.

The architects say Buck also declined their request to clad the entire bottom of the hotel in granite instead of refacing only the Michigan Avenue facade, the Rush Street entrance, and parts of the Ohio Street and Grand Avenue facades. As a result, the granite, which is supposed to create the illusion of being several feet thick, is revealed for what it is—a roughly inch-thick veneer. Along Ohio and Grand, where the new stone butts awkwardly against the old concrete, it looks like someone ran out of wallpaper.

Despite these obstacles, the architects still might have performed better. Certainly their basic idea—splitting the Marriott's banal mass into three horizontal layers comparable to the base, shaft, and capital of a classical column—was sound. It's the way they handled it that grates.

Take the square, light-green granite panels affixed to the upper facade with shiny steel buttons. Not only is this one of the biggest design cliches of the 1990s, present also on the Museum of Contemporary Art, but it is totally mishandled here. The vast, unbroken expanses of stone at the Michigan-Ohio corner make the building practically indistinguishable from a mausoleum.

Or take those big projecting "windows" the architects have attached to the facade—four along Michigan, two on Ohio. True, they endow the facade with some much-needed rhythm while the white ceramic stripes baked on their surface give a pleasing sense of texture. But when the windows are lit from behind at night, they become more like signs whose real purpose is to draw attention—and shoppers—to the Marriott. It's a bigger version of a similar device at Buck's adjacent 600 North Michigan Building, where four light fixtures are stuck on the facade and hideous red neon glows from within a cinema lobby.

This show-off architecture reaches its nadir in the choice of materials for the top of the renovated base—light-green reflective glass and a shiny aluminum tube punctuated by those tail-fin blades. These futuristic details, which already look dated, are at war with the traditional treatment of the bottom of the hotel, making the overall effect a bizarre mix of post-modern classicism and George Jetson modernism.

Rush Street Entrance

A rare bright spot on the new exterior is the reconfigured Rush Street entrance, which has a handsome glass canopy. But coming at the base of the old Marriott's 46-story wall of concrete, its impact is negligible.

Inside, things are better, though not markedly. The architects have skillfully transformed the lobby by removing escalators and lowering the ceiling about 20 feet. Not only did this change carve out room for the second floor of the two-level Virgin store, but it also made the lobby less of a dizzying atrium and more of a comfortable, roomlike space.

Unfortunately, the lobby was then turned over to decorators who gave it utterly banal furnishings, like chandeliers that seem right out of King Arthur's court and a laminated glass ceiling that is somebody's idea of faux alabaster. This has absolutely nothing to do with the hotel's new exterior.

Virgin, too, has its trademark look, a flashy, loftlike interior whose vast spaces are meant to symbolize an enormous selection of music titles. The idea, as the store's manager says, is that "you walk in and go, 'Wow! This place is huge.'"

It's a long way from the extraordinary elegance of Diana Court to a megastore whose prime selling point is the "wow" effect. Yet that is what has become of the once-Magnificent Mile—consumerist heaven, design netherworld. The new Marriott sums it up: look-at-me architecture, glitz rather than good taste, and the extinction of the regional differences that gave American cities their special sense of place. Won't somebody move this building to Dallas?

Faking History

Disney's Make-Believe Architecture Is Just What Michigan Avenue Doesn't Need

AUGUST 5, 1999

Judging by the grotesque exercise in architectural make-believe that is the new Disney Store in Chicago, the old adage that a cat can't change its stripes also applies to a mouse named Mickey.

To hear Disney's people tell it, the new retail outlet on the Magnificent Mile is not an insensitve, generic design that belongs in a mall, but a respectful homage to North Michigan Avenue's tradition of storefront retailing and Chicago's vaunted architectural heritage.

They point, in particular, to a decorative facade that evokes the swirling, intricate, nature-inspired ornament of the late, great Louis Sullivan, whose Carson Pirie Scott store on State Street is an icon of the turn-of-the-century Chicago School of Architecture.

In this case, however, imitation turns out to be the lowest form of flattery.

Poor Sullivan. Chicago already has torn down several of his master-

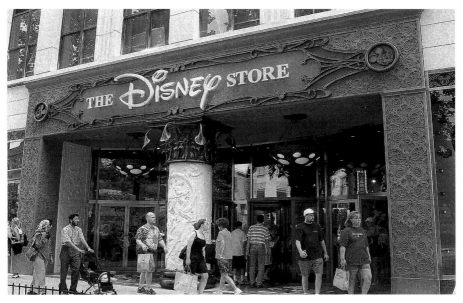

THE DISNEY STORE: Insulting the organic ornament of Louis Sullivan.

pieces, including the Chicago Stock Exchange Building in 1972. Now it is erecting vulgar, cartoonish versions of them. Look closely and you'll see that the exterior of the new Disney Store is covered with, according to my unofficial count, more than 170 pairs of mouse ears.

As for Walt Disney being a native son of Chicago—the store surprisingly makes no acknowledgment of that illuminating fun fact.

The Disney Store is a small but telling example of the way America is turning into a landscape of studied fakes that devalue the very history they pretend to honor. It also represents the latest chapter in North Michigan Avenue's descent from an exquisite ensemble of Beaux-Arts buildings to a crass visual jumble. Now, in contrast to the urban civility that once prevailed, it's every building for itself.

Shaped by an in-house Disney team, the design is based on this singularly Disneyesque pretense: the Disney Store has been at 717 North Michigan Avenue for more than a century and its facade has been altered over the years, as storefronts typically are.

So the brown terra-cotta panels that surround the vestibule represent a tip of Mickey's top hat to Sullivan and to the grandly scaled, arched entrances he created for the Stock Exchange, completed in 1894, and the Transportation Building at the 1893 World's Fair in Chicago.

A stubby white column with bas-relief sculptures of Disney characters

recalls the Depression-era realism of the 1930s, while the instant history races into the present in the vestibule, where a brightly colored terrazzo tile floor portrays a hip-looking Mickey and Minnie Mouse standing before a jazzy skyline. As a member of the Disney design team says, in the lingo of Hollywood, the tiles are the "opening credits to the story you see before you."

All this has a superficial appeal akin to the nostalgic Victorian architecture of Disney's Main Street U.S.A. There is human scale and humor. No one would call this building a one-liner. You won't be able to grasp it all in a single visit. It will seduce you into coming back.

But something in this picture isn't right—actually several things. First, the history is bogus: imagining that Louis Sullivan or any other architect would have designed a store on North Michigan Avenue at the turn of the century is preposterous.

There was no North Michigan Avenue in 1890—only a humble strip known as Pine Street, lined with saloons and soap factories. It wasn't until 1920, when the Michigan Avenue Bridge opened and Pine Street was widened and given its present name, that fancy shops began appearing north of the Chicago River.

With the store's exterior a fantasy, it is all the more disappointing that the Disney designers did not make use of the real history at hand. Walt Disney was born in 1901 on Chicago's Northwest Side in a small wood-frame house that was built by his father, a carpenter who worked at the 1893 World's Fair. At the very least, given the way Disney's creativity has touched the lives of billions of people around the world, a small window display covering the subject would have been appropriate.

But why bother with real stories when they might break the spell cast by the ones you've invented?

As for the Disney Store's many design flaws, consider that Sullivan once said he wanted his ornament to be of the building rather than on the building. In other words, his ideal was that decoration would seem to grow organically out of a building's structure rather than being grafted onto it. "A certain kind of ornament should appear on a certain kind of structure, just as a certain kind of leaf must appear on a certain kind of tree," Sullivan wrote in 1892. "An elm leaf would not 'look well' on a pine-tree—a pine-needle seems more 'in keeping.'".

Surely, then, Sullivan would be horrified that the Disney Store's dark terra-cotta facade has been plastered onto the three-story, light-gray building—no landmark, but handsome enough—whose ground floor the store occupies. And he might think it worse that garish red tile sets off the

gold letters that read "The Disney Store," making it appear as if Mickey has switched from running a fun house to hosting a house of ill-repute.

There are other faults. Compared with Sullivan's ornamental metalwork at Carson Pirie Scott, which has extraordinary depth and intricacy, the Disney Store terra-cotta looks flat and featureless. Nor is there much in the way of visual variety, another hallmark of Sullivan's ornament. The pattern on the terra-cotta looks as if it's been stamped out of a mold, while its curving lines form—oh no!—a stylized head and mouse ears.

Indeed, the closer you look at the Disney Store, the more mouse ears you see. They are everywhere—in the circles that ape similar geometry in Sullivan's arches, in the faux scrollwork around the letters that spell out the store's name, in the chandeliers within the vestibule, in the decoration surrounding the storefront windows, and in outlines formed by curving red walls in the windows themselves. The end result: the Disney Store is as much a billboard as it is a building.

How all this got by the Greater North Michigan Avenue Association, which monitors developments on the Boul Mich, and Ald. Burton Natarus (42nd), who worked himself into a snit when Victoria's Secret put racy pink underwear in the windows of its North Michigan store in 1996, is hard to fathom.

Pedestrians know an eyesore when they see one; I'm already getting nasty e-mail on this topic from normally peaceful people. Says one: the Disney Store "completes the vulgarization of North Michigan Avenue. . . . Sign me up on your team to throw bricks through the windows."

Hold the bricks. At least there are windows.

In contrast to the walled-off interior of Niketown—or, for that matter, the new Disney Quest indoor theme park, which opened in April 1999—the Disney Store adheres to North Michigan Avenue's tradition of big-city retailing, which stresses see-through storefronts that entice passersby and enliven the streetscape.

The inside of the store, which depicts Mickey and friends filming a movie about Chicago and features playful depictions of several Chicago landmarks, is much better than the outside. With a couple of exceptions (lackluster versions of the Art Institute of Chicago and the Wrigley Building), it is carried out with the flair and attention to detail that are Disney hallmarks.

The store has interactive buttons that allow the customer to get a taste of the Disney theme-park experience while distinguishing it from the more than 20 other Disney Stores in the Chicago area. Push one of the buttons and you see a miniature, 3-D cow engulfed in fake flames that

symbolize the Great Chicago Fire. (This being Disney, of course, the blaze gets put out.)

I don't mean to make too big a deal about this little store. Certainly, like Niketown, it will draw tourists to downtown, which can only be good for the city's vitality. But Mickey's debut on the Mag Mile symbolizes the Faustian bargain that Chicago is making as the theme-parking of the city advances from River North to Navy Pier and beyond.

Hello sales-tax dollars.

Good-bye elegance.

And good-bye history.

THAT COMEBACK STREET

Stately Street

Retro Renovation Puts a Once-Great Shopping Mecca on the Road to Economic and Aesthetic Recovery

NOVEMBER 15, 1996

Assessing the turn-back-the-clock, retro remake of State Street is a little like divining the prospects for a couple on their wedding day. Everyone's in a good mood, everything looks picture-perfect, and any underlying imperfections have been tucked away (or perhaps glossed over) so as not to spoil the occasion.

In truth, this may be the worst time to tell whether the $25 million renovation will restore the glory days of that once-great street. For even as State Street's now-discarded transit mall was furnished with trees, flowers, and bubble-topped bus shelters in the late '70s, there were predictions—which proved utterly unfounded—that the street might be about to undergo its biggest renaissance since the Great Fire of 1871.

A physical makeover cannot by itself alter the fundamental market forces that led to State Street's decline and boosted the fortunes of North Michigan Avenue and suburban shopping centers. But a redesign can alter perceptions of a city street as well as the reality of how it works. On that basis, it can be said that the renovation appears to be a major success and that State Street is poised for revival if (and only if) critical factors ranging from its day-to-day maintenance to its mix of stores are properly addressed.

There is a simple reason that talk of a revival can be taken seriously now, despite decades of decline: the chief designers, Skidmore, Owings & Merrill of Chicago, have worked an astonishing visual transformation,

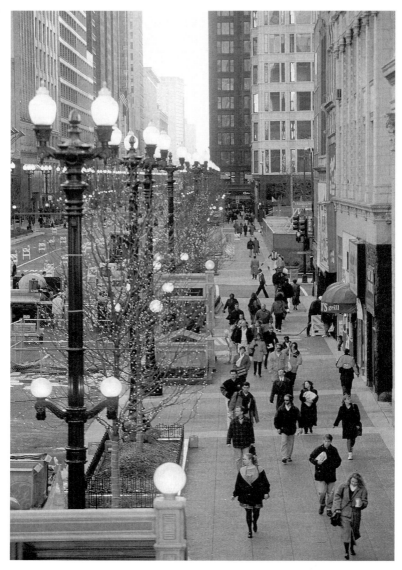

THE REVAMP OF STATE STREET: Turning a cold and colorless transit mall into an inviting public space.

turning the cold and colorless transit mall into a powerfully scaled, beautifully detailed and, above all, inviting public space. Just as significant, they have brought State back into the Loop's grid of streets by reopening it to cars and taxis, which means you can drop off the family at Marshall Field's or even do a little window-shopping from behind the wheel.

State Street, in other words, is again a magnet for strollers, not a mall for buses. Nowhere is that shift more apparent than in the historical lampposts that now line its sidewalks in the nine-block stretch between Wacker Drive and Congress Parkway; the lampposts are steel and cast-iron replicas of the ones designed for the street by the Chicago architects who carried on the legacy of Daniel Burnham. Not only are they extraordinarily handsome in and of themselves, but they also together frame a mile-long triumphal way that contrasts vividly with the depressing expanses formed by the transit mall's gloomy gray paving stones.

In that sense, despite its lack of aesthetic daring, the renovation is in perfect pitch with State Street's enduring song of Chicago. For all the battering it has taken—for all the hideous modern storefronts affixed to the ground floors of its muscular, turn-of-the-century commercial palaces—State Street retains a machismo and a magic that few other streets in America can match.

So it is altogether appropriate that Skidmore's Adrian Smith and his associate, Peter Van Vechten, have not Disneyfied this grand avenue by making it a miniaturized, cutesified version of some mythological Main Street. Rather, they have let State Street be State Street—at once strong and delicate. If their fusion of styles including the Prairie School, Art Deco, and the Beaux-Arts is not fabulous, forward-looking architecture, then surely there is something to be said for its solid, straightforward historicism—and the way it heals the wounds inflicted by modernist architects and planners.

A Good Match

For the first time in nearly 40 years, the street furnishings of State Street—its light posts, its Chicago Transit Authority stair and escalator enclosures, even its tree grates and air vents—are in aesthetic harmony with its historic buildings. With 20 bronze plaques inserted into the sidewalk as part of a self-guided tour of the street's architectural landmarks, visitors should notice such long-ignored gems as architect Howard Van Doren Shaw's eclectic Mentor Building at 39 South State Street (Shaw's only skyscraper)—and merchants should realize the value of historic preservation if, as expected, the self-guided tour brings customers to their doorsteps.

All this marks a sea change from the way State Street has been treated since its first makeover in 1958, a year that not surprisingly coincides with the high-water mark of postwar modernism and the ongoing flow of city dwellers and their shopping dollars to suburbia. To look at old newspaper photographs that show what was done to State Street back then—with ghastly George Jetson light fixtures replacing the elegant,

Beaux-Arts lampposts of 1926—is to witness the same technological hubris that rammed expressways through city neighborhoods and brought down landmarks by the score.

It has become clear with time that the 1979 renovation, which replaced a traditional big-city street with a two-lane roadway restricted to buses, was even more misguided. Not only did the transit mall's widened sidewalks and the absence of cars make State Street seem empty even when throngs of pedestrians were present. But its reedy modern light posts lacked the robust presence that enabled the original fixtures, by Chicago architects Graham, Anderson, Probst and White, to gracefully shape the public space between building fronts and the curb line.

Moreover, the boxy modern forms of CTA stair and escalator enclosures—as well as the bubble-topped bus shelters that were supposed to give CTA patrons a measure of creature comfort—blocked views of storefronts, irking merchants. Of course, those features did not cause the departure of Goldblatt's, Sears, Montgomery Ward, and Wieboldt's from State Street, but they nonetheless conspired to bring about the street's decline.

Understated Good Taste

What is so attractive about the Skidmore renovation—done for the city's Department of Transportation in cooperation with the Greater State Street Council—is the way it restores and improves upon the 1926 version of State Street, as if to say: it was a mistake to rid the street of its Beaux-Arts infrastructure, just as it was wrong to lose the historical light fixtures that have been so dazzlingly brought back to South Michigan Avenue; now, let us create a more perfect State Street.

That this has been done in understated good taste—free of the florid Victorian form-making that characterizes the new boulevard signs and kiosks erected this year throughout the city—is precisely what one would expect of Skidmore, for over the years the firm has shown the ability to design just about anything tastefully.

There is no gratuitous straining for effect in any of its moves, and there is plenty of good, old-fashioned common sense—the kind that should help the new State Street wear well after Mayor Richard M. Daley cuts the reopening ribbon.

Take the new eight-foot-wide planters, for example, with their honey locust, ash, and pear trees as well as colorful shrubs selected by Skidmore and Chicago landscape architect Ted Wolff. Yes, they recall North Michigan Avenue, but they also promise to be sturdy because their granite curbs are solid 8-by-12-inch hunks of stone—which will be far less likely to chip than a veneer when snow shovels whack them.

Or check out the 30-foot-high lampposts, with their stylized acanthus leaves and their distinctive "Y" decoration, a hallmark of early twentieth-century Chicago infrastructure that symbolizes the confluence of the North and South Branches of the Chicago River. Updating the Graham, Anderson, Probst and White original, Skidmore designed acorn-shaped glass fixtures that cast lots of light onto the street. The firm also added milky-white plastic globes near the base to give the monumental lamp-posts a human scale. Beneath the fixtures supporting the white globes are tiny purple ones that provide a subtle dash of color to the street, as do the forest green lampposts, the alternating bands of reddish and gray side-walks, and the thin strip of red neon that now marks the gateways to CTA escalator and stair enclosures. How nice. A red line for the Red Line.

In contrast to the boxy minimalism of their 1979 counterparts, the new enclosures are elegantly shaped and handsomely crafted, particularly the suavely curving ones that house escalators (those for stairs have a smaller, peaked roof). The curving enclosures represent a new take on the classic underground stair shelters of Michigan Avenue. They have roofs of glass instead of copper (which brings more light inside), plus a blend of geometric Deco and Prairie elements that relates well to the intricate pat-terns found in such turn-of-the-century masterpieces as Louis Sullivan's Carson Pirie Scott store. And because they are less visually obtrusive than the 1979 enclosures, they should make merchants happy.

What also should please merchants is the way Skidmore has returned State Street's sidewalks to their original width, 22 feet instead of as much as 40, which became the rule in 1979. Along with the historical lamp-posts and subway enclosures, this step compresses the sidewalk, pushing pedestrians closer to display windows. But there is a broader benefit, a feeling of bustle that has been missing from State since 1979. For it is axiomatic that crowds attract more crowds—and that a little jostling is a good thing, part of the street theater that draws people to the city. When it comes to the public realm of the sidewalk, less truly is more.

The Challenge: Draw Crowds

Still, in the hypercompetitive world of retailing, more is more. More shops draw more customers, which in turn helps bring in more shops. People ultimately go to a street to shop rather than to enjoy its architec-ture; otherwise, North Michigan Avenue, despite its recent descent into design mediocrity, wouldn't be drawing hordes of customers. Measured by that yardstick, State Street still comes up short; there are now suburban malls with more department stores than the once-unchallenged center of Chicago retailing.

The street also must combat a perception that it attracts too many low-income minorities. That is what a newsstand operator at State Street and Jackson Boulevard means when he says that the presence of the missions south of Congress is driving away tourists and other visitors. And that undoubtedly has something to do with State Street's decline and the parallel rise of North Michigan Avenue.

But it seems that State Street may have turned a corner in the '90s, with the opening of the Harold Washington Library Center, the renovation of the former Goldblatt Bros. department store into DePaul University's downtown hub, the exterior renovation of the historic Reliance Building, and the interior renovation of Field's. Now, the street itself has a new, old-fashioned look that has proven popular nationwide—and it may act as a catalyst, as the smartest expenditures of public money always do, to spur additional private investment.

Entrepreneurs already are converting historic buildings along the street to loft apartments. Some merchants have said they will upgrade their stores because of the renovation.

It will take that and much more, from rigorous maintenance of the new street furnishings to improving the mix of stores (with fewer discounters and more high-end merchants) to getting rid of the modern storefronts that are a visual blight.

By going backward in time, the new State Street has taken a significant step forward. But it has miles to go before it's a magnificent mile—or just plain great.

Postscript

The renovated streetscape helped set the stage for State Street's revival. Shoppers crowded the sidewalks. Rents shot up to their highest levels in years. A string of new projects began, including the conversion of Howard Van Doren Shaw's Mentor Building into condominiums. The School of the Art Institute in 2000 opened a new high-rise dormitory, designed by Chicago architect Laurence Booth, at State and Randolph Streets. On the long-vacant Montgomery Ward site at State and Adams Streets, construction began on the 35-story Dearborn Center office and retail building designed by the noted Spanish architect Ricardo Bofill. Even Sears, which had deserted the street in the late 1970s, opted to return, getting a city-subsidized deal to move into an existing building at the corner of State and Madison Streets. That store opened in 2001.

For all that the remaking of the streetscape could be termed an urban design success, State Street's resurgence was at root a result of the booming economy and Chicago's willingness to dole out millions of dollars in

subsidies to lure developers and retailers back to State. An ongoing reno-
vation of the subway stations beneath the street also helped. And, as events
would show, city planners would find their ability to retain State's power-
ful sense of place severely tested by the proposed redevelopment of the
street's largest vacant lot, Block 37 across State from Marshall Field's.

An Elevating Station

Avoiding the Tunnel Vision of the Past, the Airy Renovation of the
State/Roosevelt Subway Stop Sets a Zesty Standard

DECEMBER 3, 1996

When it comes to getting from here to there, the word "subway" all too
often is tantamount to "substandard." It's not just that the trains feel like
cattle cars, but also that the stations themselves resemble holding pens for
people—dirty, smelly, ugly, disorienting, even scary.

There are exceptions, of course. The structural vaults of Washington,
D.C.'s Metro system echo the classical dignity of the nation's capital, pro-
viding passengers an environment that is at once spacious and serene.

Boston's subway, known as the "T," features brightly colored steel
columns that identify transit lines, handsome graphics of local landmarks
that orient riders, and even doughnut shops and other vendors who bring
some of the life of the streets into a bustling underground.

Compared with these civilized examples, Chicago's subway stations are
bare-boned and brutal—nowhere more so than on the State Street line,
which never has been lauded in song as "that great subway."

Built during World War II, in part to serve as bomb shelters, its stations
once had a kind of spartan sheen, complete with polished wall tiles. Yet
that was before a vicious cycle of declining ridership and deferred main-
tenance rendered them a pathetic mess, leaving the tiles with layer upon
layer of grime.

Now, after carrying 2 billion riders over more than half a century, the
State Street stations are due to get their first major rehab—and judging by
the initial stop to be redone, there is reason to celebrate.

A week after its reopening, the Roosevelt Road stop is everything that
too many other Chicago Transit Authority stations are not: brightly lit,
clean, colorful, reasonably spacious, seemingly safe, and most of all, full
of zest about big-city life.

This is not great architecture, yet it is so much better than what we
are used to that it merits an enthusiastic "hooray." As to whether it will

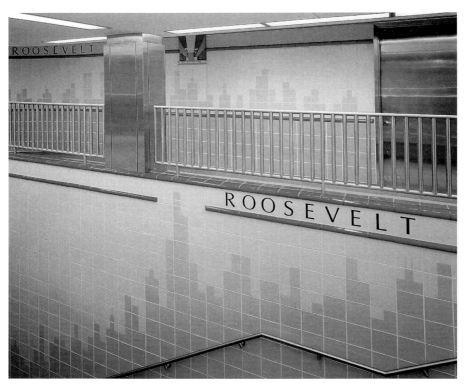

THE RENOVATED ROOSEVELT ROAD/STATE STREET SUBWAY STATION: Raising design expectations underground.

look good 50 years from now, only time and CTA maintenance budgets will tell.

Remade for $9.7 million and largely federally funded, the Roosevelt Road station is a prototype for revamping more downtown stops by the turn of the century—or perhaps beyond, if that's how long it takes to pry the dollars out of Washington.

The timing of the job could not be better, given that it immediately follows the successful "de-malling" of State Street and the return of a traditional street design there. No matter how pedestrian-friendly the street and its stores become, people will be far less likely to go there if the subway forces them to run a gauntlet of unremitting ugliness.

This station, in contrast, is about beauty. Would you believe Art Deco column capitals or tiles showing a silhouette of the Chicago skyline? These cosmetic touches and more substantive changes are all about enriching the public realm, even the one presided over by the cash-poor CTA.

Aiding Architects

That the Roosevelt Road station turned out so well is largely due to Chicago's Department of Transportation, which is responsible for the design and construction of downtown CTA stops.

In recent years, the department has let architects play an integral role in shaping public works rather than simply be a supporting cast for engineers. This innovative approach has produced praiseworthy results, such as the aboveground redo of State Street. Now, the same is true below ground, though the Roosevelt Road station easily could have been a watered-down design by committee.

It was, in fact, shaped by two firms. The first, Muller & Muller Architects, had finished drawings for the stop when city transportation officials abruptly decided in 1995 that several State Street stations, which were in various stages of being redone, needed a common visual theme. Good thing they did.

Two firms working on other stops, DLK Architecture and Daniel P. Coffey & Associates, were asked to produce designs that could be applied to Roosevelt, five other stations, and a continuous subway platform along the State Street line. Coffey's won. So while the broad outlines of the Roosevelt station were formed by Jay Muller of Muller & Muller, the decoration is Dan Coffey's. And it is a delight to behold.

Throughout, an aqua blue skyline silhouette graces walls of glazed tile; you can even make out Sears Tower and its rabbit-eared television antennas. Red tile bands and columns remind riders that the State Street line also is known as the Red Line. Blue and red Deco capitals form stylized sunbursts that radiate Jazz Age energy.

While this sunny palette lacks the understated, black-tie formality of the CTA's recently completed Blue Line station at Lake and Wells Streets and may even suggest the garish curtain walls of Helmut Jahn's James R. Thompson Center, it nonetheless communicates vividly that this is not the same old, could-be-anywhere, depressing CTA.

Ingeniously fashioned from eight different tile patterns, the skyline silhouette creates a clearly recognizable image that says "downtown." City officials say it will be easy to wipe graffiti off the tiles. We'll see, but what seems equally important is that when you treat people with dignity, they tend to respond in kind. Maybe, by improving the CTA's environs, the decoration will turn out to be a form of preventive maintenance.

If nothing else, the silhouette's airy blue color subtly conveys a sense of spaciousness, as if CTA riders were floating in the sky rather than burrowing through the underground. In another playful touch, Coffey and

his senior designer, Peter Brinckerhoff, interrupted the red tile bands to let the Sears Tower portion of the silhouette poke through, celebrating its height. These features make the station seem handcrafted and human-scaled, bringing a welcome bit of eccentricity to the institutional environment of public transit.

In general, the design is a fresh interpretation of Art Deco, nowhere more so than on the subway platform. There, red, white, and blue diagonals stained onto the concrete floor evoke the distinct chevron patterns of 1920s design and form a huge, abstracted arrow that points CTA riders to the escalators and an elevator (for those in wheelchairs) leading to the street.

A Sense of Roominess

Yet all the decoration would be meaningless if the station did not ease the flow of CTA riders, a key issue because the Roosevelt station serves the Dearborn Park and Central Station neighborhoods, as well as Soldier Field and the Museum Campus.

What mattered was not only providing an unobstructed path for riders, but also endowing the station with a generosity of space, a feature that was as commonplace to the buildings of the 1920s as torch lamps and ornamental wall sconces.

As much as can reasonably be expected in the renovation of a subway stop, where carving out more square feet can be very expensive, the architects—in concert with Meridian Engineers (now Edwards and Kelcey Design Services)—have achieved a sense of roominess.

You notice it in the two stairway canopies on the east side of State Street, their height and big expanses of glass making these enclosures seem practically luxurious, at least by CTA standards. The stairways were widened to eight feet from six feet, making them appear more spacious still.

Even if the canopies strain to strike an aesthetic balance between the frank modernism of a CTA elevated station a block to the east and the Art Deco of the Roosevelt station, they are welcoming gateways—a vast improvement on the old canopyless station entrances along the State Street subway.

Another major reason the stop seems commodious is that its interior has been treated as a series of rooms that celebrate the act of going from here to there. This approach shaped a bowing arch that forms a handsome gateway between the mezzanine and the platform. And it can be seen at each end of the platform, where concave walls create spaces

reminiscent of an apse (a semicircular recess at the end of a church) featuring the skyline silhouette. Welcome, they seem to say, to the shrine of public transportation.

In general, this station's graphics are crisp and clear. Some feature letters spelling out "Roosevelt" in a typeface following the Deco theme and stylishly departing from the modern, CTA standard. Glassed-in cabinets on the mezzanine will allow notices to be posted in a single spot, preventing a riot of flyers there.

The lighting also is well handled, particularly on the platform. There, a band of bright fluorescent lights replaces the CTA's old, dim bulbs, providing a continuous visual exclamation point for the red columns.

Not Perfect

Still, there is room for improvement. Future platforms could have brightly lit zones where passengers gather in off-peak hours—in effect, creating intimate rooms within the big room where people wait for trains. And the CTA could loosen its rigid standards for attendant stations and other features—all are now harsh, steel-clad forms at odds with the decorative quality of the new prototype.

But what is remarkable about this design is the way it manages to bring a tinge of glamorous romanticism to the low-rent modernism of the CTA. The design is a distant cousin of, but still part of the same aesthetic family as, the historic light posts and subway canopies of the new State Street. And while it may take some doing to bring those two into harmony, something more important has transpired: the underground has been elevated; a CTA station no longer seems like a holding pen.

Now, if they could just redo those cattle cars.

Postscript

The design precedent set by the State Street/Roosevelt Road subway station set the stage for comparable projects throughout the Red Line's downtown corridor. Progress was maddeningly slow—subway platforms beneath the Loop remained in abominable shape, but new mezzanines were completed at the Randolph/Washington and Jackson/Van Buren stations in the same Art Deco style. The Chicago Avenue Red Line station also was revamped following the State/Roosevelt model.

Building a Better Block 37

Good Intentions Simply Aren't Enough for High-Stakes State Street Project

APRIL 21, 2000

After a decade of delays, Chicago finally has a plan in place for the long-vacant, hugely significant chunk of real estate whose very name—Block 37—has become a civic embarrassment. With all that time and with $70 million in city subsidies behind the plan, you'd think it would fit the Loop like a glove and would provide usable public space for the taxpayers shouldering its cost.

But you'd be wrong.

This retail, hotel, and condominium complex looks woefully out of place on State Street, as if someone had picked up one of the vertical malls of North Michigan Avenue and plunked it down across State from Marshall Field's. Its architecture is equally unappealing, with a retail base that resembles a fieldstone-clad, suburban shopping mall, circa 1950, and a hotel-condo tower that suggests a sleek, mirror-glass hotel in Dallas or New York.

Very little of this is right for State Street, with its grand retail palaces, or for Daley Plaza, where mighty buildings frame a public square punctuated by the enigmatic Picasso sculpture.

Worse, this publicly supported project promises a mock public space—a rooftop garden that is supposed to ease the hurt of losing Block 37's popular summertime art program and wintertime skating rink. Yet as anyone familiar with the elegant but underused Winter Garden of the Harold Washington Library Center knows, rooftop public spaces tend to be out of sight and out of mind.

To be sure, there are some good strokes in this $251 million plan, which was designed by the New York City firm of Kohn Pedersen Fox (KPF). But the proposal needs substantial refinement and rethinking before it can meet the high standards that KPF and its lead designer, William Pedersen, already have set in Chicago at 333 W. Wacker Drive, the curving, green-glass office building that brilliantly punctuates a bend in the Chicago River.

This is how the new project, which will go by the name of 100 North State, will look once it is completed in 2004: along State would be a Lord & Taylor department store, clad in a rough-hewn, yellow limestone. The store would be topped by a roof garden with restaurants encased in dramatic wedges of transparent glass. Additional retail outlets would be located along the street and in the underground pedway system.

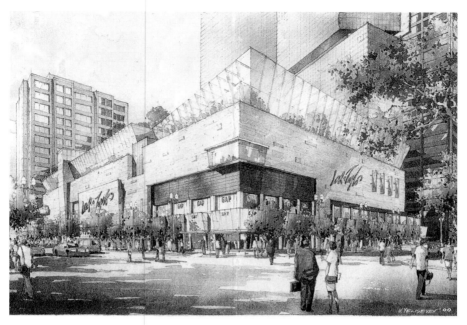

BLOCK 37 PLAN: All the wrong moves for State Street.

Set well back from State would be a sliver-thin 39-story tower, sheathed in blue-green reflective glass and consisting of two main elements above the building's 4-story base: a 13-story Marriott Suites hotel and 22 stories of condominiums. At midblock, halfway between Washington and Randolph, the tower would take a slight diagonal bend, opening room for an outdoor cafe on Dearborn and other street-level activities meant to help enliven the city's nascent theater district.

Pedersen's main challenge at 100 North State is to come to terms with the mighty structures surrounding Block 37. They range from the massive, masonry-clad buildings on State Street to the macho modernism of the Daley Center and its powerful, bridgelike spans of rusting steel.

He has chosen to relate to them not by imitation, but by juxtaposition—a yin to their yang. Instead of the obvious move—a structurally expressive, skin-and-bones box—he offers a taut, sleek, angular tower set atop that big limestone base. It's a risky strategy, one that could pay off in the long run. At this stage, however, the project's adventurous modernism is half-baked.

Surely 100 North State's unfortunate use of the familiar North Michigan Avenue formula—a setback slab rising from a retail base—is no coincidence. The lead developer, JMB Realty Corp., also was the force

behind the quintessential vertical mall, Water Tower Place, and its post-modern progeny, 900 North Michigan (which also happens to be a KPF design).

True, the plan would restore Daley Plaza's identity as a monumentally scaled public space. The plaza is a huge outdoor room, as architects say, and its walls are the buildings that surround it, including the grand old City-County building to the west. Yet the eastern part of this enclosure was destroyed in 1989 and 1990 when the city demolished almost everything on Block 37 in anticipation of a JMB-backed, Helmut Jahn–designed office building/retail galleria. That design got scrapped after the office market collapsed in the early 1990s, creating the vacant lot Chicago has been struggling to fill ever since.

Placing a tower of considerable height just to the east of Daley Plaza, as Pedersen proposes, will help the plaza regain its old character. It certainly is preferable to turning the urban renewal block into a park, as some well-intentioned people have suggested. That would have made permanent the unhappy temporary situation that now exists.

But if the broad outlines of the 100 North State design seem to work for Daley Plaza, they promise an entirely different impact on "that great street."

State is nothing if not a collection of powerful buildings—relatively tall, block-filling retail palaces that epitomize the tradition of the "Big Store." Amid this architectural Murderer's Row, especially with Field's 12 stories of white granite rising like a cliff across the street, a four-story department store seems pretty feeble.

The plan grates not just with its diminutive size, but with its off-putting street presence. Its mostly windowless, shopping mall–like base is strikingly inward-turning, a regrettable departure from State Street's tradition of sidewalk-friendly retailing. And the yellow limestone that would clad the base appears more rural than urban, as if an architect sitting in Manhattan thought: "Ah, the Midwest. Prairie School. Frank Lloyd Wright. Let's make it look like fieldstone."

The 100 North State complex also won't do much for the theater district, where millions of dollars in public funds have been invested to bring nightlife back to the Loop. Yes, there will be a restaurant on Randolph, but that's it—no movie theaters, no bright lights, almost nothing, in short, but the side of a department store.

Chances are even slimmer that the public will benefit from the proposed rooftop garden that the developers are advertising as a public space. The garden will be reached from an elevator placed along the building's State Street front. As Pedersen suggests, the garden will act as

a "fifth facade," ensuring attractive views for office workers looking down on it. But such an amenity needs to be used, not just seen, for it to work.

The trouble with this one is that public spaces on the tops of buildings invariably filter out those who lack the income or the inclination to enjoy them. Private building managers will run 100 North State's rooftop garden, all but guaranteeing that anyone who seems the least bit scruffy will be shooed away.

The end result will be a privatized public space—an enclave used largely by hotel visitors and condominium dwellers, and thus little more than a sop to a mayor who loves trees and shrubs.

Pedersen's strategy of relating to 100 North State's neighbors through contrast rather than imitation also needs substantial revision. At best, his sleek tower resembles Kevin Roche's abstractly sculptural United Nations hotel in New York, which is covered with a skin of blue-green reflective glass. At worst, it looks like it parachuted in from the Sun Belt, one of those bland mirror-glass buildings that scream out to the driver on the freeway and then have nothing else to say.

Either way, it has a long way to go before it seems at home next to either Daley Plaza or State Street. For starters, the building's stone and glass cladding needs to be far more sophisticated and urbane. The architect might also want to make his building, especially its base, more glassy and transparent; that would allow it to become, amid State Street's blocks of stone, a brilliant, jewel-like exception, not unlike Crate & Barrel on North Michigan.

Such choices all go back to the main issue—whether this project strengthens or dilutes its sense of place.

Certainly, there's reason for hope. Pedersen seems to be on the right track with the bottom of his building along Daley Plaza. There, the big stone base will engage the massive forms of both the Daley Center and City Hall without imitating them. Now his task is to expand upon and enrich that gesture, moving from initial concepts to the intricate interweaving of form and function that characterizes his best work.

The crown jewel of State Street's comeback deserves no less.

Postscript

After this critique and another attack on the Block 37 plan by former *Chicago Sun-Times* architecture critic Lee Bey, the developers ordered KPF to reshape its original design. Then they fired the architects during the redesign and replaced them with the project's associate architects, Solomon Cordwell Buenz (SCB) of Chicago.

SCB's plan had the same uses as the KPF design, but creatively rearranged them in a modernist composition consisting of simple shapes accentuated by dynamic, sculptural forms. While the Lord & Taylor department store remained too short to adequately shape the public space along State Street, it now had more storefront windows than its predecessor. The proposed hotel became L-shaped and was shifted to Block 37's southwest corner, where it promised to handsomely frame the urban room of Daley Plaza. Above the hotel's southern wing, the architects designed a condominium tower, 66 stories tall, with a swooping glass curve that should strike up a powerful dialogue with the Daley Center. Finally, the planned roof garden above the department store was made more accessible, with two elevator banks leading to it from the street rather than one, as in the initial proposal. Groundbreaking was set for fall 2001. But in spring 2001, after the developers dramatically downsized their plans due to an economic downturn, the city announced it would cancel the project and ask new developers to compete for the right to build on Block 37.

PUBLIC WORKS AND
THE PUBLIC REALM

O wing to his passion for beautification, which revealed itself in thousands of newly planted trees, scores of median planters brimming with flowers, and innumerable imitation wrought-iron fences, Mayor Richard M. Daley became known as Chicago's Martha Stewart. Yet there was a more substantive side to Chicago's makeover under Daley, and it had to do with an eye-glazing, but enormously important, concept: "infrastructure."

If a city does not regularly replace its streets and bridges and sewers, then it will soon be, with apologies to Nelson Algren, a city on the break. Under Daley and a team of architects-turned-bureaucrats, however, Chicago began operating under the enlightened premise that things once devoted solely to utility could also be about beauty. In other words, infrastructure could both make the city work and make it a more attractive place to live. Of course, there was also a hidden political agenda to the highly visible improvements: when the city looked good, the mayor looked good, too.

On the whole, though, Daley's push to upgrade infrastructure was exemplary; on occasion, it even became aesthetically adventurous, as the progression from a neoclassical bridge

at Roosevelt Road to a modern bridge at Damen Avenue would show.

Nonetheless, there were significant missteps. In 1999, *Tribune* investigative reporters revealed that some of Daley's political allies had cashed in on improperly obtained contracts for the imitation wrought-iron fencing. And early in the 1990s, in response to a widespread crime wave, the mayor backed a street-closing program that promised to divide his city rather than unite it.

Updating the Dark Ages

Daley's Walled-Neighborhoods Plan Would Do Much to Hurt the City and Little to Stop Crime

JANUARY 22, 1993

In medieval Europe, the precincts inside walled cities represented a refuge from roving bands of highwaymen. Modern-day Chicago stands on the verge of putting a new spin on that relationship: crime reigns within the city limits, and Mayor Richard M. Daley wants to erect iron gates and other blockades so today's vandals won't terrorize the citizenry.

Well, good luck, Mr. Mayor. You're going to need it.

Daley's plan, which calls for blocking off dozens of Chicago side streets to stop drive-by shootings and other crimes, has to be one of the dumbest ideas to come out of City Hall since the construction of the now abandoned public-housing high-rises the mayor is moving to tear down.

While it might make a dent in the number of drive-by shootings by outsiders, the Daley proposal threatens to cage Chicagoans inside their neighborhoods with criminals who already live next door or down the block.

And it raises a host of other problems: fire trucks, ambulances, and police cars will be delayed in responding to crime or emergencies; main streets will be choked with traffic; thousands, perhaps millions, of taxpayer dollars will be wasted if the plan is applied to areas where it isn't needed and then, like abandoned public housing, has to be scrapped.

Has anyone thought this through at City Hall? Or did the mayor, under intense media pressure to do something about the murder rate, move too

A SMASHED TRAFFIC CIRCLE ON CHICAGO'S NORTHWEST SIDE: Part of a cul-de-sac program that has slowed cars and stoked controversy.

quickly to demonstrate that he's combating neighborhood crime instead of frittering away time on failed big-ticket projects like casinos and the Lake Calumet airport?

The fundamental flaw in the mayor's urban-planning gimmick is that it tampers with one of the most basic building blocks of life in Chicago: the city's historic street grid. From Howard Street on the north to 138th Street on the south, from Lake Shore Drive on the east to the suburbs on the west, the grid is what holds Chicago together, draping the city's disparate neighborhoods in a unifying checkerboard cloak.

Nothing better represents the profoundly democratic notion that urban life is a messy, sometimes nasty, but ultimately shared enterprise; if Chicagoans are linked in only one way (besides, perhaps, the worship of Michael Jordan), it is that everyone's address is measured in relation to the "zero-zero" start of the grid at State and Madison Streets.

The grid's street network makes it easy to get from one neighborhood to the next. Easy for residents. Easy for police and firefighters. And easy, sad to say, for gang-bangers, who can drive down a street for miles, guns pointed out a window, searching for targets.

To stop them, the mayor wants to close off side streets, using iron gates, cul-de-sacs, and other blockades. His model is Dearborn Park, the

walled-in, upscale community south of the Loop where strangers are said to be quickly spotted by residents and police. If neighborhoods go along, barricades would begin going up in all 50 wards as early as this summer.

Nothing as extensive as this plan has ever been tried before, in Chicago or anywhere else. So one wonders why an upscale neighborhood should be the model for middle-class and poor neighborhoods and why the mayor is intent on introducing his plan to all 50 wards at once, rather than trying out the idea in a few test wards and studying it for a couple of years.

More Congestion, More Risk

Of course, Daley will be up for reelection by then, and a big, fat study will provide far less effective material for a slick, 30-second TV commercial than claims that walled-off streets are protecting children from violent gangs.

Yet, even without a study, there are obvious pitfalls to Daley's plan. Blocking off side streets that are now open would increase response times for police cars, fire trucks, ambulances, and other emergency vehicles. That could put sick people at risk and give criminals on foot additional time to flee. The plan also would increase traffic congestion on main streets because drivers wouldn't be able to move easily between neighborhoods using side streets.

One more problem you don't need to be an urban planner to figure out: all those gates and barricades will be plastered with gang graffiti as soon as they go up. Who in your neighborhood block club, pray tell, is going to volunteer to clean them up?

Of course, residents in some crime-stricken areas may be willing to live with such nuisances if Daley's plan delivers what it promises: safe streets where adults and children can walk, talk, and play without fear. But there is no guarantee that will happen. At least one renowned urban expert—the same expert who decades ago warned that public-housing high-rises in Chicago and around the nation would increase, rather than decrease, crime—predicts that Daley's block-the-streets plan will have similar effects.

That will happen, said Jane Jacobs, author of the classic book *The Death and Life of Great American Cities*, because the plan will turn side streets into abandoned strips where robbers and rapists who are already inside the neighborhoods can run free. "Those closed-off streets will become cages in which people are caught, in which they're at the mercy of criminals," Jacobs said in an interview from her home in Toronto. "Police have to be mobile. They're going to be thwarted by these things even more than the criminals."

From Unifying to Dividing

Not all criminal-justice experts subscribe to that view, but they warn that Daley's proposal is unlikely to reduce crime citywide because it is a generic approach, mainly designed to combat drive-by shootings, rather than a strategy tailored to the different crime problems affecting different neighborhoods.

"It sounds to me as though a solution has been dreamed up and will be applied wholesale," said Ronald Clarke, dean of the School of Criminal Justice at Rutgers University in Newark, N.J. He recommended that Daley try the plan in a few neighborhoods before implementing it in all 50 wards.

But that appears to be an unlikely course for a mayor who came to office pledging to unify Chicago and now seems to be playing the politics of a house divided.

By closing off Chicago's side streets, the mayor would further partition a city already split along racial and economic lines. His plan promises to rip asunder what little social cohesion remains in Chicago and to establish an invidious fortress mentality that pits "us," the people inside the walls, against "them," barbarians and civilized people alike, who are outside the gates.

Postscript

Daley proceeded with his street-closing plan, but significantly reduced its size and scope. While no iron gates were used, 195 cul-de-sacs—fewer than four per ward—were constructed by early 2000, according to the city's count.

City officials were reluctant to ascribe falling crime rates directly to the cul-de-sacs, acknowledging that other factors, such as a falling-off in the drug trade, may have played an equally important role. In any event, the cul-de-sacs were repackaged politically, portrayed as a tool for slowing traffic rather than fighting crime.

Other "traffic calming" measures included traffic circles, circular medians with trees and shrubs; curb bump-outs, which slowed down cars as they came to intersections; residential street humps; and alley street humps. The latter became an integral part of alley resurfacing in Chicago.

These measures were relatively harmless and sometimes even effective in making neighborhoods more pedestrian-friendly—and less prone to the invasion of automobiles. But in neighborhoods like Beverly, some residents contended that the cul-de-sacs did great harm, blocking the path of police

cars and ambulances as they sped to help those in need. Others character-
ized the cul-de-sacs as a nuisance, saying they created a street maze that
made it easy for visitors and longtime residents alike to get lost.

The Bridges of Cook County

Design Enhances Engineering in Citywide Project

AUGUST 6, 1995

At their best, bridges provide more than a way to surmount an obstacle
between point A and point B. They are gateways to the city, like the
Brooklyn Bridge with its soaring Gothic arches, or urban symbols that
enhance the landscape, like San Francisco's lyrical Golden Gate. They are
places as much as passageways, exemplified by the romantic spans of
Paris, where tramps doze below and lovers embrace above.

It follows that bridges should be something other than oversized
Erector Sets, assembled as cheaply as possible, with hardly a thought given
to the eyes and spirits of the people who walk and drive across them. For
too long, however, that has been exactly the attitude of those in charge of
building bridges in Chicago and nationwide, a traffic engineer's aesthetic
that relegated architects, and their unique ability to fuse beauty and util-
ity, to a minor role.

All that is changing now, at least in Chicago. An extensive bridge ren-
ovation and replacement program is in many cases producing laudable
results, returning the city to an older tradition of bridge-building, when
form, function, and urban development were seen as complementary.

Necessitated by the worsening condition of bridges up to a century old
and funded by a mix of city, state, and federal sources, the effort has
returned one of the city's premier civic spaces, the Congress Plaza, to the
magnificent urban stage set envisioned by planner Daniel Burnham.

In the city's neighborhoods, the program's scaled-down version of City
Beautiful grandeur has struck a harmonious chord with the traditional
architecture of nearby businesses and homes.

The most ambitious of the neighborhood projects has created a new,
but entirely old-looking, bridge where Roosevelt Road stretches over the
Dearborn Park neighborhood as well as Metra and Amtrak railroad tracks
on the Near South Side. More than 1,500 feet long and decorated with
obelisks and sculptures that represent a nearby university and museums,
the span reminds us how far we've come from the dogma of the modern
movement, which likened ornament to a crime.

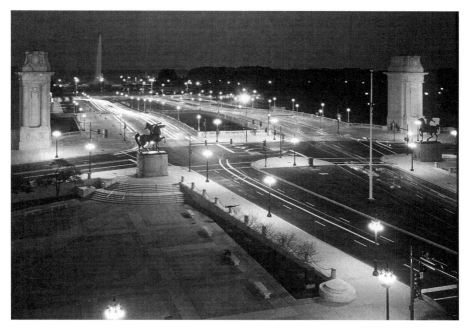

THE RENOVATED CONGRESS PLAZA: Bringing back Burnham's grand gateway.

Just about everything in Chicago is political, and so it is with the bridges of Cook County. Plans might still be gathering dust on a shelf at the city's Department of Transportation were it not for the backing of Mayor Richard M. Daley and two enlightened bureaucrats. They are Jeff Boyle Jr., the department's commissioner, and Stan Kaderbek, its chief bridge engineer. The two have at once empowered architects and challenged them to do something more creative than pull a standard bridge section out of a manual and slap it into place without regard for its users or its surroundings.

Plans are underway to renovate or replace more than 30 of the 226 bridges under the department's jurisdiction. They include fixed and movable bridges over land and water.

The program's most visible success has brought new luster to Chicago's front yard, which extends from the cliff of office buildings along Michigan Avenue through Grant Park to the lakefront. The need to rebuild a bridge that crosses the Illinois Central railroad tracks at Congress Parkway turned out to be the impetus for a much larger renovation that reclaimed Congress Plaza as a monumental gateway to the park.

Based on Burnham's famed 1909 Plan of Chicago and built in 1929 to the design of Burnham's associate, Edward Bennett, the plaza was a

Beaux-Arts classic, heavy on axial symmetry. A pair of massive pylons, with crests bearing a "Y" for the confluence of the Chicago River's North and South Branches, maximized the gateway effect. So did two heroic statues of equestrian Indians by sculptor Ivan Mestrovic. They flanked an extraordinary, 100-foot-wide staircase, which enabled pedestrians to make their way from Michigan Avenue to Buckingham Fountain and the lakefront.

In what now seems nothing less than an act of government-sponsored vandalism, the staircase was torn up in 1956 to make it easier for drivers to get from Lake Shore Drive to what is now the Eisenhower Expressway. Simultaneously, Bennett's elegant lampposts were ripped out and replaced by functional but ungainly "cobra head" streetlights. With six lanes of asphalt slicing through the plaza, the tyranny of the traffic engineers rendered the plaza an urban dead space.

The $10 million renovation by DLK Architecture of Chicago superbly recaptures both the grand sweep and the details of Bennett's design. The most important step (double meaning intended) places two pie-shaped flights of stairs at the base of the equestrian statues.

When a space is designed to be used, people invariably use it. And that is precisely what happens here, as pedestrians read books and open brown-bag lunches on handsome benches in the renovated plaza along Michigan Avenue. Or they mount the stairs, then pause along the bridge to have their pictures taken with the skyline in the background.

Given the presence of such eye-pleasing details as 42 fluted aluminum light posts along Michigan Avenue called "Boulevard Electroliers," it is easy to forget what is really at work here—not just beautiful objects, but an extraordinary sequence of spaces.

It moves from the tight confines of the downtown grid to the big, but controlled, space of the plaza. Then it runs up a slight incline to the bridge, the park, and the ultimate destination, the geyserlike Buckingham Fountain. The new stairs subtly emphasize this ascent, symbolically raising the pedestrian from the everyday world to the park's civic realm, just as the old staircase did.

DLK's Howard Decker has enriched the drama by bringing back another Bennett touch—an additional set of light posts, east of the bridge, that are low enough to tease the eye over the incline and toward the fountain. Their soft allure is especially powerful at night, when foot traffic to the fountain is heaviest.

If the 1956 dismembering of the plaza was the rough equivalent of a malevolent hand reaching into the city from the expressway and wrenching apart one of its most cherished spaces, the renovation con-

SCULPTURES AT THE ROOSEVELT ROAD BRIDGE: Forging symbolic links between infrastructure and its surroundings.

THE ROOSEVELT ROAD BRIDGE: Design that respects a neighborhood.

stitutes a major turnaround—in effect, slapping the highway's hand back and striking a new, more humane balance between the pedestrian and the driver.

Daley's bridge engineers have been busy outside downtown, too. Just south of the Museum of Science and Industry, where Lake Shore Drive crosses an inlet feeding the museum's lagoon, they have worked with Chicago architect Wilbert Hasbrouck to renovate a Burnham-designed bridge constructed for the World's Columbian Exposition of 1893. And they have rebuilt bridges, such as those over the North Branch of the Chicago River at Lawrence and Montrose Avenues on the Northwest Side, that create small-scale gateways in the city's neighborhoods.

But their most intriguing project is the $42 million Roosevelt Road Bridge. It leads to Daley's neighborhood, Central Station, and replaces a portion of a bridge constructed in the late 1920s.

The bridge is an aesthetic flash point because of its abundant use of classicism, which would have been unthinkable when architects were under the sway of the modern movement four decades ago. There are obelisks of three sizes, towering fluted lampposts, finely detailed planters, handrails that incorporate a miniature version of the Chicago "Y" found at Congress Plaza, and symbolic sculptures by Miklos Simon.

The latter emphasize the bridge's link between the University of Illinois at Chicago, which is represented by books, and the three lakefront cultural institutions that eventually will be part of a museum campus uninterrupted by Lake Shore Drive. The Shedd Aquarium is symbolized by dolphins, the Field Museum by prehistoric creatures including mastodons, and the Adler Planetarium by a celestial navigation instrument known as an astrolabe.

Some in the avant-garde point to the use of such forms as a failure of architectural nerve and a tacit admission that American culture has lost its faith in the future. There is something to that view, especially if one considers the poetic, structurally expressive bridges of Spanish-born architect Santiago Calatrava. But it does not hold here, especially in view of the alternative—the city's original proposal for a bland, utilitarian bridge that outraged residents of Dearborn Park.

The architect, DLK's Diane Legge Kemp, has fashioned an exercise in urban appropriateness that works on two scales—a city scale that recalls the grandeur of Congress Plaza and a neighborhood scale that allows the bridge to blend comfortably—at least visually—with Dearborn Park.

Of necessity, her design is as much a street as a span because it intersects Clark Street as the bridge runs east-west between State Street and the Chicago River. (At the river's east bank, the span flows into a movable

bridge that crosses the river and was renovated as part of the project.) It is altogether proper, then, that the new bridge has such unusual features as traffic lanes reserved for bicycles and that its decorative elements break down its massiveness in a way that gives it a human scale compatible with Dearborn Park.

The problem is that these forms work better as parts than as a whole; this bridge lacks the seamless melding of old and new that the architects achieved at Congress Plaza. More important, the bridge's rhetorical emphasis on connecting different parts of the city is contradicted by the reality of its underside, which consists of precast concrete panels with brick facing; they effectively create a wall between the northern and southern portions of Dearborn Park.

Despite its faults, this bridge, like its counterparts at Congress Plaza and in other neighborhoods, is a positive addition to the cityscape. While such carefully conceived bridges cost anywhere from 10 to 20 percent more than those standard designs pulled out of an engineer's manual, they possess a value that cannot be measured by accounting ledgers.

In an age of metropolitan fragmentation, they are exemplars of urban continuity and collective identity—not just transportation conduits, but civic symbols.

Postscript

By the beginning of 2000, Chicago's Department of Transportation had more than 80 bridge renovation and replacement projects underway throughout the city. Among them, ironically, was Congress Plaza, which had won an Institute Honor for Urban Design from the American Institute of Architects. According to Chicago Park District officials, however, the plaza wasn't luring enough visitors and vendors because it was too wide open and too hot in the summer months. In addition, they said, it offered too few places to sit.

So, in 2000, at the Park District's direction, legions of concrete benches and classical planter pots were added to the plaza in an attempt to make it more inviting. While the new features provided welcome shade and additional seating, the retrofit was a visual disaster, with the planters cluttering the monumental space. A year later, Park District officials implicitly acknowledged their clumsy handling of the plaza, stressing that the planters could be moved and promising to strike a better balance between creature comforts and the plaza's special role as grand gateway.

Triumphal Arches

Damen Avenue Bridge Is a Modern-Day Beauty

AUGUST 26, 1999

Chicago has a new landmark: a bridge whose bright red arches invite us to travel over the river and into the future.

Located north of the Kennedy Expressway at Diversey Parkway, the new Damen Avenue Bridge bids good-bye to the old-fashioned obelisks and other neoclassical garb in which Chicago's spans, like the one at Roosevelt Road, have been dressed of late.

Its structure is, for the most part, naked, out there in the open for all to see, and the cityscape is the better for it. It is the first modern span built by Mayor Richard M. Daley, an aesthetic traditionalist. And if the mayor knows a good thing when he sees one, it will not be the last.

Costing $12.8 million and spanning a distance greater than a football field, the Damen bridge anchors an area that is fast changing from factories to condos and mini-malls, from a city that makes things to a city that consumes them. A Vienna Beef hot dog factory lingers just to the southeast.

The span's predecessor, built in the 1920s, could be raised for the tall-masted ships that once cruised the Chicago River; railroad tracks coursed beneath a clunky viaduct that formed its northern approach. That bridge closed in early 1998, wearied by time and the heavy loads that passed over it.

Now, in its place, are tube-shaped arches that inadvertently recall the sausages made at the nearby Vienna Beef plant. But there's nothing wrong with that. The bridge offers reason to shout, "Hot dog!"

Credit for the design goes to TranSystems engineers, J. Muller International bridge engineers, and Muller & Muller Architects (no relation). The bridge was built for the Chicago and Illinois Departments of Transportation, with the state getting involved because the project received federal funds.

The bridge's color is "Chicago Bulls red," says Patrick Cassity of J. Muller International, who worked with colleague Ken Price on the job. The firm is touting the Damen span as a "signature bridge," one that not only gets you from here to there but also is a civic icon.

In truth, the bridge falls somewhat short of that high standard. Still, there are numerous benefits to this project, and they are both visual and practical.

To drivers scooting across the bridge, the most welcome change is the way the engineers have straightened the route across the river. The old viaduct had a notoriously sharp curve. Now the path is less crooked, more safe.

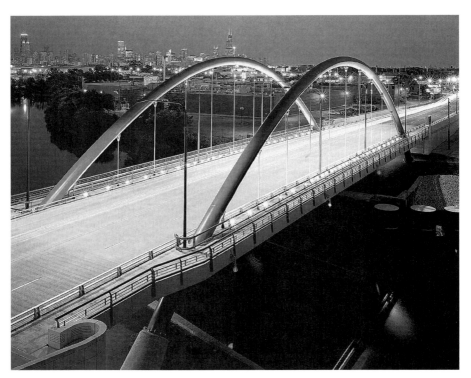

THE DAMEN AVENUE BRIDGE: Over the river and into the future.

What truly distinguishes the Damen Avenue Bridge, however, is the way that it is put together. Its arches are almost entirely self-supporting. There is no cross-bracing between them. It is the first span in North America built this way.

Made of inch-thick hollow steel pipe, four feet in diameter, the tube-like arches are inherently stiff, which means that other bulky supports are unnecessary. Their round shape lets the wind flow smoothly around them, significantly reducing the need for cross-bracing. At the same time, the cables from which the road deck hangs stabilize the arches against the forces of wind and gravity. The tubes reach well beneath the deck to concrete blocks that transfer the bridge's weight to foundations reaching to bedrock.

This arrangement is more economical than one of the signature bridge alternatives considered by the engineers—a cable-stayed bridge, in which cables extending from costly towers would have supported the road deck. Yet it is more pleasing to the eye than a conventional design, such as a flat, girder-supported span or an arched bridge with cross-braces.

The reason, in a word: openness. Because the arches carry most of the bridge's weight, the road deck can be relatively thin. Freed from braces, which would have made driving across it seem like moving through a cage, the bridge can engage the sky and the city around it. It is light and airy, its cables framing spectacular views of downtown. At night, lit from below, the arches seem floating, ethereal.

The way you reach the bridge is equally appealing. That's because the designers put curving, horizontal lines in the concrete retaining walls on the span's northern approach. Their sleek, flowing quality continues in the bright red railings of the bridge itself. The railings further echo the round form of the arches, helping to unify the span and its approaches.

Painting the arches red was another good stroke. The bright color prevents them from getting lost in the sky, especially when they are glimpsed from the Kennedy Expressway. Along with the dynamic shape of the arches, the distinctive shade helps the bridge become an urban symbol—born of engineering logic, but ultimately transcending it.

That logic is best appreciated when the bridge is seen in profile, a vantage point that allows the passerby to take in the spring of its arches from one riverbank to another. To get this view, you take a concrete stair that cascades from the northwest retaining wall of the span on down to the river. The stair is not an ugly appendage. It grows out of the bridge like an elegant piece of sculpture. You can envision Scarlett O'Hara at the top of it, dressed in one of those flowing, floor-length ball gowns, with suave Rhett Butler gazing up at her.

From the river, the arches seem graceful, elegant, as though they were bent pipe cleaners. At the same time, you feel their compressive force bearing down on the concrete anchors. Here, the mathematics of engineering and the muse of art sing in perfect harmony.

The view from alongside the river reveals another strength of the bridge: it is a forward-looking work of urban design. There's a 30-foot opening between the base of the arches and the wall that supports the bridge's northern approach. That leaves room for a planned riverwalk that will pass beneath the span—good news for the walkers, joggers, and bicyclists who someday will be using it.

Still, there are problems with the Damen bridge. Ironically, the driver crossing the span never gets the flattering profile perspective, seeing only the portion of the arches above the road deck. From there, in what surely is an unintended tribute to the Vienna Beef plant, the tubelike arches look like overly plump hot dogs. And while the designers wisely graced the span with curving overlooks for pedestrians, the bridge's sidewalks are only six feet wide—far too narrow for the bridge to invite pedestrians to

stop and linger on it. Benches are out of the question in such a tightly confined space.

Making the sidewalks 10 feet wide, as the city intends to do on a planned North Avenue Bridge, will allow people to stay awhile, maybe even sit. It also will let snowplow drivers and sidewalk sweepers do their jobs more easily. As it is, trash already is piling up on the Damen bridge while graffiti mars the span's red arches. Why build a beautiful bridge if you're not going to take care of it?

When the neoclassical Roosevelt Road Bridge was finished in 1995, it represented a key departure for Chicago infrastructure, one that went beyond the ugly, utilitarian bridges the city had built in the postwar era. Now, the Damen Avenue span can play a similar role, introducing modernism to the mix as city engineers replace Chicago's aging bridges.

There's room for both modern and traditional bridges here; the issue is not style, but city-building. Just as the Roosevelt Road Bridge blends seamlessly with the traditional housing on its flanks, so the Damen Avenue Bridge is a bold new form that strikes the right note in a rapidly changing area. Surely other communities will want contemporary landmark bridges of their own.

True, it's not a masterpiece, but the Damen Avenue Bridge is an impressive synthesis of structure, function, and beauty. It doesn't just adorn Chicago; it enhances the way the city looks and works. It points to a new direction for Chicago's bridges—forward rather than backward, breaking from the past and bringing in the new millennium.

MAKING THE PAST A PART OF THE FUTURE

Why save old buildings? Because, as the critic Lewis Mumford once wrote, they make time visible, revealing layers of history like geological strata.

That task is important in all cities, but it is a matter of singular significance in Chicago, which, by virtue of its early skyscrapers, Prairie School houses, and scores of other trend-setting buildings, is a living museum of American architecture.

For years, Chicago excelled equally at building landmarks and destroying them, this infamous, Janus-faced identity epitomized by the 1972 demolition of Adler & Sullivan's Chicago Stock Exchange Building. But a major change of attitude transpired in the 1990s, and it was most visible in the attention and resources the city devoted to one of the structures that made it a center of design innovation—D. H. Burnham & Co.'s crumbling Reliance Building. The same pro-preservation tilt, also evident in state government and private foundations, would benefit three of Frank Lloyd Wright's surprisingly fragile masterpieces—the Robie House in Chicago, Unity Temple in Oak Park, and the Fallingwater house in Pennsylvania.

Yet the biggest shift occurred as a result of a lost landmark battle: the failed 1995 effort to stop developer John Buck

from tearing down two handsome Beaux-Arts buildings and the nearby Arts Club of Chicago, a noble Ludwig Mies van der Rohe interior, to make room for a glitzy new shopping mecca. In the end, the Arts Club and the other buildings became landmarks that died so that others might live. In 1996, ordinary citizens by the score reacted angrily when the Chicago City Council covertly stripped 29 sites of landmark protection, then passed a landmarks law so flimsy that it opened the gates to wrecking crews. The ensuing outcry would be a watershed for making the past a part of the future.

Tumbling Legacy

Shortsighted Moves by the City Have the Potential to Send Architectural Gems Toppling Like Dominoes

MARCH 10, 1996

Chicago flaunted its penchant for self-destruction last week, laying the foundation for a savage assault on its most valuable cultural asset—the bricks and mortar, steel and glass, that built its reputation as the birthplace of modern architecture.

First, the City Council gutted the landmarks law, making it far more difficult to save historic buildings by such giants as Frank Lloyd Wright. Then, after Mayor Richard M. Daley spoke out against tearing down a historic coach house on West Hawthorne Place, his own building department issued a demolition permit and a bulldozer reduced the nineteenth-century building to splinters. The destruction was an isolated blunder, said City Hall, failing to acknowledge its ongoing, bungled stewardship of Chicago's architectural treasures.

Doesn't anybody get what the city is doing to itself?

As if to offer a reminder, a West Side gallery opened an exhibition devoted to Richard Nickel, the photographer who fell to his death from the unstable floors of Louis Sullivan's vaunted Chicago Stock Exchange Building while recording its demolition.

Protecting the past means finding a way to balance the clashing interests of private property rights and the public good that results from saving historic buildings. But because Chicago lacks the economic incentives to bring about

THE 1972 DEMOLITION OF THE CHICAGO STOCK EXCHANGE BUILDING: A grim reminder of squandered architectural treasures.

that reconciliation—and because politicians and preservationists are talking past each other—a new era of demolition and defacement is upon us.

The stakes could not be higher. No other art form, not the raw electric blues that sprang from the Mississippi Delta or the full-bodied roar of the Chicago Symphony Orchestra, so thoroughly embodies this city's brawling beauty and drop-dead delicacy.

Among the 29 buildings and districts now at risk are the bare-boned Chicago Building; the Gage Building, where Sullivan pinned ornaments like brooches; and an extraordinary ensemble of 1920s skyscrapers south of the Michigan Avenue Bridge, including the exuberant Art Deco Carbide & Carbon Building and the classical London Guarantee & Accident Building. Last, but hardly least, are Ludwig Mies van der Rohe's apartment towers at 860 and 880 North Lake Shore Drive, the pathbreaking steel and glass boxes that changed skylines around the world.

Collectively, these structures endow Chicago with human scale, delightful ornament, and a palpable sense of solidity that separates the city from the flimsy, mirror-glass glitz of the Sun Belt. And, of course, they draw tourists by the thousands. Without them, the city would be a less civilized place. Even the coach house added to the gracefulness of its street, a proposed historic district. Yet the values embodied by these buildings mean little to aldermen, who tend to placate the wishes of developers who finance their campaigns.

What the aldermen did was replace an old landmarks law that was bad with a new one that is worse. The old law permitted the City Council to leave proposed landmarks in a legal limbo, where they temporarily were protected from demolition, but denied permanent landmark status. Such was the case with the 29 buildings and districts. Passed with Daley's blessing, the new law requires that landmark recommendations be approved within a year; otherwise the proposal dies. Yet the law fails to mandate that the council vote on the issue. Thus, aldermen can consign buildings to the graveyard without signing their names on the death warrant—a perfect way of remaining unaccountable to the voters.

None of this means that wrecking crews will go to work on the Mies high-rises anytime soon. But the door is now open to precisely such a travesty. In the short term, lesser buildings may be altered beyond recognition by those like the developer who wants to slap a Toys "R" Us sign on the Chicago Building.

The new law also fails to close legal loopholes that allow aldermen to play by their own landmark rules. In general, for example, property owners don't have to agree when their buildings are placed on the city's list of protected structures. But Ald. Burton Natarus (42nd), whose downtown ward includes

19 of the 29 threatened buildings and districts, requires owner consent on the grounds that landmark status creates economic hardship. Even a minority of objecting owners in a district or building is enough to stall designation.

Yet no less than the U.S. Supreme Court has ruled that communities have the right to safeguard significant pieces of property, so long as they do not trample the rights of the properties' owners.

The court decision came in 1978, settling a dispute that began when the bankrupt Penn Central Railroad sought to build a 55-story office building atop New York City's Grand Central Terminal. The Beaux-Arts railroad station was a landmark and inviolable, the city's preservation commission found. The high court agreed. Because New York City allowed the railroad to sell the air rights above the terminal to nearby properties, permitting additional development at those sites, the railroad had not been denied a reasonable return, the court said.

The ruling firmly established the principle that preservation is a public good. Without a carefully crafted equilibrium between economics and aesthetics, Justice William Brennan wrote in the majority opinion, all of us would be poorer.

But if Natarus is oblivious to Brennan's balanced vision, Chicago's leading landmark advocates are equally at fault for ignoring the reality that historic preservation is as much about politics as it is about aesthetics. After leaders of the Landmarks Preservation Council of Illinois were informed in 1995 that the council had stripped the 29 sites of temporary protection, the nonprofit advocacy group did not raise its voice. Its leaders assumed the problem would be fixed—which it was, in a classic Chicago way.

The preservationists need to wise up: buildings don't become landmarks in a political vacuum. The key political questions inevitably turn on economics. Federal laws already offer tax credits to those who redevelop properties that qualify for national landmark status. Their impact would be magnified if they were linked to local measures that would hold out a carrot to real-estate developers. Such incentives are under study by a task force that includes the Cook County assessor's office. Now is the time to expedite them.

The measures would reduce the property-tax assessment rate for commercial and multifamily properties for several years in exchange for "substantial" rehabilitation of a property and its placement on the landmark rolls. Elsewhere such moves have had a dramatic impact on the cityscape.

In 1993, trying to spur the conversion of old downtown warehouses and office buildings into lofts and apartments, Dallas instituted tax breaks for owners of renovated downtown landmarks. Largely owing to the change, the number of applications received annually by the Dallas landmarks commission soared.

While the incentives reduce short-term tax revenue, they promise long-term financial gains—upgraded buildings that enlarge the tax base and reclaim the city from blight.

Putting comparable measures in place here would ease the present crisis, but won't achieve a resolution. For that to happen, the Daley-controlled council must stop weaseling out of landmark votes. And the aldermen must stop allowing the owners of private property to ignore the public good. Otherwise, the fate of the Stock Exchange will be past that's prologue: Chicago will keep destroying itself.

Postscript

This story helped spark a public debate. WTTW's Phil Ponce devoted a *Chicago Tonight* program to the subject. Hundreds of letters poured into City Hall. And the Landmarks Preservation Council of Illinois mounted a vigorous lobbying campaign.

The mayor got the message. He reversed course, precipitating a seismic shift in Chicago's landmarks landscape.

In 1996 and 1997, at Daley's behest, the City Council granted landmark status to all but one of the 29 endangered sites, the Walt Disney Birthplace at 2156 North Tripp Avenue. (Only the State Street facade of one of the 28 other sites, Tree Studios, a Near North Side artists' colony, was protected in 1997. But under a city-backed deal announced in 2000, the exteriors of Tree Studios, its two annexes, and the neighboring Medinah Temple were saved.)

Also in 1997, the City Council approved an ordinance altering the "sunset" provision that killed a proposed landmark designation if the council did not act within a year. It was replaced with a "sunrise" provision, which automatically makes a proposed site a landmark if the council fails to vote.

Still another initiative—this one approved in 1997 by the Daley-controlled Cook County Board—offered a package of property-tax breaks for landmark owners. It created a new tax classification, Class L, that now provides 12 years of property-tax reductions if the owner invests at least half of a building's assessed value in significant rehabilitation. By 2000, the measure was having a significant impact, encouraging the renovation of several aging buildings in downtown Chicago. They included North Michigan Avenue's Allerton Hotel and its whimsical Tip Top Tap sign.

Vertical Triumph

Reliance Building Restoration Is a Vote for Old Glory

OCTOBER 17, 1999

It's like seeing a great but time-worn fresco—one thinks of the Sistine Chapel ceiling—brought back to its legendary splendor. Once-vivid colors emerge from decades of dust and grime. The bold outlines and sharply etched details of the artist are revealed anew. You see a brilliant, total work of art, not faded fragments.

That is the near miracle wrought by the architects who have transformed the 104-year-old Reliance Building, the gossamer-gorgeous Chicago skyscraper that anticipated the taut-skinned, steel and glass office buildings that now etch the world's skylines. Their achievement is all the more astonishing because they have converted the renowned Reliance to an entirely new use without compromising the building's brilliant original design.

Four years ago, when the big-windowed, white terra-cotta exterior of the Reliance was returned to its ethereal glory, it was half a victory. Now, with the interior sparkling as a new 122-room luxury hotel (renamed the Hotel Burnham in honor of architect Daniel Burnham, whose firm designed the Reliance), this triumph of preserving the past is complete.

From a dazzling elevator lobby to a dramatic internal staircase, the job has been executed with meticulous attention to detail. Never has the often grubby business of recycling old buildings seemed so artful or so significant.

The Reliance boosts an already resurgent State Street and fuels the emerging trend of giving Chicago's aging skyscrapers new life as hotels or condominiums. And at a moment when a developer wants to erect the world's tallest building in the Loop, the comparatively diminutive Reliance, at just 16 stories, offers a timely reminder about what endures in architecture: not what is biggest, but what is best.

Credit for the final leg of this six-year odyssey, which cost more than $30 million in public and private funds, goes to architect of record Joseph Antunovich of Antunovich Associates of Chicago and the restoration architect, T. Gunny Harboe of McClier Corporation of Chicago.

But it would be remiss not to mention the developers who backed the project, McCaffrey Interests, Mansur & Company, and Granite Development; the hotel managers, the San Francisco–based Kimpton Group; and Mayor Richard M. Daley, without whom the restoration of the Reliance would have been impossible.

In 1994, a year after the city won control of the Reliance from a longtime owner who had allowed the building to go to seed, Daley had to endure jeers

from the City Council before recalcitrant aldermen finally agreed to fund a $6.4 million restoration of the Reliance's crumbling exterior. "This building is not worth a dime," said John Steele, then 6th Ward alderman.

Now, though, it's easy to appraise the Reliance's true value: priceless.

No other building so dramatically encapsulates the engineering and aesthetic advances that made Chicago the birthplace of the skyscraper: the shift from load-bearing walls of masonry to curtainlike walls of glass supported by an internal metal cage, the invention of elevators, and new foundation technology that gave the new cloudbusters firm footing in Chicago's soft clay soil.

The early skyscrapers, finished in the 1880s, were covered in stone, a material associated with solidity; it was used to soothe pedestrians jittery about the structural stability of the new kids on the block. But the Reliance, which was completed in 1895, eschewed the heavyweight cloak for a thin membrane of generously scaled windows and white terra-cotta panels. The latter marked the first time glazed terra-cotta had clad an office building.

Projecting window bays gave the Reliance a sense of verticality while flooding its interior with daylight, a major improvement over the dim wattage of the primitive electrical fixtures then in use. That feature proved especially useful in the examining rooms of the doctors and dentists who were among the building's original tenants. Yet for all the Reliance was a precursor to the bare-boned boxes of Ludwig Mies van der Rohe, the skyscraper partook from history, as the 1995 renovation made clear.

Once all the grime was wiped off the terra-cotta, you could see how the Reliance's designers drew upon the soaring Gothic cathedrals of medieval France to dramatize the form of the tall building. Clusters of thin columns, or colonnettes, for example, made the building's corner seem delicate rather than blocky.

But the fragile beauty did not last. Gradually the pristine white facade became encrusted with soot and blighted by klutzy signs and fire escapes. Panes of some windows were boarded up with plywood. By 1993, the building had just six tenants, including Ella's Tea Leaf Studio on the seventh floor. Its street-level retailers included a shop selling peekaboo bras and other exotic lingerie.

A principal virtue of the restoration is that it reclaims the work of two great architects—Burnham's partner, John Root, who shaped the very glassy brown-granite base of the Reliance before he died in 1891; and the man who replaced him as Burnham's chief designer, Charles Atwood, who was responsible for the Reliance's equally daring upper floors. (He gets his due in the Hotel Burnham's ground-floor eatery, the Atwood Cafe.)

To passersby on State Street, who have been eyeballing the Reliance's re-

THE RESTORED RELIANCE BUILDING: A triumph of historic preservation.

stored terra-cotta facade and cornice since 1995, the most noticeable change will be to the bottom of the building, where a temporary wall of glass and aluminum panels has been replaced by new brown granite walls that are overlaid with a delicate reproduction of Root's original Gothic filigree.

The brown granite endows the base of the Reliance with an appropri-

ate feeling of solidity without repeating the heavy, fortresslike appearance of such earlier Root buildings as the Rookery. Huge sheets of glass allow pedestrians to glimpse the tall-ceilinged Atwood Cafe while visually unifying the bottom of the building with the big windows of the Reliance's upper floors. There are new, curvy drapes up there, but they do not disturb the building's overall sense of transparency.

The hotel, whose official address is 1 West Washington Street, has entrances on both Washington and State, the former leading to a new and largely conventional hotel lobby, the latter pointing the way to a restored elevator lobby that is nothing short of extraordinary.

Here, the visitor encounters a small but soaring space that repeats in miniature the perfect proportions of the skyscraper. It has a glistening mosaic floor and exotic polished marbles—some red, some green, others black. The most striking of them, a white Italian stone with inky black and blue veins, is arranged in wall and ceiling panels that form near-perfect mirror images.

Despite the bold display of color, the lobby never goes over the top. And, like the exterior, it has an incredible sense of transparency, accentuated on one side by the Gothic metalwork of new elevator grilles and, and on the other side, by an enormous interior wall of glass. Together, they make the lobby, the cafe, and the street outside seem like one continuous space.

What marks the Hotel Burnham as truly unusual, however, is that when hotel guests venture upstairs they will get a sample of what the interior of a turn-of-the-century office building looked like. The hotel even allows architecture buffs to visit one of the building's former offices, provided they have an escort. Thus, the Hotel Burnham is something of "a living skyscraper museum," says Jim Peters, who helped oversee the project as director of Chicago's landmarks commission.

People used to beige-carpeted, white-walled corridors in modern office buildings will encounter something very different here: terrazzo tile floors, white marble wainscoting, and mahogany door and window frames. In a wonderful touch, the hotel room numbers are painted onto the translucent glass doors in an old-fashioned format that precisely echoes the style of the office numbers that once graced the Reliance.

The room numbers exemplify the balance struck by the architects and the interior designer, Susan Caruso of Los Angeles, between preserving key features of the office building and giving the interior enough welcoming hotel touches so that it doesn't seem cold and institutional. Happily, that balance continues in the guest quarters, former office cells that were small enough to be easily adapted into hotel rooms. The drapes, for example, are a clubby blue on the inside, but

white on the outside, so they blend in easily with the building's milky exterior.

Best of all, by inserting two new fire stairs in the back of the building, the architects were able to preserve the openness of the Reliance Building's richly decorated internal staircase, which sweeps through the upper-floor lobbies like a piece of sculpture.

All these painstaking details add up to a supreme example of historic preservation. A world-renowned skyscraper that could have been lost to the wrecking ball now proves that old buildings can be recycled for new uses. Long heralded for what it foreshadowed, the Reliance today can be appreciated for what it is—the culminating achievement of Chicago's early skyscrapers.

But the reconstitution of the Reliance teaches a broader lesson about architecture, and it is one that deserves special attention in a tradition-bound city that sometimes seems to have lost its nerve: the same daring that gave us the landmarks of yesterday is needed to create the landmarks of tomorrow. Only if we heed that lesson will we fully appreciate the restored glory of this total work of art.

Crumbling Icons

Some of Frank Lloyd Wright's Greatest Buildings Are Falling Apart, but the Bigger Question Is—What Can We Do to Save Them?

FEBRUARY 14, 1999

Buildings, even buildings by Frank Lloyd Wright, get old, just as people do. Their skin starts cracking. Their arteries clog. They sag in the most embarrassing places.

Now, like the twentieth century on which they made an indelible stamp, some of Wright's masterpieces are showing signs of advanced age—as well as botched stewardship and, perhaps, design errors by the man whose proficiency at the drafting board equaled Mozart's at the keyboard.

At 61-year-old Fallingwater in Pennsylvania, built as the vacation home of a Pittsburgh department store magnate, the terraces that once daringly projected over a tumbling stream have been shored up with steel beams. Without the temporary supports, structural engineers say, the terraces would have crashed into the stream.

At the Robie House, 90 years old and a landmark at the University of Chicago, the long and narrow bricks that evoked the vast spaces of the

Midwest prairie are falling apart, victims of Chicago's relentless freeze and thaw cycles. Air conditioners are jammed into windows graced by delicate, pale green art glass.

At Oak Park's Unity Temple, which just turned 91, there's no air conditioning. As a result, so much condensation is trapped in the structure's once radical, exposed concrete walls that, on the first warm day of spring, it actually rains inside. In the summer months, Wright's heavenly, skylit sanctuary turns into a hellish sauna where temperatures reach 125 degrees.

Even as Wright's popularity soars following last year's PBS documentary about him and as millions of dollars are spent on cheap imitations of his distinctive designs—there are faux Prairie Style houses, supermarkets, even car dealerships—these seminal structures, among the most beautiful and influential of the twentieth century, are slowly falling apart.

Raising the millions of dollars necessary to fix them will be an even bigger problem. That's not just because the Wright buildings will be competing for a shrinking pot of public and private funds; it's also because they're nobody's pet project, unlike Wright's Dana-Thomas House in Springfield, which surely owes something of its $6 million, state-funded restoration to the fact that it sits a block from the Illinois governor's mansion.

"The stewardship of important buildings is often left to the whim of public taste and public view—whether an important building is in somebody's face," says Jim Mann, director of the Midwest office of the National Trust for Historic Preservation, the organization chartered by Congress to preserve the nation's treasures.

That's bad news for everybody, not just the ever-growing legion of Wright buffs. Frank Lloyd Wright's buildings transcend architecture. They are icons of American civilization, capturing all of its singular tensions and contradictions in wood and glass and brick.

In the Robie House, we see nature (pronounced horizontal lines symbolizing the Midwest landscape) arrayed against the machine (the streamlined forms that led Europeans to compare the house to a steamship). There is rugged individualism (an iconoclastic design with an entrance that, in typical Wright fashion, is nearly impossible to find) playing off against the common good (bands of windows that open the sheltered interior to its neighborhood). And there is the restless American spirit (overhanging roofs that explode into space) in counterpoise with the universal desire to set down roots (the chimney that anchors the entire composition).

Yet after decades of mistreatment, the house at 5757 South Woodlawn Avenue vividly symbolizes another, far more distressing reality: many of the heroic, modern buildings that transformed American cities in the early and mid-twentieth century have become fragile and vulnerable.

THE FALLINGWATER HOUSE: Sagging concrete terraces and a cautionary tale in overreaching.

THE ROBIE HOUSE: Cracked bricks and a compromised aesthetic.

"As America's built environment ages, there will be an increasing need for support of the great buildings. We'll just get more of them, especially the twentieth-century buildings," says Lynda Waggoner, the director of Fallingwater, now a house museum.

To be sure, no one is worried that Fallingwater, the Robie House, and Unity Temple won't survive. But of the more than 400 Wright-designed buildings dotting the United States, they are the most visible examples of what might be termed demolition by default—a gradual decline, largely owing to deferred maintenance, that transforms a hallowed landmark into a hollow vessel.

"It's kind of like wearing your favorite sweater. Unless you take it off and look at it, you don't see it's not in great condition. The elbows are threadbare," says Sara-Ann Briggs, executive director of the Frank Lloyd Wright Conservancy, a Chicago-based group devoted to preserving Wright's architecture.

Most of us know these buildings through the medium of photography, in which they appear static, frozen, perfect. In reality, these buildings, just like any others, have a life that changes over time. They get attacked by water, termites, even freak windstorms, like the one last June that sent a huge white oak crashing onto the roof of Taliesin, Wright's Home and Studio in Spring Green, Wisconsin. The tree punctured Wright's drafting room roof. Estimated repair cost: $1 million.

Irresponsible owners are another problem, as illustrated by the saga of Wright's first great Prairie Style house, the 96-year-old Ward Willits house in Highland Park. When the current owners, Milton and Sylvie Robinson, bought the house in 1984, an anteroom off the dining room had a gaping hole in the ceiling. The previous owner had put a big garbage pail under it to catch the rainwater. "His advice," recounts Milton Robinson, a commodities trader, "was don't let the can get too full because it's too heavy for two men to lift." The hole is now sealed.

Almost certainly, though, Wright himself must shoulder some of the blame, owing to the sheer hubris he exhibited at such revolutionary buildings as Fallingwater.

The house represented the architect's stunning response to the International Style modernism of such Europeans as the Swiss-born Le Corbusier. Its concrete terraces soar majestically over a waterfall, employing a method of construction known as the cantilever, which allows part of a building to extend beyond its supporting wall or column. Just one problem: there wasn't enough reinforcing steel in the cantilevering terraces.

That's the view of New York City structural engineer Robert Silman, who designed the shoring that has been in place since 1997. "These were simple cantilever beams," says Silman. "A first-year concrete problem in college. There is not sufficient reinforcing in there. I don't know why."

The terrace that shoots over the waterfall now has a seven-inch sag, which was rapidly worsening before the steel shoring was installed. Adding more steel, as Silman plans to do, won't correct the problem. It will simply stop further sagging.

Asked whether the mistake diminishes Wright's masterwork, Silman is emphatic: absolutely not. "The concept of using this great cantilever was brilliant," he says. An upcoming capital campaign for Fallingwater is expected to raise about $6 million; much of that will underwrite the costly job of adding steel to the sagging terraces.

While Fallingwater's woes are as striking as the house itself, those at the Robie House show how artistry can be undone by an accumulation of mishandled details, from roof tiles that don't duplicate the low-lying profile of Wright's original design to white interior walls that depart from the architect's desired earth tones.

"The closer you get to the building, the more you see its problems," says Oak Park architect John Thorpe, the chairman of the house's restoration committee and a member of the board of directors of the Frank Lloyd Wright Home and Studio Foundation, which runs tours at the house and is responsible for its restoration.

Completed in 1909, the Robie House was at once the culmination of

Wright's Prairie Style and the vanguard of the sleek, abstract designs of the International Style. Yet as the house's reputation grew, its condition declined, particularly when the Chicago Theological Seminary purchased it in 1926.

Prairie Style furnishings disappeared. Wright's aesthetic refinements, like the red mortar joints that made its elegantly proportioned bricks appear to be continuous horizontal bands, were ignored. Not only did the seminary turn the house into student dormitories; it even tried in 1957 to demolish this landmark of modernism in order to build new dorms. Wright personally led the successful battle to save it, quipping, "It all goes to show the danger of entrusting anything spiritual to the clergy."

In 1997 the present owner, the University of Chicago, teamed with the Frank Lloyd Wright Home and Studio Foundation and the National Trust for Historic Preservation to transform the Robie House from university office space into a house museum. Since then, the foundation has drafted a master plan for the house; it will soon begin a $4 million fundraising campaign. The plan calls for a computerized climate control system, comparable to one at Wright's renovated Oak Park Home and Studio, that adjusts humidity levels as visitors walk into a room. (A lack of humidity can dry everything from wood to fabrics.)

Unity Temple has similar problems with its interior, but it is unique because it is a public building, heavily used for church services, weddings, even jazz concerts.

Working for a congregation whose church had just been destroyed by fire and with a budget of just $45,000, Wright created an utterly radical religious edifice: two adjacent cubes of exposed concrete (the larger one for the sanctuary, the smaller one for the community building). It was inexpensive and fireproof and it shielded the congregation from the noise and dirt of heavily trafficked Lake Street. Most of all, it shaped a monumental but intimate worship space in which gentle, colored light seeps in through rooftop skylights. Wright's emphasis on "the space within" foreshadowed office-building and hotel atriums by the score.

But his heating and cooling system never worked. The concrete facade cracked. The cantilevered roofs sagged. And the hidden downspouts rotted, causing water damage to the walls of the community room. It's all pretty unsexy stuff, which is why, even though the sanctuary has undergone a $700,000 restoration, preservationists fret that no one may come forth with the dollars to fix the rest of Unity Temple. "Who wants to pay for downspouting?" says Lisa Dodge, the director of tourism for the Unity Temple Restoration Foundation, which needs to raise another $1 million for the building.

UNITY TEMPLE: Water-damaged walls and a precious legacy in jeopardy.

Help isn't forthcoming from Illinois. It doesn't make grants or low-interest loans for historic preservation, as other states do. Mann, of the National Trust for Historic Preservation, bemoans the state's lack of funding for historic preservation, arguing that it's as important for the General Assembly to spur repairs of internationally recognized landmarks as it is to back the construction of affordable housing. Great architecture "brings visitors," Mann says. "It brings business. It gives a sense of place for people who live there."

But on the national level, there are signs that the tide may be turning at the right time for Wright. As part of the White House's effort to celebrate the millennium, Hillary Rodham Clinton is leading a campaign, called Save America's Treasures, that has secured private funding to restore historic buildings and artifacts such as the flag that inspired Francis Scott Key to write "The Star-Spangled Banner."

Wright's aging but still extraordinary buildings are no less important to the nation's cultural heritage. They pioneered a new aesthetic as well as new materials. They changed the way we live. As they are diminished, so are we. They ought to get the tender, loving care they so desperately need.

Postscript

The prospects for all three Wright landmarks brightened considerably following the publication of this story. Appearing at the Robie House in 1999, Hillary Rodham Clinton announced that the Pritzker Foundation of Chicago would donate $1 million to the house's restoration. In 2000, the State of Illinois authorized spending $1 million to begin restoring Unity Temple. And in same year, Pennsylvania governor Tom Ridge appeared at Fallingwater and announced a $3.5 million state grant to repair the drooping cantilevers and make other improvements. Those structural changes are expected to be complete by spring 2002, the same year exterior renovations at the Robie House and Unity Temple are set to be done.

SUBURBANIZING
THE CITY

The old adage that there is strength in numbers doesn't apply only to war and politics; it has implications for cities, too. One of them, which became apparent in the 1990s, was the growing—and often grating—impact that America's suburbs were having on its urban landscape.

Stores that typically did business in the suburbs muscled into city neighborhoods, where their blank-walled outlets were instant eyesores. Meanwhile, suburban residents were part of a growing army of tourists that marched into downtown, spurring real-estate developers to carve out sanitized, tourist districts that presented the city in caricature.

Nowhere was the shift more evident than in Chicago, where an entirely new cityscape—or was it a suburbscape?—sprouted. It extended from Navy Pier, a shopping mall–theme park by the lake, to the entertainment district of River North, whose little buildings and their oversized signs looked as if they belonged on a suburban strip. In the middle of these two was North Bridge, a nine-block tourist zone where the architecture was as generic as a complex of mirror-glass office buildings strung along a highway.

An invasion? Yes, and it raised issues comparable to those on Michigan Avenue and State Street: should Chicago regulate

growth or let it run wild? More often than not, little was done. The result, as the entertainment attractions of River North made clear, was a new, awkward combination of city and suburb.

City-Escape

A New, Schlocky Brand of Architecture Promotes a Chicago that Never Was

AUGUST 22, 1993

The big-shouldered Chicago of poet Carl Sandburg is fading into a neon-lit sunset. In its place is a new Chicago, a thin-man Chicago, a strange amalgam where city and suburb indistinguishably blur together.

The Blurbs, let's unpoetically call it.

The Blurbs are where brawny Victorian brownstones run smack into the plastic chic of the Golden Arches, where the skyscraper canyons of the Loop give way to the wide-open spaces of the commercial strip. In the Blurbs, to capture the driver's eye and business, the brightly colored signs atop buildings are often bigger than the buildings themselves.

And the architecture—the new architecture, anyway—tends to be so much junk food for the eyes.

Consider the city's River North district, just west of the hotels, office buildings, and shopping malls of North Michigan Avenue. Recently, River North has witnessed the opening of two wildly popular celebrity restaurants, Planet Hollywood and Michael Jordan's, and one equally successful tourist attraction, Capone's Chicago.

Here, on the western edge of its downtown, Chicago is losing its edge. To put it another way, the city is winning sales-tax dollars and sacrificing its soul. And it is doing so in a district that, given its location just off the Kennedy Expressway, represents a major gateway to downtown. "It's becoming our front door, and it's important to enhance it," says Valerie Jarrett, Chicago's commissioner of planning and development.

Jarrett is pushing for the City Council to enact legislation that would give her department more say in what gets built in special districts of Chicago such as River North. At present, city planners can suggest design changes only for proposed large-scale developments there—not for the small but high-profile schlock that makes up the Blurbs.

For more than a century, Chicago has transformed its raw energy into a cityscape of stunning power—not the overwhelming theatricality of

CAPONE'S CHICAGO: Turning gritty history into warm and fuzzy nostalgia.

New York or the Disneyland artifice of Los Angeles, but a what-you-see-is-what-you-get realism that has produced aesthetic triumphs ranging from D. H. Burnham & Co.'s Reliance Building to Skidmore, Owings & Merrill's John Hancock Center. Even Chicago's playlands, from Wrigley Field to Rush Street, have been characterized by a robust grittiness that embraced the city instead of offering an escape from it.

In the Blurbs, the rules of the game are different. Form follows fun, not function. And architecture remains art, but with a twist: it is reduced to the art of expediency and the quick buck, not the civilized act of building for the ages.

At Capone's, the facade has almost literally been wallpapered into place to present the illusion of 1920s Chicago—a tableau that is so unconvincing that Disneyland seems real by comparison. At Planet Hollywood, fake palm trees and searchlights try to evoke the glamour of a Hollywood premiere—and if you believe that can happen each and every night in celebrity-starved Chicago, then perhaps you're ready to wager your life savings that the Cubs will win this year's National League pennant.

Only Jordan's comes close to soaring architecturally, and the reason is that it largely forgoes the trap of gussying up an old horse stable. Even so, there are de rigueur touches from the Blurbs, such as a billboardlike facsimile of a Wilson basketball perched atop the restaurant's LaSalle Street facade.

When he drew up the celebrated Plan of Chicago in 1909, Daniel Burnham probably did not envision that the view down one of his major boulevards, LaSalle Street, would be punctuated by an oversize roundball, hovering in the sky like some wino's vision of an orange moon.

And It's Spreading

Some newspaper columnists have attacked the make-believe architecture of River North on the grounds that it does not represent the real Chicago. But that view is entirely too comforting, implying that Chicago can contain the Blurbs in a downtown theme park frequented mainly by unsuspecting tourists.

What's truly disturbing about Capone's and its ilk is that, building by building and block by block, they are becoming the real Chicago, from the strip malls of the Clybourn corridor to the vertical shopping malls of North Michigan Avenue to the suburbanized baseball stadium of the new Comiskey Park—the "Mallpark," as Chicago's *Inland Architect* magazine aptly tagged it.

River North is merely a microcosm of this trend, with its crazy quilt of parking lots, art galleries, drive-in banks, motels, nightclubs, and restaurants. They include the Rock 'n' Roll McDonald's, the Hard Rock Cafe, and Ed Debevic's—the predecessors of Capone's Chicago, Planet Hollywood, and Michael Jordan's.

To be sure, no one can deny the street-level vitality and sales-tax dollars the new places are producing. Anyone who has witnessed the urban wasteland of Detroit knows they are preferable to empty city blocks. That the three new spots are each drawing 1,500 to 3,000 people a day— 5,000 a day at Michael Jordan's during the NBA playoffs—demonstrates that they are satisfying public demand.

Yet what the public wants, it seems, is escapist entertainment—not architecture that celebrates the roughness and reality of Chicago, but buildings that present a sugarcoated, sanitized version of the city. In short, Disneyland. Why travel all the way to Los Angeles or Orlando when you can get the unreal thing right here?

Capone's Magic Kingdom

Designed by Summerdale Architects of Chicago, Capone's Chicago is strongly influenced by the architecture of the Magic Kingdom. As at Disneyland, there is an attempt to evoke the innocent, optimistic times of a bygone era through the architecture of Main Street, U.S.A. Never mind that this is at Clark and Ohio Streets, where hundreds of cars pass each day on their way to and from the Kennedy.

Windows and other details on Capone's facades are shrunken to two-

thirds or three-quarters of normal scale to appear approachable, especially to young children. The colors of individual building fronts, including bright blues and yellows, are straight out of a comic book. Ornamental streetlights complete the old-time feel. Even the commercial-strip touches—a smiling portrait of Capone on top of the building—are meant to be nonjarring in this "historically themed family attraction," as the Capone's Chicago press kit calls it.

Inside is another page out of Disney: a two-story theater in which the players are robots (including a robotic version of Capone) in dioramas created by a team of designers who worked at Walt Disney World in Florida.

It takes a huge dose of chutzpah to associate Chicago's most famous thug with the happy times of Main Street, U.S.A. It takes even more gall to assert, as the public relations material for Capone's Chicago does, that the facade of this tourist attraction "reflects a typical 1920s Chicago street scene."

If Capone's reflects 1920s Chicago, its mirror is surely cracked. Buildings of that era have a solid, substantial feel; Capone's facades, which have been glued or snapped on, look wafer thin, as if they would collapse if a heavy wind blew off Lake Michigan. If you knock your fist against the building's half-inch veneer of brick, you hear a hollow ring.

History rings hollow at Capone's too. Its cartoonish facades bear only a tenuous relationship to buildings associated with the Capone gang: the ornate Lexington Hotel where Capone had his headquarters, or a North Side hauling and storage company called SMC Cartage that was a front for illegal beer distribution. There, in 1929, four of Capone's hoods lined up seven members of the rival Moran gang and machine-gunned them to death in the St. Valentine's Day Massacre.

More than architectural hairsplitting is at issue here. If Capone's is going to fleece tourists of a few bucks, the least it can do is provide an accurate re-creation of the spots where Capone made "bang-bang" one of the most famous words in Chicago lore.

But in a "historically themed" environment, history is to be plundered—and selectively reinterpreted—for profit, not wisdom. Far from sharpening our memories of a man who murdered in cold blood, Capone's Chicago bathes him in the warm and fuzzy glow of nostalgia. A notorious criminal is transformed into a comic buffoon whose robot likeness jokes about how he "shot up" through the ranks of the organization.

A Permanent Stage Set

The knee-slapping mob also is part of the scene at Planet Hollywood, a few blocks west of Capone's Chicago at Ontario and Wells Streets. There, though, the mob's role is strictly cameo.

PLANET HOLLYWOOD: A scream of excess in a city of understatement.

In the restaurant's Chicago-themed dining room, as patrons eat low-fat turkeyburgers and pasta salads, they hear the sound of a piped-in tommy gun, while fake bullet holes in the wall light up with pretend gunfire. It's enough to raise eyebrows and pulses, particularly those of young children. But fear not. This, too, is a themed family attraction where terror passes quickly.

Unfortunately, the architecture of Planet Hollywood will not.

Its designers, Haverson-Rockwell Architects of New York, made Planet Hollywood a stage set, an appropriate identity for a joint that features authentic movie memorabilia plus a chance to glimpse one of its three celebrity owners—Arnold Schwarzenegger, Sylvester Stallone, and Bruce Willis—on the off chance they jet in from the Coast for one of those low-fat turkeyburgers.

Pretend palm trees as well as flattened metal versions of pink and green searchlights rise more than 40 feet above the sidewalk, like a superscale picket fence that separates the real city from the fantasy world within. The lighting adds to the excitement, especially at night. Dominating it all is a happy-looking Godzillalike creature who holds a blue globe with the words "Planet Hollywood" in red. A larger version of the same logo appears over the main entrance.

Capone's softens the hard world of gangsters with its Disneyland

MICHAEL JORDAN'S: Not a design disaster, but no slam dunk.

facade; Planet Hollywood hardens the soft world of celluloid with an exposed steel structure that supports the smiling green monster and the big blue globes. Corrugated plastic wrapped around the faux searchlights further lends the structure a ruggedness that is almost—but not quite—in tune with Chicago's tough beauty.

This dissonance is partly a matter of color. When was the last time you saw a husky, brawling, big-shouldered building dolled up in pink and green? Yet ultimately, the clash is a question of character: in a city of architectural understatement, where even the world's tallest office building, the Sears Tower, doesn't flaunt its height, Planet Hollywood is all about excess.

The restaurant is gold chains, baby, not Gold Coast. Comparing Planet Hollywood to the Pump Room, the urbane Gold Coast restaurant where Bogey and Bacall exchanged drolleries at Booth One, is like mentioning the Queen Mother and Fergie in the same breath. One is class, the other mass. Rarely do the twain meet.

The one place they do intersect among the latest additions to River North is Michael Jordan's.

Jordan's Stays in Control

Transforming a three-story brick building at Illinois and LaSalle Streets into a restaurant-cum-shrine for the world's most famous athlete would

have led most designers down the path of sports bar glitz. Instead, Zakaspace Corporation of Fort Lauderdale let the building, an old horse barn that previously was a Burhops restaurant, speak in a relatively straightforward Chicago way.

Okay, so the gigantic banner stuck on the front of the building— depicting Jordan flying through the air like Peter Pan—isn't exactly retiring. But His Airness is truly larger than life, and the banner is as discreet as a 30-by-30-foot sign can be. Its background color is understated black, as are the building's canvas awnings and canopied entrance. In short, the banner is overblown, but it doesn't overwhelm.

Inside Jordan's, the spaces are lively but uncluttered, with cast-iron columns, plus wood beams and joists, lending architectural realism to the high-ceilinged bar and private dining rooms. Over the bar, hung from a yellow steel beam, is a row of blue airport runway lights, an appropriate allusion to the soaring flight path of Jordan's slam dunks—and a powerful reminder of the hard-edged City of the Big Shoulders.

In Jordan's, at least, Chicago is not yet the City of the Big Charade.

Postscript

Chicago city planners never got the authority to review the designs of small, themed attractions like those in River North. So even as Capone's Chicago and Planet Hollywood faded from the scene, the tourist spots that replaced them either retained their garish designs or substituted new looks that managed to be more hideous.

In 1997, Capone's was turned into the Chicago outpost of the Rainforest Café, a restaurant and shopping chain that transports visitors to a faux jungle. With a giant frog on its roof and cackling mechanical birds inside, the Rainforest Café quickly became even more despised than Capone's.

Planet Hollywood closed in 1999 after its parent company filed for Chapter 11 bankruptcy protection. It became an outlet of Gino's East, a Chicago-owned pizza chain; the pizza parlor operators retained the gaudy fake searchlights. As for Jordan's, it, too, closed in 1999 as the allure of the retired basketball superstar waned.

Populist Playground

Navy Pier Has Shaped Up, but Aesthetics Have Been Shipped Out

AUGUST 20, 2000

It is easy to forget now, with Navy Pier's attendance expected to hit an astounding 8.5 million this year, that reasonable people once were heard to ask: what if they redid the pier and nobody came?

Of course, that was back in the early 1990s—back before Americans started flocking to cities and back before the once-crumbling municipal dock was transformed into Chicago's very own populist playground.

Today, Navy Pier has become architecture's version of the movie *Titanic*—so powerful a draw that any criticism of its carnival midway tackiness, its ugly duckling architecture, and its perennial shortage of convenient parking almost seems beside the point.

Say what you will, the crowds keep coming.

Never mind that the pier turned out to be the very shopping mall by the sea it wasn't supposed to be. Never mind that proposed parkland on the pier is parkland in name only. Never mind that the pier offers the same kind of canned entertainment you get in a theme park. Never mind that scores of enticing design details were stripped to save money. Never mind that the pier offers a go-down-easy version of city life.

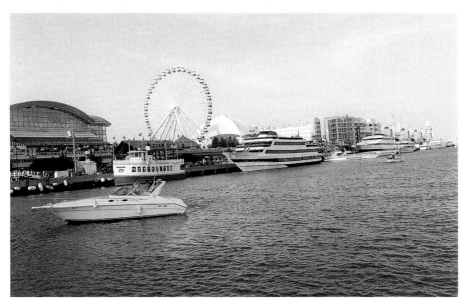

NAVY PIER: Chicago's shopping mall by the lake—a visual jumble.

The pier shows it is possible for a public space to be both an aesthetic flop and a people-pleasing triumph.

It is, in the words of one of its architects, Rick Fawell of Chicago's VOA Associates, "the people's boat"—the place where the masses can go to feel the cool lake breezes and look back at the skyline. Yet parts of it look as though they were designed by a committee of drunken sailors.

How did Chicago blow a chance to make this public pleasure ground a grand work of civic art?

Let's go back to 1991, when Navy Pier officials ran a design competition for the pier, which had been a shipping terminal and entertainment venue after it opened in 1916, a naval training facility during World War II, the Chicago branch of the University of Illinois from 1946 to 1965, and the site of the ChicagoFest summer festival in the late 1970s and early 1980s.

The participating architects were told to save the brick buildings at either end of the pier. But they were asked to replace the cargo and passenger sheds in the middle of the pier with new construction that was to include an exposition hall, a winter garden, shops and restaurants, parks, a marina, and parking for more than a thousand cars.

Some plans—like the second-place design by Chicago architect Laurence Booth, who wanted to erect a single multiuse glass building in the pier's midsection—were distinguished by a powerful architectural expression.

In contrast, the winning design by the team of Benjamin Thompson & Associates (BTA) of Cambridge, Massachusetts, and VOA made architecture a stage for the activity of people on the pier. It called for erecting several structures between the brick buildings and tying everything together with a series of dramatic light towers.

Above all, Navy Pier was to be different from the popular but heavily commercialized festival marketplaces—Faneuil Hall in Boston and Harbor Place in Baltimore—that had brought BTA national renown. Private developers had backed those projects. Because the pier was being done by a public agency—the Metropolitan Pier and Exposition Authority, created in 1989 to manage the pier and McCormick Place—its chief identity was to be cultural rather than commercial.

Or so it was thought.

"Navy Pier is not primarily about consumption or shopping in a mall," the BTA-VOA proposal said. "Navy Pier is largely about a new civic space on the waterfront."

However false some of those words ring today, they nonetheless set out a commendable goal—and possessed an unmistakable bravado. For they

were written in the early 1990s when urban America had yet to experience the full-fledged renaissance it is enjoying today.

There was good reason the first retailers at Navy Pier got sweet lease deals. It was hardly a sure bet that the pier—separated from downtown by Lake Shore Drive—would draw people, particularly in wintertime.

Give the pier five years and maybe it will attract 4.5 million visitors annually, experts told the pier's managers. Yet just three years later, in 1998, the pier drew a record-setting 8.2 million people, 2.4 million of them in the winter months alone.

The pier's chief attraction, of course, is its location. Extending 3,000 feet into Lake Michigan, it offers visitors skyline views and a feeling of being far out on the lake that they can't get anywhere else in Chicago. "If you took Navy Pier and plopped us down in a suburban mall location, we'd die," said Jon Clay, Navy Pier's general manager.

Yet the pier lures visitors with something else: the sense of being on an urban street, albeit one that is squeaky clean and unthreatening.

The architects divided Dock Street, the pedestrian promenade on the pier's southern edge, into block-like chunks with the brick-clad stair towers that appear every 250 feet or so. Then they subdivided it with restaurants, shops, pushcarts, outdoor cafes, and beer gardens that are meant to suggest stores lining a city street.

But Dock Street is not just any street. It is a special street, notable both for what it contains and what it doesn't.

Parts of the sidewalk are made of Virginia bluestone, a handsome departure from everyday concrete. There are an unusually large number of places to sit, not only in the restaurants but also in the many benches set out along the street and on the outdoor stairs that lead to the pier's upper level. And there are the Navy Pier Players, a troupe of singers, dancers, and actors who dress in costumes and provide visitors free entertainment—a page straight out of Disneyland.

On Dock Street, there are no traffic lights or intersecting streets. There are no buses spewing pollution into the air. There are almost no homeless people; the pier's distance from the rest of the city helps to isolate it, officials say. And there is very little political activity. A federal appeals court ruled in 1998 that the pier could ban demonstrations outdoors where pedestrian traffic would be obstructed, though certain areas are designated for leafleting.

In other words, Dock Street may be the city, but it's City Lite. It recalls what Robert Campbell, the *Boston Globe*'s architecture critic, once wrote about Boston's Faneuil Hall, cracking that the festival marketplace was a kind of "halfway house for suburbanites" reintroducing themselves to the city.

Whatever its faults, Dock Street still serves the invaluable, democratic function of allowing people from different walks of life to mix and mingle peacefully.

In addition, it's a far more attractive public space than the pier's indoor arcade, which runs parallel to Dock Street and was designed to provide visitors a refuge from winter cold. Not only does the arcade have a bare-bones look that resulted from the need to keep costs low, but it also feels cramped because the pier's ground-level parking garage—a big money maker—required so much space.

The arcade's shortcomings are a small thing, really, but in the end, architecture lives or dies by small things. And throughout the pier, economics trumped aesthetics, even though the state funds that backed the project were supposed to insulate the pier authority from focusing solely on the bottom line.

Along Dock Street, moneymaking carnival midway rides (like a miniature train loop) went in, while unprofitable design features proposed by the architects (like a special walkway for children, or a boardwalk that would have permitted visitors to get close to the water) were cut out.

The same mentality afflicted the powerfully scaled light towers that BTA and VOA initially included to create a sense of rhythm down the pier and to echo the two large towers at the pier's east end. "It was an envelope of light that held the composition together," said former BTA partner Jane Thompson.

Instead, the light towers were replaced by anemic space-frame flag towers. Night lighting was shaved to cut costs. Without the vertical accents of the light towers, the design lost its chance to be a strong, coherent form—the equivalent of a skyscraper laid on its side.

Design also took a beating in the middle of the pier, where the original plans for a lushly landscaped park were dropped when moneymakers like the pier's exposition hall needed more space. Instead of the crisp silhouette it once presented to the city, the pier became a visual jumble, especially in its midsection. There, the chief buildings—the Skyline Stage, an outdoor concert hall sheltered by a fabric roof; the Ferris wheel; and a 700-space, six-story parking garage—look dropped into place rather than carefully arranged. The chief merit of the fussy glass facade of the pier's Chicago Shakespeare Theater, which opened in 1999, is that it covers the eyesore of the parking garage.

One could go on and on about poor design and planning. There is the ugly brown floor tile in the west-end Family Pavilion, which helps make the pavilion feel like the shopping mall it wasn't supposed to be. There are the banal glass walls of the pier's exposition hall, which recall suburban

office complexes. And there are the pier's seemingly endless parking and traffic congestion problems.

To be sure, the pier has some commendable features, like the airy winter garden near its west end and the handsomely restored ballroom at its east end. In addition, pier officials envision changes, such as a 250-slip marina that will bring noncommercial maritime activity to the pier's north side, that will try to address its failings.

But the devil is in the details—and how well they will be handled is anybody's guess. Consider one new feature that's already in place: garish orange ceilings in the pier's food court. What's next? Covering the whole pier in neon?

So Navy Pier teaches a lot of larger lessons about urban waterfront developments—and, despite the sea of smiling faces on Dock Street, not all of them are happy ones.

Designers can make all sorts of promises, but executing them with elan is another matter. Having a public authority rather than a private developer in charge of a waterfront project is no guarantee that it won't become overly commercialized. And just because such a project is in the city doesn't mean it won't feel like a suburban mall.

Still, the pier symbolizes how cities in general and Chicago in particular have succeeded in renewing themselves. If only it excelled in the art of architecture as it does in the choreography of public space.

The Sky Above, the Dud Below

Developer John Buck Is Skating on Thin Ice When He Compares His North Bridge Project to New York's Rockefeller Center

SEPTEMBER 21, 2000

The urban tourist district, which offers the same shops, the same hotels, the same restaurants, and the same entertainment attractions in seemingly every city, is a lot like a big eraser, rubbing out the funky, the offbeat, the unexpected. Now, with the opening of a much-ballyhooed Nordstrom department store, all the pieces of Chicago's very own tourist district are about to be put into place. And the picture formed by this giant jigsaw puzzle is not pretty.

Covering nine city blocks and costing $1.5 billion, the new district is called North Bridge, but in truth, it is not really a district, certainly not in the same way you would think of, say, the French Quarter in New Orleans as a district. It is an instant district rather than one that has

GRAND AVENUE IN NORTH BRIDGE: A soulless concrete canyon.

grown slowly over time. Instead of distinctive architecture and activities—old jazzmen tooting their horns in buildings fronted with lacy iron grillwork—it presents a cityscape that is, with only a few exceptions, numbingly generic.

In North Bridge, bordered by North Michigan Avenue, along with State, Ontario, and Hubbard Streets, there are so many concrete slabs rising into the sky that you could be forgiven for thinking that one of Chicago's most hated buildings, the North Michigan Avenue Marriott Hotel, had managed to clone itself. Eyesores also are evident much closer to the ground, where there are enough windowless walls to satisfy the KGB. The small, old buildings that remain, like the Victorian mansion housing Pizzeria Uno, seem like orphans amid the new, blockbusting giants.

It takes some doing to color an American entertainment district Soviet gray, but the driving force behind North Bridge, Chicago real-estate developer John Buck, has managed to pull it off. For all the economic benefits Chicago is expected to reap from North Bridge—among them 2,800 permanent jobs and $42 million in annual tax revenue—the city is taking a visual pounding in the art that most decisively and lastingly defines it.

Yes, the sidewalks are packed with people, but commercial success is not to be confused with artistic achievement. Privately, the architects of the buildings in North Bridge are saying as much. One even sent me a fax that dissed the district. Another said in an interview, "There just isn't much to love in any of this area."

It's easy to see why the architects are upset. In most of these buildings, architecture is beside the point. They illustrate how Buck and other developers no longer are constructing glitzy trophy buildings, as they did in the 1980s, but instead are raising warehouses whose chief purpose is to contain the most space for the least cost.

Yet if the architecture at North Bridge is almost unfailingly bland, then the real-estate move it makes is breathtakingly bold: to build a metaphorical bridge, via the new district, between the high-fashion strip of the Boul Mich and the lowbrow entertainment zone of River North. "By way of analogy, where Times Square meets 5th Avenue," Buck once told a reporter from New York. On an even bigger scale, North Bridge creates an east-west, fun-oriented axis that links Navy Pier on one end with River North on the other.

Not since the 1860s when Potter Palmer shifted Chicago's principal retail corridor from east-west Lake Street to north-south State Street has a developer done so much to alter the city's patterns of daily life. But while Palmer's change produced enduring benefits for the cityscape—grand retail palaces along a newly widened State Street—this one promises little

more than short-term profits for Buck and his partner, New York's Morgan Stanley Real Estate Funds.

To grasp the significance of North Bridge, it helps to understand how the district is laid out. In essence, its nine blocks are arranged like a skewed tic-tac-toe grid: three blocks apiece on Michigan Avenue, Rush Street, and Wabash Avenue. Within the district, which gradually has been taking shape since 1990, are entertainment attractions like a Disney Quest indoor theme park, hotels, restaurants, shops, parking garages, an office building, an apartment tower, and the Nordstrom store.

The district also includes a new structure sheathed in the old Art Deco facade of the former McGraw-Hill Building at 520 N. Michigan Ave. As part of the city-backed deal that brought Nordstrom to Chicago, Buck was allowed to take the highly unusual step of cutting the McGraw-Hill's 16-story walls of Indiana limestone into more than 4,000 pieces. He then reassembled them over a new and much larger hotel-retail building at 520 N. Michigan.

To make it easy for pedestrians to move from Michigan Avenue to Rush Street, where the Nordstrom actually sits, city officials allowed Buck to construct a deck over lower Grand Avenue. Atop the deck, in the open space between the revamped 520 N. Michigan building and the Marriott Hotel at 540 N. Michigan, the developer shoehorned a four-story atrium that begins the sequence to the Nordstrom store. The atrium leads to a curving, four-story retail galleria that passes through 520. In turn, the galleria links up to a four-level skybridge that crosses Rush and feeds pedestrians directly onto each level of the four-floor Nordstrom.

In an address to a Michigan Avenue business group earlier this year, Buck's point man on North Bridge, Greg Merdinger, characterized the district as the largest mixed-use real-estate development in North America. North Bridge, he added, has roughly as much retail frontage along Michigan Avenue as Rockefeller Center has along 5th Avenue in Manhattan. But while there may indeed be a real-estate similarity between North Bridge and Rockefeller Center, it is ludicrous—in terms of architecture and city planning—to mention the two in the same breath.

At Rockefeller Center, an all-star team of architects led by Raymond Hood achieved aesthetic unity with a brilliantly arranged ensemble of buildings done in the trim, vertical look that dominated American design in the prewar era. They were grouped around the complex's great public space, a sunken plaza with a lively ice-skating rink and a magnificent sculpture of Prometheus.

At North Bridge, where many of the buildings are faced in cheap precast concrete rather than Rockefeller Center's elegant Indiana limestone,

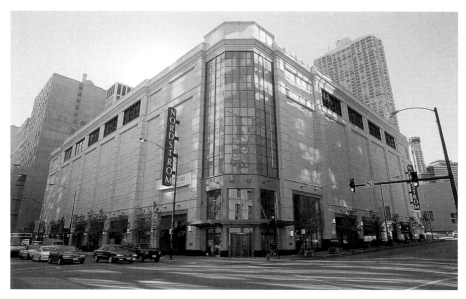

NORDSTROM: A bland box that bullies everything around it.

a different sort of stab has been made at architectural coherence, one less about overall composition than surface decoration. Under the direction of Buck's company, the bottoms of the buildings are wrapped in black granite. They have green awnings and light sconces. And they are ringed with stores and restaurants. The idea, Merdinger said in his address, is "to seed pedestrian traffic" and watch the district flower.

That aspect of North Bridge clearly works. Lining the sidewalks with storefronts makes dollars and cents as well as urban planning sense. It's a welcome shift from the modernist practice of steel and glass boxes standing haughtily on stilts, as they do at the bleak Illinois Center office complex south of the Chicago River. Yet there's much more to North Bridge than that, and very little of it is appealing, particularly the out-of-place Nordstrom store, which looks like it was meant to be built in a wide-open farm field somewhere out there on the suburban fringe.

True, the store's designers, Callison Architecture of Seattle, have tweaked Nordstrom's suburban model to a certain extent. Divided into three parts, like a classical column, the store's exterior has street-level windows that enliven the sidewalk. In addition, there's a rear entrance at Wabash and Grand, which makes the building more open to its surroundings than the typical one-way-in, one-way-out vertical mall store.

But in a city with revered examples of retail design, from Louis Sullivan's strikingly modern Carson Pirie Scott store to D. H. Burnham

& Co.'s more traditional Marshall Field store on State Street, Nordstrom's architecture can only be termed a major disappointment. The limestone buildings of Michigan Avenue wear the architectural equivalent of black tie; this one is clad in a duller-than-dishwater precast concrete. The abstract classical design, the architects say, is supposed to be timeless. It is, in reality, characterless. And it is far from the worst aspect of North Bridge.

That dubious distinction goes to the skybridge over Rush Street which leads to Nordstrom. Where there used to be sky—and a view down Rush Street to the Chicago River—now there is only bridge. Because the bridge houses escalators and restrooms, so as to free up rentable floor space in the four-story retail galleria, it is nowhere near the transparent structure envisioned by its designer, Chicago architect Anthony Belluschi. The result: a massive, wall-like structure that mars Rush Street.

Also shaped by Belluschi, the four-story atrium that serves as the chief entrance to the Nordstrom complex is little better, a needlessly grandiose gateway that darkens Grand Avenue below it and cuts off a light shaft that once created welcome open space along North Michigan. Instead, as on Rush, the street has been walled in. It is astonishing that Mayor Richard M. Daley, who has made preserving and enhancing open space a top priority, has allowed all this to happen.

Still, Belluschi deserves credit for meticulously transforming the rebuilt facade of the McGraw-Hill Building into something more than a patchwork of stone. This sheathing of an old skin over a new steel frame is easily ridiculed as architectural taxidermy, but the outcome is hard to quibble with. Not only does the revamped facade look great, especially its stunning bas-relief sculpture of zodiac figures, but it also brings the visually battered Boul Mich a much-needed dose of its old elegance.

Among North Bridge's other bright spots are the elegantly modern American Medical Association headquarters at 515 N. State St. by Japanese architect Kenzo Tange, and an imaginative Ohio Street parking garage by Solomon Cordwell Buenz of Chicago. With a facade marked by a deliberately off-kilter aluminum grid that reflects the angle of its ramps, the garage elevates the mundane act of parking into art. Another plus comes in the entertainment attractions across Ohio Street, Disney Quest and the ESPN Zone restaurant-bar, which bring to the entertainment district features that are appropriately frivolous, yet skillfully handled. Disney gives us a curving blue-green glass wall punctuated by abstracted mouse ears. ESPN's exterior offers a new spin on sculpture—fake baseballs and basketballs on fake oversized skewers.

From there, however, the quality of design at North Bridge descends rapidly, especially in its new hotel buildings, which almost match the old Marriott for architectural coarseness. One of them, the Homewood Suites Hotel by Chicago's Harry Weese Associates and San Francisco–based Gensler, has but a single virtue: it has more glass, arranged in a bigger variety of patterns, than the bunkerlike old Marriott. Better, but still tending toward the brutish, is the Hilton Garden Inn, by Atlanta architects Rabun Hogan Ota Rasche, which incorporates both a hotel and a multi-story parking deck.

North Bridge has several other design duds, like the klutzy retail–movie theater building at 600 North Michigan by New York architects Beyer Blinder Belle, or the drab 49-story Plaza 440 apartment tower at 440 N. Wabash Ave., by Solomon Cordwell Buenz. And then, of course, there is the renovated base of the Marriott, still a visual blight, in part because Buck was too cheap to spring for enough stone to completely hide its old walls of concrete.

These buildings look like they were designed by accountants, not architects. Yet North Bridge really runs into trouble when it is assessed by a different yardstick: the collective impact of its individual buildings on the public realm. Along Grand, the bleak new structures form a concrete canyon that is further hemmed in by the atrium leading to Nordstrom. Once-teeming Rush Street fares little better, especially with the giant, four-story skybridge looming over it. More than ever, Rush is North Michigan Avenue's back alley. Even on Ohio Street, with its witty entertainment architecture, the street-level fronts of the buildings are closed off from the city around them in order to create "black box" fantasy environments.

That feature suggests one of the underlying reasons that North Bridge works commercially but not creatively: The district has a mix of uses, but a lot of those uses—the indoor theme park, the department store, and the cinemas—typically wind up in buildings where the walls don't have windows. So while the mélange of uses brings activity to the sidewalks, pedestrians wind up looking at blank facades.

There are other reasons why North Bridge grates. Open space—or, more precisely, a lack of it—is chief among them. Simply put, North Bridge is missing a big outdoor area for people. The impending loss of the popular little park alongside the AMA headquarters will simply underscore the district's failure to add something to the public realm.

To be sure, the attempt to create any sort of district at North Bridge was probably doomed from the beginning; after all, there are no natural bor-

ders to set it off from the rest of the city. But slathering decoration on a bunch of undistinguished buildings hasn't helped North Bridge to become a district. Neither has its assault on public space. The end result is a generic city rather than a special place.

Now we have to live with it.

URBANIZING THE SUBURBS

As Chicago became more suburban in the 1990s, so its suburbs became more urban. Some built their own skylines. Others added performing arts centers, stadiums, and convention centers—all attractions on which Chicago once claimed a monopoly.

It is dangerous to generalize about a group of towns that differ so greatly in economic status and physical character. But certain shifts affected suburbs throughout the region. They ranged from the changing face of the shopping mall, which no longer was just for shopping, to the front lawn, which fast was disappearing as gargantuan new houses—"McMansions," they were dubbed—gobbled up once-prized open space. Traffic jams seemed worse just about everywhere.

As in Chicago, necessity turned out to be the mother of reinvention. With Main Streets withering because of competition from malls and Wal-Marts, suburbs like Arlington Heights transformed their downtowns into high-rise, high-density hubs—Mayberry with muscle.

The jury was still out on the results, but this much was clear: no one could condescendingly call the suburbs "the country towns," as the late Mayor Richard J. Daley once did.

Their new clout—and suburbia's new look—was evident at Skokie's revamped Old Orchard Shopping Center, which had more department stores than State Street.

Shopping for an Identity
Renovated Old Orchard Too Much at Once

SEPTEMBER 17, 1995

It's at times tacky and tasteless, groaning under the weight of enough nostalgic froufrou to stock an auction house—a Disneyland for the North Shore, Las Vegas for the Lexus set.

But to brush off cavalierly the renovated Old Orchard Shopping Center, where fake grapevines creep through aluminum trellises and an oversized red-and-white apple screeches to passing drivers from atop a food court, would be to miss its broader significance. (Yes, a mall can have broader significance.)

Peeling this all-too-shiny apple, you get to the core of a lot of things: how retailing has gone showbiz since the original Old Orchard opened in 1956. How once-sleepy suburbs have become bustling urban centers. And, most intriguing, how designers are struggling to express these changes through a medium called "archi-tainment."

Archi-what? Think of casinos that magically transport you to Oz, the Nile, a pirate hideaway. Or theme parks that give you New York without the stench. In this amalgam of architecture and entertainment, form follows feeling, not function, and the architect's traditional aim of transforming steel and stone into art is supplanted by a beguiling brand of artifice.

The key to appraising Old Orchard is to remember that there is good archi-tainment—witty, playful, and as carefully conceived as a piece of Disney animation—and bad archi-tainment—stilted, unimaginative, and ultimately numbing.

Unfortunately, the remade mall tends more toward the latter than the former. It has, in fact, entombed the original center within its 125 shops, 7,800 parking spaces, and five anchor stores, including a new Bloomingdale's.

Constructed just off the Edens Expressway in north suburban Skokie, the old Old Orchard was a widely imitated classic of postwar suburbia. Its white brick roadside pylons responded with elegant simplicity to the rising importance of the car in American culture. Their two interlocking O's subtly symbolized the mall's name and provided a recognizable logo for

THE RENOVATED OLD ORCHARD SHOPPING CENTER: Las Vegas for the Lexus set, an example of "archi-tainment."

motorists. The center's low-slung, boxy buildings maintained a consistently modernist character, free of the decoration traditionally applied to buildings, and were surrounded by thousands of surface parking spaces, as was typical at the time.

Yet with atypical aplomb, Chicago architects Loebl, Schlossman & Bennett (now Loebl, Schlossman & Hackl) and San Francisco landscape architect Lawrence Halprin arranged the center as a village that was open to the elements and framed a winding progression of modestly landscaped public areas.

Their limited views, in pleasing contrast to the bowling-alley perspective of the commercial strip, at once focused attention on the merchandise in the window and lured the shopper toward what waited around the bend. In the pre–women's liberation '50s, chief designer Richard Bennett could write that the plan would subliminally satisfy "the wife and homemaker," making each purchase feel like "the culmination of a quest."

Times change. Not only have millions of women joined the workforce, but men are very likely to shop with their families, at least on weekends. Millions of Americans, along with their jobs, have moved from big cities

to the suburbs. And shopping centers on the crabgrass frontier have grown greatly in scale and scope, epitomized by the Mall of America in Bloomington, Minneapolis, with its seven-acre indoor theme park.

These trends rendered the old Old Orchard an unprofitable relic and gave birth to the new one, a third larger than the original. Three firms shaped it—the Development Design Group of Baltimore; Loebl, Schlossman & Hackl; and landscape architects Ives/Ryan of Downers Grove. Thankfully, they and Chicago developer-financier Sam Zell didn't enclose Old Orchard, but kept its series of interconnected outdoor spaces. Otherwise, the place has been radically transformed.

You know it at the front door, which in suburbia is where the car encounters the sign for the mall. The old pylons and their clean-lined O's are gone, replaced by brick piers on which "Old Orchard" is spelled out in gold letters. Flower beds announce the mall's new formal garden theme.

There's a pop-art jolt at the mall's east end—that jolly, oversized apple above the food court. Designed by Chicago architect Anthony Belluschi, who did the eatery's interior, the apple is an instant landmark—a place to meet, as one would under the clocks at the State Street Marshall Field's. But it's also a cartoon and not a particularly imaginative one, while Field's giant, brass-encased tickers are timeless works of art.

There is more cartoonishness—likenesses of Bugs Bunny and Daffy Duck on canopies at the mall's new Warner Bros. store. Then comes a gateway arch decorated with those ersatz grapevines and, in front of the mall's Field's store, a row of vaguely medieval posts festooned with purple, yellow, and white banners. One expects jousting knights on horseback to do faux battle here, riding headlong toward each other on the broadly curving pathway in front of Field's.

This brick-paved urban avenue hints at the deeper transformation of Old Orchard, which is now less a village than a city, with more big department stores than State Street, a seven-screen cinema, and its own network of internal streets and gardens that have determinedly upscale names like Pear Lane.

In contrast to the chaste modernism of 1956, the new mall borrows freely from history to create a series of themed stage sets on its north-south spine: a French street here, an English garden there, a touch of Kansas City's Country Club Plaza along the way.

The steel columns that once marked a beat along the center's landscaped pathways have been encased in vinyl trellises, a detail that reveals in miniature the way the old center has been swallowed up by its postmodern progeny—and the utter disregard the architects displayed for the aesthetic integrity of the original.

The economic reality, of course, is that malls have to change; they are perishable, not permanent. So why not celebrate their fleeting character instead of dressing them up in the architectural equivalent of corsets?

Occasionally, the designers have freed Old Orchard from such constraints in ways that show how play habits have changed from the days of simple monkey bars. Lots of suburbs now have sophisticated playgrounds, with castlelike towers for children to climb, so the architects had to work hard to give kids something they couldn't get at home, thus luring their parents to the mall.

A fountain influenced by the Disney movie *Fantasia*, with water that intermittently leaps out of small holes encircling a large central geyser, is a delight. Nearby is an earth-mound garden with two concrete serpent heads and a pair of serpent "body" tunnels that kids can crawl through—a victim of its own success. Repeated use rips out its sod, forcing mall managers to post "Keep off the grass" signs that say "Serpents sleeping."

Furnished with movable chairs, benches, and tables, the new mall's public areas are in some respects a welcome change from the old Old Orchard, where the prevailing theory held that less seating meant more time spent shopping.

As a merchandising strategy, the mall's overwrought design may turn out to be brilliant. It not only is likely to excite potential patrons, but also creates the illusion that the shopper is traipsing through an estate, thus lending cachet to the same goods one could buy elsewhere.

Yet all that makes Old Orchard a social and commercial success, not an aesthetic one. If the playful spirit of its fountain and other life-size toys had animated the archi-tainment of the entire renovation, the mall could have been something other than what it is—hyperhistoricism with hardly a place for the eye to rest.

Losing Yardage

City and Suburbs Worse Off When Homeowners Gobble Up Their Green Space

AUGUST 1, 1999

The yard and suburbia go together like Rodgers and Hammerstein, Lennon and McCartney, the Cubs and the June swoon. But now the yard is shrinking and that says a lot about America—not all of it good.

Have you noticed?

Drive down a street in any affluent suburb and you'll be surprised at

A "McMANSION" IN HINSDALE: Emphasizing private amenities rather than public space.

how little green you see. Sprawling driveways, vast back decks, and mega-houses with attached garages are eating up lawn faster than an army of termites attacking a two-by-four. In the process they are gradually destroying the open, parklike environment that the great railroad suburbs, places like west suburban Riverside, raised to the level of art.

All that's missing is a tombstone, set in a concrete patio, proclaiming "R.I.P.: The Yard."

What does the disappearing yard mean? There are the obvious answers. We don't have the time or the inclination to primp and prune the lawn anymore. So we've simply decided to devote less space to it. Or there's the Economics 101 explanation: land prices are soaring in desirable neighborhoods and buyers want more interior space today than they did in the Ozzie and Harriet era. So developers are feeding the market what it wants—Goliath houses that tower over the little Davids next door while leaving hardly any room for trees and other vegetation. Their detractors have labeled these giants "McMansions."

But houses are not simply widgets, to be analyzed through supply-and-demand charts. A house is an expression of self. It's almost human. Think of a child's drawing of a house—the pitched roof like a forehead, the windows like eyes, the door like a nose or mouth. Houses—and the yards around them—say a lot about our values and our relationship to our

communities. They are cultural symbols, Rosetta stones that help decipher who we are and how we live.

And today, historians of the suburban landscape agree, we're living it up—to the detriment of the yard. Awash in stock market riches and corporate bonuses, Americans aren't shy about showing off. Take the suburban driveway, once a relatively simple affair—placed on the far side of the property, the better to leave the lawn wide open, and leading to a detached garage in the back of the lot.

Now some driveways gouge a horseshoe-shaped swath through the grass, a configuration that means the driver never has to back up. Others make an L-shaped slice through the yard, going to and from a garage appended to the front of the house. The new driveways may be asphalt, concrete, or fancy brick, but whatever form they take, they provide a way to display wealth and, in the process, obliterate the lawn—now more carscape than landscape. As suburban historian Robert Fishman of Rutgers University cracks, "It's not a real trophy house unless you have $200,000 of cars parked in front of it."

A harsh moralistic judgment? Perhaps. But the suburban yard has always had moral connotations in the United States. With people packing overcrowded cities in the nineteenth century, wealthy Americans retreated to the suburbs, where they sought haven from epidemics, corruption, and the kind of helter-skelter development that jammed two houses on a single Chicago lot.

In the suburbs, as Columbia University historian Kenneth Jackson has pointed out, the ideal house came to be viewed as resting amid a picturesque garden or carefully cut lawn. It was a badge of status, respectability—and more.

Symbolically, at least, the lawn was a verdant moat, meant to keep the temptations and dangers of the city at bay. But in such classic railroad suburbs as Riverside, laid out by landscape architect Frederick Law Olmsted in 1869, the lawn represented an asset for the community as well as for the individual homeowner. Each yard was part of a greater whole—with ornamental lawns in front of every house and arching elm trees along the street shaping the illusion of a park.

"The lawn is the owner's principal contribution to the suburban landscape—the piece of the 'park' he keeps up himself," Fishman wrote in his 1987 book *Bourgeois Utopias*. "Not surprisingly, lawn maintenance is considered a civic duty at least as important as any other form of morality. The lawn thus maintains that balance of the public and the private, which is the essence of the mature suburban style."

But venture to west suburban Hinsdale, the Chicago-area capital of the nationwide "tear-down" housing phenomenon and you see that this balance

is starting to go out of whack. Since 1986, developers have demolished about 750 houses in Hinsdale—more than 15 percent of the suburb's single-family housing stock. Even more demolitions are planned. As chateauesque minimansions rise alongside modest Victorian frame houses and postwar ranches, front yards are shrinking and the cherished parklike atmosphere is taking a hit.

Critics complain that there's less space for children to play and that neighbors can practically gaze into each others' living rooms. "If people all want to live eyeball to eyeball, they should live in Oak Park," says Mary Sterling, author of the guidebook *Hinsdale's Historic Homes.* "These people are taking away their own privacy."

Among the factors driving the change is a new space race, which is pushing the envelope of the house outward as never before. According to developers, architects, and building officials familiar with the trend, more and more children have their own rooms instead of sharing them. Master suites are as big as two or three old-fashioned bedrooms, with his-and-her walk-in closets, dressing rooms, and bathrooms of imperial splendor.

Many garages now house three or four cars instead of one or two; for the sake of convenience, they invariably are attached to the home, making already large houses even bigger. Home offices are rising in popularity, taking up still more space. And then there is the new phenomenon of the "getaway room," which allows parents to shut the door and get a moment's peace when the teenagers take over the family room. It all adds up, as Jackson says, to a new emphasis on "internalized luxury."

But for all that internal changes are making houses bigger and yards smaller, external ones matter too. In a world of expressways, cars, and malls that enable people to shop and socialize over a sprawling region rather than in a concentrated neighborhood, the sense of community is invariably diminished—and with it, the sense of civic duty that calls for maintaining a large and attractive front yard. The personal computers in all those home offices only magnify this trend, focusing the homeowner's attention inward on the World Wide Web rather than outward to the neighborhood. It's as if we're all isolated dots in space, not joined like the interlocking roots in a good, thick piece of sod.

To their credit, suburbs such as Hinsdale have enacted laws designed to preserve the lawn—restrictions on the amount of asphalt or other impervious surfaces in the front yard, plus measures that allow more square footage in the house if the garage is detached.

But no one should expect the arguments over the disappearing yard to disappear—not unless cities and suburbs do a better job of striking a balance between the rights of the individual property owner and the needs

of the community. And that won't happen until homeowners realize that greenery on their streets is just as valuable as green in their wallets.

Without it, they're likely to wind up in a "natural" setting, all right. A jungle—the kind that's made of concrete.

Suburban Skyline

Arlington Heights Fights Sprawl with Urban Innovations

APRIL 27, 2000

Tall buildings reach for the sky. Yuppies and empty nesters stroll from their high-rise condos to nearby shops and restaurants. Marquee lights blaze at the movie house.

Chicago's Loop?

Think again.

Try Arlington Heights—a suburb that's growing upward, not outward. The northwest Cook County town (estimated population: 78,000) is transforming its once-drowsy downtown into a compact, walkable area that is the very antithesis of the car-oriented streetscape of such "edge cities" as neighboring Schaumburg.

This exercise in suburban renewal is very much a work in progress; some of the new buildings and public spaces are no prize-winners. But on the whole, it represents one of the most farsighted local attempts in the national drive to combat sprawl, which is blamed for everything from crammed highways to a feeling of anonymity brought about by look-alike strip malls and shopping centers.

The enlightened effort will gather new momentum with the upcoming opening of the Metropolis Performing Arts Centre, a new but old-looking brick-faced building whose name perfectly symbolizes the aspirations of this suburb on the make.

Back when the most recognizable object on the skyline was the blue water tower off Arlington Heights Road, the use of the word "metropolis" would have been laughable. In truth, it still may be a bit overreaching, yet it is hardly nonsensical in a downtown where condo towers reach as high as 15 stories. "Times have changed. People want a little more urban living," says Doug Mosser, president of HKM Architects, the Arlington Heights firm that designed the arts center.

While nobody would mistake downtown Arlington Heights for downtown Chicago, or for that matter, downtown Des Moines, everybody agrees things look very different than they did 20 years ago. That's

THE DOWNTOWN SKYLINE IN ARLINGTON HEIGHTS: Fighting sprawl with high-rises and high density.

when competition from malls turned the downtown into a virtual no-man's-land and city officials hitched their future to a vision of condominium high-rises and free parking garages designed to lure back shoppers.

Today, on both sides of the Metra tracks that divide the downtown into northern and southern halves, there are clusters of condominiums—small by Chicago standards but virtual giants in comparison with the detached, single-family houses that rim the business district. Those on the southern side are particularly big.

Not far from the 15-story Dunton Tower, a boxy, brick-faced high-rise completed in 1987, stands the Village Green complex, where two eclectic, traditionally styled high-rises—each roughly 10 stories tall—are underway. A few blocks to the east is Arlington Town Square, a virtual city within a city made up of restaurants, shops, movie theaters, and a tiered, brick-faced condominium tower, 14 stories tall, that rises like a cliff above the flatlands around it.

It's hardly a skyline, but between the new projects and the older stores there's enough critical mass to generate lively sidewalks; even kids on in-line skates, who once might have hung out in malls, are whizzing through the downtown. More pedestrian traffic surely is forthcoming with the debut of the Metropolis Performing Arts Centre, which is part of a three-building complex with restaurants, offices, and loft apartments. An almost-completed Metra train station, which will have a newsstand, a bakery, and a McDonald's should bring out even more strollers.

Walking around Arlington Heights, as I did recently, it was easy to

sympathize with those residents who believe the high-rises have shattered the downtown's Main Street ambience; clearly, this isn't Mayberry anymore.

But it is evolving into something else—Mayberry with muscle, a downtown that's big enough to support a lively mix of activities, yet sensitive enough to its past that it doesn't feel like Any Burb, U.S.A.

This delicate balancing act is encapsulated by the new train station, which is a dead ringer for the handsome train stations of Chicago's North Shore and bodes well for Metra's new commitment to improving stations throughout the region.

Designed by DLK Architecture of Chicago, the station brings beauty to the notion of being two-faced. One side, facing the tracks, is sleek and linear, its slate-covered passenger canopy—interrupted only by a picturesque roof turret—suggesting the speed of trains. The other side, facing the town, is appropriately domestic, its roof punctuated by dormer windows. Inside there's a soaring waiting room, with powerful wooden roof trusses, that endows the everyday act of schlepping to work with a touch of ceremony.

Like the Metropolis Performing Arts Centre, this is a building that speaks volumes about the new, urban aspirations of Arlington Heights. It makes the town's old train station, with its thin classical columns and dreary, utilitarian waiting room, look like a relic from the age of pink flamingos and freshly paved interstate highways.

But the building's importance transcends style. It is the urban-planning centerpiece of the reinvented downtown, which is based on a philosophy known as "transit-oriented development." The idea, as articulated in the town's master plan, is simple: use the station, the busiest on Union Pacific's Northwest Metra line, as a focal point for new high-density housing, an entertainment center, wide brick sidewalks, historic streetlights, benches, and parking garages. Because the downtown is so compact, people can walk—rather than drive—from place to place. The more that people use the station, the more vibrant the downtown will be.

"We are trying to create a unique sense of place—a place to live, work, and shop in a downtown setting," says Charles Witherington-Perkins, director of the village's Planning and Community Development Department. "It gives people a great place to come without getting in the car" and going to Chicago or nearby suburbs.

Arlington Heights hasn't achieved that ideal yet, but it is certainly well along the way, not least because a handful of tradition-minded architects are taking their cues from the suburb's handsome older structures—like the La Tasca Building on Vail Avenue, which has a corner turret, a slate

roof, and Tudor details. They also are paying heed to some of Chicago's landmarks, another sign of the town's quest for an urban identity.

HKM's Metropolis Performing Arts Centre, done in association with theater consultant John Morros, is solid and straightforward, its grandly scaled entrance arch evoking Adler & Sullivan's fabled Auditorium Building just as its no-nonsense facade suggests the matter-of-fact architecture of turn-of-the-century Chicago. The retro look is even more pronounced in the same firm's Village Green condominiums, which sport brick cladding, big roof dormers, and a still-unfinished tower that makes the condos resemble a county courthouse.

The Village Green condos are the precise opposite of the Arlington Town Square high-rise, by Solomon Cordwell Buenz of Chicago. While Village Green is somewhat jumbled, an awkward assemblage of parts that imitate great buildings from the past, it still seems more at home in its surroundings than the clifflike, modern high-rise. The chief reason is that its considerable bulk is greatly deemphasized by the dormers and other details.

None of this is adventurous architecture, like the crazily tilting facade of Joe Valerio's otherwise well-handled 3Com Midwest headquarters in nearby Rolling Meadows. There is, perhaps, a whiff of Disney's Main Street U.S.A. in the air. Everything is designed to go down easily. "It's comfort architecture, like comfort food," as Mark Hopkins, another HKM partner, puts it.

But what matters, as in any city, is that the whole is more than the sum of the parts, and certainly that is true here, especially in comparison with the Woodfield Mall area of Schaumburg.

At Woodfield, as in Arlington Heights, there is a skyline, a dense concentration of people, and a vibrant mix of activities. There, however, buildings are loosely grouped, separated by highly trafficked highways. As a result, walking between them is, at best, an adventure and, at worst, terrifying. Few make the attempt; at lunch, office workers drive their cars to restaurants across the street.

Downtown Arlington Heights, in contrast, embraces the pedestrian. Along many streets, buildings come right out to the property line, framing a common wall that creates roomlike outdoor spaces. Brick sidewalks and historic streetlights furnish these "rooms." There are still surface parking lots, but overall the atmosphere is not only urban but also urbane— compact, walkable, emphasizing the outdoor areas between buildings rather than the internal spaces of a mall. The downtown, in short, is a district rather than a destination.

Not every public space is a success. In the retail and theater portion of Ar-

lington Town Square, which was designed by Lucien Lagrange and Associates of Chicago, the buildings surround what was meant to be a bustling internal courtyard. The trouble is, the drive-in culture demands parking spaces right in front of the shops. So the intended town square comes off more like a glorified parking lot—nowhere near as gracious as Howard Van Doren Shaw's civilized Market Square in Lake Forest.

To focus solely on such faults, however, is to miss the broader significance of what is happening in Arlington Heights. The big picture is that this suburb has made a huge shift from the prevailing national model of dispersed, placeless growth. Now the big questions are (1) whether a strong economy will continue to support its transformation, (2) whether other suburbs can—or should—follow its example, and (3) whether such transit-oriented suburbs can be something more than mere islands in a sea of sprawl.

Clearly, though, Arlington Heights' evolving downtown demonstrates that there can be an upside to the urbanization of suburbia. There's more than just traffic jams and teardown houses out there on the crabgrass frontier. There are cities waiting to be born.

Part Two

The Art of
Architecture

t its best, architecture is much more than shelter, a way to keep out the wind and the rain, or real estate, a way to extract profit from a chunk of land. It is art—art that at once expresses the spirit of its times and transcends them. And in the past, at least, no American city has raised construction to the level of art as consistently and as brilliantly as Chicago.

The skyscraper wasn't just invented on the shores of Lake Michigan in the 1880s; Louis Sullivan made it an essay in cloud-busting beauty—"a proud and soaring thing," he said it should be. In the postwar era, Ludwig Mies van der Rohe and his followers transformed the new technologies of steel and glass into a different sort of art—the exquisitely elegant glass box.

A pause in office building during the 1990s offered the opportunity to assess the muscle-bound, Miesian bookends of the Chicago skyline, Sears Tower and the John Hancock Center. By decade's end, after Sears had been stripped of its tallest-building title by the Petronas Twin Towers in Malaysia, there was a new plan for a world's-biggest wannabe to evaluate, the pencil-thin 7 South Dearborn.

In the interim, new kinds of office buildings arose, not just in Chicago but around the world. The Blue Cross–Blue Shield of Illinois headquarters, which has the unique capacity to expand upward as the company inside it grows, illustrated a shift away from the corporate palaces of the 1990s. In Frankfurt, the Commerzbank headquarters took its place as the first ecologically-conscious skyscraper. It instantly was dubbed "the Green Giant."

As always, the paramount issue was not the skyscraper itself, but its contribution to the public realm, both on the skyline and along the street. Yet in contrast to Chicago's past glories, the story of these towers—and far too many of the buildings erected in the city during the 1990s—is not a happy one: it begins with a triumph of modernism, followed by a fall from grace.

SIZING UP THE SKYSCRAPER

Still Standing Tall

Plain and Simple, Hancock Rules

JANUARY 17, 1999

It is Chicago's Eiffel Tower and Washington Monument, its Chrysler Building and Big Ben.

"Big John," as the 100-story John Hancock Center was tagged by a long-forgotten publicist who must have taken a vacation to London, is as much an urban icon as it is a skyscraper. Dark, strong, powerful, maybe even a little threatening—like a muscle-bound, Prohibition-era gangster clad in a tuxedo—the John Hancock Center says "Chicago" as inimitably as the sunburstlike summit of the Chrysler Building evokes the jazzy theatricality of New York.

Soaring above the vertical malls of North Michigan Avenue—its distinctive X-braces bolstering it against the wind whipping off Lake Michigan—the Hancock is a creature of fact, not fancy; reason, not romance; blue-collar directness, not the high life of the urban swell.

Yet like all great art, the 28-year-old Hancock, designed by Skidmore, Owings & Merrill, defies easy categorization. Indeed, the extraordinary thing about this skyscraper is the way it elevates pragmatism into poetry, though, admittedly, this is poetry on steroids—not Emily Dickinson, but Carl Sandburg.

Now there's fresh confirmation of the Hancock's genius, courtesy of the American Institute of Architects, which annually since 1969 has conferred a prestigious Twenty-five Year Award upon a design of enduring significance that is 25 to 35 years old.

Nearly all of the previous winners can be found in the art history books,

THE JOHN HANCOCK CENTER: An urban icon and brilliant synthesis of form and function.

among them Frank Lloyd Wright's Solomon R. Guggenheim Museum in New York and Ludwig Mies van der Rohe's 860 and 880 North Lake Shore Drive apartments, which in many respects are the Hancock's inspiration with their austere yet elegant, skin-and-bones design.

So this is as good a time as any to take the measure of the colossus at 875 North Michigan Avenue, assessing what it has meant to Chicago and the world, and to cut through the advertising hype that labels it "the world's most recognized building." (More recognized than the White House? Come on.)

Even in the Chicago area, where its tapering silhouette provides an instantly identifiable backdrop for television news sets, many people are unaware that the Hancock is not simply an office building but a mixed-use tower that also houses a parking garage and more than 700 condominiums.

Like Bertrand Goldberg's Marina City, which preceded it by a half dozen years and provided one of the first high-visibility alternatives to suburban sprawl, the Hancock is truly a skyscraper where you can live, work, and play.

There's nothing quite so bracing, its cliff dwellers will tell you, as going for a swim in its 44th-floor pool.

Indeed, the Hancock is not just a city within a city, as Marina City was conceived, but a city within a building—a vertical village. You can even go grocery shopping there, at a market (also on the 44th floor) that overlooks the old Lindbergh Beacon atop 919 North Michigan.

This new concept of urban living was made possible by a stunning synthesis of architecture and engineering. It grew from a major technical advance: a structural steel "tube" of exterior columns, reinforced by the big X-braces.

Early skyscrapers typically were supported by an internal cage of steel columns and beams. Though the cage allowed office buildings to reach once-unthinkable heights, it required a relatively large number of interior columns and chewed up valuable floor space. In contrast, the Hancock's steel tube created vast expanses of column-free space. It also served the building's functional needs by providing big floors on the bottom for offices and parking, and smaller floors above for apartments (later condominiums). Plus, the design was enormously economical; the tower was built for the cost of a conventionally supported 45-story office building.

The tubelike structures that undergird the twin towers of New York's World Trade Center (finished in 1972 and 1973), Chicago's Amoco Building (1973), and Sears Tower (1974) all are indebted in some respect to the Hancock. Yet what sets the Hancock apart from these other giants is the way the leaders of Skidmore's design team—architect Bruce Graham and the late structural engineer Fazlur Khan—expressed the building's bones to create a powerful skyline symbol. As Graham once explained, "It was as essential to us to expose the structure of this mammoth (building) as it is to perceive the structure of the Eiffel Tower, for in Chicago, honesty of structure has become a tradition."

The X-braces had other aesthetic advantages. They broke down what could have been an oppressive mass into a series of parts that, while not human-scaled, were nevertheless far less monolithic than the uninterrupted exterior columns of the Amoco Building (now the Aon Center). The end result was a giant, almost playful, work of abstract art, as easy to pick out of a crowd as a Calder stabile. And whereas Amoco's original cladding of white marble seemed almost prissy, the Hancock's shell of black anodized aluminum represented strength and gutsiness, two characteristics long associated with Chicago.

The Hancock quickly became the yardstick by which other very tall buildings were measured. When the architecture critic Ada Louise Huxtable derided the World Trade Center and its delicate, decorative

facades in 1973, for example, as "the daintiest big buildings in the world," she surely had the Hancock in mind when she wrote, "The most beautiful skyscrapers are not only big, they are bold; that is the essence and logic of their structural and visual reality. They are bone-beautiful, and the best wear skins that express that fact with the strength and subtlety of great art."

Sears, too, is big and bold, its great setbacks giving it a distinctive silhouette. But the Hancock's sloping shape creates a sense of lift and upward drive absent from its skyline cousin, which, by comparison, seems like a series of stacked boxes. As a result, the Hancock manages to be both earthy and soaring, one of several contradictions it handsomely resolves.

Consider its overall shape, a truncated obelisk. While that form evokes the monumentality and sense of permanence associated with the Washington Monument and its Egyptian (and French) predecessors, there also is an inherent dynamism to the Hancock's massive diagonals and sloping columns. Yet in contrast to the arbitrariness of much deconstructivist architecture, where tilting walls and columns are simply there for shock value, the Hancock's departure from right-angled rigidity is built on a bedrock of practicality. And unlike the postmodern towers of the 1980s, which were decked out in all sorts of applied ornament, the contours of the Hancock's skin are not divorced from the heavy lifting that occurs beneath them.

This is rational architecture that transcends rationalism, one that packs a powerful emotional punch—perhaps too powerful, when the skyscraper is assessed for its impact on the cityscape.

Before the Hancock went up, North Michigan Avenue largely resembled a Parisian boulevard of elegant low- and mid-rise neoclassical buildings. After the tower shattered that fragile scale, the avenue became an urban canyon of hulking blockbusters. Indeed, the very glitziness of such buildings boomeranged on the Hancock when the mushroomlike, copper-clad canopies of the Cheesecake Factory restaurant appeared at the base of the building in 1995. They remain like pimples on the ankle of a giant; one wishes for the advent of a Skyscraper Clearasil that would rid us of this urban acne.

Ironically, it has been the bottom of this skyscraper, not the top, that reveals how deeply it is ingrained in the Chicago psyche.

While big-city mayors rarely involve themselves directly in historic preservation controversies, that is precisely what happened in 1989, when Mayor Richard M. Daley attacked the owner's plan to fill in the Hancock's sunken plaza and add a three-story retail atrium to its base. After that ill-considered idea was dropped, the rectangular plaza was transformed in 1994 into a welcoming elliptical space, with cascading steps that attract tourists and office workers alike.

The renovation also replaced an unfortunate white marble cladding on the first floor, which, in the words of one tour guide, made the Hancock look like a man in a tuxedo wearing white socks. A new gray granite skin is far more sympathetic to the black and bronze curtain wall, making it seem as if the tower rests on a carved piece of rock.

Today, even with construction cranes for new condominiums jostling for a piece of the sky around it, Big John stands taller than ever, fusing form and function, economy and beauty, blue-collar and black-tie.

This is "what you see is what you get" design. What Chicago got was a triumph of modernism.

Reaching for the Sky

After Two Decades, Sears Comes Up Short

JANUARY 9, 1994

The seeds of Chicago's identity as a great skyscraper city were planted, it has been said, in the desperately flat prairie that spreads outward from Lake Michigan. There were no mountains or other natural formations to relieve the endless vistas of land and sky. So Chicago built cliffs and peaks of its own out of steel and glass and stone.

The Mount Everest of these man-made marvels, Sears Tower, is about to turn 20, which makes this an appropriate moment to reflect on Sears's two-decade reign as the world's tallest office building.

On May 2, 1973—the day before construction workers raised a beam autographed by the late Richard J. Daley to the top of the tower, 1,450 feet above the sidewalk—a *Tribune* editorial boasted that Chicago was about to redefine the word "skyscraper." "Move aside, New York," the editorial thundered in a fit of Second City braggadocio. "After tomorrow, when schoolchildren dream of big buildings, they'll no longer think of you and the Empire State Building and the World Trade Center."

Measured by the objective yardstick of height, Sears Tower indeed eclipsed the 1,250-foot Empire State, which wore the world's-tallest crown for more than four decades after its completion in 1931, and the 1,368-foot, twin-towered Trade Center, which seized the title in 1972. But considered in the subjective realm of style, Sears always has seemed to come up short. While infinitely superior to the steel and glass cracker boxes of its day, the 110-story tower is tall, but not soaring. It is a skyscraper that reaches for the sky, but doesn't scrape it.

Since its completion in 1974, Sears has failed to capture the popular

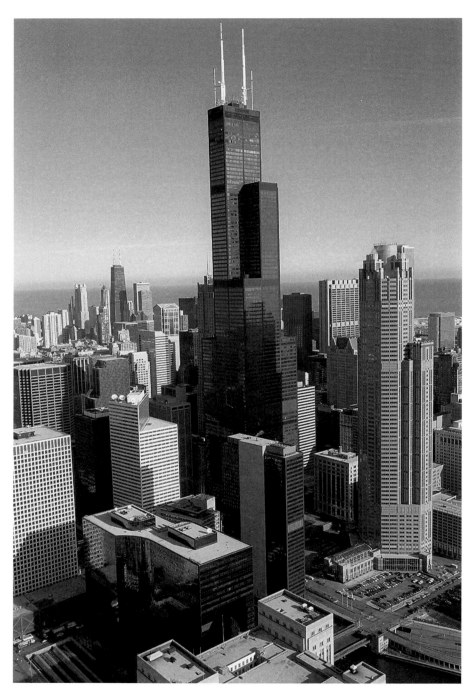

SEARS TOWER: More a triumph of engineering than of architecture.

imagination in the same way as the 102-story Empire State, whose robust setbacks and powerfully sculpted mooring mast were made to order for the celluloid climbing exploits of King Kong. Nor has Sears become a beloved urban icon in the manner of the 100-story John Hancock Center, whose bold X-braces and tapering profile lend it a skyline swagger that perfectly captures Chicago's broad-shouldered image of itself.

Sears, in short, is more a triumph of engineering than of architecture, a building that is admired more for achieving great heights than for its ability to translate its structural bravura into sky-high drama.

For all its failings, however, Sears commands a certain grudging respect. Its sense of understatement has stood up well in contrast to the shrill post-modern skyscrapers that have nudged up alongside it. And from certain vantage points, the tower possesses a stepped-back silhouette that dominates the skyline rather than simply marking it like an overgrown tombstone.

The $186 million high-rise was designed by the same team responsible for the Hancock, architect Bruce Graham and structural engineer Fazlur Khan of the Chicago office of Skidmore, Owings & Merrill. Initially, Graham and Khan proposed two office buildings in the 50- to 60-story range for the block outside the Loop's southwestern edge. But eventually, that plan was ditched for a single cloud-buster whose creators self-consciously sought to make it the world's tallest.

The tower allowed Sears, Roebuck & Co. to consolidate thousands of employees from several locations in Chicago, including its Homan Avenue campus on the West Side. The first 50 stories had massive floor-plates of 50,000 square feet, allowing the retailer to locate whole departments on a single floor. The upper stories, which were rented to tenants, had smaller floor areas and more corner offices, an advantage in leasing space. An observatory was located on the 103rd story. A pair of television antennas, not part of the building's official height, reached to 1,707 feet.

The changing floor configurations were made possible by a unique structural system devised by Khan. Nine 75-by-75-foot tubes of steel were bundled together like sticks, rising from ground level to the 49th floor, where two of the tubes were terminated. Five more of the tubes were lopped off at the 65th and 90th floors, while the last two climbed all the way to the summit. The arrangement of rigid, interlocked tubes created an immensely strong, relatively lightweight, and thus extraordinarily economical framing system that did not place a financial premium on height.

Every statistic associated with the tower seemed to trumpet the limitless advance of progress—76,000 tons of steel (enough to produce 50,000 cars), 1,500 miles of wiring, 4.5 million gross square feet (nearly equivalent to 80 football fields), a daily population of 16,500 who would require

as much electricity as the entire western suburb of Oak Park. Sears, in short, was the product of an era when "big" was still synonymous with "better."

It is a premise that has not held up with time. The huge floors in the lower portion of the tower are so vast that many office workers aren't close enough to a window to glimpse the magnificent views Sears provides. In contrast to the human scale of the Homan Avenue campus, the gigantism of the tower and its vast network of elevators discouraged social interaction among Sears's workforce. By the late 1980s, Sears executives faulted the impersonal ambience for producing a stodgy corporate culture, one of a number of factors that enabled Wal-Mart to take away Sears's standing as the nation's largest retailer.

Even the tower's main asset, its sheer size, hasn't endeared it to the public. While Sears's exterior of black aluminum and bronze-tinted glass is elegantly detailed, it lacks the muscular verticality associated with the Hancock. The latter's boldness somehow makes it human, a skyscraper Chicago didn't hesitate to call "Big John." Has anyone ever spoken of Sears in the same way? This is a mountain that demands to be climbed—not because it's loved, but simply because it's there.

In 1978, a 25-year-old former navy man went 200 feet up the tower's west face and hung a 35-foot banner protesting the killing of whales. To some, it might have seemed odd to draw attention to the destruction of ocean mammals in an inland city—and at a skyscraper, not an aquarium. Yet the protester, Joe Healy, saw no contradiction. Asked by reporters why he had taken his stand at Sears, he replied, "It's the world's biggest animal and it's dying, and it seemed like the world's tallest building was a good place."

But even mountains have their foothills. Not Sears. As architectural attitudes have shifted in the last two decades, it has become clear that the tower's seemingly benevolent trade-off—great height in exchange for open space at ground level—hasn't been a good deal.

For years, Sears's curtain walls slammed into the ground without a hint of human scale while its steeply pitched, granite-paved plaza repulsed all but the most determined pedestrians. A mailbox-shaped atrium tacked onto the building's Wacker Drive entrance, designed by Graham and completed in 1985, failed miserably in its attempt to transform Sears into a human-scaled office building.

The most recent renovation of the tower's base, completed last year by former Skidmore partner James DeStefano, added appropriately modernist entrance canopies on the west and east sides of the building. On the south side, a structurally expressive pavilion forms the new entrance to the observatory. In addition, greenery and tiered steps make the formerly sloping granite plaza more welcoming.

Ironically, Sears is finally acknowledging the city around it at a time when the city's identity has changed dramatically. If the tower once symbolized Chicago's urban might and the economic dominance of America's downtowns, the fact that it now has more than 1.5 million square feet of empty office space speaks volumes about the way the nation has changed in the 20 years since it was built.

In those two decades, suburban edge cities such as Oak Brook and Schaumburg took jobs away from Chicago, a move that climaxed when Sears moved 5,000 of its merchandise group employees to a corporate campus in northwest suburban Hoffman Estates. The retailer still has its corporate headquarters in the building, but now the name Sears Tower seems hollow—a vestige of the days when, for most Americans, going to work meant taking a commuter train downtown and scaling the heights to an office in the clouds.

Postscript

In a blow to Chicago's civic pride, Sears Tower lost its world's-tallest crown in 1996 when the spires of the Petronas Twin Towers in Kuala Lumpur, Malaysia, rose 33 feet higher than Sears's roof. It marked the first time in more than a century that the United States was not home to the world's tallest building. Yet, Chicago being Chicago, a protest ensued.

From schoolchildren to engineers at Skidmore, Owings & Merrill, Chicagoans voiced their belief that stripping Sears of the title was ridiculous. Among their arguments: if you set Sears alongside its Malaysian counterparts, people in the highest occupied floor at Sears would be looking down—by more than 200 feet—on their counterparts in Petronas.

Unpersuaded, the international arbiter of the world's skyscrapers, the Council on Tall Buildings and Urban Habitat, ruled in favor of Petronas. Specifically, the council upheld its standard that a building's height is measured by the distance from the sidewalk in front of the main entrance to its structural top. The council considers spires, like those on Petronas, part of the top while broadcast antennas, like those atop Sears, are thought to be an add-on feature.

A year later, in a transparent attempt to mollify Chicago, the council created three additional standards for measuring height: highest antenna, highest roof, and highest occupied floor. Initially, Sears could claim the latter two—highest roof at 1,450 feet and highest occupied floor at 1,431 feet. In 2000, it captured the antenna title when one of its "rabbit ears" was extended to 1,729 feet—precisely 12 inches higher than an antenna at New York's World Trade Center.

Bigger, but Better?

New World's Tallest Design for 7 South Dearborn Leaves Room for Improvement

SEPTEMBER 28, 1999

The superlatives are flying like Sammy Sosa home runs onto Waveland Avenue: world's tallest building, world's highest condominiums, and so on. But there's much more to the proposed 7 South Dearborn tower than civic bragging rights and an entry in the *Guinness Book of Records*.

Will the futuristic skyscraper, with its skin of stainless steel and aluminum, be beautiful as well as big? Will it enliven or deaden the sidewalks around it? And what does it say about a town that prides itself on being broad-shouldered that the 112-story tower looks like a pencil you could snap in two?

Don't expect the City Council to take up these issues when, as is likely, it approves the almost $500 million project. The council's focus is almost sure to be the feasibility of the skyscraper rather than its suitability for the cityscape. After all, although developer Scott Toberman says he has financing in place, he's not identifying his sources. That leaves everyone wondering if we're in for a repeat of the proposed Miglin-Beitler Tower, a 1,914-footer that was a casualty of the early 1990s building bust.

This much is certain: by selecting the firm of Skidmore, Owings & Merrill as his architect, the developer has virtually ensured that his will be a high-quality building. Skidmore, whose credits include Sears Tower and the John Hancock Center, is to skyscrapers what Brooks Brothers is to clothing—a purveyor of understated good taste, not flashiness and glitz.

Equally significant is the site at the southeast corner of Dearborn and Madison Streets, in the heart of the Loop and along the Chicago Transit Authority's Blue Line subway. That's a welcome contrast to the 1960s and 1970s, when the Amoco Building and the Hancock went up on the fringes of downtown, a good hike from the Loop's elevated trains. There's nothing like a new world's tallest building to signal the resurgence of Chicago's urban core: "The center of the tent," its chief designer, Skidmore partner Adrian Smith, calls it.

But key issues remain unresolved. Wind-tunnel studies, for example, need to be done to ensure that downdrafts near the building don't blow over unsuspecting pedestrians. And then there is the skinny skyscraper itself. As Smith acknowledges, 7 South Dearborn has miles to travel before anyone can rightfully call it architecture with a capital A.

The concept behind the building is nothing if not intriguing. It at once

THE PLAN FOR 7 SOUTH DEARBORN: An unpersuasive hybrid of skyscraper and communications tower.

recalls the skin-and-bones look of Sears Tower and the Hancock and breaks radically with it, as did the similarly curvilinear Marina City. Instead of wearing its bones on the outside, like the X-braced Hancock, 7 South Dearborn keeps them inside—with the major exception of a concrete core that shoots up its middle like a silo.

In the tower's most distinctive feature, this core is revealed by notches that divide the skyscraper into four main parts: a lower portion contain-

ing parking and offices; two middle sections, each housing condominiums; and a topmost tier, exclusively for broadcasting equipment, that would rise to 1,550 feet. That would nudge the building 67 feet higher than the Petronas Twin Towers, which stripped Sears of its world's-tallest-building crown in 1996. Two broadcast antennas—not counted toward official height measurements—would soar to 2,000 feet.

Whatever its merits, the proposal belongs squarely in the Chicago tradition of pragmatic, modernist architecture. Its chief structural innovation, which would cantilever the condominiums off the building's steel-reinforced concrete core, is a major shift from conventional construction, in which an inner cage consisting primarily of steel is used to support the building. Because it is relatively easy to build, the unique structure will shave at least six months off the normal construction schedule, saving the developer $10 million or more. The planned opening date is late 2003.

But one cannot measure a skyscraper by technical achievements alone. The best ones, like the Hancock and the Empire State Building in New York, transcend engineering and become civic art, oversized embodiments of their cities. They appear on postcards and souvenir plates, in the backgrounds of television news sets. Certainly, Sears and the Hancock—dark, muscular, even a bit menacing—vividly express Chicago's identity as a no-nonsense, blue-collar town.

And that is why, at least at first glance, 7 South Dearborn seems odd—a flyweight in a field of heavyweights, more communications tower than building, all thin spire and no hefty base. In contrast to Sears and the Hancock, which are to varying degrees monolithic, its setbacks and notches split the building into clearly recognizable parts. The question is whether Smith can fuse them into an aesthetic whole.

If he can, 7 South Dearborn will fulfill its potential as a shimmering beacon with a bold profile, a thing of the sky rather than of the ground. If he can't, the tower will resemble four medium-sized office buildings impaled on a spike.

Speaking to his departure from the Chicago tradition of broad-shouldered buildings, Smith points out that 7 South Dearborn has a single major reason for being: its topside antennas, which will transmit high-definition television signals. The old city that stacked wheat and butchered hogs is long gone. "It's a different age," Smith says. "This is the age of e-mail, the Internet, and the Web. Communications is what it's all about."

Fair enough, but clearly the tower needs tweaking. While the rounded corners of its middle reaches are particularly appealing, recalling the streamlined shapes of Art Deco, the uppermost section is far too right-

angled. If the building is to become a captivating presence on the skyline, its summit should be more sculptural. (In an interview, Smith said he was likely to fix that flaw.)

While the tower's top is square where it ought to be round, the base is round where it should be square. Occupying a third of a block, a parcel now home to a worn office building of roughly 15 stories, 7 South Dearborn would stand in a dense area of buildings whose facades come right out to the property line. They are like walls that shape an outdoor room, the public space of the sidewalk and the street.

So there is something unsettling about Smith's plan to bring the curving walls of the tower right down to the ground rather than set the building on a rectangular base. In the 1980s, Smith made his reputation by designing skyscrapers, such as the AT&T Corporate Center in downtown Chicago, that responded sensitively to their surroundings. Rounding the corners of the tower's base appears to be a departure from that philosophy, a return to the outmoded, midcentury idea of making the building a sculptural object on a plaza.

If the tower must be set back from the street, it does not seem unreasonable to ask that outdoor tables and other features enliven the open area. The idea is to make it a welcoming space rather than a grandiose entrance to the world's tallest building, the pose Sears has long struck. Including as many ground-floor shops as possible will add energy to 7 South Dearborn's surroundings, as will tying a belowground concourse into a revamped CTA subway station along Dearborn.

The architects also need to study whether wind will hit the upper portions of the tower and whoosh down the side, knocking pedestrians off balance or even off their feet, a problem that has plagued skyscrapers here and elsewhere. To be sure, the building's curves and setbacks may lessen the wind's impact, but the outcome should not be left to chance.

Shadows to be cast by the building do not appear to be a major problem. If anything, Smith says, the tower's aluminum and stainless steel cladding will reflect midday light onto the popular sunken One Bank One Plaza (formerly One First National Plaza). Finally, city officials say the project will create only a minor increase in automobile traffic because it is next to the Dearborn Street line.

In short, this tallest-building proposal is very much a work in progress. City Council approval of the skyscraper by no means assures that it (a) will be built, (b) is a finished design, or (c) will be an aesthetic and financial success. If the architects intend to make this tower worthy of Dearborn Street, where the world comes to see the Monadnock Building and other renowned early skyscrapers, they had better raise the level of their game.

Postcript

The City Council unanimously approved the 7 South Dearborn plan in 1999, but the skyscraper was declared dead in 2000 when Chicago Planning Commissioner Christopher Hill said that financing for the project had failed to materialize.

Inner Beauty

Stunning Atrium Offsets New Skyscraper's Public Face

OCTOBER 14, 1997

Chicago's first skyscraper in five years is a singular oddity—tall on the inside, but not on the outside. Almost as wide as it is high and thus a squat presence on the skyline, it has a not-so-little surprise waiting within the front door: an atrium that soars more than 400 feet from floor to ceiling.

This is not just any atrium, like the kind you might find in one of those cavernous Hyatt hotels by Atlanta architect John Portman or an enclosed shopping mall like Water Tower Place. It is a tightly defined vertical space, bathed in soft northern light, where exposed elevators whoosh up and down in near-ghostly silence. Their cables and counterweights are plainly visible, too, as they ascend and descend. The Museum of Science and Industry could sell tickets here and get a crowd.

If you suffer from fear of heights, this won't be your favorite place to work. But if you prize natural light and that rare commodity within modern office buildings, big open spaces, this skyscraper represents an important innovation. Surely it promises to run more smoothly as a workplace than that other Chicago high-rise with a hole inside, Helmut Jahn's James R. Thompson Center.

The $223 million, 30-story office building is known simply by its address of 300 East Randolph St., which says a lot about the spartan spirit in which it was built.

Its site could not be more prominent, just east of the 80-story Amoco Building on the northern edge of Grant Park. But the building's owner and sole occupant, Blue Cross–Blue Shield of Illinois, formerly housed in nearby Two Illinois Center, didn't want a pretentious-sounding address or an ego-tripping design statement. That was OK in the Extravagant Eighties, when the corporate credo was "when you've got it, flaunt it," but not in the Nervous Nineties, the decade of corporate downsizing. In addition, a huge glut of office space has all but halted major commercial construc-

300 EAST RANDOLPH: A spartan building for spartan times.

tion in downtown Chicago; the last new downtown skyscraper was the Chicago Title & Trust Tower, finished in 1992.

So, as designed by James Goettsch of Chicago's Lohan Associates, 300 East Randolph is no-frills modernism. But there's a twist that could magnify its presence: this is an office building that can grow as the company inside it grows.

Now 30 floors and 411 feet tall, the building eventually could reach 54 floors and 731 feet, roughly half the size of the Sears Tower. The foundation has the steel needed to support the extra floors, and if the time comes to expand, the roof can simply be taken off and new steel columns bolted directly atop the ones that are there now.

As much as all this seems to make sense for the bottom line of fast-growing Blue Cross, saving on moving and leasing costs as employees are added to the payroll, it raises a tricky architectural issue: how do you design a building that will look good when, in essence, it's only three-fifths complete?

Adding to the design challenge, Blue Cross wanted office floors of 36,000 square feet, a third larger than the typical downtown office building built in the eighties, to improve the flow of paper and increase productivity. That all but guaranteed that 300 East Randolph would look chunky.

Faced with these constraints, Goettsch designed an essentially rectangular building, notched diagonally on its short ends. These sides consist of a mix of granite and glass, while the broad faces of 300 East Randolph are sheathed in stainless steel, aluminum, and glass. If floors are added, the new facades will match the old.

A Pleasing Scale

At a distance, the result is not unattractive. Seen from Lake Shore Drive and Grant Park, 300 East Randolph has a quiet dignity, free of the architectural pyrotechnics of the nearby spike-topped Two Prudential Plaza. Certainly, it is more interesting to contemplate than the big but bland Amoco Building.

Unlike Amoco, whose white granite columns rise to the building's summit without interruption and thus produce a disorienting scalelessness, 300 East Randolph is divided into a base, a middle, and a top, like a classical column. Exposed stainless-steel columns in its midsection and uppermost stories break down its considerable mass. Other details, like closely spaced bands of stainless steel, further define the building's summit.

The proportions aren't ideal, and the mix of stone and glass cladding almost makes the structure seem like two buildings (one designed in the eighties, the other in the nineties). But on the whole, this is a modernist high-rise that successfully incorporates the lessons of history—at least when it is viewed from afar.

At close range, 300 East Randolph is at best a mixed bag. It is a reasonably good neighbor, framing the wall of buildings along Grant Park as well as the plaza of the set-back Amoco Building. It also provides an attractive public plaza on its northern end. In addition, Goettsch has designed certain details, like a ceramic pattern baked on the exterior glass, that create a sense of texture and human scale for the pedestrian.

Even so, there is almost nothing to close the gap between the scale of the skyline and the scale of the sidewalk. An entrance canopy helps, but if

you look up at 300 East Randolph's great sheet of glass, what you see is every bit as scaleless and almost as disorienting as Amoco.

Inside the front door, however, 300 East Randolph is an entirely different world. Its minimalist 27-foot-tall lobby lacks neither sensuousness, with two service elevator cores clad in ridged red Verona marble, nor drama, with an oval-shaped acrylic disc hovering like a spaceship above the reception desk.

Yet the best feature is at the back of the lobby: the atrium, which allows natural light to pour in through the building's north face and, visually at least, brings the green space of the plaza within. The atrium creates a completely unusual, and most welcome, sensation for the inside of a skyscraper—the feeling of height. In no way is it wasted space.

Goettsch has taken advantage of the need for expansion by reserving two towering vertical spaces, each flanking the center of the atrium, that would serve the building's additional 24 floors. For now, two eight-car elevator banks back up to the empty spaces, and the exposed elevator machinery puts on a dazzling show as the cabs ride up and down steel rails visible through an open grid of silvery columns and beams.

Open Meeting Rooms

The top-to-bottom atrium is meant to symbolize organizational unity. But what it communicates even more powerfully is dynamism—the inner workings of a great machine, albeit one that's as fun to watch as a toy.

This extraordinary space is in the best Chicago tradition of elevating simple, pragmatic construction to the level of art. It also adds a new social dimension to the skyscraper. For rising in the center of the atrium is a series of three-story spaces with lounges and meeting rooms.

As employees meet in these open areas, they can watch the elevators whizzing by. Yet Goettsch prevents a fishbowl effect by adding various grid patterns to the glass walls. Similarly, the glass walls of the elevators are translucent without being transparent. Steel stairs within the lounges allow employees to walk from floor to floor, cutting down on elevator traffic, while their zigzagging sculptural presence is a delight.

With the lone exception of a woman who confessed to a fear of heights, employees had high praise for the atrium's wide-open spaces. They use the lounges for meetings, but also for routine breaks from the workday.

Nothing could be more different from those humdrum wedges of flat space where most of us toil each day. Even 300 East Randolph's large office floors, which are separate from the atrium, have been democratically laid out, with the best southward views to the lush green landscape

of Grant Park reserved for staff, while managers' offices are on the east and west flanks.

Here's where good design is good business, for 300 East Randolph's amenities can only help Blue Cross–Blue Shield in attracting and retaining a talented workforce. The company made an even more important move in that respect by keeping its new headquarters in Chicago and avoiding suburban sprawl.

It's too bad that most people will never set foot inside 300 East Randolph; they will only see its all-too-plain public face. You almost wish you could turn 300 East Randolph inside out, showing its tall interior to the city. That would allow the building to fulfill Louis Sullivan's mandate that a skyscraper be "a proud and soaring thing."

Green Giant

Germany's Commerzbank Is a Breath of Fresh Air for Stale Skyscrapers

NOVEMBER 20, 1997

A hundred years ago, a clerk in the white, terra-cotta-clad Reliance Building in Chicago could lift a window sash and feel the wind rush against his face. Today, in the gleaming glass office buildings that dot America's cities and suburbs, the secretary toils a country mile away from a window, and as for opening one—well, forget it. The modern skyscraper is as hermetically sealed as an old Mason jar.

Yes, air-conditioning is a blessing in the summertime, and the Sun Belt couldn't have sprawled without it. But at what cost? Something's out of sync when a high-rise in tropical Kuala Lumpur is interchangeable with one in frigid Chicago, and it's not just that these look-alike buildings rub out regional distinctiveness. Everywhere, the modern office tower has severed its inhabitants from direct contact with fresh air, plants, the rhythms of the day.

A new bank headquarters in Frankfurt offers a prescription for this malady: color the skyscraper green.

Let windows open. Fill offices with natural light. Put four-story-tall rooms with trees, plants, and seating ledges right in the middle of the building, so office workers can come in contact with nature and with each other.

At 57 stories, the white-and-gray glass home of Commerzbank is Europe's tallest building. But its size shares equal billing with its radical, ecologically conscious design. Already dubbed "The Height of Horticulture" and "The Green Giant," it invites us to rethink and reconfigure the modern workplace.

COMMERZBANK IN FRANKFURT: A humanistic experiment in the movement for Green Architecture.

Designed by London's Sir Norman Foster and Partners, Commerzbank won't go into the history books as a great skyscraper. Its spacious, light-filled interior is uneven in both temperature and design quality. Its blocky, asymmetrical exterior looks oddly unfinished, as though it were a rocket launchpad. It is, in short, more important as an idea than as a building.

Commerzbank is best understood as a great experiment, and like almost all experiments, it has brought a mixture of skepticism and complaints. Yet it demonstrates, as only a major monument built by a major corporation can, that the fledgling movement known as "Green Architecture" has moved decisively into the mainstream. If, as expected, the tower drops energy costs and raises productivity, it could represent a watershed for the way the world does business.

That Commerzbank springs from German soil is no coincidence. This is the nation, after all, that produced the environmentalist Green Party. Germany takes Green Architecture so seriously that one of the movement's major principles—that new office buildings should give all workers direct access to natural light—is encoded into law. That mandate marks a return to a more humanistic way of building tall.

As recently as the 1930s, skyscrapers had windows that opened. The windows were necessities because they admitted light and air, making office space attractive to renters in the days before air-conditioning and fluorescent lighting. But in the postwar years, such technologies freed the high-rise from its dependence on nature. The result, also brought about by the abstract forms of the International Style, was the fully air-conditioned building with identical office floors, where some poor souls toil as far as 70 feet from a window, as at Sears Tower.

Commerzbank explodes this model. Instead of putting elevators in the middle of the office building, where they typically go in American high-rises, Foster and Partners pushed them to the corners of the three-sided tower. That freed the middle for a triangle-shaped atrium that runs nearly the full height of the building, interrupted only by three transparent glass floors that would block smoke in the event of fire.

Spiraling around the atrium are four-story, wedge-shaped "sky gardens," which have seating and vending machines and which are tall enough to house large trees. Each of the sky gardens takes up one-third of a floor, and their vegetation changes depending on the direction they face. Those facing west have North American plants, such as maples and cedars; the east-facing ones get bamboo trees and other Asian plants, while those turned to the south offer Mediterranean flora, such as olive trees.

As long as temperatures are not extreme, the building's managers can open banks of windows along the perimeter of the sky gardens, letting in fresh air. In the offices, workers simply press a button and their windows open, bringing the outdoors inside.

There's a social dimension to this ecological design. Each sky garden, which serves about 200 people on four floors, is meant to promote a villagelike quality, breaking down the anonymity of the typical American

high-rise, where you're most likely to encounter people who work on other floors in the cramped space of an elevator car.

The realization of these ideas makes Commerzbank a mixed success.

Green, yet Sterile

Among the pluses is the sense of spaciousness one feels within the tower, a rare thing in the upper reaches of a skyscraper. Yet here, owing to a bold structural system that keeps both offices and sky gardens free of columns, the bank worker who has been crunching numbers on the computer screen for too long can clear his head while taking a break under a maple tree only a few steps from his desk.

Sitting in one sky garden, you can look across the atrium to the one below and the one above. So there's not only wide-open space here, but spatial variety. Even on a cloudy day, natural light fills the offices along the atrium.

Still, the space lacks the drama and the vitality of Chicago's new Blue Cross–Blue Shield Building, where exposed elevators whiz up and down a 400-foot-tall atrium that, unlike this one, shoots directly from ground floor to roof. The sky gardens are sterile-looking, almost dreary. With the trees and plants in big planter boxes, these spaces seem less like gardens than interior courtyards in a shopping mall. You wonder, at times, if the plants were made by Mother Nature or some plastics manufacturer.

More troubling, the building's air-handling system turns out to be a very sensitive instrument. Without the right fine-tuning, it creates dissension among the very office workers whose welfare it is supposed to improve. On a recent fall day, with temperatures in the mid-40s, some employees complained that they wanted to hold business meetings in the sky gardens but couldn't because of the cold. They also fumed that Commerzbank had carried out its green mandate almost to a fault; in order to save energy, the wash basins in the building have only cold water.

That's ironic because Commerzbank supposedly is about giving people control over their environment, expanding rather than restricting their choices. Allowing employees to open windows, it is hoped, will raise morale and productivity while lowering costs. Spencer de Grey, the Foster partner in charge of the project, predicts that the building's green features will drop its total energy bill by 25 to 35 percent, though it's too early to tell whether that goal will be achieved.

Some Chicago architects say that large-scale commercial real-estate developers aren't jumping on the green bandwagon because initial costs are too high. But according to de Grey, Commerzbank's cost per square foot was exactly the same as other American-designed high-rise buildings

in Frankfurt. With Germany's pro-ecological Green Party in control of the local government, Frankfurt officials allowed the bank to build more office space than normal in exchange for its green features.

Hold that idea. As just about everybody in Chicago knows, Mayor Richard M. Daley loves planting trees to soften the hard edges of the cityscape. Why not follow Commerzbank's example and encourage developers to put big trees and plants high up in their office buildings, with windows that open and bring in fresh air? The skyscraper was invented in Chicago. That's where the green skyscraper could be perfected.

Postscript

Foster won the Pritzker Architecture Prize in 1999. A year later the sponsors of the prize, the billionaire Pritzker family of Chicago, announced that he would design a $350 million, 60-story office building at the northeast corner of Wacker Drive and Monroe Street. Scheduled to be completed in 2004, the skyscraper will be anchored by the headquarters of the Pritzker's hotel company, the Hyatt Corp.

It was unclear whether the Pritzker tower would incorporate "green" features, but environmentally-sensitive architecture cropped up elsewhere in Chicago, including a City Hall rooftop garden spurred by a 1997 Daley trip to—where else?—Germany. Visiting Hamburg, the mayor noted a proliferation of rooftop gardens. Three years later—presto!—City Hall's rooftop was transformed into a lush garden loaded with 20,000 plants from 150 different species of shrubs, vines, flowers, and grasses.

Designed by a team of experts including Green Architecture guru William McDonough of Virginia, the $1.5 million project is supposed to determine whether rooftop greenery can lower the building's heating and cooling costs and also reduce summertime rooftop temperatures that can contribute to the creation of ozone. The adjoining County Building— actually the eastern half of the same structure as City Hall—is being left untouched for comparison purposes. As the *Tribune*'s City Hall correspondent, Gary Washburn, wryly noted, the project promised to give new meaning at City Hall to the color green, which typically has been associated with unmarked bills stuffed into envelopes and the hue of accessories worn by aldermen and payrollers on St. Patrick's Day.

UNSUNG HEROES

sk an architecture aficionado in Chicago to name his heroes and you're likely to hear the names Sullivan, Wright, and Mies roll off the tongue. But the city is stocked with great buildings and urban spaces that emerged from the drafting boards of unsung heroes—or those who once were heroes but have since been consigned to the ranks of the damned.

Among the latter is a fellow named Daniel Burnham, who has been caricatured as an urban planning megalomaniac—big plans, big buildings, the City Beautiful but Not Livable. There's a grain of truth in this view, yet anyone who has experienced the eminently livable spaces of Chicago's lakefront or double-deck Wacker Drive knows it's not the whole story.

Also deserving a fresh look are the followers of Ludwig Mies van der Rohe, who have been unfairly portrayed as uncreative supplicants to the master modernist. Why is it, then, that so many of their buildings have stood the test of time so well?

Finally, there is Harry Weese, who, inconveniently for architectural historians, had no signature style and therefore could not be easily categorized. Too bad, for the humanism

and the humor of his approach are well worth celebrating; they are the building blocks of the living city.

The Man with the Plan

Revisiting Daniel H. Burnham, the Architect Who Bent Entire Cities to His Will

JUNE 12, 1996

We soothe our frazzled nerves in the lakefront parks he envisioned and indulge our every material want in the soaring, bejeweled spaces of his department stores. We are dazzled by the sun-washed atriums of his office buildings and the monumental hall of his museum, the one with the stuffed elephants. We have snapped family pictures at the geyserlike fountain he foresaw, although, as if he were a member of the family, we take him too much for granted.

Long after his death, Daniel Hudson Burnham continues to shape the lives of millions of Americans, nowhere more so than in Chicago, the city whose towering skyscrapers and vast front yard epitomize his oft-quoted credo to "make no little plans."

Burnham did so much and yet, relatively speaking, he is worshiped so little. His name rarely is uttered with the same reverence accorded the Holy Trinity of Chicago architecture: Louis Sullivan, Frank Lloyd Wright, and Ludwig Mies van der Rohe. And that undoubtedly has something to do with the myopic point of view that Burnham's classically inspired buildings are retro with a capital R, nowhere near as original as Sullivan's swirling ornament, Wright's earth-hugging Prairie houses, or Mies's seemingly weightless glass boxes.

In truth, they aren't. But aesthetic originality long has ceased to be the sole yardstick by which we measure the greatness of an architect. The framework of the city, which Burnham bent to his will more than his more celebrated counterparts combined, matters just as much.

So it is fitting that a new exhibition at the Art Institute of Chicago champions Burnham in the 150th anniversary year of his birth. Burnham, of course, is hardly a diamond in the rough waiting for revisionist historians to polish his reputation. Yet the show, titled *Daniel H. Burnham and Mid-American Classicism* and curated by Annemarie van Roessel, nonetheless presents an opportunity to reassess the legacy of a man for whom bigger was definitely better.

The show, which consists of 90 drawings, models, and photographs from the museum's permanent collection, occasionally manages to be larger than

THE PEOPLES GAS BUILDING ON SOUTH MICHIGAN AVENUE: Endowing Chicago with tough beauty.

life despite its modest size. A set of drawings from Burnham's epic Chicago Plan of 1909 are, in a word, breathtaking. Rendered by Burnham and the plan's coauthor, Edward Bennett, as well as masterly delineator Jules Guerin, the drawings at once evince the enormity of Burnham's vision and the enormous skill it took to express that vision with the pre–computer age tools of chalk, graphite, ink, and colored pencil.

Burnham's impact was national and international. His Washington Plan of 1902 rescued and enlarged the original grand design for the capital laid out by French-American architect Pierre L'Enfant in 1791. Strolling the magnificent national greensward today, most Americans surely are unaware that, at the turn of the century, the Mall was a cluttered mess with a Baltimore & Potomac railroad depot beneath Capitol Hill.

Burnham got rid of the unsightly depot with a power-brokering push that was quintessential Chicago. He persuaded the railroad's owners, who had hired him to design a new station on the Mall, that they should build off the Mall—on the site of what is now Union Station, Burnham's monumental gateway to the capital. For this feat, the principal political patron of the Washington Plan, Sen. James McMillan of Michigan, dubbed him "General Burnham."

The sobriquet was apt. As his biographer Thomas S. Hines relates in *Burnham of Chicago: Architect and Planner*, Burnham was a master at marshalling forces. He forged architects and artists from around the nation into a remarkably cohesive machine that produced the hugely successful World's Columbian Exposition of 1893. And subsequently, it was his D. H. Burnham and Co. that broke the mold of the small European atelier and anticipated the large-scale, postwar American architectural firms whose organization mirrored that of their corporate clientele.

"General Burnham" knew that, in a democracy, a planner needs to mold public opinion if he is to get things done. For only in rare instances do rulers acquire so much power that they can alter the face of the city by fiat. So Burnham was a consummate salesman, tirelessly promoting his ideas to the leading businessmen of Chicago so that his plan eventually became their plan. "The people of Chicago have ceased to be impressed by rapid growth or the great size of the city," he said after introducing the Chicago Plan. "What they insist on asking now is: How are we living? Are we in reality prosperous?"

The elegant rhetoric flowed from the mouth of an architect who never went to college or professional school and felt intellectually insecure all his life because he failed the entrance exam to Harvard. In the view of his biographer, Burnham compensated by establishing a partnership with the talented John Root and later by hewing to the Beaux-Arts classicism that won such popular acclaim at the 1893 World's Fair. His bearing and looks enabled his triumphs too.

A Magnetic Personality

Standing more than six feet tall, he was known for his erect posture and a voice that was deep and resonant. A draftsman recalled that "he had a

beautifully molded head, a great crown of dark brown hair that curved low over his broad forehead, a thick reddish mustache above his powerful jaw, a quick, direct glance out of his deep-blue eyes. He had a magnetic personality. That, combined with his magnificent physique, was a big factor in his success."

He was born on September 4, 1846, near Henderson, N.Y. His family emigrated to Chicago in the 1850s to better their economic lot. Burnham did poorly in school but excelled at drawing. He eventually found work in the office of architect William Le Baron Jenney, then skipped off to Nevada, where he ran unsuccessfully for the state senate as a Democrat (he later would become a Republican). Returning to Chicago in 1872, he worked in another architect's office, where he met the able Root.

The partnership of Burnham & Root was symbiotic: Burnham got the jobs and drew the floor plans, while Root tended to aesthetic expression. The duo produced such great early skyscrapers as the Monadnock and Rookery Buildings. The latter has a central atrium that provides natural light to offices and writes a dazzling essay in the lightness of curtain-wall construction.

But after Root died suddenly of pneumonia in 1891, Burnham was left to his own design devices, and he veered from the Romanesque designs of his late partner toward a muscular Beaux-Arts classicism. The conventional view of this shift, influenced by Sullivan's diatribes against the 1893 Chicago fair, is that it marked a great leap backward. Even Burnham's biographer says it reflected a "lack of creative vision and courage."

Today, we think otherwise. Such unsung, recently renovated skyscrapers as the Railway Exchange and Peoples Gas Buildings, both on South Michigan Avenue, endow Chicago with its extraordinary tough beauty. If they lack the individual brilliance of Sullivan's Carson Pirie Scott store, they make up for it by constituting a remarkably civilized urban ensemble. At their best, they transform traditional classicism into a new identity consistent with modern functions and technology. Marshall Field's State Street store and the Field Museum of Natural History brought the same approach to retailing and culture, while Bennett's delightfully sea-themed Buckingham Fountain extended it to the civic realm.

The Art Institute exhibition could have spelled out more clearly how this brand of classicism came to be peculiarly mid-American. In Chicago, large lots and height limits framed the hefty office blocks, whereas Manhattan's narrow lots and relative lack of height restrictions allowed for thinner, more graceful towers. Even so, the show rescues from obscurity the talented designers who produced these buildings under Burnham's supervision. And it demonstrates how the architects conceived of their buildings as set pieces in an urban theater, populating their drawings with human actors.

The exhibition also makes clear the genesis of Burnham's planning ideas, as seen in an impressionistically rendered watercolor on paper depicting a green belt sweeping along the curve of the lakefront. Here is the seed that flowered into the far more comprehensive 1909 plan, and a famous drawing of the plan's Civic Center is appropriately displayed alongside it. In other renderings, we see how Burnham conceived of a City Useful as well as a City Beautiful, proposing to improve not only Chicago's shoreline and parks but also its streets and transportation system.

Grandiose Visions

And yet in some of these plans, like the one proposing the huge domed Civic Center at Halsted and Congress Streets, the human scale of the earlier renderings all but disappears. As Hines has pointed out, it was not too great a step from these grandiose visions to the megalomaniacal rally grounds of fascist dictators.

There were other limits to both the plan and its conceptual approach. It did not address slum housing, schools, or the small scale of city neighborhoods. It saw the physical form of the city as fixed rather than ever-changing. Author Jane Jacobs later would skewer the City Beautiful as a City Monumental, its vainglorious monuments cut off from the life of the teeming pedestrian precincts around it.

That criticism may be true of some civic centers like San Francisco's, but in Chicago, at least, Burnham's architecture and urban planning not only are woven into the fabric of the city—they are its fabric. Far from being retro, they are truly progressive—a reminder that there can be expressions of unity amid the diversity of a democracy, that our infrastructure can be beautiful as well as useful, and that the public sector plays an essential role in shaping the public realm.

Surely that explains why, 150 years after his birth, Daniel Burnham remains not a historical curiosity but a living force.

Masters of Understatement

Miesian Architects May Get No Respect, but Their Boldly Simple Style Suits Chicago to a T

FEBRUARY 6, 1998

They have been unjustly painted with a broad brush, even turned into villains like those in old Victorian melodramas, the kind who wear black stovepipe hats and waxed, coiling mustaches. All too often, that's the way

THE INLAND STEEL BUILDING: How Mies van der Rohe's followers created continuity of structure and form.

the game of architecture is played, as the proponents of one style stereo-type another in order to advance their own agenda.

That certainly describes the fate that has befallen the followers of the late, great modernist Ludwig Mies van der Rohe, whose bare-boned steel and glass architecture—direct and strong, like Chicago itself—was honed to hard-edged perfection at the Illinois Institute of Technology. And per-

haps they deserve it, because some of them, at least, did the same thing to the classical architects whom they were ready to dump on the ash heap.

"The Miesians," they are called.

Back in the early 1980s, when I was in architecture school, the conventional wisdom about them went something like this: Mies was the master. The Miesians were copyists. Mies had an extraordinary grasp of materials, proportions, and placement. The Miesians didn't. Mies's buildings would stand the test of time. The Miesians' would be forgotten.

But time and experience have revealed this way of thinking to be a caricature. There is indeed terrible Miesian architecture out there—sterile stuff that looks as if it had parachuted in from another planet. Yet there is also plenty of very good work and, with the benefit of hindsight, we can see why it has stood up so well and assess the contributions it has made to modern Chicago, which are considerable.

Miesians designed such seminal structures as Sears Tower, the John Hancock Center, O'Hare International Airport, the second McCormick Place, and others less well known but no less well conceived. Think of it—the supertall skyscrapers, the airport that for years has claimed the title of world's busiest, the big convention hall with its acres of enclosed space. Buildings like these were inconceivable at the dawn of the century. Now, we simply take them for granted. Perhaps we do because, although the buildings were revolutionary, the Miesians endowed them with familiarity, brilliantly expressing Chicago's traditional identity as an urban heavyweight.

This is a particularly good day to take the Miesians' measure because IIT is scheduled to announce the winner of an international architecture competition for a $25 million campus center at State and 33rd Streets. The center, which will include everything from an auditorium to a bowling alley, is supposed to introduce an architecture for the next century, much as Mies forged a framework for the one now drawing to a close.

He did so by breaking with previous styles and championing an austere, abstract architecture that was most perfectly realized in such structurally expressive tours de force as the apartment high-rises at 860 and 880 North Lake Shore Drive and S. R. Crown Hall, home of the College of Architecture at IIT. These skin-and-bones buildings looked deceptively simple, as if anybody could do them. "What makes Mies such a great influence," the architect Philip Johnson once said, "is that he is so easy to copy."

Easy to copy, we know now, but hard to match.

At worst, aided and abetted by real-estate developers and public officials who wanted modernism on the cheap, the Miesians produced an architecture of expediency: cold, sterile, could-be-anywhere boxes, like the three bland office buildings immediately north of the Spanish Revival

Wrigley Building on North Michigan Avenue or the shlocky high-rises that line Third Avenue in Manhattan. They were easy targets for criticism, which fast became an across-the-board condemnation of Mies's rational approach to building: it produced look-alike glass boxes. It was incomprehensible to the average person. It tore apart the fabric of cities, with banal towers that sat on windswept plazas.

This certainly was true in many American cities, especially those in the East, where the postmodern revolt against Mies embraced fantasy, decoration, populism—all the things that Mies's version of modernism did not. Playing on the famous Mies aphorism, "Less is more," the Philadelphia postmodernist Robert Venturi cracked, "Less is a bore." (Venturi later took it back.)

But Chicago, at least, was different. It already had an esteemed tradition of modern design, the turn-of-the-century Chicago School of Architecture, whose leader, the great Louis Sullivan, coined the phrase "form follows function."

Moreover, many of Mies's best followers were here, architects and engineers like Jacques Brownson, Myron Goldsmith, Stanislav Gladych, Bruce Graham, Fazlur Khan, Gene Summers, and the trio of Louis Skidmore, John Merrill, and Nathaniel Owings. (Their Chicago-based firm of Skidmore, Owings & Merrill, SOM for short, followed Miesian precepts so faithfully that it was dubbed "Three Blind Mies.") At their best, the Miesians (who, with Mies, constituted the so-called Second Chicago School of Architecture) saw searchingly, not blindly, and the cityscape was better off for it.

A Good Neighbor

Take SOM's fine Equitable Building at 401 North Michigan, which proves that not all glass boxes are created equal.

There's nothing flashy or attention-getting about the Equitable, but the way its architects have handled site planning, materials, and proportions is nothing short of exemplary. First, the building is a good neighbor; it is set well back from the property line to preserve a view of the neo-Gothic Tribune Tower from the Michigan Avenue Bridge. Second, its steel frame is boldly and precisely articulated, with the columns extending beyond the wall plane to give the building a powerful, almost sculptural presence. Third, the rectangular panels beneath the Equitable's windows are made of black granite, a departure from the steel and glass norm that represents a subtle nod to the Beaux-Arts masonry facades of North Michigan Avenue. Along with the subtle green hue of the exterior, this detail gives the Equitable a quiet flair, like a custom-tailored olive suit.

Look around downtown and you'll find several buildings that represent a variation of this theme, like the Harris Trust and Savings Bank Tower at 115

South LaSalle Street (also by SOM) or the CNA Center, 55 East Jackson Blvd. (by C. F. Murphy Associates; its red exterior was originally painted black). Their frank expression of the structural steel frame gives them a mighty mien that could not be more different from the mirror-glass towers of the Sun Belt, whose glittering, smooth facades look like so much tinfoil.

But what about the criticism that stripped-down Miesian architecture is unable to convey a message to the common person, as traditional buildings do with their decoration and reliance upon conventional forms—church steeples that signal our intention to connect with the divine, for instance?

Undoubtedly, there is something to this view. Not everyone cottons to steel and glass architecture; it's like fine wine—an acquired taste. But the best of these buildings exert an almost physical force on the viewer.

Who can stand before Jacques Brownson's Daley Center at Dearborn and Clark, the courts building with the cross-shaped columns and the bridgelike beams, and not feel himself in the presence of Chicago's industrial might? The self-weathering, reddish-brown Cor-Ten steel cladding actually was developed for railroad hopper cars.

The same muscularity is present in the tapering shape of the First National Bank of Chicago Building at Dearborn and Madison, by Perkins & Will, and in SOM's John Hancock Center, the truncated black obelisk at 875 North Michigan Avenue with its big X-braces. This is a building that can't communicate? Then why is it a beloved icon, drawn by thousands of schoolchildren as a series of stacked X's in a trapezoid?

Even SOM's Inland Steel Building at 30 West Monroe Street, no macho monolith, forthrightly expresses itself, its exterior of silvery stainless steel symbolizing the Eisenhower era's faith in the machine.

Respect for Tradition

To be sure, superscale buildings like McCormick Place or the Hancock lend credence to the view that Miesians were insensitive to the scale of the pedestrian. The worst offender in this regard is Illinois Center, with its dreary plazas raised on a podium and surrounded by a forest of black office towers.

But the better Miesian buildings are profoundly respectful of the traditional city, just as Mies's own architecture was. Far from being a tower isolated on its plaza, for example, the Daley Center forms a modern version of a traditional European square, hosting every urban activity from polkas to protests. Similarly, the First National Bank Plaza has become downtown's equivalent of a sunken living room, attracting office workers by the score.

What is most apparent as you walk around the Loop is the way the Miesian architecture relates so well to the early skyscrapers of the First Chicago School and their gridded, but more decorated, facades. In both

schools, the horizontal grid of the Loop's streets is replicated in the vertical dimension by a skeletal frame. In both, too, broad sheets of glass are the primary enclosing element. The result is an extraordinary coherence of right-angled forms and wide-open spaces. It is a distinctly Midwestern version of Metropolis, at once compact and spacious.

Buildings by the Miesians also have stood the test of time for more practical reasons, such as durability, a quality you experience as you walk through Stanislav Gladych's high-ceilinged, column-free buildings (Terminals 2 and 3) at O'Hare. Their terrazzo floors shine. Light pours through the big expanses of glass. Even as the number of passengers has soared, these Miesian pavilions possess an ampleness of space and an overall sense of comfort that other airports conspicuously lack.

It is no accident that the terminals have held up so well. The masonry floors, for example, are easy to clean. Spill a latte and someone can mop it up, as IIT architectural historian Kevin Harrington points out. Anywhere else, you'd have a coffee stain on a beige carpet.

Now that's God in the details, but the Miesians' legacy to Chicago amounts to much more. While they remade the fabric of the city to a new and modern scale, they also sewed through it a thread of architectural continuity. On the whole, their buildings have endured exceedingly well. They are expressions of technology that transcend technology, adhering to Mies's ideal of a universal architecture yet adapting it to create a sense of place. If the buildings sometimes seem anonymous, perhaps we should recall the words of Mies himself: "Greek temples, Roman basilicas and medieval cathedrals are significant to us as creations of a whole epoch rather than as works of individual architects. Who asks the names of these builders? Of what significance are the fortuitous personalities of their creators? Such buildings are impersonal by their nature. They are pure expressions of their time."

Weese's Legacy
Historical Society's Exhibit Salutes a Consummate Man of the City
AUGUST 24, 1997

Brilliant designer, consummate city man, piercing wit, Harry Weese is such a Chicago original that only he could have invented himself. For decades, he was the city's conscience, chastising the way it despoiled the urban landscape while he gave it a diverse and sometimes extraordinary series of buildings. Now 82 years old, battered by ill health, the former engineering officer for navy destroyers lives in a veterans home in downstate Manteno, unable to recognize old friends, even his family.

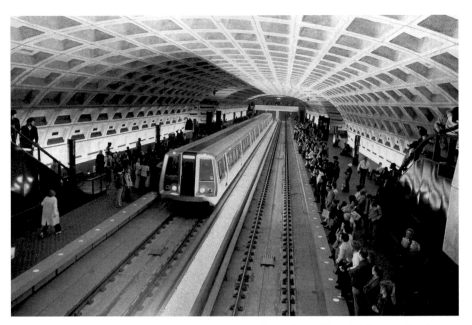

THE METRO SUBWAY IN WASHINGTON, D.C.: Among the world's most civilized transit systems.

This year marks the 50th anniversary of the firm Weese founded in 1947, so it is an opportune time to reflect on his legacy.

His much-honored work here includes the muscular Time and Life Building at 541 North Fairbanks Court and the federal prison at 71 West Van Buren Street, a slit-windowed triangle that's as fresh today as when it rose in 1975. His masterpiece undoubtedly is the subway system in Washington, D.C., one of the few in America that clearly bears the imprint of an architect and by far the most handsome.

A fine new exhibition at the Chicago Historical Society opens a window into the mind of an architect who often found a way to resolve tradition and innovation, standardization and humanism.

Titled *An Architect at Work: Drawings by Harry Weese,* the show presents more than 40 examples culled from the thousands of files and drawings the Weese firm has donated to the museum. There are pencil-and-ink drawings and watercolor sketches, as well as studies. They reveal a straightforward truth: how an architect thinks affects how he builds, and thus, how we live.

Weese, the exhibition demonstrates, possessed the rare ability to think globally and locally. Big plans didn't matter unless they were conceived down to the most minute level of human experience. Yet artful details meant little unless they were part of a carefully conceived whole. Even if

the show's rather thin wall text, by cocurators Bernard Reilly and Walter Reinhardt, doesn't make this point forcefully, the drawings do.

From the beginning of the show, where a huge horizontal mural of the Chicago lakefront stretches across the wall, you see Weese's big-picture view and how different it was from the sterile utopias sketched by other modern architects. His quick, freehand strokes depict a city pulsing with activity. Tiny triangles represent sailboats on Lake Michigan. The bridges across the Chicago River rise in heroic splendor. The beacon atop the old Palmolive Building at 919 North Michigan Avenue shoots into the sky. New towers soar on the fringe of downtown.

In this 1980 drawing, probably done for a public presentation, the city is not a machine—cool, rational, efficient. It's a thriving organism, with the new layered upon the old, and Weese celebrates both its diversity of forms and apparent chaos.

Yet if his sketches resemble cartoons, his thinking was anything but cartoonish. Its highly analytical search for order is made clear by another vast horizontal work—this one from 1959 and consisting of a series of pictures and handwritten text analyzing a visit to an airport. The sequence begins with the driver's view from behind the windshield, showing a confusing tangle of expressway spaghetti. Then it shows rain falling on the traveler because his parking space wasn't near the terminal. Finally, with minutes to spare, the poor fellow huffs and puffs to the gate and collapses in his seat.

What matters to travelers, Weese is saying in this drawing, isn't the glamorous image of a building like Eero Saarinen's swooping, bird-shaped TWA terminal at New York City's Kennedy Airport. The total package of reliability, service, and design counts. His prophetic call for a "Union Station of the air" anticipates by 25 years the way Helmut Jahn would put a new spin on the old romance of the railroad stations in his United Airlines Terminal at O'Hare International Airport. Moreover, Weese's emphasis on the machine serving the traveler, instead of the reverse, foreshadows how his people-friendly approach would impress federal officials in the mid-1960s and win him the coveted job of designing Washington's subway system.

Metro, as the system is known, is among the world's most civilized transit systems. Its graffiti-free underground features spectacular concrete vaults that evoke, but do not imitate, the capital's classical monuments. They are based on prototypes that, while adjusted to the specifics of each site, give the system a consistent visual identity. Disappointingly, the show has only a smattering of Weese drawings for the project. Even so, they are fascinating, portraying his unrealized plans for moving passengers directly to train platforms from street level (bypassing a conventional mezzanine) and for using skylights to infuse the subway with natural light.

The exhibition also serves up delightful dollops of Weese's humor. His capacity for satire was as light-touched as his drafting pencil. Sketching eight variations of the single-family house for *Life* magazine in the early 1960s, he drew houses that reflected local climates and customs, such as a Deep South house with palm trees, overhanging porches, and a carport. There was one exception: a could-be-anywhere box called "SOM," a reference to the Chicago architectural firm of Skidmore, Owings & Merrill, which in the 1960s remained under the sway of Ludwig Mies van der Rohe and the International Style.

Departing from the International Style and its search for a universal architectural grammar, Weese was unafraid to reinterpret the past even as he anticipated the future. An example in the show is the U.S. Embassy in Accra, Ghana, of 1956, in which Weese used inexpensive native mahogany and elevated the building on stilts to catch the breezes, long before energy conservation became fashionable.

In recent years, following the departure of its namesake, the firm of Harry Weese Associates has turned out solid, sometimes top-tier work, such as the award-winning restoration of Buckingham Fountain and the fine student union at Chicago State University. The latter has a conical skylight that suggests traditional thatched dwellings in Africa, an appropriate gesture because the student body is predominantly African American.

Chicago architect Jack Hartray has written of his former boss: "In the '50s and '60s, when Mies was leading most of Chicago's young architects up the straight, gray road to perfection, Harry Weese provided a few of us with a meandering, sunlit detour. He taught us to follow our senses, even when our intellects objected, and to trust in the abundance of the material world rather than in ideal systems which were distilled from it. . . . Harry built to adorn human activity rather than to mold or direct it."

True, Weese left one clunker, the graceless Marriott Hotel at 540 North Michigan Avenue, and there is a certain uneven quality about his buildings when they are considered as a whole. But that's an inevitable by-product of not being bound by a rigid formula. In fusing the past with the future, and in recognizing the uniqueness of every work of architecture while searching for patterns that could be broadly applied, Weese constructed a humanistic way of thinking and building. It still speaks to us today.

Postscript

Harry Weese died in 1998. The firm that bore his name did not last much longer. In 2000, Harry Weese Associates closed its doors and some members of its staff joined the Chicago office of San Francisco–based Gensler, a design firm with offices worldwide.

OPPORTUNITIES LOST (AND FOUND) IN CHICAGO

With its vaunted past making for an intimidating yardstick, Chicago hardly dazzled the world with its architecture in the 1990s. There were good buildings, to be sure, but the cutting edge of innovation had moved elsewhere.

Was the problem that the once-brawling, youthful city had settled into a complacent middle age, afraid to take the sort of chances that catapulted it to global prominence in the late nineteenth century? Was it that the traditional tastes of the First Client—Mayor Richard M. Daley, who personally reviewed every major building in his city—were exerting a chilling effect? Or did Chicago's retreat from risk-taking simply mirror trends that were evident across America, where very few clients seemed willing to invest in the kind of forward-looking buildings going up in Europe and Japan?

This much was clear: Chicago had numerous opportunities to extend its legacy of aesthetic leadership in the 1990s. And almost without fail, it frittered them away, lacking the creative nerve needed to seize the day—and the future. The pattern was present in commissions large and small, from a range of civic buildings constructed early in the decade to the Museum of Contemporary Art to the new—but not so adventurous—Arts Club of Chicago.

Doing the Wrong Thing Flawlessly

The Arts Club of Chicago Holds on to the Past Instead of Exploring the Future

APRIL 6, 1997

You've got to hand it to Chicago architect John Vinci. He's no weather vane, changing direction with the winds of architectural fashion. His new Arts Club of Chicago, just off North Michigan Avenue, is an austere brick block, resolutely right-angled, that snubs its nose at trendiness and aims instead for timelessness. Its uncompromising toughness recalls the defiant attitude of Ludwig Mies van der Rohe, who once said, "I don't want to be interesting. I want to be good."

Whether the Arts Club is indeed good should be of considerable consequence to anyone who prizes Chicago's identity as a center of design innovation. For small though this two-story building is, it nonetheless looms large, sending a message to the world and to Chicago itself about the state of the city's architecture.

That message is not encouraging. The new $9 million Arts Club is a banal box that looks backward rather than forward. It unimaginatively takes its formal cues from a lithe, white-painted steel stair that was salvaged from its former Mies-designed home and has been reassembled in its new one. It is less a reinterpretation than a recapitulation.

To offer such a harsh assessment is not to deny the integrity of Vinci's approach, his sound handling of proportions and materials, and the precision of his detailing, particularly the care he has lavished on the famous stair. In many respects, he has done the wrong thing flawlessly. But his reverence for the past, which has made him a leader in historic preservation, has prevented him from taking a creative leap into the future, which is what the Arts Club is all about.

The reason its little building is freighted with such symbolic significance is the club's storied history of enlightened patronage. Not only has the private, nonprofit group fearlessly championed avant-garde artists such as Pablo Picasso since its 1916 founding, but it also has been a strong supporter of progressive architecture.

In selecting Mies in 1947 to shape an elegant second-story suite at 109 East Ontario Street, which was reached from street level by the famous staircase, the club decisively signaled its embrace of the clean-lined architecture of International Style modernism instead of the florid forms of the Victorian era.

The choice foreshadowed—and, by virtue of its imprimatur, fostered—

THE NEW ARTS CLUB OF CHICAGO: Looking backward rather than forward.

three decades of dominance by the International Style in Chicago, a creative surge that produced such masterpieces as the John Hancock Center.

The Arts Club itself lasted more than four decades following its 1951 completion. Then Chicago's self-destructive streak took over. Despite an international outcry in 1994, the Commission on Chicago Landmarks failed to stand in the way of Chicago developer John Buck's plan to raze an entire block, including the club, for what turned out to be another one of North Michigan Avenue's garish temples of consumption.

Fortunately, the Mies stair and its thin steel railings were saved from demolition even though the rest of the club was destroyed in 1995. Meanwhile, the Arts Club, flush with cash from the $12 million sale of Constantin Brancusi's sculpture *Golden Bird* to the Art Institute of Chicago in 1990, purchased a new site at 201 East Ontario, three blocks east of the old one.

Thus, the way was paved for a new debate: should the stair be reused? If so, how? And what kind of face should the Arts Club show the world? The club, after all, always had been a tenant. By erecting its own home, it

had to confront the question of its public identity—and whether its building would maintain its tradition of supporting the avant-garde.

So in 1995, the club turned to three respected figures to select an architect: Carter Manny, former director of the Graham Foundation for Advanced Studies in the Fine Arts; James Wood, president of the Art Institute; and Myron Goldsmith, a former partner at Skidmore, Owings & Merrill. After reviewing more than 40 candidates, all Chicago firms, the jury settled on Vinci, a principal at Vinci-Hamp Architects. The runner-up was Ronald Krueck of Krueck & Sexton Architects, who unlike Vinci, did not favor retaining the Mies stair.

Vinci's building consists of two adjoining masses, one taller and narrower than the other, at the southeast corner of St. Clair and Ontario Streets. The materials—buff brick, with black granite windowsills and white steel window frames that evoke the stair—are nobly restrained. The building, in essence, is a masonry monolith out of which the architect has chiseled deeply recessed openings. To the extent that this treatment makes a small building seem monumental, the exterior is a success.

But it has to do more than that—and doesn't. A casual passerby could be forgiven for wondering whether Vinci sought to mimic the red-brick U.S. Post Office, circa 1956, two doors to the east on Ontario. The two nestle at the base of a skinny silver office tower like bookends, both exhibiting a sense of institutional anonymity.

It's as if architecture had been trapped in a time warp and modernism still had to learn from Las Vegas about responding to its surroundings, no matter how ugly, ordinary, and neon-lit they might be. Now, having survived the postmodern assault, modernism again is pushing the envelope, with advanced glass technology enabling today's state-of-the-art structures, like Jean Nouvel's Cartier Foundation for Contemporary Art in Paris, to resemble diaphanous veils.

Compared with Nouvel's gem of a building, which houses gallery space as well as corporate offices for the international jewelry producer, the new club cannot help but seem old and tired. Yes, the form of the club's exterior suggests the functions within (art galleries below, dining room and salon/theater above) in the classic modern manner. But Mies knew that functionalism was a dead end; a wiser course, he showed, was to infuse architecture with an expressive spirit. It's one that's sadly missing here.

While the Arts Club is a less than appealing aesthetic object, it also fails to enhance the public realm. True, Vinci deserves credit for a facade that democratically reveals ground-floor gallery space and thus invites pedestrians inside. But the building marks its corner bluntly, and its outdoor landscaped garden along St. Clair gobbles up too much of the sidewalk.

The interior, which has 50 percent more space than the old club, is much better, but not brilliant. It all revolves around the stair, which Vinci has placed in the middle of the rectangle-shaped building, not along the sidewalk, as it used to be. So the visitor moves through one of three handsomely proportioned, naturally lit galleries and reaches the stair, which is off-center in keeping with Mies's penchant for asymmetry. This arrangement has the further advantage of allowing those in wheelchairs to proceed directly to an elevator that brings them to the top of the stair, a functional necessity Mies did not face.

The stair itself looks wonderful. Its travertine marble walls and floors have been lovingly rebuilt. The stone is sensuous, ravishing, while the steel railings and the landings seem as gravity-defying as ever. Vinci has placed a translucent skylight above the stair to ensure that it is bathed in a cool, northern light, as in the old club. In its new position, the stair becomes a platform from which to view the galleries below, a happier prospect than the street traffic one saw at 109 East Ontario.

Yet even as there is an undeniable benefit in seeing the real thing preserved and reused, something has been lost. Unlike the Stock Exchange Trading Room at the Art Institute, which Vinci and a team of architects heroically rescued and rebuilt when Adler & Sullivan's Chicago Stock Exchange Building was foolishly demolished in 1972, the stair cannot stand alone. It has to connect with what's around it.

Before, as Krueck has said, the stair was a stem to the flower of the suite of rooms above it. Now, it more closely resembles an object under glass—a revered reference point from which all else springs. Ironically, though, its presence is diminished by both its off-center placement and its new, expanded surroundings.

The other spaces, especially upstairs, are hard to fault—a reception area outfitted with new editions of Mies's exquisite Barcelona chairs; a salon/theater that is far more spacious than its predecessor at the old club; and a light-filled, pavilion-like dining room, with windows facing north and west, as at 109 East Ontario Street. But ultimately, this simply cannot be the old Arts Club.

That interior was every bit a creation of its time, and so is this building insofar as it bespeaks our nostalgia for Mies's clarity of vision. Engaging the stair in a dialogue with the architecture of today would have been a more adventurous solution than having past and present speak the same language. It might have been wiser still to place the stair in a museum, acknowledging that the time had come to move forward—and to create a new landmark instead of paying homage to an old one.

A Fumbled Chance at Greatness

The Museum of Contemporary Art Tries but Fails to Extend Chicago's History of Design Triumphs

JUNE 16, 1996

Time to bring back Christo. Twenty-seven years ago, the outlandish Bulgarian-born artist covered the converted bakery that was Chicago's Museum of Contemporary Art with 8,000 square feet of tarp and rope. Now that the museum has moved to more impressive quarters, five times larger than its old place and about as inviting as a chancellery, Christo's billowing fabric is just what's needed to transform a cold, colorless culture palace into something warm and welcoming.

A city raises a major art museum once or maybe twice a century, and the irony of this $46 million blown opportunity is that Berlin architect Josef Paul Kleihues has tried to enrich and expand Chicago's vaunted design tradition—only to produce what, on the outside at least, is more fortresslike than the National Guard Armory that once occupied the site.

Still, it would be wrong to cavalierly dismiss this building at 220 East Chicago Avenue. Its serene and contemplative interior strikes up a pointed dialogue with the explosive spontaneity of much contemporary art. Clearly organized and relatively compact, it improves on those sprawling, mazelike museums that literally require a map to get around. Above the barrel-vaulted galleries housing the permanent collection, high-tech louvers control the flow of natural light, at once protecting art and drawing in the rhythms of the day.

Yet this remains a project of vast, unrealized potential. The chance for greatness arose not only from a magnificent site between the Water Tower and Lake Michigan but also from an international search that ultimately led to Kleihues, who seeks to enliven the functionalist aesthetic of look-alike glass boxes with what he calls "poetic rationalism."

In German works, like his Museum of Prehistory in Frankfurt, this approach has yielded an architecture that stirs the memory even as it brings a new identity to its surroundings. But in this, his first project in the United States, Kleihues has failed to freshen the past.

His design, a five-story building with a sculpture garden that terraces downward toward the lake, pays homage to Ludwig Mies van der Rohe's structurally expressive glass boxes and employs the modular floor plan of Louis Sullivan's turn-of-the-century masterworks. It also evokes Sullivan's decorative ironwork with its cast aluminum facade. A base of Indiana limestone attempts to relate the museum to North Michigan Avenue land-

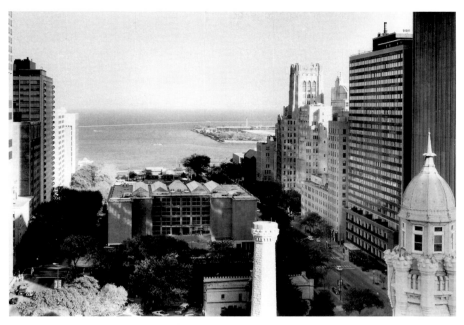

THE MUSEUM OF CONTEMPORARY ART: Cold, uninviting, a project of vast unrealized potential.

marks clad in that warm material, and there are references as well to the German classicism of Karl Friedrich Schinkel. The symmetrical entrance facade gives the impression of having been cleaved in two, a void of glass between solid walls, the ideal being a see-through building that visually unites North Michigan Avenue and the lake.

In reality, though, the MCA is as much a wall as a link. The visitor does not truly experience its transparency until reaching the upper floors. And until a way is found to open its sculpture garden to the city park just to the east, the garden will remain, in essence, a private compound.

True, a plaza fronting the main entrance blends seemlessly with the open space of a park to the immediate west. But this gentle gesture is confounded by the brute monumentality of the entry itself, particularly a flight of stairs that is 32 intimidating steps high—19 more than at the Art Institute. Compared with this scaleless forecourt, the Art Institute's front is a veritable tot lot, its bronze lion sculptures like cocker spaniels. Worse, instead of being grand portals, the MCA's bowing entrance canopies are squashed by the rigid geometry of its gridded facade.

The exterior is not all bad, in part because it serves as an antidote to North Michigan's visual cacophony and also because it is nicely scaled to the city around it. Entrances to the ground-floor museum store and edu-

cation center have been placed at the building's western corners, activating the streetscape. They free the main entry from the tawdry commercialism present at so many museums, where the profit-generating store is shoved alongside the entrance, and provide a dignified gateway for people who are disabled. And, though the sides of the building are utterly uninspired, the facade looking to the lake is handsomely proportioned and softened somewhat by the terracing sculpture garden.

Yet, in the main, the museum could not be more off-putting. The cast aluminum walls and limestone base appear unfinished, as if they were concrete. The subtle touches by which Kleihues has tried to endow the facade with texture, from the buttonlike steel pins that affix aluminum panels on the building to the three-eighths-inch pyramids that form the panels' surface, fall flat unless seen in bright sunlight.

In these ideal conditions, the MCA's silver-brown, heavy metal jacket is transformed into a velvety coat, refined and elegant with an almost golden hue. The steel buttons sparkle, making the building more the joyous treasure box Kleihues intended it to be. The trouble is that for much of the year, Chicago has slate gray skies, which turn that animated treasure box into a lifeless, oppressive mass. Whatever the light, the prickly pyramids of the industrial-strength facade are harsh to the touch, in contrast to the soft vegetal forms of the ironwork at Sullivan's Carson Pirie Scott State Street store, so receptive to the human hand.

In contrast, the interior is notably inviting. It opens with a sun-dappled, main-level entry hall and a 55-foot-tall atrium that slices through the building's midsection to a restaurant along the lakeside wall. With James Lee Byars's huge ball of gold-leafed bronze sitting dead center in the atrium, the message is unmistakable: this is an art museum, not an office building or a downtown mall, an impression not made by the dizzying lobby of San Francisco's year-old Museum of Modern Art, which is bereft of art.

Two temporary galleries flanking the atrium are big boxes of space, sizable enough to handle large-scale contemporary art yet flexible enough to be divided into more intimate spaces that are, in essence, rooms within a room. They are, perhaps, too flexible. The museum's curators have chopped them up so much in the initial installation that it is impossible to grasp the broad sweep of these big spaces, their column-free expanses made possible by 104-foot-long roof trusses. Some will wonder if the concrete floors of the artificially lit galleries await carpeting (the answer is no—this is a workshop aesthetic). Even so, the galleries realize Kleihues's aim of allowing the viewer to experience art without significant distraction.

Those wishing to forgo prosaic elevators can move upward in a poetic stairwell tucked into the building's northwestern corner. Its lyrical,

shiplike form is the interior's most memorable flourish, which Kleihues deferentially has placed away from the art. Exquisitely crafted and rigorously detailed, the stair has a dynamism that contrasts vividly with the galleries' static spaces.

Then comes the payoff—views of Lake Michigan, glimpsed from a space overlooking the atrium and leading to fourth-floor permanent collection galleries. There are four of these galleries, which resemble loaves of bread lined alongside each other, and they are among the best spaces in the building, although they, too, have been sliced up somewhat by the curators. Defined by crisp barrel vaults, the galleries benefit from the natural light that seeps through the vaults from a topside light-mixing chamber. Their layout as a suite of rooms contributes mightily to their success. So does the counterpoint between their magisterial reserve and the often offbeat art within them.

The implication of this dialogue is clear: there is an underlying continuity between contemporary art and all that has preceded it. The same is true of architecture and the way Kleihues has sought to go back to the basics of Chicago's design tradition and interpret them anew. That he has failed so miserably on the outside and succeeded so admirably on the inside is in marked contrast to Sullivan's graceful interweaving of form and function. No one, after all, would think about asking Christo to wrap Carson Pirie Scott.

Postscript

The MCA's grand staircase was little used, offering plenty of places to sit, but not much natural light and, even more important, not much of a passing parade to see from the steps. Nothing could have been more different from the Art Institute's weathered stone steps, where crowds gathered to bask in the sun, and to see and be seen along Michigan Avenue.

Structural Damage
Chicago Has Forfeited Its Title as the Nation's Architecture Capital

JANUARY 21, 1996

After reigning for more than a century as the unofficial capital of American architecture, Chicago's preeminence has vanished—its crown knocked off, its nerve lost, its capacity for future greatness diminished.

The most tangible evidence is a series of major projects, completed in the first half of the 1990s, which collectively represent a squandered opportunity to extend the city's design leadership into the next century. But the trouble runs deeper and must be addressed from the ground up if the city is to regain its role as wellspring of design innovation.

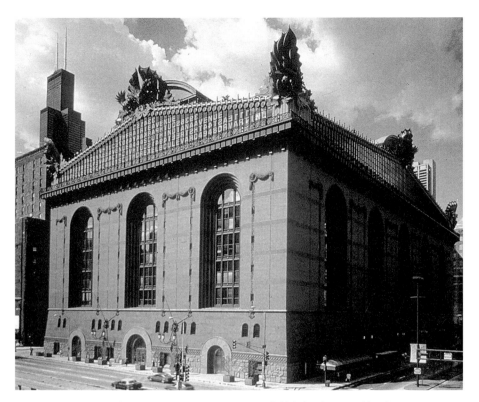

THE HAROLD WASHINGTON LIBRARY CENTER: Bold design, but trapped in a time warp.

The newly renovated Navy Pier is a third-rate festival marketplace and convention hall that lessens the majesty of the lakefront with its jumbled silhouette and cheap construction details.

Four-year-old Comiskey Park and the year-old United Center are shopping mall–like behemoths, bigger but in no way better than the human-scaled, distinctly urban stadiums they replaced.

And while the Harold Washington Library Center is more thoughtfully conceived, it nonetheless is architecture in a time warp—its leaden facade seemingly built at the close of the nineteenth century, not a decade before the onset of the twenty-first.

The bungled big buildings matter enormously. For architecture is the art that most visibly and viscerally defines Chicago—its tough beauty, its hustler's pragmatism, its quintessentially American optimism.

To be sure, Chicago retains enormous strengths, from a public that is astonishingly conversant about architecture to a cache of historic build-

ings that no other American city can match. But a range of factors, including the absence of a tough-minded design journal and a lack of permanent leadership at the city's two major architecture schools, is hindering the flow of ideas that is essential to the creation of great architecture.

More important, a cautious clientele—epitomized by the First Client, Mayor Richard M. Daley—seems content to live off old laurels rather than be part of the creative process that gives birth to new ones. Indeed, Chicago has become a prisoner of its past.

No One's Taking Risks

When architect Carol Ross Barney submitted a dynamically modern design for a West Side public library completed in 1994, city officials forced her to make the library look more like the Prairie School houses of Frank Lloyd Wright. Had they been around 100 years ago, those officials surely would have been telling Wright to ditch the Prairie School and to revert to something Victorian.

This is the central problem of Chicago architecture today: it seeks reassurance and runs from risk.

When Cleveland of all places is outdoing this city in putting up adventurous modern architecture—as it has done recently with I. M. Pei's Rock and Roll Hall of Fame and the Jacobs Field baseball park—alarm bells ought to be going off.

As recently as 1991, designers polled by the American Institute of Architects ranked Chicago first among U.S. cities on the basis of design quality and innovation. Indeed, from Louis Sullivan's poetic essays in the skyscraper to the flowing interior spaces of Wright's Prairie houses to the parks and public spaces envisioned by Daniel Burnham to Ludwig Mies van der Rohe's glass-box office buildings, Chicago fearlessly invented the American city's future.

But ever since the plague of postmodernism hit Chicago in the 1980s, the quality of large-scale projects here has dropped dramatically while many smaller commissions, though competent, have hardly set the world on its ear. When the dean of American architecture, Philip Johnson, suggested during an appearance here last fall that Chicago no longer was at the forefront of design, no one bothered arguing the point.

If a single city has replaced Chicago as the vanguard of change, it undoubtedly is Los Angeles, where the freely expressive, explosively sculptural houses of architect Frank Gehry and his followers have won wide acclaim.

More important than a particular style, however, is an approach to design that opens the door to new ideas, technologies, and urban forms—

precisely what gave Chicago its advantage over the tradition-minded cities of the East at the end of the nineteenth century. After all, it is in age-old Europe and Japan, not just in relatively youthful Los Angeles, that some of the world's most exciting architecture is emerging.

Helmut Jahn's experience is telling. For while the architect goes virtually without work in his adopted hometown, he is pushing the envelope in his native Germany. In Munich, he has completed an airport hotel, the Hotel Kempinski, that will eventually be the hub of a commercial airport "city." The hotel is striking not only as a building type, which deals in a visionary way with the edge cities now clustering around airports, but also as a work of design. Crossing roof arches enclose a soaring lobby-garden between the hotel's two wings. The visual transparency of the lobby-garden makes it a legitimate public space, entirely different from the typical hermetically sealed hotel atrium.

Why Chicago Became Timid

It may be that Chicago's reticence to embrace the realities of the present simply reflects America's nostalgic mind-set as well as construction management practices designed to save money rather than build better buildings.

Yet architecture, like politics, is inevitably local, and two structures stand out in explaining Chicago's timidity.

The first—Jahn's glassy glitter palace, the State of Illinois Center (now the James R. Thompson Center)—suffered highly publicized air-conditioning problems after its 1985 opening. Coupled with the rise of postmodernism, the Thompson Center spawned a reaction against risk-taking that turned reactionary, leading to such backward-looking buildings as the Washington Library, by Hammond, Beeby and Babka of Chicago; and the United Center and Comiskey Park, both by the HOK Sports Facilities Group of Kansas City, Missouri.

The second significant structure, the $284 million McCormick Place expansion completed in 1986, piled up $75 million in cost overruns, leading to a move to construct public buildings in Chicago for a fixed cost. Though this arrangement protects the taxpayer, it often cheapens the quality of the built environment, enabling a construction manager to cut key aspects of a design, effectively shaping the building for the architect.

That's what happened at Navy Pier, where the original scheme by Chicago's VOA Associates and BTA Architects of Cambridge—no prize-winner to begin with—was substantially downgraded in the course of construction.

But more than impersonal trends explain Chicago's fall from grace.

When Richard J. Daley ran Chicago, he knew modern architecture would dispel downtown's image as being over-the-hill. It was no accident that the acclaimed Civic Center courts building (now the Richard J. Daley Center) was designed as a modern skyscraper, as gleaming as any corporate headquarters upon its completion in 1965.

In contrast, Richard M. Daley reflects the current popular disillusionment with modern architecture. Whereas the building programs of his father were pathbreaking, his tend to be conservative, from the renovation of neoclassical bridges to the de-malling of State Street.

Daley's leanings are positive insofar as they stitch together the physical fabric of the city. But they don't spur innovative architecture. Significantly, the one major recent project here that has won across-the-board critical acclaim—the modern International Terminal at O'Hare International Airport, by Ralph Johnson of Perkins & Will—was begun under Mayor Harold Washington.

What Needs to Be Done

Just as great architecture requires enlightened patrons, it flowers in cities that seed new talent, cultivate new ideas, and meticulously care for its design institutions. Yet those things aren't happening in Chicago.

The city's two major architecture schools have been without permanent leaders for nearly three years—the University of Illinois at Chicago since Stanley Tigerman was ousted in early 1993, and the Illinois Institute of Technology since Gene Summers resigned in spring 1993. New and creative directors are needed to attract talented students and faculty.

Once, Chicago had a distinguished design journal in Inland Architect. But ever since the feisty but debt-ridden magazine was purchased by trade publisher Real Estate News Corporation in 1994, it's traded critical bite for toothless puff pieces. Every effort should be made to get a new architectural magazine staffed and funded.

Chicago also needs curators and gallery owners who will fearlessly exhibit experimental work, like that of the postmodern "Chicago Seven" architects who challenged modernist orthodoxy in the late 1970s. Modern-art museums in New York and San Francisco have architecture departments. Why doesn't Chicago's Museum of Contemporary Art?

What the city must do is to reinvent itself, not by imitating old glories, but by understanding the essence of what made the city great—and by bringing that intelligence to bear on contemporary problems and processes.

That approach still activates the work of such designers as Jahn and Johnson. And it presents a significant alternative to Los Angeles. For while the houses of Gehry and his followers have won critical acclaim, they have

yet to make an impact on the American mainstream in a way comparable to Chicago's previous triumphs.

Chicago's challenge is to reestablish the crucial link between use and beauty, form and function that originally made it America's architectural capital. To do that, the city must realize that it's more than a static museum of architecture. It's a living museum that should have a living tradition.

Postscript

This piece sparked a heated debate in Chicago's architecture community and among the public at large. John Callaway, the host of WTTW–Channel 11's *Chicago Tonight*, did a program about the issue. Later in 1996, the Chicago chapter of the American Institute of Architects held a seminar titled "Has Chicago Lost Its Nerve?"

The dissenters argued that it was absurd, so soon after the AIA survey ranked Chicago first in design quality and innovation, to assert that the city no longer held its primary role. Others noted that, of the four major projects in the story, three (Navy Pier and the two stadiums) were designed by non-Chicago firms. Still others said that Chicago's failure to innovate simply represented the same broader tendency throughout the United States.

Whether one disagreed or not, it was indisputable that significant changes followed. Both architecture schools brought on new and forward - thinking directors—Donna Robertson at the Illinois Institute of Technology and Katerina Ruedi at the University of Illinois at Chicago. Robertson would orchestrate the international design competition for IIT's campus center, won by Rem Koolhaas, while a UIC faculty member, Doug Garofalo, would attract widespread attention for a series of house additions whose unorthodox shapes were made possible by the computer. Most important, as the decade ended, the city's institutional clients, such as the Adler Planetarium, became patrons of adventurous architecture.

A Star Is Reborn

Underappreciated *Adler Planetarium Rockets into the Future with Daring New Addition*

DECEMBER 30, 1998

Chicago's lakefront has a new landmark: a dark semicircle of steel and glass that seems to have descended from the clouds like a flying saucer. The $30 million Sky Pavilion of the Adler Planetarium and Astronomy Museum is the most daring building in years along a shoreline dotted by gleaming white museums based on the temples of antiquity.

THE SKY PAVILION OF THE ADLER PLANETARIUM: Not parroting the past, but conversing with it.

What is truly risky about the Sky Pavilion, however, is that it is an addition to one of Chicago's most underappreciated architectural gems—the original Adler, an Art Moderne masterpiece topped by a picturesque, shingled dome.

After the museum proposed an expansion a few years ago, some Chicago architects dubbed the chosen design, a C-shaped glass pavilion by Chicago's Lohan Associates, "the bra" for the way it cupped around the Adler's voluptuous dome. The only responsible course, these critics argued, was to build the addition underground.

Yet now that the Sky Pavilion has been completed, the fears that it would mar the old Adler have turned out to be groundless. The pavilion, which houses a new planetarium theater, exhibit spaces, and a 200-seat restaurant with extraordinary skyline views, walks a nervy high-wire act, deftly taking its cues from its landmark predecessor without mimicking it.

In other words, the pavilion is not an instant replay of another space-shiplike building, Helmut Jahn's 13-year-old James R. Thompson Center, which still seems like a brash intruder butting up against the classical dignity of Chicago's City Hall. This is futuristic architecture of a different sort: Yes, it makes a strong statement. No, it is not an alien that you wish would phone home—and go there too.

The addition demonstrates a broader lesson: the present doesn't have to parrot the past to respect it. In fact, imitation may not be the greatest sign of flattery. It's far more adventurous—and fulfilling—when the architecture of one era plays off against another, as I. M. Pei did in his jewel-like glass pyramid at the Louvre.

True, bad things can happen to good buildings through such an approach; parts of the exterior of the Sky Pavilion are architecturally undistinguished and fail to honor the exquisite quality of the original Adler. Yet overall, the pavilion speaks to the virtue of design dialogue. It is both a sensitive expansion and a spectacular addition to the lakefront—every bit as much an expression of its era as its distinguished predecessor.

Shaped by Dirk Lohan and Al Novickas of Lohan Associates, the Sky Pavilion is markedly different from the Oceanarium addition to the neighboring John G. Shedd Aquarium that the same firm completed in 1991. Though the Oceanarium has a glassy lakeside facade, the white marble walls that flank it strive to be virtually indistinguishable from the original Shedd, which was completed in 1929. To put things in musical terms, the aim at the Shedd is harmony; at the Adler, it's counterpoint.

But to anyone familiar with the history of the Adler, whose architect was Ernest Grunsfeld Jr., the decision to break decisively with the past was very much in keeping with the old building. Instead of looking backward to Greek and Roman precedents, as did the architects of lakefront edifices such as the Field Museum, Grunsfeld sculpted an object without precedent: a 12-sided structure of straight, simple lines, clad in a dark, richly textured, granitelike stone.

Adorned at the corners by sculptor Alfonso Iannelli's bronze plaques picturing the constellations, the Adler was topped by a dome that perfectly punctuated the end of a land bridge reaching into Lake Michigan, now called Solidarity Drive.

Over the years, however, insensitive alterations took some of the luster off this diminutive jewel. A 1972 underground addition, by C. F. Murphy Associates, and a 1980 glass pavilion just to the west of the Adler, by Hammond, Beeby and Babka, had the combined effect of creating a bizarre entry sequence. You did not enter the Adler, as Grunsfeld had intended, by ascending its magnificent granitelike steps. You reached this shrine to the heavens by descending the stairs (or the elevator) of the glass pavilion and tunneling through a series of dark, dreary underground exhibition halls.

That literally was just the beginning of the Adler's problems. Exhibition areas were far apart, making it a chore to move between them. And though the planetarium sat along the lake, the building gave visitors little opportunity to look out to the water—or to the very skies that are the subject of its exhibits. Meanwhile, the addition of the Oceanarium at the Shedd and blockbuster exhibitions at the already giant Field made the Adler, way out there at the end of Solidarity Drive, seem like the little museum that couldn't.

Clearly, the addition attempts to change that. Pure and simple, it's a statement building, the kind meant to draw crowds and make contribu-

tors open their wallets—not an easy thing to do with invisible, underground architecture.

Yet the Sky Pavilion is about more than look-at-me imagery. As with Pei's pyramid, the sexy part—the steel and glass pavilion—is merely the tip of the iceberg. The core of the job is a planning exercise that will radically reshape the Adler when a revamp of the old building is complete in October 1999. As part of that renovation, the 1980 glass pavilion will be demolished and the building again entered via its steps (or by ground-level doorways that will accommodate school groups and the disabled).

Even now the benefits of this reshaping are apparent. Much of the heretofore underground exhibition space has been moved to the bright and cheery Sky Pavilion, and there are other galleries, easily reachable, directly beneath it. To make room for the pavilion, upper-level offices that once hogged lakefront views have been put downstairs, though their inhabitants have been compensated with skylights. Space for the pavilion also was made by removing a circular road that used to ring the planetarium; a side benefit is new parkland and a promenade on the building's lake side.

The belowground exhibition space in the pavilion has a traditional post-and-beam structure and houses "black box" venues such as the planetarium theater. In contrast, the aboveground portion has an utterly unconventional structure—an off-kilter A-frame that provides a sweeping volume of column-free space as well as stunning vistas of the lake and the skyline. At once serene and full of motion, the pavilion is one of the finest meldings of space and structure in Chicago since Jahn's masterful United Terminal at O'Hare International Airport was completed in 1988.

What truly makes it of our time—beyond the nervously tilting columns at the edge of the pavilion—is the fact that it would have been impossible to design without a computer that could calculate its innumerable complex angles. In the precomputer era, such an unconventional structure would likely have been overengineered, with massive and clunky-looking columns and beams, to ensure that it didn't collapse. But with computers, the structural members don't have to do any more heavy lifting than is absolutely necessary. So they can be light and lacy—and, thus, open to sunlight and views.

All these structural gymnastics would have been meaningless if the form that resulted from such attention to function destroyed the jewel-like quality of the original Adler. For the most part, however, the reverse is true: the new pavilion handsomely complements the old planetarium. For example, the C-shape of the pavilion subtly reinforces the symmetry of the original, creating the equivalent of bookends that set off the domed front.

A more explicit link is made with the reuse of the old planetarium's

swirling, granitelike stone to clad the base of the new building. Yet even that move creates a subtle interchange between past and present because the new stone is set horizontally rather than vertically, as in the original.

Seen from afar on Lake Shore Drive, the pavilion strikes up a powerful conversation, not merely echoing the curved profile of the dome, but playing off its stable, symmetrical shape with a dynamic, raking silhouette. From the new lakefront promenade, the pavilion is an extraordinary sight, seeming to hover above a new berm that weds the building to the park around it.

But the view is far less pleasing from other vantage points. As early models made by the architects show, the glass of the pavilion was supposed to be a neutral membrane that revealed the structure supporting it—transparent in contrast to the opaqueness of the original building. According to the architects, however, exhibition designers wanted the glass to be dark so the exhibits and computers would not be subject to blinding daylight. The museum went along, presumably because it sought to keep the pavilion from turning into a superhot greenhouse with out-of-control air-conditioning bills.

Visually, the result is disappointing, though not disastrous. The structure is concealed rather than revealed, and the end walls of the pavilion are dark and glowering, as though this were Darth Vader's flying saucer. Worse—and this cannot be blamed on the exhibition designers—those walls have banal detailing, especially in contrast to the exquisite stonework and crystal doors of the original building. They look like a typical suburban office building, hardly what is called for when adding to a building of such distinction.

What saves the pavilion, however, is the intelligence of its plan, the integrity of its structure, and the art that infuses its architecture, albeit not in every detail. One of the best moments is a skylit corridor in the pavilion that nudges up alongside the old building. It allows the visitor a previously unobtainable close-up view of Iannelli's masterful bronze plaques of the constellations.

Yet the relationship between old and new is truly realized in the way the radiating structure of the pavilion, expressed on the exterior by sleek aluminum fins, seems to emanate from the dome of the original like the rays of the sun. Here, the Adler becomes a whole that is more than the sum of its parts, not two buildings merely set alongside each other.

In contrast to the wave of architectural conservatism that came in the wake of Jahn's glitzy Thompson Center, the Sky Pavilion is futuristic architecture that gives one faith in the future. Through both its exhibits and its architecture, it reminds us of the virtue of reaching for the stars. What better way to usher in the millennium?

ARCHITECTURE WITH A CAPITAL "A": LOOK ELSEWHERE

While buildings such as the Adler Planetarium's Sky Pavilion certainly merited praise, it was best to venture away from Chicago in the 1990s if you were searching for architecture with a capital "A." With Frank Gehry leading the way, Los Angeles emerged as the creative center of a new, strikingly sculptural school of design that evoked the nervous spirit of the times. Yet Gehry's most spectacular success came not in his hometown, but in a seemingly unlikely location—a gritty, centuries-old Spanish port town named Bilbao. There, an outpost of New York's Guggenheim Museum electrified the world.

Perhaps, in retrospect, Bilbao was the perfect place to create epoch-defining architecture. For though the city was old in years, it was young in attitude. Its economy was so battered that it was willing to take aesthetic risks—much as Chicago had done a century earlier. The same progressive spirit was evident in war-scarred Berlin, where Helmut Jahn's Sony Center healed old urban wounds and set new standards for entertainment architecture.

Another extraordinary building, the Rose Center for Earth and Space in New York, artfully put us in our place—within the enormity of an ever-changing cosmos. Meanwhile, the U.S. Holocaust Memorial Museum in Washington showed

that making a creative statement is possible even in the most tradition-bound of cities. Together, these buildings powerfully revealed architecture's ability to expand perceptions, to elevate everyday activity into art, and to encourage us to remember what never should be forgotten.

Monument to Memory

The Holocaust Memorial Museum Is a Searing Space of Pain and Healing

APRIL 11, 1993

Their names will be attached forever, like barbed wire, to one of the darkest nights in human history: the systematic murder of 6 million Jews by Hitler's Germany.

Auschwitz, Buchenwald, Treblinka.

These were among the death camps where the Nazis executed what they referred to as "the Final Solution to the Jewish Problem." The vast majority of the victims—who included Gypsies, Poles, homosexuals, Jehovah's Witnesses, and the disabled—were herded to gas chambers that prison guards told them were showers. Others were used as human guinea pigs in the mad genetic experiments of Dr. Joseph Mengele. Still others were shot at point-blank range and heaved into mass graves by SS guards. When the Allies liberated the camps in 1945, bulldozers were needed to clear the mounds of corpses that hadn't been burned in crematoria.

How can architecture evoke the experience of such horrors amid Washington's optimistic classical monuments? How can it turn casual visitors, families in blue jeans and T-shirts, into empathetic witnesses? How can it stir our collective consciousness so the crime of genocide is never again perpetrated against humankind? And how can it accomplish all this without descending to the level of Disneyland kitsch?

Architect James Ingo Freed, himself a refugee from Nazi Germany, has provided a stunningly powerful answer to these questions in the new $168 million United States Holocaust Memorial Museum. The building will open to the public one week after the 50th anniversary of the uprising by the Jews of the Warsaw Ghetto.

This is an architecture that sears the memory and invades the dreams. It manages, as no other building of recent years, to link the visual and the visceral, transporting the visitor—as the steel doors of its three main ele-

THE HALL OF WITNESS AT THE HOLOCAUST MEMORIAL MUSEUM: Linking the visual and the visceral to memorialize the unthinkable.

vators clank shut—from the happy greensward of the National Mall to a world where the sky darkened with the ashes of human flesh.

Wisely forsaking the temptation to literally reproduce the Jewish ghettos or the death camps, Freed subtly refers to them in a relentless journey through the physical and psychological landscapes of the Holocaust: the bridges that separated Jews from the public streets running through the ghettos; the packed railroad freight cars that delivered their human cargo to the camps; the chilling selection, upon arrival at the camps, of the first victims; the prisoners' feeling of constantly being watched; and the palpable sense that the walls of the camps were inexorably closing in on them.

There is also a place of healing in this building, a hexagon-shaped Hall of

Remembrance whose six sides are likely to suggest for many visitors the six points of the Star of David or the 6 million Jewish victims of the Holocaust.

The museum is, above all, a memorial to those victims, not a conventional architectural monument. Like the nearby Vietnam Veterans Memorial, it commemorates, but does not celebrate. Yet the Holocaust Memorial Museum also manages to come to terms with its surroundings, forging a sympathetic relationship with monumental Washington even as it sets itself apart from the grand, neoclassical city.

The museum occupies a 1.9-acre site approximately one-quarter mile southeast of the Washington Monument. The site is sandwiched between two heavily traveled thoroughfares, 14th and 15th Streets. In the block in front of the museum, 15th Street has been renamed Raoul Wallenberg Place in honor of the Swedish hero who rescued thousands of Hungarian Jews from the Nazis in 1944.

A curved neoclassical facade asserts the building's presence even as it maintains the wall of structures along 14th Street. This gracious limestone screen, Freed freely admits, is a false front concealing the prisonlike toughness of the brick and steel structure—the real museum, as it were—that sits behind.

While it may be lost on all but the most sensitive visitors, the screen deliberately recalls the gates of the death camps and the falsehoods they communicated to those about to become prisoners. "Arbeit macht frei," said the infamous gate at Auschwitz, the first of layer upon layer of deceits. "Work makes free."

Rows of four peaked towers on the long sides of the building suggest sentry posts. The towers are connected by steel footbridges; it takes no great leap of the imagination to envision guards with machine guns patrolling them.

Ever aware of the museum's urban context, Freed employed materials that blend with neighboring structures—red brick that matches the Victorian Auditors' Building to the north, limestone to acknowledge the neoclassical facade of the Bureau of Engraving and Printing to the south.

Only to the west, where the museum faces a grassy area flanking the Mall, did Freed break free and create a powerful geometric form that appears, at first glance, to partake of the Washington tradition of monumental, symmetrical architecture. In reality, however, the six-sided, limestone-faced Hall of Remembrance doesn't fit into this category. The corners of the hall are slit open to admit shafts of light. More important, the hall's hexagon shape has an inherently unstable, shifting quality. The skylit room it frames, albeit a place of quiet contemplation, has an underlying restlessness—a place for healing, but not closing, the wounds of war.

The visitor begins his journey by passing through one of two doors on the 14th Street side of the museum: individuals to the left, tour groups to the right. Again, the reference to the death camps is likely to escape all but the most observant visitors. When prisoners arrived in the camps, the SS officers pointed one way for the able-bodied, who became slave labor; another way for the elderly, young children, pregnant women, and the disabled, who were immediately put to death.

Once inside the museum, the visitor enters personal data into a computer and then is given a computer-generated ID card of an actual Holocaust victim of the same sex and a similar age. The aim of this computer-age gimmick is clear: to personalize mass killings. The card can be inserted in computer terminals in the museum's permanent exhibition space, allowing the visitor to learn the fate of his demographic double as the Final Solution is carried out.

The interior is organized around the Hall of Witness, a three-story rectangular room with harsh brick halls and boarded-up windows that is topped by an intentionally warped, diagonal skylight. The western edge of the room is framed by a black granite wall, into which is chiseled a quotation from the Hebrew prophet Isaiah, "You are my witnesses." A white marble wall marks the eastern edge. Some may interpret it as a sign of hope, others as a reminder of the snows in which Jews perished on Nazi death marches.

These dualities are intentional. Because the Holocaust affected different people in different ways, Freed sought not to prescribe meaning, as in a conventional classical monument, but to construct a building that would be a kind of emotional resonator, attacking the emotions of every visitor in a distinct manner. "You shout into this and you get your own echo back," the architect said.

Still, there are clear-cut architectural references, forms growing out of forms from the most horrible killing fields of the century. The load-bearing brick walls in the Hall of Witness recall the brick buildings near the killing wall of Auschwitz, where prisoners were shot to death. The railings of a gray steel staircase on the western edge of the hall recede into a brick arch, suggesting railroad tracks that led to the arched brick gate of the death camp at Birkenau. If the visitor glances upward from the Hall of Witness to the glass-block floors of the footbridges, he sees the ghostly steps of scholars who may remind him of prison guards on watch.

Even if one does not fully grasp these references, the disorienting and displacing effect of the Hall of Witness is deeply felt. The effect continues as the visitor passes into one of three steel elevator cabs that proceed to the exhibition space.

This three-floor zone is divided into three periods: the rise of Nazism

from 1933 to 1939 and the initial persecution of minorities; the Final Solution of 1940–45, with its mobile killing units, concentration camps, and death camps; and the period from 1945 to the present, highlighting stories of resistance. The exhibitions continue the visceral effect of the museum's architecture, displaying, for example, a model of a Nazi killing center.

There is pathos of a different sort as one passes through footbridges linking the exhibition spaces on the north and south sides of the museum. Baked into the glass walls of the fourth-floor bridge are the names of thousands of towns obliterated by the Nazis. The third-floor bridge depicts the given names of several thousand people killed in the Holocaust.

Upon leaving the exhibition spaces, one moves into the skylit 60-foot-tall Hall of Remembrance. Directly ahead is a steel box that contains soil from the death camps; an eternal flame rises above it. Ledges along the perimeter of the space allow for the lighting of memorial candles. Triangular openings in the limestone walls will remind some visitors of the triangular badges the Nazis used to identify those destined for deportation to the camps. A reddish floor of cracked Indian marble suggests a field of dried poppies—or dried blood.

This pantheon of tears may be among the most moving rooms ever built. Its exterior already has become a rallying point for human rights demonstrations against the killings being committed in the name of "ethnic cleansing" in the former Yugoslavia.

Freed's considerable achievement is to have evoked the horrors of the Holocaust while respecting the nation's most hallowed ground. At the same time, he reminds us that modern architecture's utopian "machine for living" could just as easily be turned into the perfect death instrument—in effect, a machine for killing. The Holocaust Memorial Museum inextricably links architecture and memory; bricks, mortar, and metaphorical barbed wire, with the deepest trial of the human soul.

Star Attraction
The Hayden Sphere Has Landed and It's Friendly to Earthlings
MARCH 13, 2000

The stars have aligned in New York, bringing together a talented architect, an adventurous client, and lots of money. The outcome: an architectural big bang that ought to explode forever the outdated theory that modernism is incapable of making civic monuments.

That may be the most enduring design revelation of the $210 million

THE ROSE CENTER FOR EARTH AND SPACE: Bold geometry and a mind-expanding journey in space and time.

Rose Center for Earth and Space, whose signature image is a giant off-white sphere that seems to levitate within a transparent glass cube. But this new cathedral of the cosmos teaches other down-to-earth lessons, and they have to do with how the present can respect the past without copying it, and how architects can create people-friendly spaces even as they use the most up-to-date building technology.

Yes, there are problems with the Rose Center—visitors reportedly are

finding some of the exhibits full of impenetrable science jargon. But if NASA could bring a wounded *Apollo* 13 back to Earth during the moon-landing era, then surely those glitches can be solved.

Designed by New York architect James Stewart Polshek, a 70-year-old Akron native, the Rose Center occupies the site of the old Hayden Planetarium, which sat near the western edge of Central Park at 81st Street.

The new building is attached, both physically and in spirit, to the American Museum of Natural History, which fronts the park with a powerful, neoclassical facade that resembles a Roman triumphal arch. The Rose Center is tucked behind the museum's north wall and faces 81st.

Originally, Polshek was charged with a mere renovation of the Hayden, the domed planetarium where New Yorkers had gone stargazing since 1935. But he sensed that his client, museum president Ellen Futter, whom he describes as a populist master builder, wanted something more ambitious. And so he gave it to her.

One day, Polshek walked up to the desk of one of his assistants, who was doodling over a picture of the dome's half-sphere. Polshek took a compass and traced the entire circle of the sphere. "What if we did that?" he asked. Thus, the new Hayden Sphere—the ball in the box, weighing 4 million pounds and housing the museum's new planetarium—was born.

It was not an easy birth. Preservationists fought a losing battle to save the original Hayden Planetarium, which was much beloved for its Art Moderne design. And yet, the Rose Center bears the unmistakable imprint of the past—the distant past. Polshek's globe recalls a visionary eighteenth-century design by Frenchman Etienne-Louis Boullee, a giant sphere that was meant to be a monument to the hero of the Enlightenment, Sir Isaac Newton. Boullee's sphere was intended to suggest a planet, and its interior was supposed to display the night sky, with the "stars" illuminated by holes drilled through the sphere's shell.

That unbuilt design typically is dismissed as wildly impractical. And yet, here it is, proof positive that drafting-board dreams can come true, at least with a little help from advanced twenty-first-century technology.

Nearly 100 feet tall, the exterior walls of the glass cube that houses the Hayden Sphere are made of a very expensive, colorless glass known as "Pilkington water white," which is remarkable for its transparency. The walls are supported by a space-frame structure that consists of tube-shaped steel trusses braced by stainless-steel rods. Steel fittings, with spindly features that resemble spiders' legs, help hold the single-pane sheets of glass in place.

Unencumbered by a conventional window frame, the glass seems pure and free. It is all one big window, as it were. The glass cube rises from a

one-story base of gray granite. The stone is at once a subtle doff of the hat to the exterior of the natural history museum and a visual trick that prevents the visitor from seeing the three tilted steel columns that support the Hayden Sphere, thus making it appear to levitate.

The result is an architecture of astonishing boldness and simplicity. The Rose Center is an incredible, almost ghostly presence, at once rational and romantic, as if a giant moon were hovering over the horizon. Yet for all that it is an exercise in jaw-dropping, otherworldly beauty, it somehow seems at home on Manhattan's Upper West Side—anything but a weird object that dropped in from another planet.

This is partly because of the Tinker Toy quality of the structural system, which helps to give the building a human scale. But the deeper reason is that the Rose Center strikes up a pointed dialogue with the Beaux-Arts architecture of the natural history museum.

Like the main museum, it is severely geometric, monumental, and imposing. Yet in contrast to its neoclassical predecessor, it is ethereal rather than earthly, a void rather than a solid. And the contrast is about more than how the Rose Center looks; it is also present in how the new building works.

You reach its gently curving entrance arch by descending a series of pathways from 81st Street rather than ascending a flight of steps, as you do in the museum proper. So the Rose Center is both literally and symbolically accessible—not just to those in wheelchairs, but to everybody who passes by. It beckons you in, inviting you to partake of such brain-blowing concepts as the origin, age, and size of the universe.

In the entrance lobby, Polshek plays the familiar "press and release" game of lowering the ceiling in order to make the burst of space in the main hall all the more impressive. But there's a new twist: black floors of synthetic stone that seem to twinkle because they are embedded with glass shards. This is just the right touch, populist without being kitschy, and it sets the stage for the spatial drama that is to follow.

That drama arises from the essence of modern architecture—space, light, and structure. Its centerpiece is the Hayden Sphere, which is clad in perforated aluminum panels and an underlayer of sound-absorbing fabric to ensure that the Rose Center's interior does not become a maddening echo chamber.

The visitor descends to a lower-level exhibition area known as the Hall of the Universe, where the sphere looms menacingly above. "It was very important that the sphere not be perceived as some dumb golf ball on a tee, but something that was vaguely threatening," Polshek says. That way, it would suggest the sheer power of planets hurtling through space.

The architects took equal care not to mimic the interior of the old

museum, which is closed off from daylight. Nothing would have been more wrong for a museum devoted to the heavens than to repeat that mistake. Appropriately, then, the inside of the Rose Center is washed in a cool, natural light.

Also in contrast to the old museum, where everything seems to be symmetrical and in perfect balance, the architects devised an edgy, ever-changing series of spaces that evokes the constantly shifting character of the universe. It also creates innumerable different views of the Hayden Sphere.

For instance, ride the glass-walled elevators up to the planetarium, which is housed in the upper portion of the sphere and features a dazzling three-dimensional tour of the universe. From this vantage point, the sphere no longer seems dangerous. Instead, it floats serenely in space.

Or walk along the perimeter of the Rose Center, where scale models drive home the enormity of the sun and other stars, and you see the sphere in counterpoint to the city around it, a collision of old and new made possible by the building's transparency.

Or head down the spiraling ramp from the big-bang exhibit that occupies the lower portion of the sphere and you are hugging the ball's curved surface, descending a 360-foot-long sloping ramp that seeks to explain the 13 billion years of cosmic evolution that followed the big bang.

Visitors to the Rose Center have complained that some of these exhibits are hard to grasp. But on another level, the exhibits and the architecture perfectly complement each other, both through their sleek modernism and because the architecture reinforces the subject of the exhibits—time and space, and our place in the cosmos.

In that sense, the Rose Center is a humbling experience, yet Polshek never makes the visitor feel small or insignificant. As you come down the ramp that spirals around the sphere, you see people watching you, people moving around the ramp, people outside the museum. "It's a kind of reattachment to the human being," Polshek says. "I call it theater."

It is indeed that, which is why, in the end, the Rose Center seems so at home here. For New York is nothing if not a collection of theatrical experiences—not just those performed on the Broadway stage but the urban theater of everything from the ice-skating rink at Rockefeller Center to the vitality of the city's packed sidewalks.

The Rose Center is a new kind of theater—one that makes vivid drama of dry science and puts the art of architecture in a starring role.

Welcome to the Future

Frank Gehry's Stunning New Guggenheim Museum in Spain Is the First Great Building of the Next Century

OCTOBER 19, 1997

As much as it is a spectacular futuristic object, a shimmering mass of titanium, the new Guggenheim Museum in Bilbao, Spain, is a remarkable exercise in the recycling and reinvention of an old city that still knows how to flex Rust Belt might.

American architect Frank Gehry designed the $100 million museum to take in and transcend its iron-pants surroundings, from a steel suspension bridge to a murky, smelly river.

Putting neither the building nor its art up on a classical pedestal, Gehry has fashioned—or should one say forged?—an art museum that reaches out with a shipbuilder's beefy arm, as well as otherworldly light and magic, boldly inviting you to partake of Miro and Mondrian.

The museum is a model for the postindustrial future and a triumph for Gehry, who has long been taking humble, even despised materials—chain-link fence, for example—and transforming them into high art. Now, he has done it on a larger, urban scale, with a purposely off-kilter design that is every bit the iconoclastic equal—and then some—of Frank Lloyd Wright's Guggenheim Museum on New York's 5th Avenue.

Both museums burst the boundaries of right-angled geometry—Wright's, with its corkscrewing rotunda; Gehry's, with its colliding assemblage of interconnected forms. Both have massive central atriums—Wright's actually would fit comfortably within Gehry's.

But only Gehry's museum possesses the virtue of not overwhelming the paintings and sculpture inside. Instead the art looks as if it were destined for its new quarters, which include a 450-foot-long gallery that's specifically intended for large-scale works like postminimalist sculptor Richard Serra's *Snake*, three serpentine curves more than 13 feet tall and 100 feet long.

That all this is happening in Bilbao—one of Europe's leading shipbuilding cities, Spain's fourth-largest city, and home to nearly half of the 2.1 million residents of the Basque region—seems serendipitous, given Gehry's penchant for tough beauty. I was going to hire a translator to ask the Basques what they thought of Gehry's creation, but no translation is necessary when children are running joyfully up and down the museum's cascading limestone steps, when adults are pressing their noses up against windows to glimpse what's inside, and people of all ages are rapping their fists on that mysterious-looking titanium.

THE GUGGENHEIM BILBAO: A remarkable exercise in the reinvention of an old industrial city.

Clad in a handsome light-brown Spanish limestone at its base, with its roof and sides covered with silvery titanium shingles, the museum is entered from a descending flight of stairs. That both inverts the customary way of getting inside a house of high culture and allows the building to follow the slope from the downtown to the Nervion River.

Then visitors make their way to a 165-foot-tall atrium, which is topped by a petal-like roof of titanium that Gehry refers to as "the metallic flower." From there, galleries of varying shapes, sizes, and heights fan out in nearly all directions. The 450-foot-long one actually swoops beneath a city bridge; on the other side of the span, the museum explodes upward in a splaying, limestone-clad tower, its steel frame partially exposed. The tower has no function other than being a "high reader," Gehry says, comparable to the spire of a cathedral—and why not, considering museums are often likened to cathedrals where we worship art?

The singular design, inspired in part by the futuristic urban vision of Fritz Lang's 1926 movie *Metropolis*, overshadows the fact that the new Guggenheim is simply the most prominent example of the urban renewal that is remak-

ing Bilbao. Hard hit in the 1980s by an economic slump and still trying to overcome the stain on its image created by Basque terrorists, Bilbao has been making no little plans for the twenty-first century.

Not only did it bid boldly for the Guggenheim, with regional and provincial governments footing every peseta of the construction bill, but it also has hired star architects such as Britain's Norman Foster, who completed the first leg of a sleek new subway line in 1995; Spain's Santiago Calatrava, who has graced the Nervion River with one of his lyrical bridges and who will remodel the now minor-league airport; and Cesar Pelli of New Haven, Connecticut, who has developed a master plan for parks, offices, and other activities along the waterfront.

Although the rest of downtown Bilbao is surprisingly charming, with circular plazas, handsome boulevards, and an old city with picturesque, narrow streets, the waterfront around the museum remains hardscrabble, with one side of the building flanked by huge yellow cranes that snatch big containers off railroad flatcars and transfer them to trucks. A passenger railroad line runs right below the museum, just as Metra's cars pass beneath the Art Institute of Chicago.

Abandoned industrial buildings and a parking lot used to fill the site, cutting off downtown from the river. Now, the museum forms a bridge between the city and the river, though, at first glance, as a businessman from Tampa who was here told me, the building "sticks out like a sore thumb." But look closely and you see how it manages to be a part of its place, reveling in all the toughness of the landscape, while expressing the nervous energy of our time.

The museum's high, sloping walls echo the steep and lush green hills that surround the city. Its massive silver volumes recall ships' prows and power plants. A round column that supports a huge-scale umbrella-like visor on the museum's river side is in subtle sympathy with the massive concrete supports of the nearby bridge. Here, Gehry has treated the city as a great collage, drawing everything into his composition, even the ugly and the ordinary, without lapsing into a postmodern pastiche.

Above all, the museum is superbly crafted, the double curves and tilting edges of its titanium made possible by the application of a computer program, called Catia, originally developed for making French Mirage jet fighters and their highly complex curving contours. Catia enables Gehry to realize his unorthodox shapes with great precision, and here, with his first use of titanium, a natural element used for airplanes and golf clubs, he has done so to stunning effect.

It is a delight to move around the museum, watching its forms recompose themselves. Here, it is an erupting volcano; there, an otherworldly spaceship;

somewhere else, a sleek boat. Its titanium shingles shift in color depending on the light, variously different shades of silver, blue, gray, black, or white.

If most museums are inanimate containers, either neoclassical palaces or modernist boxes, this one seems like a living, breathing thing. And nowhere does it exert itself with more force than when you stroll down Bilbao's main shopping street and the museum suddenly appears at the end of an intersecting street—framed by old brick and limestone buildings, a magic mountain shimmering serenely in the sunlight.

To see that view is to understand how Gehry has fit into Bilbao, not through imitation, but through counterpoint. You feel poised on the threshold of the new millennium. The museum's design is enormously persuasive—at once tough and lyrical, an extraordinary sculptural object that dives into the chaos around it and still forges a greater urban order.

Inside, the museum is nearly every bit as successful, with the building's nervous geometry rarely, if ever, getting in the way of the interplay between the viewer and the art. In some respects, it enhances that interaction, infusing it with dynamic energy.

Gehry approached the inside from a typically unconventional point of view. He is a close friend of Serra as well as other artists, and they have told him they are not enthralled with the traditional notion that a museum ought to be a neutral container and defer to the art within it. He recalls their words this way: "You idiot. We don't want to be in a neutral space. A neutral space is not engaging."

Well, they got their wish. If you want neutrality, head for Switzerland, not Spain. Very little in the new Guggenheim can be described as neutral.

The colossally scaled atrium is a huge void of space with an explosive geometry that verges on the indescribable. Glass stair and elevator enclosures warp. Voids crack open between sloping walls. Curving bridges shoot through the space. Light pours in from glass slits in the titanium skin.

There is no single spot—the 100 percent point, architects call it— where you can stand to take in the room, wholly and satisfyingly. You are in the building's midpoint, but it has no true center. Yet, while the atrium comes perilously close to going over the top, there's an order beneath the chaos. You simply move up the atrium, in contrast to the downward spiral of Wright's Guggenheim, and pick your gallery, another difference from the way Wright forced you to view art in a prescribed sequence along his tilting ramp.

Classically proportioned galleries provide a sense of relief from the off-kilter energy of the atrium. They are perfectly proportioned homes for the abstract canvases of such modern masters as Mark Rothko. To prevent these galleries from seeming like a separate museum within a museum, Gehry

gives them unusual-shaped ceilings and reveals the bottom of the steel studs behind their drywall surfaces. This is likely to drive traditionalists who want perfect galleries crazy, but it does not represent a major distraction and it is in keeping with the building's rough-edged personality.

Other, odd-shaped gallery spaces that roughly correspond to the unusual contours of the building's exterior are superb environments for art, particularly a room with curving walls painted red, green, and blue by Sol Lewitt. The 450-foot-long, column-free gallery might seem better with slight subdivisions; even so, its curving ceiling engages in a lively dialogue with Serra's snaking arcs.

The galleries vary in ceiling height and most of them have skylights, preventing the museum from seeming either monotonous or claustrophobic. Further breaking the mold of the hermetically sealed art house, Gehry opens up the building to spectacular views of the city and its environs—the green hills, the bridge, the railroad. Art and life, he seems to be saying, are one.

That is the most profound lesson this building teaches, channeling the chaos of daily life into artistic expression without becoming chaotic itself. Gehry has walked a fine line here—and my question is whether, like Wright, he's a genius who stands alone or whether others can follow his example of buildings as sculpture without doing serious damage to cities.

We've just emerged from an era in which modern architects were vilified for designing buildings as sculptures—high-rise towers on broad plazas, which ripped great gashes in the urban fabric. Gehry, of course, knows better; he's stitching the fabric back together, even if, in his hands, it resembles a crazy quilt.

It takes enormous skill to pull that off, however, which is why I'm tempted to hang a sign on the new Guggenheim that says, "Looks like a breeze, but don't try this at home." Gehry doesn't buy it. "What are you gonna do?" he says. "You've got to bumble forward into the unknown." Perhaps he's right. Shattering aesthetic convention, his Guggenheim unites disparate parts of the cityscape into a fragmented whole.

It is a supreme creative achievement, the first great building of the next century.

Postscript

The Bilbao Guggenheim far exceeded expectations, becoming an instant landmark and drawing nearly 1.4 million visitors in its first year. Still, the museum's success was marred, at least temporarily, when the *Philadelphia Inquirer* reported in 2000 that some of the museum's titanium shingles had become discolored. According to the newspaper, museum officials cited

faulty manufacturing while the titanium supplier defended its product. For his part, Gehry asserted that the titanium had been dirtied by air pollution and therefore was cleanable rather than permanently discolored. Maintenance workers were scheduled to fix the problem by late 2001.

Berlin's Leading Edge

Helmut Jahn's New Sony Center Helps Turn a Wasteland into a Thriving Urban Center that Draws Together East and West

JUNE 18, 2000

This is a city that has been devastated by bombs, by a wall, and by modern architects who dropped faceless buildings on windswept plazas. So when the Berlin Wall came down 11 years ago and the door opened to building on the no-man's-land around it, there was every reason to fear that Berlin would take another pounding—and that a historic opportunity to knit together its long-divided east and west sides would be lost.

But after the opening of the $1 billion Sony Center, a triangle-shaped wedge of offices, apartments, condominiums, and entertainment attractions designed by Chicago architect Helmut Jahn, it is clear that the scars created by World War II and the Cold War are being healed. It is also apparent that modern architecture has matured—and so has Jahn, 15 years after his glitzy, ill-functioning James R. Thompson Center made its disastrous debut.

With an umbrellalike roof sheltering a towering central space, the Sony Center bears an unmistakable resemblance to the Thompson building, still reviled for the way its pink and blue walls intrude upon the classical dignity of Chicago's City Hall. But the two differ in critical ways, none more significant than Jahn's move from his flashy postmodern period to a self-assured modernism characterized by exquisitely transparent walls of glass.

While the Sony Center is not a design triumph on the order of Frank Gehry's stunningly sculptural Guggenheim Museum in Bilbao, Spain, it is no less miraculous in the way it restores life to a once-moribund area. Here, on a chunk of land where just 10 years ago there was nothing but empty space and buildings pockmarked with shrapnel, a city is being reborn—one that is a real place, not just a tourist quarter.

The rebirth is apparent not only in the Sony Center, where the big, under-the-tent public space brings a taste of dizzying American atriums to the Continent, but also in the neighboring Daimler-Benz district, where the architect Renzo Piano has laid out buildings and plazas in a more traditional European manner. Cafes are crowded. Sidewalks teem

THE SONY CENTER IN BERLIN: Setting new standards for entertainment architecture.

with skateboarders, dog walkers, and parents pushing baby strollers. What had been the gloomy eastern edge of allied Berlin, back in the days when the wall loomed menacingly nearby, is increasingly the city's vital center.

But there is much more to the Sony Center than that. It aspires to elevate the low art of entertainment design to the same pedestal occupied by buildings devoted to the visual arts and classical music. It is an example of environmentally conscious "Green Architecture," that allows office workers and apartment dwellers to open windows and breathe fresh air. Most of all, it sends powerful messages about the changing face of Germany's capital.

Built on Potsdamer Platz, a once-thriving square that was destroyed by Allied bombs during World War II, Sony Center consists of seven buildings, all 10 or 12 stories tall, with the exception of a 26-story office tower. The lower structures include three office buildings, one of which houses Sony's European headquarters; a condominium building whose public areas feature restored rooms from a grand hotel once frequented by Germany's kaiser; and a film center that will house the Marlene Dietrich archives.

Following design guidelines established by Berlin planners, these buildings ring the perimeter of Sony's triangular plot. In contrast to the old modernist formula of isolating towers on a plaza, their outer walls ful-

fill architecture's traditional role of creating roomlike spaces along the sidewalks of a city. But Jahn, a native of Nuremberg, has never been one to re-create the past and Sony proves no exception.

In the middle of the triangle is an oval-shaped public space called the Forum that is longer than a football field and nearly as wide. Reached by gatewaylike openings that lead in from the sidewalks, it is topped by a massive roof of glass, fabric, and steel that is put together like a bicycle wheel. Restaurants and an IMAX theater line the oval; beneath it and its curving reflecting pool are eight movie theaters with more than 2,000 seats. A skylight in the theaters' lobby puts on a show of its own, allowing moviegoers to look upward through the pool to the Forum's spectacular roof.

A visitor from Chicago might be tempted to call this space Thompson Center II, but in reality, the Forum differs dramatically from its American predecessor. It has a much broader mix of uses; they should keep it hopping around the clock. It is, moreover, partly exposed to the elements rather than hermetically sealed; fresh air flows in through a 30-foot opening at the top of the roof and through the hollows in a curving beam that helps hold the roof up. As a result, the Forum has a distinctly ambiguous identity—one feels inside and outside at the same time.

This ambiguity permeates the entire Sony Center and holds the key to how Jahn's modernism differs from that of the legendary Ludwig Mies van der Rohe. Whereas Mies's steel and glass cages were "skin and bones" buildings that strove to reveal their internal structure, this new approach seeks a highly transparent skin and nearly invisible bones. It has been facilitated by advances in technology that make glass clearer, and freer of supporting walls, than ever before.

At the Sony Center, this approach has yielded some supremely elegant architecture, like that of the 26-story office building, where Jahn wraps a curving wall around the front of the tower, then slices the wall's outer edge on a dramatic diagonal. The building seems to float, making for a spirited counterpoint to a far more solid-looking, brick-covered tower across the street at Daimler-Benz. Together the two mark an impressive gateway to the new Potsdamer Platz, much as Tribune Tower and the Wrigley Building create a powerful portal to North Michigan Avenue.

Though only 10 stories tall, Sony's headquarters is equally impressive. Set on the corner of the site that fronts the sprawling park called the Tiergarten, the building has a so-called "double-wall," one of the most striking innovations of Green Architecture. In general, double walls comprise an inner wall with office windows that open and an outer wall with slits that admit fresh air. The approach has practical benefits, saving energy and improving worker

comfort, yet in Jahn's hands it is raised to the level of art, with a diagonally canted inner wall resembling a diamond within a polished case.

Earlier in his career, when Jahn was dubbed Baron von High Tech for his showy displays of technology, he was incapable of such subtlety. Still, Baron von High Tech hasn't entirely disappeared, as the Sony Center's gigantic fabric and glass roof makes clear.

Jahn meant the big umbrella to relate to the sloping, hill-like roofs of the Kulturforum, a performing arts center designed by the German architect Hans Sharoun that sits just north of Sony Center. He wanted Sony, as he has written, to be a new kind of Kulturforum, one where "pop culture and entertainment challenge the fine arts of classical music, theater and painting."

But Jahn doesn't quite carry it off with the Forum's roof, which, in contrast to Sharoun's organic forms, sits awkwardly atop the rest of Sony's buildings, as if Jahn had set down one of those broad-brimmed black hats he wears. Berliners are fond of sticking buildings with deflating nicknames; it is not inconceivable, given the opening in the Forum's roof and its translucency, that Jahn's grand gesture could someday be ridiculed as "the Lampshade."

What saves the Forum is the way it connects to the city around it—it's no Berlin mall, as some German critics have charged. Whereas the typical mall is sealed off from the outside, Jahn's Forum extends the modernist ideal of continuity between interior and exterior to new levels. The glass in the roof is so clear that it's nearly impossible to tell that it's there; in the winter, after a snowfall, one can see snowflakes resting on the glass without sensing what's holding them up. The transparency not only creates fantastic patterns of light and shadow, but also sends the message that on this urban stage set, it's okay to behave as though you're outside.

Pathways through the Forum are squeezed tightly by the restaurant tables and railings around them; that's a plus because crowding—not overcrowding, but the kind of density that makes elbows rub—is essential to good city streets. The parade of humanity, and the people-watching, should get even better as Sony's office and residential buildings fill up and increase the project's density.

To be sure, there are weaknesses. The Sony Center is more about spectacle than schmoozing. The best public spaces give the visitor a range of scales, both grand and intimate, that this one lacks. Nevertheless, the Forum's connections with the city and the seemingly chaotic urban pulse within it distinguish it from isolated, overly ordered urban theme parks. It works because it is public and permeable rather than private and protected.

One of the Sony Center's other strengths is that it offers linkages in

time as well as space. The lower-floor public spaces of the condominium building contain restored rooms of a grand hotel, the Esplanade, that once occupied the site and was a hub of Berlin's social life. These neobaroque rooms once hosted Kaiser Wilhelm II and film stars such as Charlie Chaplin. Jahn has appropriately displayed some of the rooms in glass boxes that resemble museum display cases.

The end result is that Sony Center's instant city does not feel like it was created overnight. There is just enough memory, just enough architectural variety, and more than enough spatial excitement and people-friendly activity to make this place seem real. It still feels like a European city, not a piece of Manhattan or the Loop transported across the Atlantic.

Certainly, Jahn was aided by the fact that the more traditional Daimler development was across the street, letting him use its walls of brick and terra-cotta as a foil for his glassy buildings. But his sophisticated artistry and sure-handed urban planning have gone a long way toward making the project work—and setting new standards for entertainment architecture.

More important, he has created a sense of place, one fraught with meaning. Rising from the site of the former wall, the Daimler and Sony buildings symbolize the triumph of capitalism—but in a way that is inviting, not vainglorious. Jahn has helped give this city a thriving new center where once there was only a forlorn edge.

IMPORTING "STARCHITECTS"

O nce, Chicago was primarily an exporter of architecture and urban design, from the pioneering skyscrapers to Burnham's City Beautiful civic plans to Mies van der Rohe's glass boxes. Yet in the 1980s, as the city turned away from the modernist austerity of the Miesian model, developers began importing star architects—"starchitects," for short—who wrapped anonymous office space in fetching, postmodern packages.

Though postmodernism fell out of favor in the 1990s, the practice of bringing in acclaimed outsiders only gathered steam, spurred no doubt by globalization. By 2001 four winners of architecture's most prestigious award, the Pritzker Architecture Prize, had major commissions in the city: Frank Gehry, a band shell and pedestrian bridge in Grant Park; Rem Koolhaas, a campus center at the Illinois Institute of Technology; Renzo Piano, an addition to the Art Institute of Chicago; and Norman Foster, a 60-story office building at the northeast corner of Wacker Drive and Monroe Street. If a single client epitomized the trend, it was the University of Chicago, which commissioned new dorms by Mexico's Ricardo Legorreta, an athletic center by Connecticut architect Cesar Pelli, and a new Graduate School of Business by Rafael Vinoly of New York.

Some Chicago architects argued that they should have been offered the plum jobs, ignoring conveniently the fact that Chicagoans have never hesitated to invade other cities for work. In addition, Chicago has a rich tradition of outsiders who have served as catalysts for creativity, among them Boston's Henry Hobson Richardson, whose muscular Marshall Field warehouse strongly influenced Louis Sullivan. Gehry, with his band shell, promised to reprise that role.

Yet there were pitfalls associated with the phenomenon of the visiting star, and they were illustrated most visibly in another Midwestern city—Cincinnati, where the University of Cincinnati tried to upgrade its campus (and undoubtedly, its image) by hiring such formidable figures as New York architect Peter Eisenman. Acclaimed when it opened in 1996, Eisenman's Aronoff Center for Design and Art wound up being a cautionary tale for Chicago and other cities who import outsiders: however dazzling the underlying concept, a work of architecture has to be built well in order to endure.

Koolhaas's IIT Campus Center
Success Will Be in the Details

FEBRUARY 15, 1998

It's been a decade since Chicago produced a major building that pushed the envelope of creativity and justified the claim that this is the first city of American architecture. But now that Rotterdam architect Rem Koolhaas has won the international competition for a new campus center at the Illinois Institute of Technology, such an outcome finally is within reach— if and only if Koolhaas can translate a brilliant idea into a finished building that upholds the Chicago tradition of elevating construction into art.

Tall enough at 6 foot 5 to be an NBA small forward, witty enough to be a talk-show quipster, the 53-year-old Koolhaas has rocketed to superstar status on the basis of books and buildings that articulate a vision for the postindustrial city that is equal parts chaotic and erotic. (The cover of his acclaimed 1978 book, *Delirious New York*, wittily pictures two postcoital skyscrapers, the Empire State and Chrysler buildings, in bed.) No one else

THE WINNING PLAN FOR THE IIT CAMPUS CENTER: God needs to be in its details.

so vividly personifies the globalization of the practice of architecture and, perhaps, the danger inherent in that phenomenon.

One day, Koolhaas is in Chicago. The next day, he is in Ann Arbor, Michigan. Then he's in New York. Then Germany. Then Rotterdam. Reached at a German hotel for a midnight (European time) telephone interview, he is savvy enough to say of the IIT campus center, "I fully intend to be involved in this building myself and to make sure that it's not a kind of hit-and-run situation." Yet Chicago architects who have seen his large-scale work say it lacks jewel-like precision. "He's known for doing crude details," says one, who has eyeballed Koolhaas buildings in France and Holland.

Such little things add up to a lot, especially on a campus like IIT's with 20 buildings by Ludwig Mies van der Rohe, who famously said, "God is in the details." They count for even more when you understand that the competition was no beauty contest but a way to provide a proud yet forlorn inner-city campus with a vibrant gathering place for its students and faculty and those who live nearby.

So I want to sound a cautionary note about a proposal that tempts a rush to judgment: Koolhaas's plan for the $25 million campus center may

turn into a masterpiece, but it's not one yet. It ought to be assessed for what it is—a concept that has miles to go before anyone can reasonably compare it to the epoch-defining modernist statement Mies made at IIT's Crown Hall at State and 32nd Streets. Even James Ingo Freed, a distinguished New York architect who served on the four-member jury that picked Koolhaas, said as much when the winner was announced.

In brief, Koolhaas proposes a block-long building bounded by Wabash Avenue and State Street on the east and west, and 32nd and 33rd Streets on the north and south. The low-slung glass-walled rectangle, which will be known as the McCormick Tribune Campus Center and is due to open in spring 2000, will reach beneath the Green Line elevated tracks. A stainless steel tube on its concrete roof will encircle the tracks and block out noise from the trains. (The unusual arrangement is permissible, according to a Chicago Transit Authority spokesman.) Diagonal passages will slice through the interior, leading to a bookstore, a barbershop, a Mies interpretive center, a copy center, and much more.

There's a buzz in the air that Koolhaas and his Rotterdam-based firm, the Office for Metropolitan Architecture, got the job because of Harvard connections. He teaches at the Harvard University Graduate School of Design, where the jury's chair, Atlanta architect Mack Scogin, used to be chair of the architecture department, while another juror, K. Michael Hays, is a professor of architectural theory at Harvard. The buzz is balderdash. Koolhaas clearly devised the best design, the one that most thoughtfully addresses the needs of IIT's 6,100 students, graduate and undergraduate. None of the proposals by the other four teams—Peter Eisenman; Zaha Hadid; Kazuyo Sejima and Ryue Nishizawa; and Werner Sobek and Helmut Jahn (whose 1988 United Airlines Terminal at O'Hare was the last great major building in Chicago)—came close.

I realized this most vividly on a recent day when I was in Mies's Commons Building, a brick, steel, and glass box at 3200 South Wabash Avenue that is perhaps the world's only Mies building with a 7-Eleven. (Koolhaas, incidentally, proposes to place the Commons under the roof of his campus center, where it will serve as a food court). A Rollerblader whizzed across the Commons' black terrazzo tile floors, looking as out of place as the blue neon sign at one of the building's shops, Luigi's pizza stand. I have nothing but respect for the integrity and the quality of Mies's architecture, but it is certainly too stern, too institutional, for teenagers and twenty-somethings. With Koolhaas, architecture accommodates human use rather than the other way around.

You can see that in the way Koolhaas created the diagonal passageways that cut through his building like the dirt paths on a village green, a clear

departure from Mies's rigid, right-angled geometry. Yet the result could not be more different from the new but old-fashioned town squares of New Urbanist planners. By condensing the elements of a traditional downtown into a single building, the campus center promises to be a bustling indoor city, bursting with color and life.

There's another key difference between Koolhaas and Mies. Whereas the master modernist stripped everything to its essence, homogenizing urban space, Koolhaas accepts the hybrid impurity of city life. So he has no trouble cheekily mixing the sacred (a mosque and a chapel) with the secular (an open-air basketball court), the studious (a bookstore) with the social (a cafe). Nor does he start from zero, as Mies did in laying out a brave new world at IIT; a wall displaying images of Mies and his buildings snakes through the building. It will at once pay homage to the master and remind us that the past, imperfect, cannot be wished away.

There's a lot more to like about Koolhaas's plan. There are no arbitrarily tilting walls meant to express the frenzied state of contemporary culture; this is not a deconstructivist train wreck by the train tracks. It is, instead, the proverbial "dumb box," which I intend as a compliment even though it doesn't sound like one.

Chicago is filled with "dumb boxes," like Louis Sullivan's Carson Pirie Scott store on State Street, whose lack of showy zigs and zags allowed precious dollars to be spent on details that are the difference between architectural prose and poetry. Long a Mies devotee, Koolhaas effectively employs such simple geometry to relate respectfully to Mies's rational steel, brick, and glass buildings at IIT. He does so even as he asserts himself on an urban scale with the stainless steel tube, a move reminiscent of another of his favorite architects, Wallace K. Harrison, whose boldly geometric Trylon and Perisphere forms were the romantic icons of the 1939 New York World's Fair.

Yet the campus center is about much more than imagery. Walk the site, a stretch of parking lots and grass beneath and alongside the elevated tracks, and you realize what is deeply appealing about Koolhaas's proposal. It is as much a work of urban design as architecture. It seeks to transform that no-man's-land, now a wall that divides IIT's academic buildings to the west from its dormitories to the east, into the equivalent of a bridge that brings the two sides together. An urban divide will become an urban center, a transition now in progress around the once-isolated Brandenburg Gate in Berlin. Surely it is no coincidence that Koolhaas, who knows Berlin well, equates reurbanization with reunification.

Thank goodness his plan has a broader importance; the last thing this competition needed to come up with was a one-off dazzler, like Frank Gehry's new Guggenheim Museum in Spain, that lesser talents cannot

imitate. Especially in the growing cities of Asia and Africa, as Koolhaas states in his cinder-block-sized 1995 book *Small, Medium, Large, Extra-Large*, this is the era of urbanization without urban planning. That is the problem of our time, just as Mies and his followers confronted the problem of the postwar era: devising the means, both technical and aesthetic, to build the supertall skyscrapers, airports, and clear-span convention halls that were unimaginable at the dawn of the century.

We know, with the benefit of hindsight, that Mies raised pragmatism and problem-solving to an art; he was the poet of practice, as the Columbia University historian Joan Ockman observed at IIT last fall. Koolhaas's challenge is to heed that legacy so God is in his details. Take that steel tube he wants to wrap around the El tracks. If it isn't properly designed, it will recall nothing so much as a corrugated metal sewer pipe, and IIT's bid for a new image will go down the drain. The same goes for all other aspects of the building, from its exterior glass walls to the deftness (or lack thereof) with which old construction (Mies) meets new (Koolhaas). Finally, Koolhaas has to ensure that his lively mix of functions does not turn into an aesthetic jumble and that the building's diagonal passageways don't prevent it from adapting to future uses that cannot be anticipated.

What Koolhaas might do, as other renowned out-of-town architects typically have done when working here, is to associate with a respected Chicago firm (A. Epstein & Sons International, Holabird & Root, and Perkins & Will all come to mind) that excels at producing solidly detailed buildings and will help him do the same. In the meantime, Koolhaas deserves a salute for a plan that promises to rekindle the flame of innovation in Chicago. Even so, it's only a promise. He still has to make good.

Postscript

Koolhaas, who was named the winner of the 2000 Pritzker Architecture Prize, has a penchant for inciting controversy. The IIT campus center proved no exception.

At first, things went smoothly. Koolhaas brought on Holabird & Root to be his associate architect. The Chicago Transit Authority approved his El-encircling, oval tube idea, though the agency insisted that a long, rectangular opening be cut into the top of the tube so train drivers would not be plunged into darkness.

But controversy erupted in 2000 when a group of IIT faculty members led by Chicago architect John Vinci, an esteemed preservationist, charged that Koolhaas's design would insensitively alter Mies's Commons building. Although Koolhaas no longer planned to cover the Commons with the roof of his campus center, the opponents urged him to clearly separate the two buildings.

State historic preservation officials were called in to referee the dispute because IIT had been selected to receive a $9 million state grant for the tube. In 2000, they announced a compromise plan that will let Koolhaas place the campus center directly alongside the Commons, but will make the old building visible through the glass walls of the new one. The battle helped push the campus center's projected opening from spring 2000 to fall 2002.

Gehry's Chicago Band Shell

Outsider Art Is Catalyst for Creativity

NOVEMBER 7, 1999

Frank Gehry's newly unveiled design for a band shell and outdoor seating area in Chicago's Grant Park is more than a brilliant piece of architectural sculpture, more than a wholly fresh image for a park long identified with glorious old Buckingham Fountain.

The plan delivers just the right creative shock for a city that has lost its architectural nerve in recent years, afraid to take the kind of risks that made it for more than a century a renowned center of innovation.

That concerns us all, not only because architecture is the art with which we live, but also because no other art so vividly expresses what Chicago is and where it is going—whether we build solely to raise the bottom line or also to elevate the spirit, whether our aspirations soar or we're simply content to muddle through.

Undoubtedly, Gehry's design will strike some observers as a mere shrunken version of his hugely popular Guggenheim Museum in Bilbao, Spain, a two-year-old art museum that, depending on one's perspective, resembles either a metallic flower or a crumpled spaceship.

Yet this isn't "2001: An Architectural Odyssey," where the story ends with a futuristic object plummeting from the sky into Grant Park. For Gehry has shaped his plan with great sensitivity to its surroundings.

The focal point of his design, which will form the centerpiece of the $230 million Lakefront Millennium Park now being built in Grant Park's northwest corner, is a band shell topped by curling ribbons of stainless steel. Already, they have invited comparisons with shaved wisps of chocolate atop a cake or Betty Boop's eyelashes.

Immediately south of the band shell will be something new for Gehry—an airy steel trellis, open to the sky and likely to be painted silver. It will vault over both permanent seating for 4,000 and an oval-shaped lawn with room for another 7,000. Much of the seating will be in a sloping bowl that allows for good sight lines.

THE NEW BAND SHELL FOR MILLENNIUM PARK: Ribbons of steel, reams of creativity.

The $15 million facility is to host concerts of the Grant Park Symphony Orchestra, as well as small and medium-size summer festivals, now held at Grant Park's Petrillo band shell. Other activities are planned year-round. The opening date: spring 2001.

Gehry's design is as much sculpture as it is architecture. And, in that sense, it recalls the famous Picasso sculpture in Daley Plaza, that enigmatic head of rusting steel that suggests the artist's drawings of his wife and his Afghan hound.

Just as Picasso was the world's foremost sculptor in 1967, when the late Mayor Richard J. Daley presented the artist's creation to a mostly baffled public, so Gehry is today's top architect-sculptor, and Mayor Richard M. Daley is ready to reap the rewards. They are not just about cultural prestige, but the tourist dollars that come from having a must-see trophy building in your town.

Yet, in the end, Gehry's design is about art rather than commerce, music instead of money. To his considerable credit, the 70-year-old architect started his design process not with eyes, but with ears. He has spent three decades fiddling with the acoustics at the Hollywood Bowl and his output includes a long-delayed concert hall for the Los Angeles Philharmonic. So he knows that, above all, sound matters.

In that vein, his band shell—its steel ribbons projecting above and around

the stage—will project music into the audience, much like a cupped hand. Loudspeakers will hang from the trellis, promising that the listener at the back of the lawn will hear nearly as well as someone sitting third-row center.

To be sure, there are legitimate questions about Gehry's mountain of metal, which, everyone should remember, remains a preliminary design. Will it whistle—or worse, rattle—in the wind? Will his wispy steel ribbons be able to withstand the fierce gusts blowing off Lake Michigan? Will they become encrusted with snow and ice?

These issues, and many others, must be dealt with before this dazzling concept is translated into a finished masterpiece. But that should stop no one from appreciating the extraordinary merits of Gehry's plan, both urban and architectural, and what they mean for Chicago's design scene.

The band shell seems destined to become an instant landmark, the close of the century's answer to Buckingham Fountain, which began spurting in 1927 and was the product of an America that still looked to Europe, specifically to Paris, for its aesthetic models. No more, dude, says this design, which was hatched in Gehry's Santa Monica, California, office near the surfing beaches of the Pacific.

Like the fountain's jet of water shooting into the sky, the band shell's ribbons of steel are elegant and exuberant, festive and fun. Yet they are unmistakably of our time and, even more important, they are comparatively restrained—sizable enough to make a statement amid the vast scale of Grant Park, but not so big that they threaten to dominate.

We undoubtedly will be hearing from skeptics who would shear off these steel curls, arguing that they are a mere frill. Yet the ribbons truly are functional if it's understood that the band shell is a sculpture that exists to delight not only concertgoers, but also those using the park at other times.

Gehry's trellis—which will consist of rounded steel pipes that will form a lattice 600 feet long, 300 feet wide and 60 feet high—is an equally fine blend of logic and intuition, strength and delicacy. If detailed properly, it could be this project's tour de force.

The trellis represents a thoughtful step beyond the mindless custom of putting a bunch of poles in the middle of a field, hanging speakers on them, and calling this visual mess "an outdoor performance venue." In addition, its exposed steel structure pays homage to the Chicago tradition of forthrightly expressing a building's structural frame, a trait most evident in the powerful X-braces of the John Hancock Center. But there's a twist, literally.

Even as Gehry tips his hat to Chicago's maestros of metal, he's making steel sing his tune. In both the band shell and the trellis, it's curvy rather than right-angled, dynamic rather than static.

Best of all, his design respects the natural world of Grant Park as well

as the skyscrapers that flank the park. A trellis suggests greenery and those ribbons of steel evoke leaves—or, as Gehry says, the petals of a flower. Maybe that's why Daley, the great beautifier, didn't feel the need to ask the architect to plant some petunias.

Of course, Gehry's design can't be looked at in isolation. It is simply one part of the new Lakefront Millennium Park, which seemed anything but millennial in spirit when the park's principal architects, the Chicago office of Skidmore, Owings & Merrill, presented their old-fashioned Beaux-Arts plan last year. Gehry wasn't added to the mix until last April, when the Pritzker family gave the city a $15 million gift to underwrite his design.

Pairing a radical, heavy-metal guy like Gehry with a conservative shop like Skidmore was a little like asking Wolfgang Amadeus Mozart and Jimi Hendrix to play a duet. But Gehry is proving that he's no prima donna who only wants to do solo turns.

Grant Park, you see, is divided into a series of "rooms," rectangle-shaped, outdoor spaces framed by the trees around them. Skidmore's design rather slavishly continues this pattern, but Gehry plays with it, using the oval-shaped "Great Lawn" that Skidmore laid out as the basis for his oval trellis. Here, Gehry seems to be saying, is another kind of room, one where you can listen to music and look up at the stars—or, because most of the lawn will be flat, throw a Frisbee and have a picnic lunch.

The round, stainless steel–clad columns at the perimeter of the trellis certainly are a gesture of goodwill to the classical columns in Skidmore's plan. Although, as Skidmore architect Adrian Smith warns, the stainless steel may wind up covered in fingerprints, there is, here, the beginning of a genuine aesthetic dialogue.

The broader value of Gehry's band shell has less to do with Grant Park than with opening the door to risk-taking architecture—a door Daley and his underlings have slammed shut on local talent.

The mayor's streets, bridges, and other infrastructure deserve praise for the attention they pay to design, but overall they've been conservative, looking as if they were built at the turn of the century—the last century. So Gehry promises to inject pizzazz into Daley's public works. He can be a catalyst for creativity, not just another imported superstar.

That is the surprise hidden in his shimmering metal wrapper.

Postscript

Gehry altered his design to stay on budget, simplifying some of the band shell's original complex curves and making them more angular. Yet his strongly sculptural forms remained intact. The architect even added a third element to the band shell and trellis combination, a snaking, stainless steel–clad pedestrian

bridge. It will cross Columbus Drive, linking Lakefront Millennium Park with another section of Grant Park, Daley Bicentennial Plaza, to its east.

Owing to a series of delays and cost overruns plaguing the construction of Millennium Park, the scheduled completion date for the band shell was pushed back to July 2003. City officials say the bridge will be finished in 2003 or 2004.

Eisenman's Aronoff Center in Cincinnati
For a Design to Stand the Test of Time, the Building Must Do the Same
MARCH 19, 2000

Utter the phrase "social responsibility" in the company of architects these days and the talk usually turns to housing for the poor. But because architecture is the inescapable art, there's another, much broader way to define social responsibility: buildings ought to last. They are not supposed to fall apart. They have to be able to take whatever pounding their users deliver. Or they have to be so beautiful or dignified that they all but insist that people treat them well.

The issue strikes a strong chord today as fast-buck developers squeeze as much profit as they can out of the current building boom and as dot-com companies set up shop in offices they expect to last no more than a few years. But in reality, it's as old as humanity.

Buildings, the Roman architect and author Vitruvius once wrote, should exhibit the qualities of firmness (solid construction), commodity (usefulness and convenience), and delight (giving pleasure and enjoyment). It's telling that firmness goes first in that triumvirate. Without it, there can be little in the way of commodity and delight.

All this came to mind during a recent visit to the University of Cincinnati, which has been importing star architects to improve the quality of student life and, not incidentally, to get media attention.

Certainly its most attention-getting building is the Aronoff Center for Design and Art, a highly unconventional building that made one very splashy debut in 1996. The center was designed by New York City architect Peter Eisenman, a brilliant thinker who only recently has had the chance to transform his ideas into large-scale commissions.

Television host Charlie Rose made a public-television program about it. Noted architects like Richard Meier and Michael Graves flocked to Cincinnati to be part of a symposium about it. The dean of American architects, Philip Johnson, suggested that it had "no equal in American architecture."

Some skeptics raised red flags at the time. Chicago's Stanley Tigerman,

THE ARONOFF CENTER FOR DESIGN AND ART: Where attention-getting form matters more than enduring quality.

a longtime friend of Eisenman's, predicted that the Aronoff Center, home of the university's College of Design, Architecture, Art, and Planning, would not wear well because it had been constructed of inexpensive materials. Such concerns were brushed aside, however, by those who were dazzled by the building's sharply angled form, which made it appear that the Aronoff Center had been shaken by an earthquake.

Now, just four years later, it is possible to glimpse the first signs that those warnings are coming true, especially in the Aronoff Center's much-photographed entry plaza. Fist-size holes have been gouged into its ground-floor cement stucco walls. Graffiti mars the facade. The plaza is stark and un-inviting, a *Blade Runner* landscape that adds to our sense of chaos rather than creating an oasis of civility. "We're having a lot of problems with kids in that area," acknowledges campus architect Ronald Kull, lamenting an influx of skateboarders. "All the edges are getting worn in the seating area."

To be sure, the Aronoff Center's interior, which has a multilevel con-course that is as spatially intriguing as a winding medieval street, appears to be holding up well. In addition, let's give Eisenman a break—campus buildings are notorious for getting beaten up.

Even allowing for unruly behavior, however, what's happened to the Aronoff Center is deeply troubling. This is a building that is supposed to teach by example. But its lessons appear to have very little to do with

Vitruvius and his celebration of solid construction. Instead, it seems to say, "Eye-catching forms matter more than durable materials. Being provocative outweighs building well."

It's tempting to label this stance an inevitable outcome of Eisenman's penchant for deconstructivism, an approach to design that warps and skews orthodox, right-angled geometries. After all, iconoclastic form-making isn't cheap. Tilting walls can be budget busters. An easier course, for both architects and contractors, is the "dumb box," a simple structure that allows for rich detailing and materials.

Yet the University of Cincinnati campus has another striking building that discourages a quick dismissal of deconstructivism as decadent, irresponsible design. A few blocks to the east of the Aronoff Center is Frank Gehry's new Vontz Center for Molecular Studies, whose curving exterior walls seem to twist and bend. Even more than the Aronoff Center, it resembles a piece of sculpture.

There's an important difference between the two, however: Gehry has designed a building that seems far more likely than Eisenman's to endure. That is not just because its chief occupants will be scientists, but because it is covered in an inherently durable material—brick.

The reddish-pink brick has other advantages. It makes Gehry's strange play of geometries somehow seem at home in Cincinnati, where brick is the material of choice for many of the houses that hug the city's hillsides. In contrast, Eisenman's building seems out of place on its hilltop site, its pinks, blues, and greens looking like something out of a comic book or a computer screen.

That points to an underlying problem with the Aronoff Center: while it must have made a stunning image on some draftsman's computer screen, it shows how tough it is for architects to translate concepts from the two-dimensional world of cyberspace into the three-dimensional world of real space.

With more and more buildings being designed on the computer, and with more and more clients interested not in building for the ages but for the next fiscal quarter, the challenge for our time is to construct buildings that are rich in both ideas and materials. Not every building can be draped in marble and granite, of course. But whatever architecture is made of, it needs to endure to be socially responsible.

Part Three

Architecture as a Social Art

Architecture is not only a fine art. It is a social art. It can isolate or congregate, express the diverse strains of a culture or stifle them, lift the human spirit or crush it. From plazas to schools to stadiums to public-housing projects—for better and, all too often, for worse—Chicago in the 1990s held examples of all of the above.

The city's public spaces and public buildings generally fared well in the prosperous decade, their resurgence especially evident in two projects. One was the renovation of the city's unofficial town square, the Richard J. Daley Plaza. The other was the conversion of a North Side library into a kind of indoor town square that became the new home of the Old Town School of Folk Music. In both cases, architects were up to the creative challenge of reinventing the old while respecting original designs.

The cause of public space also got a boost when Chicago business leaders borrowed a seemingly unlikely idea from Zurich, Switzerland—putting hundreds of fiberglass cows on city streets. The ensuing success of the Cows on Parade public art exhibit proved that, even in the age of the Internet, the city's ancient role as a place for coming together remained very much alive.

THE RENOVATED DALEY PLAZA: Humanizing Chicago's great gathering place.

PLACES AND CATALYSTS FOR GATHERING

Town Square I

Face Lift Improves Daley Plaza and Maintains Its Special Character

AUGUST 26, 1996

Barefoot children wade into the splashing fountain and slide down the Picasso sculpture. Lawyers, briefcases in one hand, yak into cellular phones held by the other. Brown baggers munch their lunches or pretend to read a book. Old folks sit on folding chairs and take in a lunchtime concert, while young couples nuzzle, as if they were alone in a living room.

They are in a living room of sorts, but it belongs to everyone in Chicago; the plaza at the Richard J. Daley Center is an outdoor room framed by the walls of the buildings around it. Daley Plaza is quintessential Chicago—hard-edged, action-packed and, now, handsomely renovated.

After an $8.6 million revamp, one of several spruce-up projects completed in time for the Democratic National Convention, the plaza has emerged more people-friendly than ever while losing none of the bold beauty that makes it one of Chicago's great public places.

The alterations have been carried out with such subtlety and respect for the minimalist original design that some plazagoers haven't even noticed them. That is, ironically, a high compliment to those responsible for the job: Chicago architect Howard Decker, Chicago landscape architect Peter Schaudt, and their client, the Public Building Commission of Chicago, the state-chartered agency that is the Daley Center's landlord.

One of the most difficult feats in redesigning a familiar building or urban space is to improve it, while making the new version seem as if it had been there from the beginning. Thankfully, that is precisely what hap-

pened here. Indeed, what wasn't done to Daley Plaza is every bit as important as what was done to it.

The plaza's vast open space, which provides the perfect setting for public programs, political protests, and mass celebrations, hasn't been planted with a forest of evergreens, as some feared tree-loving Mayor Richard M. Daley would insist. Views of the Picasso haven't been blocked. Nor has the plaza been gussied up with gaudy, umbrella-topped cafe tables or a fountain with jets of water that jump cutely through the air. Those features are fine elsewhere in the city, but they would have been grossly out of place in a civic space that, while lively on the surface, possesses tremendous underlying dignity.

Ostensibly, the 31-year-old plaza needed to be fixed because scores of its one-and-a-half-inch-thick granite slabs had cracked over the years. When three Chicago architectural firms—C. F. Murphy Associates; Skidmore, Owings & Merrill; and Loebl, Schlossman & Bennett—designed the plaza and its muscular courts building in the early 1960s, they did not foresee that trucks and other heavyweight vehicles would be rumbling over it during events. As a result, rainwater leaked on the subterranean Cook County offices directly beneath the plaza and the cracks had to be patched with unsightly concrete.

Seeking a New Look

But the scope of the renovation went beyond repair. Daley wanted more greenery, reflecting a popular view that the plaza—bounded by Randolph Street on the north, Washington Street on the south, Dearborn Street on the east, and Clark Street on the west—was stark and unwelcoming. Seating was to be added, too, in part because several North Loop towers had risen in the wake of the Daley Center's completion, and the plaza had the opportunity to become a haven for office workers and others looking for a place to sit.

All well and good, but how does one remake an icon? And where would new granite for the plaza come from? A most unlikely source, it turns out: the overhead outdoor walkways at the University of Illinois at Chicago. That heavy-handed Brutalist campus was finished in 1965, the same year as the Daley complex (originally known as the Chicago Civic Center and renamed for Mayor Richard J. Daley after his death in 1976). By chance, the walkway's huge granite slabs had been extracted from the same Minnesota quarry as Daley Plaza's—and at precisely the same time.

A builder's dream! After the core of the campus was taken apart to make way for a human-scaled plaza introduced last year, a contractor carted away the walkway slabs and warehoused them. So a relatively inexpensive supply of granite was ready—and it gave a team headed by Chicago's Walsh Construction Co., which included the firm that had removed the granite, a leg

up in bidding on the job. When Walsh got it, the granite was sliced like bread into fresh three-inch-thick slabs. Then, in an astonishing bit of architectural recycling, it was laid over a new, waterproof membrane, as though it always had been meant to be on Daley Plaza.

And that's the way it looks today. Flecked with black, white, and pink, just like the original, and with the same flat finish, the granite resembles an exquisite flannel-gray carpet—perfectly furnishing the plaza's outdoor living room and providing just the right understated counterpoint to the courts building's assertive Cor-Ten steel cladding.

That it comes off so well is no accident. Decker, a partner in the Chicago firm of DLK Architecture, spoke at length with Jacques Brownson, the Daley Center's chief designer, who now lives in Colorado. Such deference is all too rare in the ego-driven world of design, and it surely enabled Decker, who prefers a traditional architectural language, to speak in a crisp modernist idiom here. A critical, but almost invisible, example of his shift: expensive bronze edge rails that ring the plaza's planters. Without them, the planters would look shabby.

Yet Decker has not approached the plaza meekly; he has thoughtfully reconfigured it, though always in concert with Brownson's intent. An eternal flame honoring fallen war veterans has been moved from the plaza's south side, where it cluttered the open space for public events, to the east side, where it is more at home with fixed elements such as the Picasso. The fountain near the plaza's southwest corner has more nozzles than before—a seemingly minor detail that lets its "white noise" wash out the sounds of passing vehicles more effectively and helps render the plaza an oasis for those who wish to use it that way.

The best urban spaces always present the people who use them with choices—they are, in a sense, multipurpose rooms that offer intimate nooks and crannies as well as wide-open gathering spots. By acting as a transparent wall that separates the plaza's big public space from small-scaled seating areas, the fountain creates the illusion of rooms within a room—in which entirely different kinds of activities can go on simultaneously without disturbing each other.

Meanwhile, in matters arboreal, the art of compromise has preserved the plaza's artfulness. Handing Daley a victory of sorts, the design increases the number of trees on the plaza sixfold, to twenty from the original three. But where it counts—in the plaza proper, to the south of the courts building—there are only six trees. The rest are in granite-clad planters to its north.

The remaining six trees—all honey locusts, a species prized by architects for its elegant wispiness and the one used here in 1965—manage at once to retain the plaza's openness and to increase its intimacy. That is due entirely to

their location. Just one of them sits near the Picasso, as in Brownson's design, keeping that end of the plaza clear of clutter. The other five are set in a pair of planters on the plaza's southwest side, where they are grouped in minigroves so their branches extend outward like canopies.

It is a promising landscape—still a bit thin, as most new landscapes are, but an attractive stylized representation of a tall-grass prairie, which includes ornamental grasses. Its earth-toned palette relates well to the russet-colored Daley Center.

A Smart Redesign

To be sure, this is not a perfect job. The new honey locusts lack the visual poetry of the old ones, whose gnarled branches made them resemble trees in a Japanese screen painting. The planters and ginkgo trees on the north side of the Daley Center may disappoint purists who feel they disturb the plaza's uninterrupted flow of space. And, of course, through no fault of the designers, the eastern border of the plaza remains "wall-less" because of the vacant Block 37 across from Marshall Field's State Street store.

But those are quibbles; the revamp has been carried out with a deft hand and a searching intelligence. It springs from the enlightened notion that postwar modernism is now part of history, and that its masterpieces deserve to be treated with as much respect as the Beaux-Arts office buildings of Daniel Burnham or the Prairie School houses of Frank Lloyd Wright.

Seeing their task in terms of evolution, not revolution, Decker and Schaudt did not try to radically remake the plaza; they simply made it better. Their achievement is worth celebrating. Chicago's living room remains true to itself, while demonstrating that architecture is an art for living.

Postscript

Because planned granite benches turned out to be too costly, less expensive, umbrella-topped tables were placed on the east side of Daley Plaza in 1997. Fortunately, they were sleekly modern, so they did not have a disruptive, carnival-like effect. Instead, they made the plaza more people-friendly without compromising its singular style.

Town Square II
Folk Music School's New Home Strikes the Right Note

DECEMBER 22, 1998

There's a built-in drawback to theaters: when there's no performance, the theaters—and the sidewalks around them—typically go dead. It's the

THE OLD TOWN SCHOOL OF FOLK MUSIC: Giving new meaning to the theater's old identity as social center.

same problem cities face with football stadiums that get used only a dozen times a year or megasized convention centers that occasionally pulse with activity but otherwise are urban black holes. How to make them come alive 365 days a year?

An intriguing answer has taken shape on Chicago's Northwest Side. On a given day at the new home of the Old Town School of Folk Music, the 425-seat concert hall might play host to a music teacher and a student sharing a cup of coffee, or two friends having an intimate conversation, or 100 would-be Woody Guthries strumming their guitars at an evening class.

It's a new variation on an old theme—the theater as a social center, town square, cabaret. Best of all, it sings visually, a model of transforming old buildings to new uses.

Officially known as the Chicago Folk Center and located at 4544 North Lincoln Avenue in the former Frederick H. Hild Regional Library, the building is described as the largest facility in the nation dedicated to the performance and preservation of folk music. That makes it sound imposing, even intimidating, as if somebody had built a folk-music version of Orchestra Hall. A visit reveals otherwise.

While the renovated library is much larger than Old Town's old quarters, a storefront at 909 West Armitage Avenue that remains open as a children's music center, it manages to be intimate as well as grand, as familiar as an old folk song and as fresh as a newly written melody.

The more time you spend there, the more you see it's really a democratic version of the old, aristocratic opera halls of Europe, where people ate, drank, and flirted. Here, they just do it in blue jeans.

The principal credit for this handsome, $7 million job goes to the young Chicago firm of Wheeler Kearns Architects, which had overall responsibility; Morris Architects/Planners, also of Chicago, which imaginatively handled the folk center's concert hall; and the City of Chicago, which performed capably in rehabbing the building's exterior.

The team was lucky to be working on this stretch of Lincoln Avenue, which hasn't been gussied up with Mayor Richard M. Daley's faux historic street lamps or other decorative touches. It's still a slice of the real city, not a sanitized version, with three bars, two soccer clubs, and a pair of especially distinguished architectural neighbors.

A block north of the folk center is the intricately ornamented Krause Music Store, the great Louis Sullivan's last commission. One block south is the Conrad Sulzer Regional Library by Thomas Beeby, a proud but inviting postmodern landmark. It replaced the Hild library in 1986, opening the way for an architectural recycling of the building.

Adapting old structures to new uses is fraught with aesthetic risk. Think of the soaring church interiors that have been chopped up into yuppie lofts: the building is saved, but its spirit is destroyed.

Fortunately, that didn't happen here. Indeed, it seems as if the folk center was meant to be in the old library, a minor gem with a simple but powerful Art Deco front facing Lincoln and a modestly scaled back along a quiet residential street lined with frame houses.

One of the best things about the renovation is that it doesn't try to paper over this terrific little building, the lone major Chicago commission of the little-known architect Pierre Blouke. Instead, colorful Old Town banners and

signs have been added to the library's facade, matter-of-factly layering one generation of history atop another. The lone misstep is a klutzy, flashing electric sign, a donation that Old Town, unfortunately, did not refuse.

Step inside the library's old, high-ceilinged entry hall and you instantly feel welcome; instead of a cool, corporate receptionist's desk, there's an old wood table, flanked by chalk boards that convey messages to students and concertgoers. The scale of the entry hall is civic, but the furnishings are domestic, homey and handmade rather than machined—the right note to strike at a school devoted to the down-to-earth art of folk music.

Directly ahead, hollowed out of the lobby's back wall, is a big rectangle that opens like a huge window to the music hall's stage and, behind it, to the two-tiered hall itself. It's a wonderful spatial trick, giving the visitor the vicarious sensation of being part of the show.

Once you step into the music hall, the rectangular cutout (which is closed with a sliding door during performances) allows you to look back through the lobby and sense the presence of people and cars outside. That feature subtly recalls the storefront identity of Old Town's former home and reinforces the new building's connection to the city. Nothing could be more different from a typical "black box" theater.

The hall is linked to its surroundings through how it's used as well. It's arranged like a cabaret, with movable tables and chairs set both in front and in back of the fixed seats. A little cafe is strategically placed outside the hall, giving students the perfect excuse to wander in and schmooze. The happy result: the social activity of the sidewalk isn't held at bay; the theater simply lets it filter in.

What is truly remarkable about the hall, however, is that it manages to look as if it was always there, even though, of course, it wasn't. In part, that impression arises from the way the hall's mustard-yellow and brick-red walls take their cues from a restored Works Progress Administration mural, a vestige from the old library, that stretches above the new proscenium arch. But it also comes from an elegant structural arrangement that is invisible to the visitor.

In the old library, which was shaped like half a drum, radiating book stacks supported the roof. Now, the roof is suspended from two new steel beams that extend higher than the rest of the building. Bolts reach down from these beams to the roof, grasping it like fingers gripping a circus trapeze. Steel trusses extending inward from the hall's round back wall enable the balcony to cantilever close to the stage. The room has a strong architectural presence, but the architecture never overwhelms the activity it contains.

Two raked floors—there are 275 seats on the main floor, 150 in the balcony—provide excellent sight lines and improve upon Old Town's for-

mer concert hall, where flat floors can make viewing difficult. No seat is more than 45 feet from the stage, which allows concertgoers to glimpse the facial expressions of the artists. And judging from the music made at a recent guitar class, the acoustics—which take amplification into account—are well handled.

Although its narrow exit areas can cause traffic jams at concert intermissions, the hall still ranks as one Chicago's finest recent reuses of an existing interior. Other parts of the building maintain the same level of design, though it must be noted that parking is almost as inconvenient as at Old Town's former home.

Among the highlights: the "Different Strummer" music store, where rows of guitars hung on the wall create pleasing visual rhythms, and a loftlike gallery in the library's former print shop, which is used for everything from dance classes to art exhibitions.

At night, the gallery and classrooms along the building's perimeter glow with light, projecting a feeling of activity and transforming the sidewalk into an impromptu theater. The students in the rooms are on stage, the passersby on the sidewalk are the audience, and admission is free. The public realm of the street seems vital, energized.

Here, reversing the identity of the theater as urban dead zone, both an old building and the city around it brim with new life.

Postscript

Easing its perennial parking crunch, the Old Town School of Folk Music joined with the City of Chicago and opened a 115-space surface parking lot across Lincoln Avenue from the former Hild Regional Library in 1999. The lot was given the Daley beautification treatment, its borders defined by imitation wrought-iron fencing.

Moo-ving Tale

Cows Broke Down the Fences that Keep Us Apart

NOVEMBER 3, 1999

May I make a confession? I'm going to miss the cows.

Yes, I know. I'm not supposed to like them. Too many of them are commercials for their sponsors. And too few of them, very few, have much to do with art.

But for anyone who cares about public spaces and what they say about America, the soon-to-close Cows on Parade exhibit has been a joy

THE COWS ON PARADE EXHIBIT: A playful reminder that cities are still the place to be.

to behold. It brought thousands of people, including suburbanites who hadn't been to Chicago for years, back to city streets. It got people excited about public art instead of annoyed at it. And it revealed how cities around the nation are turning to an often controversial remedy, tourism, to heal what once ailed them.

Back in the 1980s, assorted doomsayers were asking the last urban dweller to please turn out the lights. After all, shiny new office buildings were popping up like mushrooms on the suburban fringe. And why have dense clusters of skyscrapers, anyway, if the World Wide Web was going to bring everybody together in one big chat room?

As usual, the experts were wrong. That ought to be plain to anyone who has seen Chicagoans and visitors ogling the cows, petting the cows, posing for pictures with the cows and, best of all, talking to one another—total strangers, no less—about the cows. These are the very same folks who supposedly were so terrified of big cities and the people in them that they were barricading themselves in gated subdivisions.

Yet something funny happened on the way down the cul-de-sac: to people in the suburbs, the cities they'd left behind became distant and alluring—"urban exotica," in the words of Saskia Sassen, a sociology professor at the University of Chicago. And what could be more exotic than

300-plus fiberglass bovines gallivanting along the sidewalks, as if Chicago had been transformed into a neater, cleaner version of Calcutta, where sacred cows roam the streets?

In a city of right-angled streets and buildings that seem dressed in black tie, the cows were refreshingly curvy and colorful. If the architecture in Chicago is tough and almost too serious for its own good, the cows injected a welcome note of softness and playfulness.

They were different, too, from what we are used to seeing in public art. The cows were small and easy to touch, not monumental and out of reach like the classical sculpture of the hero on horseback. They were accessible rather than esoteric, welcoming rather than confrontational—the very opposite of Richard Serra's *Tilted Arc*, the menacing 120-foot-long hunk of rusting steel that blocked the path of pedestrians in Manhattan's Federal Plaza before being removed in 1987.

True, when taken one by one, the cows tended to look like Public Art Lite—a red-and-white striped cow plopped in front of the red-and-white striped awning of a candy store, for example. But when seen together, they were an entirely different animal—one that proved superbly equipped to enliven the shared spaces of a city known as "the public realm."

With scores of cows laid out along the streets, the Cows on Parade exhibit really was like watching a parade. Except, of course, the cows didn't budge. We were the ones who moved past their alluring array of colors, textures, and patterns—in one stretch alone, a cow in a leather jacket, a cow on skis, a cow jumping over the moon. When we stopped to look, the cows broke down barriers by doing what art does best—lifting us beyond the everyday. They enabled people who normally would zip by each other on the sidewalk to pause, look, drop their guard, and maybe even chat.

This seems like a small thing, but life is an assemblage of small things. This one explains why there's still enormous appeal to visiting the old village square—even as the Internet brings us closer to the ideal of the global village. "People come into the city to find something you can't find even in the most extraordinary suburb—the old architecture, streetscapes and crowding," said University of Missouri political science professor Dennis Judd, coeditor of a new book titled *The Tourist City*.

Crowding, especially, matters. We live in a fragmented metropolis where the family from the suburbs rarely comes face-to-face with the family from the inner city. By allowing people from disparate walks of life to rub shoulders, events like the cow exhibit help stitch together the fraying social fabric.

And, of course, they boost the local economy—in the case of the cows, by somewhere between $100 million and $200 million, according to official estimates.

So does all that mean we should have one of these exhibits every year? People already are talking about the city's next animal act. How about pigs? Bears? Or maybe buzzards, the latter to represent all the crooked aldermen who've been sent to the slammer?

Yet Chicago, I hope, will resist the temptation to try to duplicate the overwhelming success of the cows. Not only will it be hard to repeat the spontaneous outpouring of affection they inspired, but also there's reason to be cautious about the rising influence of tourism on the urban landscape.

The trend has led many cities, including Chicago, to become theme-park versions of themselves, as in the 1993 debut of the now-closed Capone's Chicago. *Tribune* columnist Mary Schmich memorably opined at the time that this tourist trap had turned a cold-blooded killer into your sweet, chipmunk-cheeked Uncle Al. The trend has continued this year with the opening of the new Disney Store on North Michigan Avenue, its facade a grotesque parody of Louis Sullivan's nature-inspired ornament.

Would-be cow towns also should think twice about following Chicago's lead if they lack this city's rich assortment of architecture, culture, and handsomely refurbished streets, like North Michigan Avenue.

Could Cows on Parade have been a hit in bedraggled downtown Detroit? I doubt it. Still, as the cows have shown, the tourist boom is more boon than bane for cities. Cynics may sneer that the exhibit was nothing more than a boosterish scheme to jack up hotel revenues and store sales. But they should be reminded that the marketplace and public space have long been synonymous.

Generating traffic for merchants doesn't cancel out the experience of people who were dazzled by the glitter of the rhinestone cow, or stuck their arms through the Swiss cheeselike "Holy Cow," or fiddled with the miniature yellow construction crane on the back of the "Cow Udder Construction."

I won't miss the endless cow puns. Yet I will miss the cows, especially for what they symbolized: Americans who once fled cities are venturing back, ready to partake of the pleasures of urban life—and of each other.

Postscript

Undoubtedly motivated by the prospect of raking in millions of tourist dollars, many other U.S. cities in 2000 imitated Chicago's Cows on Parade. Cincinnati, once known as "Porkopolis" for its hog slaughterhouses,

adorned its downtown sidewalks with fiberglass versions of pigs. In horse country, Lexington, Kentucky displayed fiberglass thoroughbreds. Even New York City, which prides itself on not being a cow town, unleashed scores of fiberglass bovines on the sidewalks, though its cow parade turned out to be far less popular than Chicago's. Perhaps it would have been more appropriate if New York's animal art festival had been an homage to its most famous creature—the rat.

Chicago, meanwhile, launched a summer 2001 sequel to Cows on Parade, putting hundreds of pieces of furniture-turned-art—including sofas, chairs, and ottomans—onto its sidewalks. In contrast to the cows, which were imported from Zurich, this idea was homegrown. The public art display was called "Suite Home Chicago," in part because the city once was a national furniture center.

RAISING AND RAZING
TEMPLES OF SPORT

Chicago began the 1990s with four of the nation's oldest and most treasured stadiums—places that magnified the exploits of stars named Jordan, Hull, Banks, and Fisk while serving as great equalizers between fans whose collars were white or blue. When the decade was done, it had just two, Wrigley Field and Soldier Field.

On the South Side, old Comiskey Park disappeared for a newcomer that borrowed its name but failed to recreate its urban character or its intimacy. On the West Side, the Chicago Stadium, the fabled "Madhouse on Madison Street," was torn down for the United Center, which exemplified the transformation of once-simple sports facilities, where the game had been all that mattered, into glitzy, mini–theme parks.

The blunders were all the more galling because teams in other cities—facing the same need to build revenue-generating facilities to keep up with skyrocketing player salaries—built stadiums that were far more responsive to their settings and their fans. Ironically, those stadiums were designed by the very same architects who had performed so poorly in Chicago.

Comiskey Park

New Neighbor Not Necessarily New Friend

JUNE 26, 1991

New Comiskey Park is big and brawny, like many of the highly paid athletes who play in it. But will this building ever be beloved?

Don't bet on it.

Sure, the White Sox are the American League's second-best draw this year (the Toronto Blue Jays rank first). And, yes, Comiskey has an exploding scoreboard, handsome arches, and other features designed to make it a new-age park with old-time charm. But wait until the novelty wears off. And wait 'til next year, when the new Camden Yards ballpark opens in Baltimore.

Now under construction, the Baltimore park was shaped by the same architects who cranked out Comiskey. It's likely to become what Comiskey can only claim to be: a modern stadium that has the grace of an old ballpark—a cozy, intimate place that draws both its contours and its energy from the city around it.

Make no mistake: Comiskey is a big improvement on the dreary, multipurpose stadiums that went up in the 1960s, kin to the steel and glass skyscrapers that make Houston indistinguishable from Hartford. The new park has natural grass, wide concourses, spacious locker rooms, some tremendous lower-deck seats, and a spot where children can get their pictures taken for their very own baseball card.

And if it were in Miami or Denver, that might be good enough.

But this is Chicago, where mankind invented the skyscraper, Frank Lloyd Wright walked the streets, and a trip to the ballpark isn't supposed to feel like a drive to the shopping mall. Yet that's what the soul of this new baseball machine is all about. As if to prove the point, the Sox are going to put up a parking lot across 35th Street. That's where old Comiskey is unceremoniously being ripped apart.

The old ballpark wasn't pretty, but when you plopped down in one of its green wooden seats, you felt close enough to the field that you could reach out and touch home plate, smell the turf, and hear what was going on when the catcher, pitcher, and manager conferred on the mound.

And you knew you couldn't be anywhere else.

Babe Ruth swatted home runs in old Comiskey, legend has it, after quaffing between-inning beers at McCuddy's bar on 35th Street. The Black Sox threw the World Series there. Baseball's first All-Star Game was played there. Greg Luzinski and Ron Kittle hit "roofers" there. Even better, the outfield arches of old Comiskey opened the inside of the park to

COMISKEY PARK: The last of the soulless suburban stadiums, bereft of character.

the city around it, leaving no doubt you were watching a baseball game at 35th and Shields Avenue.

A Field of Dreams? Not quite. Designed by Chicago architect Zachary Taylor Davis (whose credits include Wrigley Field) and opened in 1910, old Comiskey was as tough and tart as a Chicago cop. Sure, it had postage-stamp-sized locker rooms and columns that blocked the views of a couple of thousand seats. But those columns and the overhanging roof broke down the vast spaces of the park, giving it an intimacy shared today only by Wrigley Field and Boston's Fenway Park. That intimacy is one quality the architects—the Hellmuth, Obata & Kassabaum (HOK) Sports Facilities Group of Kansas City—sought to re-create in new Comiskey.

Before evaluating what they've done, it's worth recalling how Illinois taxpayers came to spend nearly $135 million on a new stadium that's across the street from the old one and has only a few more seats (44,177 versus 43,951 for old Comiskey).

With Sox owners Jerry Reinsdorf and Eddie Einhorn threatening to move the team to St. Petersburg, Florida, the Illinois General Assembly passed a $150 million Save-Our-Sox bill as the clock struck midnight on June 30, 1988. The new stadium opened on April 18, 1991—on time, more than $2 million below budget, and with HOK architect Rick deFlon declaring he had followed this charge from the Sox: "Don't turn your back on the old Comiskey."

At first glance, deFlon seems to have succeeded. The precast concrete arches of new Comiskey recall the arches of the old park and reprise the original reddish-brown color of its brick facade (which was painted white before the 1960 season).

But most of new Comiskey's arches are hidden by clunky, switchback ramps that were slapped onto the facade with little regard for its architectural comeliness. Inexpensive? Yes. Efficient? Absolutely. Beautiful? No way. It's the rough equivalent of building a handsome, postmodern skyscraper in the Loop and gracing the entrance with a concrete parking deck. That ungainliness is compounded by the sparse, almost unfinished appearance of the park's upper deck, where some carefully worked-out architectural details wound up on the drafting-room floor because of a tight budget.

Too bad, because those details would have gone a long way toward visually tying the upper deck with the lower portion of Comiskey, much as the ornamental cornice of a Victorian house links the roofline to the gingerbread below. As built, however, the facade of the new park is a whole that's less than the sum of its conflicting parts. "We did the best we could with the money we had," says deFlon. "What you see is a real building that had the realities of budget and schedule play on it."

Comiskey's tightly constricted site and its immediate surroundings presented the architects with an even tougher challenge. For unlike the friendly confines of Wrigleyville, the area around Sox Park is an urban demilitarized zone separating the wall of public housing on the east side of the Dan Ryan Expressway from working-class Bridgeport to the west. No architect can bridge that tragic gap. But it isn't asking too much for a taxpayer-financed public works project to begin healing the city's wounds.

Instead, deFlon, the Sox, the City of Chicago, and the Illinois Sports Facilities Authority have done little to bring life back to the streets around new Comiskey. The park swims alone in a sea of parking lots, like a suburban shopping mall. Houses in the South Armour Square neighborhood have been torn down because Chicago officials didn't offer the Sox a less disruptive site for Comiskey. And some of the streets in the neighborhood no longer exist.

South of 35th, what was once Shields Avenue is buried under one of the new park's switchback ramps. North of 35th, street-level shops, including McCuddy's (demolished in 1989), should have been included in a pedestrian ramp that leads fan to the stadium. They weren't, deFlon says, because it would have gone beyond the General Assembly's mandate to the Sports Facilities Authority. "Put yourself in the shoes of the guy who has been instructed by the legislature to get a stadium done on time and on budget," he

says. "And then someone says, 'Put retail in the base [of the ramp] and redevelop the neighborhood.' You're going to feel like you've got your hands full."

If there's a street that has some life here, it's inside Comiskey, on the 40-foot-wide main-level concourse that runs around the park and is surrounded by picnic tables, snack shops, and souvenir stands. It's a lively update of the old park, where the smell changed magically as you walked by everything from tacos to kosher dogs.

Yet the real test of a ballpark is how well it lets fans taste the flavor of baseball. It's a game of nuances—the pop of a fastball in the catcher's mitt versus the soft thud of an off-speed pitch—so it thrives on intimacy. It lacks the explosiveness of a Michael Jordan slam-dunk, so its drama needs to be accentuated to captivate the fan.

At Comiskey, as at all modern ballparks, that quality is determined by a series of trade-offs involving everything from the complexities of structural engineering to the need to maximize skybox revenue because of skyrocketing player salaries.

Thus, Comiskey has no obstructing columns, but its upper deck is much higher than at old Comiskey; moving the columns to the back of the lower deck makes the stadium taller. The upper-deck seats also got pushed higher because of the 84 skyboxes, which rent for $55,000 to $90,000 a year and account for 25 percent of total admission revenue, according to club officials.

The Sox tried to balance these trade-offs by instructing deFlon to move most of the seats within the foul poles. The architect positioned each seat by computer and tried to give the park a womblike intimacy by enclosing it and making all the seats one color (blue). It works—at least in the lower deck, the bleachers, and the three skybox levels. All provide glorious vantage points from which to watch the game unfold.

The upper deck is another story. It is canted at a 35-degree angle (compared to 14 degrees in the lower deck) in an attempt to bring fans closer to the action and to compensate for the height of the seats. But it turns out to be anything but fan-friendly.

Combine the upper deck's steep angle with its 29 rows and you have an intimidating seating bowl that resembles a ski jump. Without a roof to provide a sense of enclosure, fans feel as if they're floating up in the clouds. Worst, the first row of seats in the upper deck of new Comiskey actually is farther away from home plate than the last row of seats in old Comiskey's upper deck. After one recent game, a fan sitting in the upper deck said, "My seat was so high that not even the highest fly ball came close to my eye level. It was like looking into a pit."

As bad as the upper deck is, it is simply the most visible symptom of a much deeper problem: new Comiskey has the trappings, but not the spirit, of an old-fashioned ballpark. It cuts itself off from the city and cuts off fans from the game. It may have that exploding scoreboard and other bells and whistles, yet it seems destined to be anything but beloved.

Postscript

New Comiskey was bedeviled by bad timing as much as its bad site and bad clients. It was the last of the soulless suburban stadiums. A new wave of ballparks in Baltimore, Cleveland, and other cities, many of them designed by the HOK Sports Facilities Group, would prove far more sympathetic to their surroundings and far more popular with fans.

Comiskey drew more than 2.9 million fans in its inaugural year of 1991. But by 1999, as complaints about the upper deck mounted, Sox attendance slumped to 1.3 million. In 2000, after years of blaming the team's attendance woes on fan resentment over the 1994 players' strike, White Sox Chairman Jerry Reinsdorf finally conceded that drastic changes had to be made to the stadium and announced a multimillion-dollar renovation project designed to make Comiskey more intimate and exciting. Completed in time for Opening Day 2001, the project resulted in 1,900 new lower deck seats. Some were along the foul lines while others were located in the former "moat" between the outfield fence and what had been the first row of outfield seats. The project also brought in the outfield fences near the foul poles. It wasn't Wrigley, but it certainly was an improvement.

The Stadium

The End Is Near for Chicago's Shrine

MAY 17, 1994

You wish it could end like one of those maudlin old movies, with an 11th-hour phone call from the governor and a reprieve from the executioner. It won't. No matter how long the Bulls extend their playoff run, Chicago's earsplitting temple of sport will get the architectural equivalent of a bullet in the head.

The Chicago Stadium's only crime is that it isn't a printing press that spits out bills in six-figure denominations. No pricey skyboxes or club seats to fill the cashboxes of the Bulls and Blackhawks. You'll find those

THE CHICAGO STADIUM: Even in death, it united fans and players, including former Blackhawk Keith Magnuson.

across West Madison Street at the new United Center and at all those new cater-to-the-rich sports palaces.

The Stadium, which is likely to be demolished in late 1994 or early 1995, is a people's palace. "The man who pays the lowest admission price has as much right to see the show as those who sit at the ringside," said its architect, the late Eric Hall of Chicago, who also designed additions to the nearby Cook County Hospital and the bungalow of one Richard J. Daley at 3536 South Lowe Avenue.

It's fitting that Hall had a hand in both the hospital and the Stadium because each building, in its own way, is about healing—the former through the science of medicine, the latter through the art of escape. The Stadium made people forget their troubles with three-pointers and three-ring circuses, hat tricks and hard rock.

When it opened in 1929, the Stadium was billed as the "world's greatest indoor arena and convention hall," the right blast of hype in a town where the radio stations have call letters that once stood for "World's Greatest Newspaper" (WGN) and "World's Largest Store" (WLS).

The Stadium was built for $7 million by Chicago sports promoter Patrick "Paddy" Harmon, who would die in a car wreck in 1930, with control of the Stadium passing to the present owners, the Wirtz family, in

1933. By virtue of its capacity (more than 25,000 for the largest events) and its proximity to the Loop, the big barn at 1800 West Madison was advertised as the perfect site for conventions, exhibitions, flower shows, concerts, and sports spectacles, including six-day bicycle races.

From the first, then, the Stadium was intended as a gathering place for mass entertainment. And everything about it, from its name to its site to its nobly proportioned exterior and the exquisite sight lines it offers nearly all fans, communicated the message that it was a civic structure—of, by, and for the people—even though the building was, in fact, privately owned.

It's called Chicago Stadium, not Harmon Hall or Wirtz Arena, as though its blueprints had been drawn up in the mayor's office on the fifth floor at City Hall. Because it sits on Madison Street, the dividing line between the North and South Sides, it favors neither part of town, and boosts the bedraggled West Side. Its architecture cleverly appropriates the weighty, neoclassical look of public buildings in Chicago (City Hall, the Cultural Center) and skillfully transforms that style into a simplified Art Deco version of classicism that was au courant in 1929.

In typical Deco fashion, the exterior columns of the block-filling building are flattened out instead of bulging roundly, like the columns at City Hall. Long vertical windows are arranged in groups of three, another signature Deco touch, and hint at the grand space within. Relief sculptures of athletes—shot-putters, discus throwers, sprinters, cyclists, boxers—ring the top of the masonry facade (limestone on the north and south, tan brick on the east and west). Circular medallions above street-level marquees depict wrestlers in full grapple.

Back in the 1940s, when the Near West Side was chock-a-block with three-flats and corner stores, fans might have paused to appreciate these aesthetic flourishes. But in recent decades, confronted by an urban wasteland of public housing and parking lots, they scurried inside, and the Stadium became a drive-in, drive-out sort of place—Wrigley Field without Wrigleyville, a supremely urban building that was approached, then left behind, like a suburban shopping mall.

Yet the exterior is still a temple, the interior a shrine. Why else does the booming Barton Pipe Organ have its own loft, dead-center behind the basket or the hockey goal, as if it were in church? No church, of course, has ever been so boisterous, so joyously packed—at least, when the Blackhawks were skating and the Bulls had a marquee player like Michael Jordan to pull in the crowds.

Architect Hall was no Frank Lloyd Wright, but America's greatest draftsman never shaped an interior that gave so much pleasure to so many. The noisiness of the Stadium, which came to be a sixth man for the Bulls,

an extra skater for the Blackhawks, may have been unintentional. An early promotional brochure bragged about the facility's "splendid acoustical properties." Yet the excellent sight lines arose from talent rather than mere chance.

Hall used steel roof trusses that required no intermediate supports. Steel columns allowed the first and second balconies to overhang the back of the mezzanine, thus bringing the cheap seats as close as possible to the arena floor.

The myth is that there are no obstructed seats at the Stadium, but the people who work the ticket booths in the Madison Street lobby will tell you that the columns and the first balcony overhang cause about 1,000 seats to have partially blocked views. Yet the trade-off for this relatively small number of imperfect seats is, for the vast majority of fans, an extraordinary sense of being on top of the action—even in standing room atop the second balcony.

All theaters give us drama. The Stadium intensifies it. It is a theater that is at once vast and intimate, where even the actors feel compelled to survey the grand sweep that envelops their stage. Like the crowds who watch them, the players want to steal away with memories instead of bricks and mortar.

On the last night that his St. Louis Blues played in the place, Brett Hull, son of the Golden Jet Bobby Hull, stood near center ice as Wayne Messmer belted out the national anthem, accompanied by the big Barton organ. The din of the crowd crescendoed as Messmer, who would be shot in the neck by an armed robber early the next morning on the Near West Side, sang what would be his last "land of the free and the home of the brave" at the Stadium.

Almost no one noticed as Hull, hockey stick in hand, gazed to his left, then to his right. "I was just taking it in," he said after the game as his famous father shook hands with well-wishers in a hallway inside the Stadium. "I just had a baby. So I wanted to be able to look back and tell him what it was like when the organ plays and Wayne Messmer's singing his lungs out."

Messmer survived the shooting incident, though it's not known if his booming baritone will ever return. The fate of the 65-year-old Stadium, in contrast, is sealed. There will be those who weep when its walls come crashing down. But who ever said that the theater of Chicago sports—and life, for that matter—was anything but a tragicomedy? The Stadium has already taught us that.

Postscript

Messmer made a miraculous recovery, not only returning to sing the national anthem before Chicago Cub games and hockey matches, but also becoming an executive with the Chicago Wolves, an International Hockey League team. The Stadium did not fare so well.

Demolition began on February 3, 1995, and was completed a few
months later. The site became a parking lot for the United Center—prom-
ising, as former *Tribune* sports writer Mike Kiley aptly put it, "a future of
oil leaks where legends once cavorted."

Former Blackhawks star and coach Keith Magnuson was among a crowd
of about 200 people who looked on as the wrecking ball swung. He said of
the Stadium, "You couldn't make a move as an athlete in this building with-
out everyone seeing it. I think that won't be true for the [United Center],
where there are lots of other distractions. In the Stadium there was only the
games. You couldn't get away from it." As the array of entertainment attrac-
tions in the United Center would show, he could not have been more right.

The United Center

Don't Take Me Out to the Mall Game

FEBRUARY 5, 1995

Mt. Scottie had just erupted. Thrown out of a Bulls–San Antonio Spurs
game by referee Joe Crawford, star forward Scottie Pippen had retaliated
by heaving a red folding chair onto the United Center's hardwood floor.

It was an operatic moment of pent-up frustration, uncontrolled rage,
and unmitigated arrogance. One expected the boos of the capacity crowd
to crescendo to an earsplitting din, as they might have at the old Chicago
Stadium. Instead, as soon as the banished leading man had been escorted
offstage and a timeout had begun, kids raced tricycles around orange
cones placed on the court for the "AT&T Long Distance Road Rally."

The bizarre juxtaposition of authentic athletic drama and staged com-
mercial schtick had a predictable effect. There were boos when the game
resumed, but they were hardly full-throated. The palpable intensity that
accompanied Pippen's outburst had been allowed to go pfffffffft.

I mention the muted reaction to Pippen's explosion because I went to
the United Center to evaluate the new arena under game conditions. It is
something that architecture critics rarely do. Because we are in a business
that values fresh stuff over that which is day-old, we tend to review build-
ings when, figuratively speaking, they are hot out of the oven and untest-
ed—and it's hard to tell whether the ideas that shaped them were well
conceived or half-baked.

So I headed for the West Side to answer this question: how would the
interior of Chicago's new sports palace measure up against the Stadium, a
place fabled for its extraordinary intimacy and decibel levels?

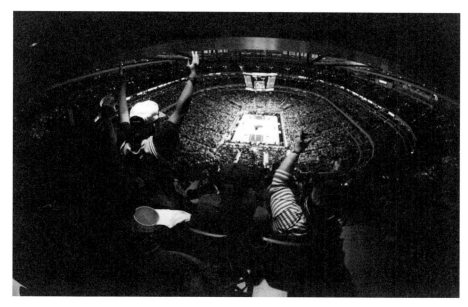

THE UNITED CENTER: High on amenities, low on intimacy—and no match for the old Stadium.

In a review last fall, I had concluded that the exterior of the United Center was a design dud, a bigger and blander copy of the Stadium's muscular Art Deco classicism. But that evaluation appeared before any games had been played, so no definitive conclusion could be reached about the handling of the interior by the architects, the Hellmuth, Obata & Kassabaum (HOK) Sports Facilities Group of Kansas City, Missouri.

Since then, the United Center had received decidedly mixed notices, with Bulls coach Phil Jackson going so far as to suggest that the place's tomblike quiet had contributed to his team's slow start.

As I approached the United Center, though, it seemed anything but deadly dull. Two searchlights atop the building sliced through the night sky, joining with backlit marquees above the main entrances to create the feeling of a Hollywood premiere. White stretch limos pulled up to the building's south entrance. A stream of luxury cars made its way into a fenced-in parking lot, a compound meant to assure drivers that no one from the surrounding public-housing projects would harm them or their vehicles.

Passing through gate 6, I made my way to the main concourse that rings the United Center's ground level and, with its endless concession stands, has the cheery, predictable feeling of a suburban shopping mall. There was canned entertainment, an eight-piece mariachi band. Then came "Fandemonium," the slick Niketown-meets-Hall-of-Fame sports

merchandise shop where rickety wooden seats from the Stadium were on sale for $250 apiece and the Bulls' NBA championship trophies were displayed in a glass case.

Walking up a long flight of stairs, I passed a plush seating area, reserved for holders of high-priced tickets, that looked like a hotel lobby. I arrived at an upper-level concourse that has been compared to the United Terminal at O'Hare, probably because its concrete ceiling arches recall the terminal's vaulted steel and glass roof. Backlit advertising signs were on every conceivable inch of wall space. Food concessionaires didn't sell peanuts—too messy, they said.

There weren't enough tabletops in the concourse, so people set their drinks and hot dogs atop trash cans. There was a hint of the circus: free attractions resembling sideshows. One, called "Hang Time," allows fans to jump and try to slap their hands against metal basketball replicas placed at different heights.

When I'd first seen the United Center, the rich, burgundy color of thousands of seats had created an impression of coziness. But now, with people present to provide a yardstick of human scale, the interior seemed incredibly vast. I took my seat—section 314, row 3, number 11. "It's like the Grand Canyon here," someone in row 4 said.

Even where I was sitting, in a $30 seat near the bottom of the upper deck, you barely could hear the bounce of the ball, the squeak of the players' shoes, or the ball rippling through the cords of the net. It was as though the players were swimming in a fish bowl and we spectators were simply staring inside.

The view wasn't terrible, but it certainly was farther from the floor than it would have been in the Stadium's second balcony. True, there were no obstructed-view seats (the Stadium had plenty of them) and the seats themselves were more comfortable and had cup holders. But the trade-off—more individual amenities, less collective fervor—struck me as the equivalent of leaving a packed and lively city neighborhood for a spacious, boring suburban subdivision.

As in all modern sports arenas, this lamentable situation is attributable to the presence of high-priced luxury suites and extrawide mezzanine-level club seats that are sandwiched between the upper and lower decks and served by waiters. The suites and club seats guarantee owners millions of dollars in revenue. But they inevitably push seats in the upper deck far away from the action.

In the United Center, the only consolation for fans of modest means is that there is a ring of so-called penthouse suites above the upper deck. Their views must be terrible. I find it astonishing that self-respecting busi-

ness executives are shelling out $55,000 to $75,000 a year to lease one of these skyboxes, which are so high above the floor that oxygen tanks should be part of their amenity package.

But maybe that's the point of the United Center. The game, the sole focus of attention in the Stadium, is no longer what really matters. If we're not hard-core sports fans, we come to the United Center for the same reason we go to Disney's Magic Kingdom or to the Mall of America—for warm-and-fuzzy entertainment experiences that are squeaky-clean, walled off from the perceived danger of the city, and largely restricted (by virtue of ticket prices) to the middle class and the wealthy.

NBA Commissioner David Stern once wished upon a star that the Stadiums of his league could be like a series of theme parks, those sugar-coated versions of reality that are so popular with the American public. Having witnessed a game, I can say without qualification that the United Center has made Stern's wish come true.

The hypercommercialized arena is part theme park, part shopping mall, part circus, part movie theater, part hotel lobby, part airline terminal, part Niketown—everything, in short, but a match for the Madhouse on Madison Street. Maybe Benny the Bull should wear mouse ears instead of horns.

Postscript

Phil Jackson and Michael Jordan, who would return to the Bulls in 1995 after his short-lived flirtation with baseball, would eventually warm up to the United Center. The Bulls won NBA championships there in 1996, 1997, and 1998 and games were always sold out. But once Jordan retired, Bulls tickets became far less desirable, suggesting that it was the star—not the United Center—that had been responsible for the string of sellouts.

BUILDING A
BETTER LIFE

Chicago long has been a magnet that attracted people
who wanted to make a fresh start, whether they were
European immigrants or sharecroppers from the Deep
South. For their part, the city's architects have given physical
form to the identity and aspirations of the newcomers.
Churches and synagogues served as portals for immigrants,
offering a reminder of the Old World and a refuge in the new
one. Settlement houses taught the newcomers the customs of
their adopted homeland.

These roles took new forms in the 1990s, particularly as
the Hispanic population surged both in Chicago and nation-
wide. Designing an elementary school in a Mexican-
American neighborhood near the long-gone Chicago
Stockyards, architect Carol Ross Barney faced the challenge of
making the building tough but joyful. Meanwhile, in the vio-
lence-plagued inner city, noted architect Stanley Tigerman
was called upon to provide an oasis of calm in a day-care cen-
ter for children six weeks to five years old.

At the same time, as old churches assumed new identities,
their leaders remodeled the buildings, inviting the wrath of
parishioners who had found the buildings as comfortable as
a well-worn shoe. One such project, designed by architect

Laurence Booth, unfolded in the shadow of Sears Tower and other downtown high-rises. There, Old St. Patrick's Church, which survived the Great Fire of 1871, was remade in an endeavor fraught with peril, aesthetic and otherwise.

A Leap of Creativity

Old St. Pat's Is New Again

DECEMBER 23, 1999

There's more than one way to take a design risk these days, and it isn't just by doing an oddball modern building that looks like something out of *The Jetsons*. Ask any priest or rabbi who has had the courage to remodel a familiar, beloved place of worship. The reactions they get from the faithful tend to give new meaning to the term "holy war."

That was the specter confronting Pastor John Wall and Chicago architect Laurence Booth in 1992 when they embarked on a revamp of Chicago's oldest public building, Old St. Patrick's Church at 700 West Adams Street. People loved the homey feel of the place. Its architecture was not grand and Gothic but humble and Romanesque. Its stained-glass windows were renowned for swirling forms based on ancient Celtic designs. Change only seemed to open the door to dissent.

But now that the $6.5 million project is done, there is every reason to be glad that Wall and Booth took a leap of creativity. For the renovation has done more than restore the extraordinary assemblage of Celtic ornament that previously graced the 143-year-old church; it has transformed Old St. Patrick's into a complete work of art that it never was before.

Previous phases of the three-part project restored the church's stained glass and returned the delicate, interlacing lines of Celtic decoration to the walls and ceilings of the sanctuary. Curving pews of cherry wood were added, as were a marble floor, lacy ceiling lanterns, and a new circular altar. The altar was brought closer to the congregation, in accord with the spirit of the Second Vatican Council.

Now, in the manner of bookends, the final touches have been put into place. On one end of the sanctuary is a new altar screen, which houses the church's old statue of St. Patrick. On the other end, just inside the vestibule, is a baptismal fountain with Celtic decoration, a gold-leaf ceiling dome hovering above its waters.

It all works together, not unlike a precisely composed baroque fugue.

THE RENOVATED OLD ST. PATRICK'S CHURCH: Building bridges between the old world and the new.

Indeed, the real feat is the way Booth has managed to instill a sense of order into what easily could have been a riot of shapes and colors. In its new incarnation, the sanctuary is at once joyous and disciplined, perfectly in keeping with the spirit of Chicago artist Thomas O'Shaughnessy, who gave Old St. Patrick's its stained-glass windows and original stenciled wall decoration between 1912 and 1922.

Standing just west of the Loop, its facade built mostly of Milwaukee common brick, Old St. Patrick's is an official Chicago landmark for good reason. No other house of worship in the city is so powerfully connected, by virtue of its design and its history, to the story of Irish Americans. Typically, an Irish immigrant to Chicago would leave the nearby train stations and head to Old St. Patrick's, where he or she would receive food and shelter. This was more than material nourishment; the church reaffirmed the very culture the newcomer had left behind.

In that sense, the story of the church's renovation transcends architecture. It is about how buildings connect us to the past even as they form a sense of community in the present. And it is about how churches tell stories—not only religious stories, but stories about the migrations that changed America.

Certainly, the decoration that is the church's most distinctive feature has special meaning to Irish Americans. O'Shaughnessy's forms were based in part on one of Ireland's national treasures, the late-eighth-century *Book of Kells*, an illuminated manuscript of the Gospels drawn by Irish monks. At the same time, they have a broader resonance in Chicago, recalling the naturalistic ornament of the late architects Louis Sullivan and John Wellborn Root.

O'Shaughnessy died in 1956 and, as time went on, his wall stenciling was obscured with layers of paint. It wasn't until after the first wave of renovation began in 1992 that his stencils were discovered—too damaged by neglect and age to be restored, but intact enough to serve as an artistic guide.

Booth, head of Booth Hansen Associates, wanted to re-create the master artist's rainbow of stencil colors, all 56 of them. But before he could, he had to get approval from Wall, who had presided over the rebirth of Old St. Patrick's from the time, about 15 years ago, when its congregation was down to four registered members and the church itself was in disrepair. At first, Wall balked, wondering if he was about to alienate his growing flock with a new look. "Maybe they were right to paint it over," the pastor said at the time.

Eventually, though, he signed off on the idea, and the stencils—formed by paint passed over cutout screens—were re-created by artisans from a small Wisconsin shop who worked under Booth's sure-handed direction.

Instead of applying the stencils willy-nilly to the walls, Booth arranged them in a rigorous pattern that joins them to the decoration of the stained-glass windows. That keeps all the ornament in check. O'Shaughnessy's sandy-colored walls and the earth-toned palette of the stenciling further rein things in. The curving pews even play a role in unifying the design, their far ends turning in such a way that they line up perfectly with the church's side walls.

The sanctuary has been compared to sitting inside an Easter egg, yet for all its profusion of decoration, it is never smothering; rather, it seems airy and open, as if the sun were shining not only through the stained-glass windows but also through the snakelike patterns of Celtic ornament. "The result," the architecture critic M. W. Newman wrote in a 1996 *Tribune* review of the project's early phases, "is a worship space where windows, walls, ceiling and statues merge into a lyrical whole."

Now that whole is a little holier, especially in the new altar screen that dominates the sanctuary. Handsomely proportioned, its three arches echoing the three doors at the front of the church, it is decorated with plaster whose gorgeous white interlacing patterns resemble sugar sprinkled on a cake. Their sculpted shapes, which were designed by Booth's associate Gisele Taxil, represent the creation story—from the earth and water to plants, fish, animals, and angels. The symbols of the Trinity are visible atop the screen.

Booth deliberately kept the colors of the screen to white and cream. The screen thus stands apart from the multicolored walls and ceiling even as it evokes their interlocking Celtic ornament. Crisp and modern, it updates tradition rather than mimicking the past.

The altar's prominence is subtly accentuated by the new baptismal fountain at the back of the sanctuary. Instead of placing the fountain on the side of the sanctuary, where it might have gone in the days before the Second Vatican Council, Booth put it in the center, on an axis with the middle of the altar.

Symbolically, he says, the fountain is a "primitive Irish well," a place from which the worshiper draws strength and spirit. Just below the surface of its waters is a circular bronze labyrinth that echoes the interweaving Celtic decoration of the sanctuary. The fountain's exterior is covered with a chiseled Italian marble that has an incised, undulating pattern that suggests waves and expresses a sense of eternity.

While it looks as though Booth has reverted to old-fashioned craftsmanship in these details, the reality is that computer-age technology made many of them possible. A marble inlay pattern on the floor of the altar, for example, was cut by a machine that uses the high pressure of water jets to trace a design onto stone.

Best of all, the project has been designed with a human dimension. The refurbished vestibule at the back of the church functions as a crying room because its wooden doors have windows that allow parents to look into the sanctuary. The altar has been made accessible to the disabled with a marble-covered ramp. And the curving pews enhance the feeling of community in the 876-seat sanctuary; instead of sitting face-forward in military-style rows, now people can see each other.

In the end, the renovation has done much more than take O'Shaugh-nessy's two-dimensional stencils and stained-glass windows and translate them into the three dimensions of the sanctuary. It has rejoined this church to the past even as it expressed and enabled a dynamic future. Buildings have a powerful ability to tell stories. The message this one sends is that a land-mark of the American immigrant experience has been born anew.

Where Learning's Fun by Design

Back of the Yards School Is a Neighborhood Beacon

FEBRUARY 6, 1994

Progressive design and the public schools of Chicago rarely get mentioned in the same sentence, much less the same article. Why should they?

Bad news about the schools, from repeated threats of a teachers' strike to gang-banger shootings on school grounds, reflects inner-city turmoil as well as urban power politics. But those images can blind us to stories of hope in a picture that seems hopeless.

One such story concerns the New Seward Elementary School in Chicago's gang-plagued Back of the Yards neighborhood. About a half mile west of the legendary, but now razed, Chicago Stockyards, the new school has become a beacon of knowledge for its predominantly Mexican-American "port of entry" neighborhood. And it's that rare thing: a work of architecture that inspires joy as well as respect.

The school's colorful brick facade is nearly free of graffiti in an area where some people joke that spray painting rivals the telephone as a form of communication. Its ample ground-floor windows, which skeptics pre-dicted would be shattered by rocks—or worse—remain intact, admitting light to classrooms where kindergartners count "uno, dos, tres" as well as "one, two, three."

It is impossible to explain why gangs have not attacked the school, but one suspects it has been spared because well-designed, well-constructed public buildings generally are well treated, while their shabby and poorly maintained counterparts invite disrespect. The latter foolishly seek to look as though their designers had been miserly with the taxpayers' money. The former give us grandeur on a budget.

Built to siphon off an overflow of students from Back of the Yards' older public schools, New Seward has proved immensely popular with the area's families. Enticed by the beautiful new facility as well as by the prospect of tuition-free education, many parents have taken their children

NEW SEWARD ELEMENTARY SCHOOL: Teaching lessons that extend beyond education.

out of Roman Catholic schools and sent them to New Seward instead. Partly as a result, the school has nearly 700 students instead of the 550 for which it was planned. Yet even in its overcrowded state, the school has a lasting lesson to teach about the art of architecture—how to work magic with durable, low-cost materials, bright colors, and simple geometric shapes.

Designed by Ross Barney & Jankowski Inc. of Chicago and constructed for $6 million—its per-square-foot cost is comparable to that of new Chicago public schools—New Seward occupies a sliver of land one block west of Ashland Avenue.

Dumpsters and the back sides of stores line an alley on the eastern edge of the property, at 4747 South Marshfield Avenue, a former city parking lot. Across Marshfield to the west are modest frame houses and an old corner tavern with a Budweiser sign hanging from its facade. A Goldblatt's department store is to the north, its old-fashioned water tower harking back to the days when the noses of South Siders would crinkle from the pungent smell that wafted to areas around the stockyards.

This is hardly a context to inspire architectural monuments, but like the small-town Midwestern banks of Louis Sullivan, New Seward at once accommodates its surroundings and ennobles them. Its chief designer was Carol Ross Barney, who first attracted widespread notice in 1991 for a

west suburban post office whose red, white, and blue brick stripes suggest an American flag.

To Barney, schools should be as enticing as shopping malls—or perhaps, post offices. She is not, she says, a fan of educational institutions that have a "brown brick governmental building sort of appearance." Yet before Barney could deal with the colors of New Seward, she had to resolve the more basic issue of the school's configuration.

The lack of room on the narrow site led her to stack classrooms in a three-story building, with the rooms on just one side of the hallways instead of the conventional double-loaded corridor. To shield the schoolyard from the rough-edged alley, Barney set the classrooms well back from the street, reversing the traditional arrangement of school in front and schoolyard in back.

The solution affords at least visual protection to children in the schoolyard, who can be watched by teachers gazing out of classrooms and neighbors looking out from houses across the street. So far, there have been no major gang-related incidents, according to principal Sandy Trabak. A waxlike substance applied to exterior walls has made it easy to remove the small amounts of graffiti that have been applied to the building.

To prevent New Seward's almost 400-foot-long facade from appearing monolithic, Barney divided the building into three parts, giving unusual shapes and splashes of color to activity centers like the library while facing the blocklike classroom wing in a quiet red brick.

The school's lunchroom and gymnasium wing is clad in vivid bands of tan and yellow brick. A square box housing a library and multipurpose room is decorated with a lively checkerboard pattern of blue and gray brick. At night, a translucent fiberglass pyramid atop the library is lit from within, making the school a beacon in fact as well as symbol.

Other pyramids protrude from the base of the library. Further playing on the pyramid theme, Barney accented the gymnasium with three roofline triangles of yellow brick and used an oversize yellow wall, also triangular, to conceal the wing's fire escape stairs.

Her design has several practical advantages. The centrally placed library neatly divides the play yard of kindergarten and preschool students from the one used by bigger, and sometimes rougher, first through eighth graders. At night, the library can be used for community activities while the rest of the school is sealed off. By separating the library and gymnasium wings from classrooms, Barney allowed the wings to be supported by long, relatively lightweight spans instead of heavier—and more expensive—structural beams.

Freeing dollars to be used elsewhere in the building, the intelligent

structural planning contributed to a visually arresting design that has been compared to Lego blocks. Barney's playful use of color sends the message that learning can be a thing of joy. Yet her simple, abstract forms possess an underlying monumentality, conveying the age-old notion that education is the ticket to a better life. It is a coincidence, Barney says, that the pyramids remind the neighborhood's Mexican Americans of the triangular silhouettes of ancient Mayan temples.

Having been educated in the idealistic 1960s—and having witnessed the failure of much socially activist architecture—Barney is too worldly-wise to think that bricks and mortar can produce straight-A report cards. Yet she is not so cynical that she has lost her belief in architecture's capacity to inspire people to learn. If the exterior of New Seward exemplifies that idea, so does its humanistic interior.

Students enter the school by walking under canted yellow canopies that flank the library. Inside is a light-filled, two-story vestibule with a confetti-like assortment of red, white, blue, and salmon floor tiles extending into the single-story main lobby. A pyramid-shaped pattern of square, yellow-tinted windows dominates the lobby's concrete wall, recalling the exterior's triangular forms and hinting that pyramids will mark other key doorways.

To visually soup up the school's long corridors, Barney used what she calls "a cheap trick," painting deep window frames with yellow and other colors to create the illusion of light shining through stained glass. To take the pounding dished out by students, the architect placed particle-board wainscoting at the base of hallway walls. The corridors seem even less institutional because they contain no lockers. Instead, Barney gave each classroom a cloakroom.

There are other welcoming touches in the classrooms, including high ceilings (an amenity achieved by placing mechanical equipment to one side of the ceiling). In contrast to the Technicolor brightness of the hallways, the classrooms are neutral in tone, emphasizing the seriousness of study.

The classrooms form an appropriate architectural backdrop for the most memorable place inside New Seward, the library, which is reached by crossing a bridge over the vestibule and passing through a pyramid-shaped door.

The library is a powerful reminder that extraordinary architecture can be created with ordinary materials. Although it has inexpensive tiled ceilings and concrete block walls, the room has a pride of place missing from many a baronial salon.

Bands of punched windows flood the library with daylight, as does the pyramidal skylight. There is not a single classical column in the room, yet it is hard not to think of Thomas Jefferson's domed Rotunda at the head

of the great lawn at the University of Virginia—"the collective brain of the institution," as the architectural historian Vincent Scully once described it.

The New Seward library is neither as grand nor as exquisitely detailed as its Jeffersonian predecessor, but the idea from which it springs is fundamentally the same: the light of learning illuminates the temple of wisdom. In a democratic culture, everyone should be able to study in such a sanctuary and build a better life. Perhaps that is why a school for the children of Mexican immigrants on the South Side of Chicago has become a symbol of hope as well as learning.

Postscript

Reflecting the Mexican-American character of its neighborhood, the New Seward Elementary School was renamed the Cesar Chavez Multicultural Academic Center in 1994. The building continued to be treated with respect and affection by both its students and its neighbors, but it remained an exception to the generic prototype schools built elsewhere in Chicago. Carol Ross Barney, meanwhile, was selected to design the federal office building that will replace the now-demolished Alfred P. Murrah Federal Building in Oklahoma City. That structure is scheduled to open in 2003.

Day-Care Package

Tigerman Leads the Way toward a Bootstrap Architecture that Gives Low-Income Kids a Leg Up

JUNE 8, 2000

The eyes, not the ears, are the tools we typically use to judge whether buildings are beautiful. But at a bright new day-care center across South State Street from the glowering high-rises of the Robert Taylor Homes, it is sounds, as much as sights, that make the most powerful impression.

Listen to young children pushing tiny tricycle pedals, or swooshing down a slide, or singing, "If you're happy and you know it, clap your hands." Listen to the laughter that pours from a protected courtyard and spreads to the light-filled corridors that surround it. And listen to the confidence in the voice of a mother who brings her three- and four-year-old boys to this day-care center, so near a violent public housing project: "I don't have to worry about that," says Schenea Hardy, 21, who lives on Chicago's South Side. "I have peace of mind."

Anywhere else, all this would be taken for granted. But in the area around the Taylor Homes, where the crack of gunfire is almost common-

THE EDUCARE CENTER ON CHICAGO'S SOUTH SIDE: A national model for inner-city day care.

place, the sounds of normalcy are sounds worth celebrating. Inside this building, which was designed by the noted Chicago architect Stanley Tigerman, the only hint of the dangerous world outside is the wail of a police siren piercing the quiet of a spring afternoon.

Already serving as a national model—the actress Jane Fonda has visited the day-care center and signaled her intention to open a comparable facility in Atlanta—the $4 million building at 5044 South Wabash Avenue speaks to the essential role that design can play in giving the poorest kids a chance to lead normal lives. Yet it also sends a message to millions of American children who come from much wealthier families, but who still get day care in dark church basements or in confining office buildings.

That message has been best articulated by Irving Harris, the former board chairman of the Ounce of Prevention Fund, a not-for-profit group that strives to improve the well-being of children and adolescents, particularly those in inner cities. "This," Harris says, speaking of the day-care center, which his group brought into being with help from Head Start, the State of Illinois, the Chicago Public Schools, and private donors, "lets kids know how much we value them."

Called the Educare Center and offering full-day care for up to 158 kids who are six weeks to five years old, the building replaces an Ounce of Prevention day-care center located on the second floor of a Robert Taylor high-rise at 4848 South State Street. To reach that facility, moms, dads, infants, and toddlers had to run the gauntlet of a stairwell controlled by drug dealers. There was no suitable outdoor play space—playgrounds had broken equipment and were littered with broken glass. In any event, there was little reason to go outside: with rival gangs fighting it out, shots were fired with alarming frequency. "The children would drop. They knew the drill," says Brenda Dobbins-Noel, the director of child and family support services for the Ounce of Prevention Fund.

At the new building, they are flowering, not dropping. The 69-year-old Tigerman, who in the 1960s led an architects' group that sharply criticized the practice of putting public-housing families in high-rise buildings like those at Taylor, has created an island of serenity in a sea of chaos.

Sandwiched between Farren Elementary School on the south and DuSable High School on the north, the Educare Center recalls a college quadrangle: structures arranged in a square that wrap around a sheltered courtyard. Instead of lordly Oxford dons striding to their classes, this open space is filled with African-American kids who do what children do: squeal, sing, and get into spats with each other. Ringing the courtyard, which has two gymnasium buildings inside it, is a light-filled hallway, which is itself circumscribed by classrooms, as well as offices, conference rooms, a lobby, and a kitchen.

The arrangement represents a new wrinkle. In most day-care centers, classrooms are on both sides of a hallway and the play space is on the outside of the building—exactly where it shouldn't be in neighborhoods plagued by drive-by shootings.

Yet here, the classrooms are on just one side of the corridor, allowing light to filter in from the courtyard. True, because it results in a bigger perimeter, this feature drives up the cost of the building, to $4 million from $3.25 million, Tigerman acknowledges. But in the inner city, the payoff is priceless: a playground that provides all sorts of protection, from the threat posed by violent outsiders to the possibility that kids will drift off and get lost. "We don't have to worry about anything coming in or anybody going out," says one teacher, Shantonia Appling.

That part of the design is utterly rational, but there's also some post-modern whimsy at play here, which, coming from Tigerman, is no surprise. His previous buildings include a parking garage at 60 East Lake Street where the facade resembles the grille of a Rolls-Royce, and an animal shelter at 157 West Grand Avenue where the front evokes the face of a droopy-eared dog.

At the Educare Center, the classrooms for kids between six weeks and three years of age suggest houses, with pointed roofs and fake chimneys. Those for children age three to five echo schoolhouses, their fronts punctuated by nonworking clocks whose hands are set at three, four, and five o'clock. That move is meant to symbolize the ages of the children and to help them identify—and identity with—their classrooms. The synthetic stucco exterior walls of all the classrooms are painted in bright pastels—yellow, pink, blue, and green—as if someone had colored them with crayons.

Unfortunately, all this comes off as Disneyesque, cartoonish. It looks as if the Educare Center parachuted into the South Side from Orlando. But talk to the people who use the building and you hear another story: the area around the Robert Taylor Homes could use a little of the fun-filled, fantasy architecture of Walt Disney World. For those who live in the public housing, this place looks like an ideal version of home. "When [parents] walk in here, it's like they're somewhere else," says teacher Sheila Mahon.

Whether or not one approves of the Educare Center as a work of architecture, it is hard to dispute that Tigerman has deftly maintained a sense of innocence in a building that, above all, had to be shielded from its surroundings.

With its peaked roof and metal-clad columns, the entry pavilion—found near the corner of East 51st Street and South Wabash—evokes a miniature Greek temple. "Welcome," it says, not "go away." But there's toughness here; it's simply well masked.

A layer of perforated aluminum over a window in the front door guards the main lobby from bullets. Neatly turning armor into decoration—and thus making it seem less menacing—Tigerman uses the same aluminum as the background material for a sign marking the entrance to the building. In a similar vein, windows that face outward to the street are located behind fences that have a double layer of mesh, but are playfully painted. In the lobby, there are no windows on the walls; light comes from above—through an eight-sided skylight.

The lobby sets a kid-friendly tone that is in evidence throughout the building. Wood chairs are low-slung, making it easy for a child to see eye to eye with adults—and not feel intimidated. In the hallways and the building's two gyms, Tigerman has lined the lower parts of the walls with the same gray and white tiles that are on the floor. That way, children can run their hands along the walls, as they are wont to do, yet the walls easily can be cleaned. The courtyard itself has a rubbery floor that prevents scrapes and cuts. Classrooms are bright, furnished with warm wood, and perfectly scaled to the kids. So are bathrooms—a key feature for the age group undergoing toilet

training. "A lot of kids are scared of the toilet. If it's their size, they're not scared," Appling says.

The need for internal supervision is also sensitively handled. Because the corners of the square building house teacher offices and conference rooms, adults in these areas have straight-shot views down the hallways. But the hallways are not stalaglike. Tigerman has placed wood storage closets in them. And on the same side of the hallways as the closets, he has set built-in seats where kids and their teachers can have an intimate, one-on-one talk. He did it, he says, because he stuttered as a child and frequently needed to talk privately with his teacher in the hall.

It's a good stroke, making the halls activity-filled rooms instead of anonymous corridors. Still, there are faults, inside and out.

The color coding of the floor tiles isn't different enough from hallway to hallway. As a result, because each section of the building is virtually identical, it's easy for a visitor to get disoriented. In the outdoor play space, there are no trees or shrubs, so the playground has a harsh look. Yet, these are quibbles when you compare the Educare Center with the atmosphere at the Robert Taylor Homes.

Standing in the courtyard, the high-rises across the street are visible but seem a world away. One feels sheltered, protected, upbeat. Kids ride trikes and tip their wooden rockers. And there are sounds to savor: the children singing and the whisper of warm breezes running through the trees across Wabash Avenue. "This kind of gives the kids a chance to feel more free," Appling says.

That the Educare Center does, which is why it represents such a welcome departure—not only from typical day-care centers, but also from the self-indulgent form-making of so much of today's architecture. With the intent of evoking the chaotic quality of modern life, many designers are shaping buildings that look like they just went through an earthquake; in contrast, Tigerman isn't just commenting on contemporary problems; he's helping to solve them.

While his building is more a social success than an aesthetic one, it nevertheless provides a humanistic model for the pressing national problem of improving day care, not only for kids in the inner city but for their counterparts in edge city suburbs and elsewhere. Here, the social promise of architecture can be seen in the faces of the children and in their sounds of joy.

PRIVATE HOUSING: BUILDING BOOM, ARCHITECTURE BUST

Chicago is legendary not only for its skyscrapers and commercial buildings, but also for its houses and the way they have shaped livable neighborhoods. In the late nineteenth century, Frank Lloyd Wright and his colleagues changed the course of American domestic architecture with the earth-hugging, space-flowing designs of the Prairie School. In the mid-twentieth century, Ludwig Mies van der Rohe and his followers brought about a similar revolution, giving the world its first set of glass houses—the acclaimed apartment high-rises at 860 and 880 North Lake Shore Drive.

Against this background of innovation, there was not much to celebrate in the booming Chicago housing market of the 1990s. True, the city's neighborhoods were reinvigorated by record numbers of new town houses, single-family houses, and high-rise condominiums and apartments. But for all the frenzied activity, there was precious little good design. A new "Slab City" of concrete residential towers deadened the visual vitality of the downtown skyline. The neighborhoods, meanwhile, suffered a rash of numbingly generic, red-brick condo buildings.

Strange Neighbors

Bright New Condos Add Vitality to the City—but Something about Them Is Just Not Right

JANUARY 21, 1999

There's a new kid on the block in Chicago's fast-growing neighborhoods, a new-looking, old-looking kind of building that's trying to fit in but can't quite bring it off.

Walk along any of the side streets lined with pale-hued, wood-frame houses and you'll see them, sticking out like the red spots that dotted your skin when you had the chicken pox.

They're new condominium buildings, usually faced in red brick, and even as they're driving up real-estate values in "hot" Chicago neighborhoods such as Lincoln Park and Lake View, they're leaving some residents feeling burned.

It's not just that these buildings tower over their modestly scaled neighbors, blotting out views and casting shadows. Nor is it simply that the condos have packed once-livable neighborhoods with so many people that getting a parking space is as easy as finding an honest alderman in City Council. Or that their side walls typically are made of concrete block—not exactly what most neighbors want to see out their windows.

Something more subtle is at stake: that intangible but unmistakable thing called a sense of place. You know it best when it's being violated, as it is here.

Over the years, through custom and tradition, a way of building evolves that indelibly defines a city. Boston has its three-deckers, Baltimore its rowhouses, San Francisco its Victorians. Chicago's tough-guy image is expressed as much by its built-for-the-ages bungalows, graystones, and three-flats as by the John Hancock Center.

Fast becoming ubiquitous, the condos hark back nostalgically to these buildings by including such touches as brick fronts, window bays, and quoins, the alternating patterns of brick and stone that accentuate a building's corners. Yet for all their attempts at go-down-easy familiarity, the condos seem strange and off-kilter, as if they really belonged in one of those suburban subdivisions where all the houses look alike.

Although aldermen have enacted zoning laws that try to inoculate the cityscape against future outbreaks of this design disease, it seems to be spreading anyway. It even has mutated into new forms—like a mean-spirited little box with gray stripes fit for a prison uniform.

So what is to be done? Should we blame the aldermen, who control what gets built in their wards? Throw up our hands and be happy that the

THE NEW RED-BRICK CONDOS: Better than the old four-plus-ones, but still grossly out of place.

condos are replacing ramshackle old houses? Draw the blinds and wish the condos would go away?

Before you decide, it's important to understand what the condos are—and aren't. They're not town houses, which are attached single-family houses with several floors. Nor are they lofts, which typically feature wide-open, timber-framed interiors carved out of old warehouses. Instead, the condos are a variation on the old, stacked three-flat. But in contrast to most three-flats, the units are occupied by owners rather than renters.

Brokers "are seeing a new move-up buyer," says Diana Turowski, a spokesman for the Chicago Association of Realtors. "People may have owned a studio or a one-bedroom. Now they want something larger, but they don't want a single-family home and don't want to move to the suburbs."

So the condos try to make what is new seem old. They are "meant to fit into Chicago," says Koenig & Strey real-estate broker Sean Conlon, who has put together many of the condo deals.

In some ways, they do fit in, especially when compared with that horrible brand of housing from the 1960s, the four-plus-one, which consists of four stories of small, cheaply built apartments atop a floor of parking. Whereas the typical Chicago house occupies a 25-foot-wide lot, the four-plus-one takes up several lots, sprawling 150 feet along the sidewalk. It has little if any decoration to relieve its mass of brick. In addition, there are no stoops or porches where people can sit and survey the street.

This is the worst of trickle-down modernism—expedient, uninspired, antiurban. The condos, in contrast, fit on a 25-foot lot. They have stoops. They have bits of decoration. So why do they seem so out of place? Here are a few key reasons beyond the obvious one—their height:

Color: their brick is a reddish-orange that leaps out from the pale blues, greens, yellows, and browns of the frame houses. It doesn't work for the same reason that brightly colored painted lady Victorian houses look silly in Chicago; this is a town that likes its buildings big and bold, but understated.

Details: early versions of the condos have very little decoration, and the ornamental touches they do have are utterly unconvincing. Check out the skinny columns on the porch of a building in the 1500 block of West Oakdale Avenue. They look like no. 2 pencils you could snap with your bare hands, hardly conveying a sense of permanence.

Proportions: the old frame houses have steeply pitched roofs, and, typically, their windows are smaller on top than on the bottom because they have an attic story. But to allow for a maximum amount of livable space upstairs, the roof pitch of the condos is much shallower. And, in most cases, all their windows are the same size. As Chicago architect Laurence Booth puts it, it's as if the building's facade had been determined by the Pella window catalog.

That hints at what is truly grating about these buildings: they seem mass-produced rather than handcrafted. In the old three-flats, you sensed hour after hour of work in the beveled glass that graced the windows or the delicate brick corbeling. That gave them—and their occupants—a sense of individuality. Not so the condos.

If they aren't clones of one another, then certainly they belong to the same design family—one that looks equally out of place in any city neighborhood dominated by frame houses. They are, perhaps, best understood as the urban cousins of the cookie-cutter houses that have inspired suburban antimonotony ordinances. And in that sense, there's a larger irony at work here.

The promise of postmodernism, which embraced history and strove to create buildings that were tailored to their environs, was that it would

spare us from the worst of modernism, which sought universal design solutions but succeeded only in making every place just like every other place. Here, though, instead of getting buildings that fit their surroundings like a glove, we have architecture that is utterly generic. Even when the condos are relatively sophisticated as individual buildings, they detract from Chicago's sense of place.

Take the 800 block of West Wrightwood Avenue, where there's a row of condo buildings that replaced wood-frame houses destroyed in a 1994 fire. One of them might be okay, but the collective impact of these heavily ornamented buildings is a Matterhorn of masonry that overwhelms everything around it.

To prevent other such incursions, the City Council has passed zoning laws that limit building heights in some residential districts and require developers to provide one and a half parking spaces for every new unit— a rule that effectively discourages new three-flat condos.

But do not underestimate the power of the profit motive to get around such restrictions. Forced off many side streets, developers have moved the brick condos to the main streets, like Belmont Avenue or Lincoln Avenue, where zoning permits greater heights and densities. Here, the brick condos seem more at home amid old brick commercial buildings. Yet when the condos are designed as single buildings that stretch across several lots, as they are in the 2600 block of North Ashland Avenue, they are every bit as overpowering as the brick behemoths on West Wrightwood.

The other course, seen at its worst in the 1400 block of West Diversey, is to stack two duplexes in a single flat-roofed condo building. This gray-striped one looks as if it would be right for someone who just got out of Stateville. "I keep thinking I should go spray our name off of it," says architect Booth, of the Chicago firm of Booth Hansen Associates, of a sign in front of the building.

Citing the building as a cautionary tale, Booth argues that developers should spend a little more money to create better facade designs that will fit into the neighborhoods. But Conlon says rising land costs and tighter profit margins make that very difficult to do.

The likely result? More buildings that raise real-estate values in Chicago's neighborhoods, but rob them of their sense of place.

Postscript

Spurred by a profusion of tall condominium buildings that blocked views and towered over the much-smaller houses beside them, the City Council in 2000 imposed a height limit on residential construction. Under the new law, the height of buildings in neighborhoods with R-4 and R-5 zon-

ing is limited to 38 and 45 feet, respectively. In a further effort to protect the fabric of the city's neighborhoods, Daley in 2000 announced a bargain financing plan for Chicago bungalow owners who want to fix up homes with the distinctive architectural style, as well as financial incentives for those who want to buy them. But there was no stopping the condos. They took over whole blocks of main streets such as North Damen Avenue, making the cityscape more undistinguished than ever.

Tall Building Comes Up Short
New Apartment Tower Is a Drag on the Skyline

DECEMBER 15, 1999

The cruel irony of Chicago's building boom is that it breathes vitality into downtown and drains beauty from the skyline. Exhibit A: a new 52-story apartment building, One Superior Place, that is almost totally bereft of character. Look at it and all sorts of analogies come to mind—hulking brute, monotonous mountain, oversized tombstone.

Maybe that last one is too kind. At least tombstones bring a hint of grace to the cities of the dead that are our cemeteries. But One Superior Place deadens the cluster of skyscrapers that symbolize the city. From afar, this sheer-walled slab of concrete resembles the 46-story tower of the North Michigan Avenue Marriott Hotel, which is only slightly more ungainly than One Superior Place.

Does anybody see a pattern here? We are tearing down old high-rises for the poor while erecting new ones for the rich. The trouble is, deadly dull design does not discriminate on the basis of income. Because architecture is the art with which we live, visual blight leaves everybody a little poorer, at least in spirit.

There are, to be sure, some positive features to One Superior Place. Most can be found at ground level, like the decoration that adorns its parking garage. Yet in the end, these touches are the design equivalent of putting mascara on an elephant. An ugly giant is an ugly giant, no matter how you camouflage it.

One Superior Place did not turn out to be an architectural flop because a penny-pinching real-estate developer forced the architect, Jim Loewenberg, to cheapen his design. Along with his business partner Joel Carlins, Loewenberg is the developer of the $112 million project.

Refreshingly modest, at least compared to other architects, the 65-year-old Loewenberg does not tell people how to live. He believes in giv-

ONE SUPERIOR PLACE: One inferior design, as daunting as a cliff.

ing them what they want. Apartment interiors, not building exteriors, hold the key to renting buildings quickly and profitably, he believes. So that's where he puts his money. And it shows.

Step into the studios or the one- and two-bedroom apartments in the 809-unit building and you are instantly impressed with their airy, open

feeling. Luxury features such as granite countertops are included, Loewenberg says, to get prospective tenants thinking, "This is top grade. I should stretch and pay a few extra bucks for this apartment."

The slick CD-ROM with which Loewenberg is marketing his building touts One Superior Place as "the last word in urban indulgence." One wishes, however, that the architect had splurged on the public face of the building as much as he did on its private amenities.

The project, whose official address is 1 West Superior Street, occupies the southwest corner of State and Superior Streets, across State from the golden-hued Holy Name Cathedral. It consists of the tower, which fronts on Superior, and, behind it, an 850-space public parking garage that stretches back to Huron Street, a block south of Superior.

Fortunately, the tower is located in the middle of the block, its narrow side set back from State Street, which gives both the nearby cathedral and "that great street" a much-needed respite from its overwhelming bulk. Yet the tower's 239-foot-wide front rises straight up from Superior, as daunting as a cliff.

The street-level face of the building isn't so bad, because it's clad in a gold-colored, precast concrete that gives the building a human scale and sends a sympathetic nod in the direction of the cathedral. The rest of the seven-story base is a pastiche of traditional features, such as a decorative grid done in inexpensive synthetic stucco. It's passable, though only barely.

The parking garage is even less appealing. Lacking glass or grilles that would mask parked cars and sport utility vehicles from passersby, it is, plain and simple, an eyesore. There ought be a law against stuff like this, and there is. Earlier in 1999, the City Council passed a measure that encourages developers to screen their garages—too late for One Superior Place.

At least the garage has flattened classical columns and other decoration. Another plus is that it's ringed with glassy storefronts instead of presenting the pedestrian with nothing more than a forbidding wall of concrete.

But there is nothing to celebrate in One Superior Place's presence on the skyline.

Loewenberg has tried to break up the tower's massive midsection with different materials and textures—flat concrete, pebbled concrete, balcony railings, bands of windows. Yet they make One Superior Place no less gargantuan, simply dividing the building into vertical stripes. Worse, as in the architect's other condominium buildings, such as the recently completed, 17-story 21 West Chestnut Place, it looks as if two architects had designed the building—a neotraditionalist shaping the decorated bottom, a neobrutalist doing the overly austere top.

In almost every respect, the boxy top of the tower is a visual bore, for-

going the opportunity to make a statement on the skyline. For a building more than 450 feet tall, that is a major shortcoming.

The best one can say about One Superior Place is that it is not quite so tall that it stands out when seen from afar—say, from the Kennedy Expressway west of downtown. Still, from anywhere closer than that, it is plenty large enough to make an impression—and that impression is unrelentingly dull.

Loewenberg acknowledges that One Superior Place could have been better. Leading a visitor around the exterior, he says, "This does not make great architecture and I know it." He would have liked to use more expensive materials, he says, or to have given the tower a more distinctive top. But the interior—and profitability—had to prevail.

Perhaps squeezing good design out of a tight budget is as hard as coaxing water from a stone. But it may be just as true that Loewenberg isn't bringing enough imagination to the table. All his fussing with the exterior is to no real end; it tries to make a huge building dainty when One Superior Place would have been better off emphasizing the fact that it's very, very big.

In his planned One North Halsted Street condominium tower, by contrast, Chicago architect Ralph Johnson has cut enormous, windowlike openings into the facade of the 38-story high-rise to create a distinctive skyline presence. Yet no one would accuse One North Halsted of being a gargantuan monster; its design makes it look like a series of interconnected towers rather than a hulking monolith.

This is the sort of innovation that would have made One Superior Place soar in presence as well as height. As it stands, however, the tower is a monument only to this lesson: there is no substitute for creativity if Chicago's building boom is going to leave a greater legacy than skyscraper-size profits.

PUBLIC HOUSING: SHELTERED BY DESIGN

One of Chicago's great shames is that it is home to the Poor House as well as the Prairie House—Cabrini-Green, the Robert Taylor Homes, and other high-rise public-housing projects that constitute a roll call of infamy.

Such was the destitute condition of the projects—and so corrupt was the Chicago Housing Authority—that, in 1995, the federal government seized control of the troubled agency. In turn, the U.S. Department of Housing and Urban Development promised to institute a wave of reforms, all of which would break up the isolated pockets of poverty that were perceived to be the root cause of the projects' woes.

Did design have a role to play in the effort to make better lives for the poorest of the poor? The 1995 series "Sheltered by Design," which appeared shortly after the federal takeover, argued that architecture could make a difference—but only with help from job training, social services, and a host of other factors. The series examined the neo-traditional designs of the New Urbanists, the crime-fighting concept known as "defensible space," and the contentious issue of renovating rather than demolishing public-housing high-rises. It began with an overview that contrasted the sordid reality of public housing in Chicago with success stories from around the nation.

Housing that Works

Politicians and Bureaucrats Have Been the Real Architects of Public Housing, but It Doesn't Have to Be that Way

JUNE 18, 1995

Viewed from an airplane window, the pattern appears again and again. As the cities unfold below, their outlines revealing America's values, it is easy to spot the public-housing projects.

Not only do their drab and boxy high-rises look different from other places where people eat, sleep, and raise children, but the streets are cut off from adjoining neighborhoods. Even at 10,000 feet, you suspect that others look down upon the people in these isolated zones.

The stereotype of the "vertical ghetto"—the rampant violence, the out-of-control drug dealing, the wasted lives and tax dollars—obscures a better way to shelter the poorest of the poor.

It is visible from the sky and at street level, where children feel free to leap off playsets and adults begin to climb out of poverty.

Amid the garbage-strewn lots of Cleveland's Near East Side, round white columns evoke the classical style of the White House and the democratic spirit of the architect-president Thomas Jefferson.

At what was once a notorious Boston public-housing project, reassuring rows of brick suggest the historic district of Back Bay, their rooftop gables marking a steady beat along both sides of a grassy mall.

On the low-rent side of a freeway in the affluent suburb of Menlo Park, California, blue town houses have handcrafted birdhouses that symbolize the renewal of life, unlike the asphalt no-man's-land at Cabrini-Green that children call "The Killing Field."

These are the faces of housing that works.

They are not utopias. But they are so different from Chicago's high-rise projects that they demand to be understood as the nation undertakes a great debate about the future of public housing, a debate that centers on the takeover by the Department of Housing and Urban Development (HUD) of the Chicago Housing Authority, the nation's third-largest and most troubled public-housing agency.

Unlike the modernist straitjacket that confined public housing after World War II, the new designs are tailored to their regions and the people who live in them. Some enable low-income housing to blend with its surroundings. Others help decrease crime or turn once-nightmarish towers into decent places to live. All provide interiors that lift the spirit instead of crushing it.

CLEVELAND'S RENAISSANCE VILLAGE: Porches that provide public housing residents with private entrances and the dignity of classicism.

Yet the future of public housing is about more than design. It is about bureaucracies and the people whose lives they control, and is thus a test of their ability to put people first. It also is about the power of local government, specifically the power of Mayor Richard M. Daley and the City Council, to determine the use of land—who profits from it, who lives on

it, who is displaced from it, who plans it, and whether those plans serve the public good.

"Power designs cities," the late architectural historian Spiro Kostof wrote, "and the rawest form of power is control of urban land."

Brute local power begat the physical isolation of Chicago's worst public-housing projects when the City Council in the 1950s and 1960s placed nearly all of them in areas that remain overwhelmingly poor and black. Over time, well-intentioned but ineffective federal laws ensured that the projects would be populated almost exclusively by the poor.

HUD's takeover of the CHA presents an unprecedented chance to shatter that isolated concentration of poverty—if it doesn't simply reisolate the poor. The distinction is crucial because of the little-discussed link between reforming welfare and remaking public housing. Welfare reform is supposed to move poor people into the economic mainstream. It would be counter-productive, therefore, to leave them stuck in housing that thwarts that goal.

"I have to be home when my sons get out of school because the shooting starts around 4 P.M. every day," a 30-year-old Chicago resident told the National Commission on Severely Distressed Public Housing, saying she would not work because she refused to leave her children alone in the projects.

The Power of Design

No one should suppose that buildings can magically transform troubled people into model citizens, a self-deception the theologian Reinhold Niebuhr once labeled "the doctrine of salvation by bricks." But it would be equally foolish to underestimate the power of architecture and urban design to remake the physical environment and thereby alter a range of perceptions and realities.

The six birdhouse-bedecked town houses of Willow Court in Menlo Park are cleverly designed to resemble detached single-family houses, fighting the "not-in-my-backyard" movement that blocks the construction of low-income housing. Boldly scaled trellises lend a dignity to Willow Court that belies its modest size. When a resident of one of the town houses, Jessica West, was asked to compare her home with the expensive single-family houses across U.S. Highway 101, she responded, "I don't live in nothing less."

There is dignity and something more in the classical columns of Cleveland's 90-unit Renaissance Village. Drug dealers and prostitutes once controlled the stairwells of the three-story apartment buildings. Now, the development is almost crime-free after the stairwells were replaced by front porches that give tenants their own entrances.

The reduction in crime undoubtedly was aided by residents who

TOWNHOUSES AT WILLOW COURT IN MENLO PARK, CALIFORNIA: Fighting the not-in-my-back-yard syndrome with low-income housing that resembles single-family homes.

pledged not to use drugs and signed a covenant that underscores their promise. Architects believe such steps are crucial. "We are firmly committed to the proposition that architecture can change people's lives, but not everybody and not immediately and not on its own," said San Diego architect Christine Killory, who has designed two award-winning low-income developments in Escondido, California. "It needs some support."

Housing that works is concerned with more than housing. It must rebuild people as well as cities, provide social services to troubled families, and link homes to neighborhoods that have stores, banks, and jobs.

Those traits are compressed in an innovative social-services mall nearing completion at Renaissance Village. With an entry through a three-story glass atrium at the base of a high-rise, the mall will offer a food co-op, job training, and day care. Its services will be available to public-housing residents and the surrounding battered neighborhood, a connection its architecture will subtly reinforce.

The very openness of the mall will make it a welcoming symbol. At night, with light shining outward, it will be a beacon to its neighborhood. And the mall will remind taxpayers that low-income housing can serve the community instead of simply being a drain on the public purse.

Such examples emerge from visits to a broad range of low-income housing—public-housing projects, as well as subsidized housing built by private

developers and not-for-profit organizations. They are also based on interviews with more than 200 architects, urban planners, developers, housing officials, managers, security personnel, and public-housing residents.

The innovative efforts cost from $17,000 to $140,000 per unit and were funded by an array of sources, ranging from the federal government to private investors. They house a broad spectrum of low-income people, including the working poor and welfare families. Most have been built or renovated in the last 10 years. Some are ongoing successes. In others, the luster has faded.

The Unseen Forces

Whatever the outcome, the examples shatter the myth that has grown since the famous 1972 demolition of three Pruitt-Igoe high-rises in St. Louis: that the failures of public housing could be blamed on the architects of the high-rises.

The real architects of public housing were not the designers whose names appeared on the blueprints of Pruitt-Igoe, Cabrini-Green, or Desire in New Orleans. They were politicians who wanted to keep blacks penned inside ghettos (white politicians out to maintain segregation, black politicians out to maintain their voting blocs); national legislators who unwittingly drove working families from public housing, turning the projects into pathological concentrations of poverty; local housing authority officials who failed to screen out troublemakers and ignored routine maintenance needs, allowing projects to decay; and federal and local bureaucrats who stripped humane touches, such as ground-floor bathrooms that would have provided young children an alternative to urinating in the elevators.

It is no coincidence that much of the best low-income housing is produced outside the legal and administrative lockstep of the federal government by not-for-profit developers—or that HUD is desperately trying to emulate those examples as it fights for its political life.

One of the nation's most respected low-income housing architects, Michael Pyatok of Oakland, refuses to work for HUD and characterizes the department as the equivalent of the old Ma Bell, a monopoly that is distant and disconnected from the people it ostensibly is there to serve. Pyatok, who designed Willow Court, prefers as clients those community-based not-for-profits that are unfettered by federal rules and are, he said, far more accountable to the poor. Federal housing officials are "nine-to-five clock punchers," Pyatok said. His nonprofit colleagues, such as Thomas Lauderbach, director of housing development for the Jubilee West nonprofit in Oakland, go home wearing beepers.

Architects who must work with HUD have devised ways to circumvent

GOVERNMENT-SUBSIDIZED HOUSING AT 850 WEST EASTWOOD AVENUE: Where a glass tile mural makes a high-rise feel like home.

its rigid rules. In a quintessential bit of Chicago subterfuge, architect Peter Landon slipped $15,000 into the budget for a $4 million renovation of a government-subsidized Uptown high-rise completed in 1992. The money paid for a luminous mural of glass mosaic tile in the vestibule of the 16-story tower. Its abstract shapes and radiant hues of gold, red, blue, and green express the identities of people from more than 30 countries living there (the alphabetical list of tenants in the lobby index goes from Aasi to Zemenfeskudus).

A relatively inexpensive touch like that can make all the difference between impersonal housing and a place that feels like home, but it never would have made it past the bureaucrats if Landon had listed it as "art" in his budget. Instead, he called it "tile."

Chicago's Distress

To be sure, HUD officials have promised to cut red tape to improve living conditions for CHA residents. Under Secretary Henry Cisneros's leadership, HUD has loosened some of its burdensome procedures and regulations and moved to reintroduce economic and social stability in public housing by encouraging working families to return.

Yet in Chicago, the agency faces the nation's toughest public-housing problem. No other city has Chicago's volatile mix of high-rises and gangs

who control entire buildings. No other stretch of public housing is such a vision of despair as the wall of buildings that runs for almost three miles along South State Street. Its hellish tableau of drug trafficking, gang violence, and physical decay made Robert Lewis Jr. of Boston, who runs a youth-service program, weep on seeing it for the first time.

Only the New York City Housing Authority, the nation's largest, has more high-rises than Chicago; its official tenant population of 450,000 dwarfs the CHA's 86,000 official residents. But New York has a long tradition of mixing working and welfare families as well as rigorous management procedures that have made its public-housing towers livable, though hardly untouched by crime.

Of the nation's 1.3 million public-housing units, about 86,000, or 6 percent of the stock, are classified by the federal government as "severely distressed," a category that refers to developments plagued by crime, obsolete mechanical systems, and high vacancy rates.

Yet the official number of troubled public-housing units is merely "the tip of an iceberg of broader distress," said Lawrence Vale of the Massachusetts Institute of Technology, a consultant to the National Commission on Severely Distressed Public Housing.

The reason for the widespread disarray, he said, is that public-housing residents are getting poorer. In Chicago, 9 of every 10 CHA residents who live in family housing do not work. The typical CHA household has an annual income of $4,000, less than 10 percent of the Chicago-area median income for a family of four.

While there is no consensus on precisely how many units are "severely distressed," it is indisputable that the high-rises are highly charged political symbols and decaying hulks that beg to be renovated or replaced.

Cisneros's desire to tear down one of every three high-rises in the State Street corridor implies that two of every three will remain and will need to be made livable. Yet the peril that HUD will squander precious funds there is enormous.

After Vincent Lane became CHA chairman in 1988, the agency renovated 21 of the 28 buildings at Robert Taylor, enclosing elevator shafts that were open to the elements and making other changes intended to improve security. The cost per building: $900,000.

Today, the elevators don't break as often as they did, but conditions in most of the renovated buildings are as squalid and unsafe as ever. The renovation's designer, Chicago architect Thomas Hickey, called it "a Band-Aid."

Cisneros and the CHA don't need Band-Aids. They need good management, architectural changes, and tenant screening to make selected high-rises livable.

Success Stories

Such models exist not just in New York, but in Chicago, particularly at the Ida B. Wells Extension, where six seven-story elevator buildings have been renovated for just $40,000 a unit—less than half of what it costs to construct scattered-site public housing in Chicago.

The Wells renovation, designed by Chicago architects Dubin, Dubin and Moutoussamy, is no-frills architecture that does all of the basics right. Glass-block exterior walls are tough enough to take a pounding but transparent enough to emit natural light to lobbies of the boxy buildings. That's a welcome change from the dark, prisonlike atmosphere that greets residents of most CHA complexes.

The renovation works because screening eliminated many problem tenants, and the Wells Extension is privately managed by the Woodlawn Organization.

Whether they proceed by renovating high-rises or by constructing town houses, HUD must plan with residents, not for them. Participatory planning is essential if the federal housing agency is to break down long-standing mistrust between residents and the CHA bureaucracy. It also matters because the poor are not monolithic.

They are of different ethnicities (though the vast majority of CHA residents are black), family configurations, and ages. When architects hold workshops to gauge how poor people live instead of divining that essential information secondhand or thirdhand, the fit between form and function is usually airtight.

As he shaped the nearly completed Villa Del Norte rental complex in the Los Angeles suburb of Rancho Cucamonga, Pyatok took note of a demographic reality that occurs with increasing frequency among the poor: live-in grandmothers who provide day care for the children of single mothers.

So he carved out a special area in many of the development's 88 apartments, essentially a bedroom with its own bathroom. The unit is next to the kitchen and just off the rear door of the apartment, allowing the grandmother a measure of independence because she doesn't have to march through the family's living room to get to her separate space. And there are other advantages: "Frequently there are clashes between the generations, and the grandmother doesn't want to talk to anyone for a couple of days," Pyatok said, "so she can sulk at her own end of the house."

At the other end of the age spectrum, some public-housing projects are virtual communities of children; in Chicago, more than 45 percent of the residents in family housing are under 15 years old. But here and nationwide, their needs are underserved.

MARCUS GARVEY COMMONS IN OAKLAND: Despite design that blends with its neighborhood, obstacles remain to link low-income housing with the rest of America.

All too rare is the attention to detail shown at the two 15-story towers of Lake Parc Place, the CHA's mixed-income development in the 3900 block of South Lake Park Avenue, where basketball courts and splash pools are reserved for different age groups.

That there is no "one-size-fits-all" model for such small things is an idea that applies equally to the large-scale question of urban design and how to connect public housing with the rest of America.

An example is in Boston, where a public-housing project that was that city's Cabrini-Green is now a mixed-income development called Harbor Point. The 1,283-unit complex has red and brown brick apartment houses, blue and gray clapboard-covered town houses, a waterfront promenade, a grassy mall—and a 97 percent occupancy rate that has confounded skeptics who predicted that white middle-income professionals would never live alongside black welfare families.

A Matter of Priorities

Can that be done in Chicago?

It all comes down to questions of money, power, and political will. The CHA has funds available for major renovation and construction—about $600 million, including $120 million in unused modernization funds,

according to HUD officials. But that will not be enough to address the agency's huge backlog of modernization needs.

So leveraging private funds with public money will be critical. And, as always, there will be a conflict between quality and quantity—providing decent housing for as many people as possible versus making sure that what gets built benefits its inhabitants and its neighborhood for decades, not just on move-in day.

The political choices largely reside with Daley, who will have a major say in any HUD policy regarding the CHA, and Daley has signaled that he wants to keep public housing isolated within its present borders. Cisneros has spoken eloquently about reintegrating public-housing residents into American life and building "communities of opportunity." But so far, he has not challenged Daley's course.

In the short term, the mayor has every reason to move cautiously, not only because he would alienate his Bungalow Belt voter base by dispersing large numbers of public-housing residents throughout the city but also because Chicago can ill afford the flight of middle-class residents that probably would occur.

No one, as the African-American Ald. William Beavers (7th) bluntly acknowledges, wants public housing in his ward. But in the long term, there should be but one policy: the wall, both actual and symbolic, that separates Chicago's projects from the rest of the city must come down. Otherwise, the rhetoric of Cisneros and the words Daley uttered last April on the night of his reelection will forever ring hollow: "My administration has been an administration of breaking down barriers, of taking race and religion and ethnic identity out, and of moving the city forward."

Postscript

Chicago regained control of its housing authority from the federal government in 1999. In the same year, the CHA announced a 10-year, $1.5 billion plan to remake public housing in Chicago. The plan, its price tag later adjusted to $1.6 billion, called for tearing down all 51 of the CHA's family high-rises by 2011. Management of all CHA property is to be privatized. The plan will mean temporary or permanent relocation for nearly all CHA residents.

Cisneros's successor, HUD Secretary Andrew Cuomo, pledged that his agency would waive inflexible federal regulations to allow the CHA to pursue its plan. More important, HUD is to give the CHA block grants and other funding, including $1.5 million in redevelopment funds, to demolish and replace public housing.

Even before the blueprint was made public, Daley reversed his earlier decision to isolate public housing and made city-owned land available for the redevelopment of Cabrini-Green and the Henry Horner Homes on Chicago's West Side. Mindful of a history of broken promises, however, tenant leaders greeted the plan with skepticism while housing advocates asked the perennial question: "When the high-rises come down, where will all the people go?"

Urban Mosaic's Lost Piece

Creative Planners Have Discarded the "Tower-in-the-Park" Model that Disconnected Public Housing from Its Surroundings

JUNE 19, 1995

Connecting public housing with its surroundings requires more than visionary plans, T squares, and bulldozers. It takes a leap of the mind.

To make that leap entails a complete rethinking of projects and their relationships to a city. There is no better person to show the way than author Jane Jacobs, whose influential urban-planning study, *The Death and Life of Great American Cities*, delivered the classic critique of public housing in 1961 and still shapes the way people think about urban form and function.

"One of the unsuitable ideas behind projects," Jacobs wrote, "is the very notion that they are projects, abstracted out of the ordinary city and set apart. To think of salvaging or improving projects, as projects, is to repeat this root mistake. The aim should be to get that project, that patch upon the city, rewoven back into the fabric—and in the process of doing so, strengthen the surrounding fabric too."

Is that just one urbanologist's unbuildable dream?

No, it turns out. A new approach to urban design shows how public-housing projects such as Chicago's Cabrini-Green can be linked to their cities. It's called the New Urbanism, and it argues that all people, rich and poor, are impoverished if they are disconnected from their surroundings.

Originally intended to heal woes associated with suburban sprawl—traffic congestion, air pollution, and a perceived lack of community—the New Urbanism has become a force in very low-income inner-city neighborhoods. In cities and suburbs, it endeavors to frame spaces that encourage people to socialize and watch out for each other.

At one housing development shaped by the New Urbanism, Boston's Harbor Point, Elva Parker sat on her porch one afternoon while a neighbor swept the porch next door. "It's peaceful," Parker said. "I don't have

TOUCH FOOTBALL AT HARBOR POINT: A new public realm—and new hope for breaking down social barriers, fruits of the New Urbanism.

to worry about ducking and dodging bullets. I can let my kids play outside. It's less stress in the head."

Design codes at the New Urbanism's most visible achievement, the decade-old Florida Panhandle resort of Seaside, mandate that houses have front porches close enough to the lot line to enable a homeowner in a rocking chair to converse with a passerby on the sidewalk.

Music to the ears of the husband-and-wife team who planned Seaside, Miami architects Elizabeth Plater-Zyberk and Andres Duany, is the thwack, thwack of the screen door slamming at the corner store, where friend meets friend over a cup of coffee.

This idealized Small Town, U.S.A., appears to have little in common with the vexing problems of public housing. But it does, especially if one takes seriously the aim of Housing and Urban Development Secretary Henry Cisneros "to transform the physical face of public housing so it is better integrated into the community."

HUD's takeover of the Chicago Housing Authority and its plans to remake the Cabrini-Green and Henry Horner developments create an opportunity to use the New Urbanism to break down that isolation. But the approach has limits. Many city dwellers won't support efforts to con-

nect public housing with its surroundings, especially if they live in those surroundings. It seems unlikely, for example, that residents of the Gold Coast would urge Mayor Richard M. Daley to reopen streets that once joined their neighborhood to Cabrini-Green.

Even when New Urbanism designs are built, they don't always work as intended. A neo-Victorian public-housing complex in San Francisco, the Robert Pitts Plaza, is a decidedly mixed success—much safer than the high-rise it replaced, but already battered by wear and tear.

And in the urban wastelands where public housing has driven out all semblance of a housing market—and there are many of them amid the long stretch of public housing on Chicago's South Side—the New Urbanism is practically irrelevant. There is no community into which public housing can be integrated.

"Garden" Varieties

The name of one project in that stretch, Stateway Gardens, hints at the thinking of the generation of planners and reformers who created public housing. Why Stateway Gardens? For that matter, why Cochran Gardens in St. Louis? Or Clason Point Gardens in New York?

The answer goes beyond old newspaper photographs that show that the projects once had community gardens and lush green lawns residents were fined for crossing. The bucolic names and amenities are rooted in a proposal for an ideal "Garden City" made in 1898 by Ebenezer Howard, an English court reporter and urban planner. His utopian diagram called for the creation of small, self-sufficient towns surrounded by a green belt and divided into separate zones for housing, industry, commerce, and culture.

Later architects and planners swallowed whole the idea that a city's activities should operate in relative self-containment and that the best housing sat wholesomely amid grass. By the 1920s, the Swiss-born architect Le Corbusier issued a famous, though unrealized, design for Paris that called for a "vertical garden city" of apartment towers standing in vast parks.

Among the leading proponents of this "tower-in-the-park" model of urban planning was Elizabeth Wood, former head of the Chicago Housing Authority. Public housing must be "bold and comprehensive," Wood argued in 1945. "If it is not bold, the result will be a series of small projects, islands in a wilderness of slums, beaten down by smoke, noise and fumes."

Thus the tower-in-the-park model of public housing—and the dictatorship of the planners—took shape. In city after city, public housing was organized around oversized blocks called superblocks, not streets, because Garden City planners thought that grassy parks were healthier than teeming streets. Influenced by cubist art and its explosion of the human figure, de-

signers freely composed the placement of their austere towers on public-housing sites. This meant that the front of one high-rise might face the street, while its neighbor showed the street its back. Invariably, following the Garden City model, the towers were positioned far from the sidewalks and from each other to admit light and air to every apartment.

What the urban reformers never foresaw, however, was how politicians would use the projects as tools of racial segregation, how housing authorities would let them run down, how federal admissions policies would drive working families out, and how the architecture and urban design would cut off public-housing tenants from each other and their communities.

The taller buildings meant that fewer parents were close enough to the ground to supervise their children playing outside. The huge open spaces and large parking lots did away with the narrow streets that gave people a place to socialize.

In *The Death and Life of Great American Cities*, Jacobs related that residents at a public-housing project in New York's East Harlem viewed its lawn with utter disdain. "Nobody cared what we wanted when they built this place," one of them said. "They threw our houses down and pushed us here and pushed our friends somewhere else. We don't have a place around here to get a cup of coffee or a newspaper even, or borrow 50 cents. Nobody cared what we need. But the big men come and look at that grass and say, 'Isn't it wonderful. Now the poor have everything.'"

The cruelest twist was that lawns around the high-rises were either not maintained or paved over in a shortsighted effort to trim costs. The transformation of the vertical Garden City was complete: the tower in the park had become the tower in a parking lot.

Boston Breakthrough

What would a housing development based on the New Urbanism look like? Nothing like public housing, if the remarkable transformation of a Boston project called Columbia Point is any indication.

Built in 1953 on a peninsula that juts into Boston Harbor, Columbia Point once was the Cabrini-Green of New England. In fact, its size makes it roughly comparable to the southern high-rise portion of Cabrini-Green. Using an unimaginative approach typical of public housing, Columbia Point's architects laid out 28 flat-topped buildings, three and seven stories high. All were clad in drab yellow brick.

Over time, the 1,502-unit development was afflicted by the same ills that plagued public housing nationwide. By 1984, just 350 families remained in the complex. Then with the blessing of the Ronald Reagan administration, the Boston Housing Authority leased the land to a part-

nership of the tenants and a Boston-area developer—Corcoran, Mullins, Jennison—for 99 years at $1 a year.

The team remade Columbia Point into a mixed-income complex where there is no difference between market-rate apartments, which account for two-thirds of its 1,283 units, and those housing low-income residents who used to live at Columbia Point. Because their numbers had dropped markedly, no Columbia Point residents were displaced by the new complex, renamed Harbor Point, which opened in 1988 and was completed in 1990.

That it is nearly all leased five years later demonstrates powerfully that architecture and urban design can shape how people perceive a development and whether they would be willing to live there. The key to this transformation, as Jacobs had suggested more than a quarter of a century earlier, was to stop seeing public housing as standing apart from the rest of the city.

The chief architects of the renovation, Goody, Clancy & Associates of Boston, based their design on the layout of thriving Boston neighborhoods such as Back Bay and the New Urbanism idea that cities are enriched by the creation of a "public realm" that affords amenities such as waterfront views to everyone.

Along the harbor, where thieves used to dump stolen cars, is a six-acre landscaped park where a visitor hears not gunshots but screeching seagulls and water coursing over rocks. Slicing through the center of the complex is a 1,000-by-119-foot grassy mall with old-fashioned street lamps, benches, and tennis courts patterned after Boston's Commonwealth Avenue.

The public realm at Harbor Point extends beyond such grand gestures. Columbia Point's mazelike arrangement of streets "diabolically" prevented tenants from seeing the harbor unless they lived in a waterfront apartment, according to architect Joan Goody. Her firm designed a new grid for the development. Canted at 45 degrees to the water's edge, it opened views of the harbor and the Boston skyline to all residents.

Narrow by design, the streets are tightly framed on each side by apartment buildings and town houses in contrast to the open spaces and freely placed structures of tower-in-the-park urbanism. Front doors and most apartment windows face the streets. The arrangement eliminates unsupervised pockets of dead space where drug dealing and other illicit activities can occur.

To create what Goody calls "the subtle variety and texture you associate with a neighborhood grown up over time," the architects designed a variety of building types—blue and gray town houses covered with wood clapboard, as well as red and brown brick apartment houses.

Ten of Columbia Point's low- and mid-rise residential buildings were given peaked roofs, decoration, and a reddish stain that makes them vir-

HARBOR POINT: Remaking a public-housing project with new and renovated buildings, as well as amenities ranging from waterfront views to a tree-lined central mall.

tually indistinguishable from the new apartment houses. Visual subtleties such as rounded and pointed rooftop gables communicate unmistakably that Harbor Point has been freed of the stigma of public housing.

Here's the catch: Harbor Point is among the safest neighborhoods in Boston, yet its safety is partly explained by a fence along its border and the guard station at its main vehicular entrance. The developers took that step to prevent outsiders from harassing tenants.

In other words, Harbor Point remains physically isolated from the rest of Boston.

But maybe not forever. The architects designed Harbor Point's street grid so that it someday can be extended to join with streets on the peninsula where it is located. That idea provides a model for reshaping developments such as Cabrini-Green with new roads that can be linked to the Chicago grid.

Today, though, Harbor Point seems too much like a world apart, a residential complex that has adopted the forms of the city without the functions, like corner bars, that fill neighborhoods with life. Harbor Point, in short, has mixed incomes but not the mixed uses that make cities hum. Its architecture, while free of cloying postmodernism, still has the contrived variety of a planned community.

And yet, given what was there before, Harbor Point is an extraordinary achievement, powerful evidence of the transformations that the New Urbanism can achieve.

Utilizing Isolation

Confronted with more daunting conditions than at Harbor Point, architects in other cities have taken an approach different from the New Urbanism, redesigning public housing to increase its isolation. Their aim is to create islands of order in a sea of urban chaos.

The strategy usually involves fencing the borders of existing public-housing complexes and redesigning their internal areas to replace the wide-open spaces of tower-in-the-park urbanism with human-scaled niches such as tot lots.

Such designs have created safe, decent housing at Lake Parc Place, two 15-story towers on Chicago's South Side that are a mixed-income development of the CHA, and Renaissance Village, a 10-building complex within the King Kennedy Estates development in Cleveland. A similar approach has been proposed for the Ida B. Wells Extension, a CHA complex of 10 seven-story buildings on the South Side.

Though this method appears to repeat the root mistake of isolating projects as projects, as Jacobs warned, it may offer a more realistic alternative than the New Urbanism to the nightmarish conditions in urban ghettos. When Jacobs made her case in 1961, there still were neighborhoods around public-housing projects.

Today, jobs have moved to the suburbs and the factories that once pumped life and money into the inner cities are gone. "Because the surroundings of public housing vary so widely, urban-design strategies for relating the project to the city also must vary," said Richard Dagenhart of the Georgia Institute of Technology. "One [project] might be seamlessly rewoven into a stable surrounding neighborhood. The other might be reorganized as an enclave, entirely separated from a surrounding area that has de-urbanized."

Even in neighborhoods that retain an urban fabric, the New Urbanism has had trouble overcoming the sheer mass of poverty that weighs down public housing.

Limits to Low-Rises

In San Francisco, just down a hill from a much-photographed row of painted lady Victorian houses, the Robert Pitts Plaza development goes out of its way to blend in with neighboring apartment buildings. Its architecture—projecting cornices and pastel shades of blue—would have been unthinkable for public housing a generation ago.

ROBERT PITTS PLAZA IN SAN FRANCISCO: The New Urbanism goal of fitting into the neighborhood isn't enough.

The 203-apartment, neo-Victorian complex replaced a notorious high-rise called Yerba Buena Plaza West, where many Pitts residents once lived. When the project was completed in 1991 and hailed by politicians as a model for a new kind of public housing, it was photographed for the marketing portfolio of the architects, San Francisco-based ED2 International. A picture of a rectangular internal courtyard shows newly laid, lush sod in the foreground, a colorful playset in a spotless bed of sand, and bushes and trees neatly lined up in rows.

Yet by last fall, the sod and the sprinkler heads were ripped out. Broken glass was strewn in the sand playlot. Bushes and plants had disappeared. Profane graffiti covered concrete seating ledges. Community gardens were unused. Burglar bars had been placed on ground-floor windows inside the courtyard after a rash of burglaries believed to have been committed by residents.

Standing in the courtyard, the on-site manager of the complex, Ken Babb, explained the mess by saying that tenants—fewer than a quarter of whom work—did not have an ownership mentality. "Many old tenants have come back with their old habits," said Babb, who now works at another public-housing development.

Babb turned to the first-floor apartment of a tenant who once grew vegetables in a fenced-off area just outside the front door. Kids living in the

project stole and destroyed the vegetables, Babb said. The man stopped growing them. Kids threw a brick through the man's window. The man put wire mesh on it.

The development's main courtyard is so troubled that residents of other San Francisco housing projects asked planners to eliminate public spaces like it in low-rise replacement housing and turn the leftover space into private yards.

Still, many residents and a tenant leader said they feel far safer at Robert Pitts than in the high-rise it replaced. There, said the leader, Eva Mae Williams, people got shot and killed. "This is a much better place. Before, you had to worry about your life."

Despite a planning process that involved residents, Robert Pitts is far removed from the New Urbanism ideal of the thwacking screen door at the corner store. The blunt truth, expressed by its former manager, is that new buildings won't bring about new behavior.

When University of California at Berkeley researcher David Schnee asked residents whether their neo-Victorian surroundings looked like public housing, some said "no." Others, surprisingly, said "yes"—the architecture had changed, but the people hadn't. "A rose is a rose; it's still public housing," as one succinctly put it.

Harbor Point shows how connecting low-income housing to its surroundings should begin—through a return to traditional urban forms that replace the tower-in-the-park model of urban planning and by creating a mix of income groups that shatters public housing's social isolation.

Robert Pitts presents a cautionary tale about replacing high-rises with low-rise apartments and doing little else. Without social services, job training, and proper maintenance, new apartments and town houses run the risk of becoming low-rise ghettos—containment of the poor with a happy face.

Postscript

In 1996, after Daley announced a multimillion-dollar plan to remake Cabrini-Green into a normal neighborhood, the City of Chicago hired Goody, Clancy & Associates and the Chicago office of Michigan-based JJR Associates to prepare a Cabrini-Green master plan. Following New Urbanist principles, the plan urged the reinstatement of the city street grid, the replacement of high-rises with low-rises, and the creation of pocket parks and other public spaces. Four years of court battles followed, with the tenant leaders charging that "mixed-income housing" was a bureaucratic code word for kicking them off their land. In the meantime, expensive rowhouses and detached single-family houses crept right up to the borders of Cabrini-Green, intensifying the residents' sense of paranoia.

Then, in 2000, the residents signed an agreement with the city and the CHA which promised them an ownership stake in a mixed-income community to be built in the southern half of Cabrini-Green. The agreement calls for the demolition of six high-rises and the construction of 2,100 mixed-income units, including 700 for public-housing residents in the area bounded by North Avenue, Orleans Street, Chicago Avenue, and the Chicago River. The tear-downs were underway by 2001.

Building a Sense of Security

Fences, Individual Front Doors, and Porches Create Safe Spaces that Can Free Residents from Being Virtual Prisoners of Drug Dealers and Prostitutes

JUNE 21, 1995

Anyone who has set foot in a troubled public-housing project knows the feeling: an almost palpable sense of not being in control, of being vulnerable to criminals. Even the police, normally cocksure, seem troubled at such places as the Robert Taylor Homes on the South Side. Patrolling the grounds, they crane their necks, searching high-rise windows for snipers.

The usual way to deter murder, rape, and assault in the projects is this simple formula: more police equals more safety. But another, more sophisticated approach argues that the form and arrangement of buildings can prevent encounters with criminals. This idea is called "defensible space."

At its most basic level, defensible space holds that certain layouts of buildings favor criminal activity, while others enhance neighbors' ability to watch over their surroundings. For example, drug dealers, pimps, and prostitutes once controlled the stairwells inside the three-story buildings at the King Kennedy development in Cleveland, making residents virtual prisoners in their apartments. Eliminating the stairwells and giving residents private front doors in 1993 helped lead to a major decrease in crime.

But defensible space ideally extends beyond changes in the physical environment and builds a sense of community. Indeed, the very notions of urban civilization and community policing are bound up in Western history; the word "police," like the word "politics," derives from the Greek word polis, meaning "mother city."

Does it work?

Defensible space is most effective wrapped in a bundle of social and management changes, as when residents of the renovated Cleveland complex signed a covenant that obligates them not to use drugs. But applied

RENAISSANCE VILLAGE: Where design allows a parent to monitor children while talking to neighbors, an example of "defensible space."

without such measures at the most troubled projects, defensible space has proven powerless to endow residents with the same sense of security other Americans take for granted.

At the Robert Taylor Homes, whose 28 U-shaped towers comprise the world's largest public-housing project, a haphazard use of defensible-space techniques in the late 1980s wasted millions of taxpayer dollars and left residents as vulnerable as ever to crime.

That effort should serve as a warning to officials of the Department of Housing and Urban Development now that they have taken over the Chicago Housing Authority (CHA). HUD Secretary Henry Cisneros is an avid backer of defensible space and has even written a brochure this year touting its virtues. Now, he and other HUD officials must decide when, where, and how to use this technique if they are to make good on their promise to immediately improve the quality of life for the CHA's 86,000 official residents.

The stakes are higher than making people feel safe within the borders of public housing. Many public-housing residents, especially single mothers, have expressed a reluctance to find jobs, frightened that children left at home will be victims of violence. And in a cycle that is typical of public-housing's history, escalating spending for police and security guards drains resources earmarked for improving its aging buildings.

The CHA in fiscal 1994 spent about $70 million on security, nearly double 1992 expenditures. That amounted to $4 of every $10 the agency got from the federal government for modernization improvements such as fitting older apartments with new stoves and cabinets.

Residents Want Safety Now

The defensible-space concept grows out of the work of urbanologist Jane Jacobs, who suggested in her classic 1961 urban-planning study, *The Death and Life of Great American Cities,* that one of the uses of city sidewalks, besides facilitating the movement of pedestrians, is promoting safety.

The more people on a sidewalk, Jacobs reasoned, the more pedestrians would feel safe amid the strangers one invariably encounters in a city. People sitting on stoops and neighbors looking out the windows of row-houses built to the lot line provided another informal deterrent, which Jacobs memorably labeled "eyes on the street."

In 1972, New York City planner Oscar Newman took this idea and dramatically expanded it, coining the term "defensible space." "Architecture is not just a matter of style, image and comfort," Newman wrote in a book bearing the name of his then-radical theory. "Architecture can create encounter and prevent it. Certain kinds of space and spatial layout favor the clandestine activities of criminals."

Comparing crime-plagued high-rises with smaller-scale public-housing developments of equal density and an identical social profile, Newman documented that the high-rises were far more dangerous. A simple but powerful factor explained why the residents of the high-rises were so besieged: the configuration of the physical environment.

With the towers set in vast open spaces, far back from the street, it was virtually impossible for residents to casually supervise activity on the sidewalk from within their apartments. The corridors, elevators, and stairwells of the high-rises constituted a virtual maze in which criminals could hide and escape. Their drab architectural style instantly identified them as the home of the most vulnerable members of society. And because middle-class communities did not want low-income housing, the projects invariably were located amid downtrodden neighborhoods plagued by crime.

Defensible space recently has come under attack from those who believe it wrongly fixes the major share of the blame for problem projects upon design, distracting attention from the root cause—the clustering of the very poor in isolated areas of cities.

It's true that changing that deep-seated problem must be the goal of public-housing officials. But doing so is likely to take years, even decades. In the short run, public-housing inhabitants confront the threat of vio-

lence every day. CHA residents are about twice as likely as other Chicagoans to be victims of violent crime. So it should come as no surprise that defensible space strikes a resonant chord among public-housing residents—they want help not eventually, but now.

Claiming Their Space

Help came two years ago to a crime-plagued, 10-building section of the King Kennedy development. Located on Cleveland's troubled Near East Side, the project is operated by the Cuyahoga (Ohio) Metropolitan Housing Authority, which runs public housing in the Cleveland area.

Crime problems in the development's three-story walkups were not limited to stairwells. As is typical in public housing, there was no fence to control access to the project. Criminals easily evaded police by entering one side of a stairwell, then slipping out the other and darting any which way. Police cars would sometimes roar through the project as they chased fleeing drug dealers.

Today, after a federally funded $5 million redevelopment, residents leave lawn chairs and barbecue grills outside on porches overnight. There has been only one complaint of drug selling since the revamped area, called Renaissance Village, opened in spring 1993.

Much of the improvement undoubtedly is attributable to careful screening of tenants by the housing authority. In addition, the residents underwent home-management training and signed the no-drug covenant. But the residents affirm that their return to normalcy has been aided by physical alterations that make it difficult for criminals to prey on them.

One of the essential defensible-space concepts used by the designers, Cleveland architect Michael Benjamin and Cleveland landscape architect Jeffrey Kerr of Behnke Associates, divided Renaissance Village into a series of public, semipublic, and private zones.

A six-foot-high galvanized steel fence, placed around the perimeter, breaks this portion of the sprawling King Kennedy project into a village-scale enclave that enables residents to recognize each other easily and thus determine who belongs and who doesn't. The fence also prevents criminals from escaping on foot in whatever direction they choose.

Like the waist-high picket fences that grace houses throughout America's suburbs, the fence is as much an implied barrier as a real one. In the manner of suburban fences, it declares to outsiders that they are entering a semi-private zone, apart from the public realm of the sidewalk. To the people inside it, it means that they are in control. "That fence says a lot of things," said Pearlie LeSure, a nine-year resident of the complex. "This is my space. If you want to come in, you've got to conduct yourself in the right way."

RENAISSANCE VILLAGE: Fences that give residents a sense of control and allow lives to flower.

But defensible space entails more than erecting a fence. Ideally, it addresses all aspects of the physical environment, large-scale to small. It also strives to personalize people's surroundings, encouraging a sense of ownership.

At Renaissance Village, the most obvious change of this type altered the 20-year-old brown brick buildings, whose institutional identity was summed up in the way residents termed them "the browns," just as high-rises at Cabrini-Green are known as "the whites" and "the reds." To enable a resident to point to his building with pride, Benjamin stained the upper stories of "the browns" one of three colors—blue-gray, beige, or reddish brown. Half-circle classical decorations, which differ from building to building, add to the distinctiveness of each facade.

But most important was the elimination of the crime-prone central stairwells, a prime example of unsupervised interior space. The porches that replaced them endow Renaissance Village with the inherent dignity of classicism. And by giving residents a place to park folding chairs, they create the opportunity for "eyes on the street." Tot lots and seating areas offer additional places to congregate, putting more "eyes" around the development.

There is no brilliantly innovative architecture here, but the social transformation is profound. Benjamin downplays the significance of the physical changes, characterizing them as a hedge against the bet that other fac-

tors—the screening, the household training, the anti-drug covenant—would alter residents' behavior. "It's like a scale," he said. "The more you load up one side with social services, screening and other things, then the less work the architecture has to do. . . . You can't deny [that public housing] is a different population. Not everyone is upbeat, wants to get a job. You have to protect against that."

Entry Problems Exit

Benjamin and other architects stress the importance of designing defensible space in consultation with low-income residents and community-based nonprofits, particularly because they know their neighborhoods in ways the designers don't.

Planning a Mission-style complex in Oakland, architect Michael Pyatok eliminated two entrances on the flanks of the 92-unit building after his non-profit clients warned that the entrances would permit former boyfriends to harass female tenants. Now the complex, Sungate Apartments, has one way in—a lushly ornamented gate—and an additional security checkpoint at the entrance to each of four courtyards. A sign of its safety is that residents leave shoes on their apartment welcome mats.

At the mixed-income Harbor Point development in Boston, architect Joan Goody depended on low-income residents to help her design safe parking lots. They told Goody that when the development was a public-housing project called Columbia Point, some parking lots were too far away from the apartments, forcing tenants to walk long distances through threatening areas. Goody shaped small parking clusters near apartments that enable residents to reach their front doors quickly.

Listening attentively to residents also helped Goody solve a perennial problem of public housing: entries that are vulnerable to criminals because large numbers of children pass through them, leaving lobby doors unlocked or doors jimmied open. At Columbia Point, intercoms between street level and the apartments often were broken.

"An outsider might say, these people [public-housing residents] won't keep their front door locked," Goody said, "but when you saw the quantities of young children coming in and out, you understood why the door was unlocked and why it was so easy for people to do drug deals in the lobby."

So the architect placed apartments for larger families on the ground floors of Harbor Point's new mid-rise elevator buildings and made those apartments into town houses with their own front doors. Only smaller apartments share a common door. That reduced considerably the number of families with children sharing an entry—one of several design elements that have made Harbor Point one of Boston's safest neighborhoods.

THE ROBERT TAYLOR HOMES: Defensible space that couldn't overcome the deep-seated problems of public housing.

"It took understanding the problems of living as seen through the eyes of the people who actually lived there to come up with the right solution," Goody said. "It wasn't a problem of hardware. It wasn't that the intercoms didn't work. It was that families with lots of children aren't likely to be able to control their children at lobby entries."

Such success contrasts with the use of defensible space at the Robert Taylor Homes, which present a classic case of the security problems associated with public-housing high-rises. Arranged in U-shaped configurations of three buildings, the Taylor Homes enable rival gangs that control different buildings to shoot across the U at each other, catching innocents in the cross fire. Such an outbreak occurred one weekend in 1994, when

there were 300 separate shooting incidents and a building manager was taken at gunpoint out of one high-rise. The open-air corridors, or galleries, of the high-rises make it easy for snipers to fire on rival gang members, then escape by running down the gallery and into stairwells.

The renovation began simply and with good intentions in 1988 after Chicago real estate developer Vincent Lane became CHA chairman. The CHA moved to replace the elevators at Taylor, which are located in the center of each building's long facade. The renovation architect, Thomas Hickey of Chicago, persuaded housing officials to go a step further, enclosing elevator shafts that had been left open to the elements in order to save money when the buildings were constructed in 1962.

The enclosure was formed by a precast concrete stairwell and a synthetic stucco exterior wall. Hickey specified sturdy glass-block windows to enable natural light to penetrate the stairwells. His aim was to turn the new stairwell into a way for tenants to walk from floor to floor while sealing off the two side stairwells to halt intruders.

In a prototype carried out at the Taylor high-rise at 4555 South Federal Street, Hickey devised a defensible-space system that had two checkpoints. One was at a ground-floor security office. The other consisted of two floor-to-ceiling metal doors on each floor that had long windows to make them seem less prisonlike. Near each door was an intercom from which visitors would be buzzed in to apartments.

The idea was to split the original galleries, which were lined with ten apartments, into two sections of five apartments, an attempt to create the same kind of division of space and feeling of community that would eventually succeed at Renaissance Village.

It did not work, though the elevators don't break down as often as they once did. The ground-floor security guards spent a lot of time in the offices, Hickey said. Intruders got by them easily. Gang members cut the wire from which the metal doors were hung, making the doors inoperable. Metal conduit enclosing the intercom wire was ripped out and possibly sold for scrap, CHA officials said. Gangs punched holes in the synthetic stucco elevator enclosures and stored weapons there. The gangs also knocked out glass-block windows in the stairwells and used them as gun portals.

Hickey and the CHA made modifications in later versions of the design, which was used for 21 of the 28 Taylor buildings at a cost of $900,000 per building. But the results were largely the same, according to CHA officials, except in some buildings with strong resident organizations. "It's buying time before these buildings are torn down and replaced with something better," Hickey said.

The fundamental problem with the design, as Hickey readily acknowledges, is that it dealt with individual buildings, not the whole site, as at Renaissance Village. The border of the complex was not secured. Nothing was done to make the parking lots safer, and no social and managerial changes were introduced in tandem with the new bricks and mortar.

That left Taylor residents to rely on contract security guards for their safety. Stationed in building lobbies, the guards can be easily intimidated by gangs. "If a gang-banger puts a gun to your head and gives you a $100 bill and says you're gonna live for the next eight hours, what are you gonna do?" asked Richard Kozak, acting director of CHA public safety.

The Taylor changes show the limits of what defensible space can accomplish, especially when it is used as an isolated fix for deep-seated problems. At Renaissance Village, where it was introduced as part of a package of social programs, defensible space has had a chance to achieve what it couldn't at Taylor, improving security, building community, and easing the fear that still grips too many projects.

Postscript

The Chicago Housing Authority used defensible-space techniques in both new and renovated buildings in the 1990s, but as at the Robert Taylor Homes, some of these efforts were overwhelmed by problems of much greater magnitude. On the site of the former Henry Horner Homes high-rises, for example, new rowhouses were designed with front stoops and windows meant to allow residents to supervise the street. Yet in one troubled block, gang members simply commandeered the stoops, intimidating the residents and forcing some to move out.

Myth Must Be Exploded

Stereotyping Ignores Factors that Make High-Rises Livable Buildings or Monumental Eyesores

JUNE 22, 1995

Based on the two-dimensional images of the Robert Taylor Homes and Cabrini-Green that television brings us, it's easy to reach a one-dimensional conclusion about high-rise public housing: if we could just dynamite those big old buildings and replace them with nice new town houses, the problems of the people in them magically would disappear.

That view, however, is what needs to be blown up.

THE RENOVATION OF IDA B. WELLS MID-RISES: How small, inexpensive changes can make a big difference.

Around the country and in Chicago, there are places where "high-rise" is not a synonym for "hell." In them, young boys gather in homework clubs instead of gangs, toddlers play within the protecting walls of day-care centers, and parents stride through safe lobbies on their way to work.

Now that the Department of Housing and Urban Development (HUD) has taken over the Chicago Housing Authority (CHA), there are no more

pressing urban planning questions than whether to renovate or replace the CHA's troubled high-rises, and what impact the choice will have on the agency's 86,000 official residents.

Rehabbed high-rises in Chicago and other cities hold enormous significance for this debate, for they show that public-housing developments, like their residents, are not all alike. Some high-rises can be made livable, at far less cost than building replacement housing, even though others, clearly, must be dynamited.

The stereotype of a public-housing high-rise obscures a range of factors—location, interior layout, management structure, income mix, and resident involvement—that spell the difference between a building that works and a boarded-up eyesore.

Even within a project, conditions can vary widely. At Cabrini-Green, where the 1992 sniper shooting of seven-year-old Dantrell Davis shocked the city, a high-rise at 1230 North Burling Street has a spotless light gray facade and a second-floor nursery, with yellow and blue hearts painted on the walls. Its tenants manage the building.

At the Ida B. Wells development, where five-year-old Eric Morse was dropped to his death last year from the 14th floor of a high-rise, smaller elevator buildings have been rehabbed and provide decent, no-frills shelter. They are managed by the Woodlawn Organization, a nonprofit group.

From the perspective of many longtime residents, CHA high-rises were once good places to live. Then things changed: bad tenants weren't screened, rules weren't enforced, and maintenance stopped. "It wasn't the building," said CHA resident Cora Moore, who is the manager at 1230 North Burling Street. "It was the people and their behavior."

To tenants like her, the high-rises are less monuments to failed public policy than homes that can be made livable with the right combination of funding and resident involvement. In this view, tearing down the towers would repeat the mistake made when the city's slums were bulldozed, destroying not only the buildings but their social structures as well.

That is not the way all tenants see it, of course, especially those in violent, gang-dominated high-rises. Thousands of CHA families have jammed phone lines, seeking to participate in a voucher program that would enable them to move to the suburbs or safer city neighborhoods.

Clearly, high-rises are not ideal for large numbers of low-income families. Parents in upper-floor apartments cannot supervise children playing at ground level. Elevator breakdowns force residents to walk up stairwells. Drug dealers take over lobbies. Families double up and overload the plumbing.

Indeed, CHA policy requires all new housing for families to be less

than four stories tall. But there is not enough money to tear down and replace every high-rise. Nor are there many sites for replacement housing that won't stir cries of "not in my backyard."

So revamping high-rises has to be on the agenda. HUD Secretary Henry Cisneros, who wants to tear down one of every three towers in the State Street corridor of public housing, acknowledges that "in some cities, public-housing high-rises work very well."

"The demon is not high-rise public housing," Cisneros said before the takeover.

A Parallel Case

The myth that high-rise public housing is destined to fail springs from the widely publicized 1972 demolition of three buildings at the Pruitt-Igoe development in St. Louis (the remainder of Pruitt-Igoe was leveled in 1976).

But Pruitt-Igoe's problems went far beyond design, as historian Katharine Bristol demonstrated in a 1991 essay published in the *Journal of Architectural Education*. Tightfisted bureaucrats hamstrung Pruitt-Igoe's architects, Leinweber, Yamasaki & Hellmuth of St. Louis, who originally proposed a mix of high-rise, mid-rise, and walkup structures. Because that arrangement exceeded federal cost standards, U.S. officials insisted that the project consist of identical 11-story elevator buildings. Under pressure to keep costs to a minimum, the designers were forced to eliminate amenities such as children's play areas, landscaping, and ground-floor bathrooms. Spending on apartments was trimmed to the bone.

"The quality of the hardware was so poor that doorknobs and locks were broken on initial use. . . . Windowpanes were blown from inadequate frames by wind pressure," political scientist Eugene Meehan wrote in 1979. "In the kitchens, cabinets were made of the thinnest plywood possible."

Over time, Pruitt-Igoe came to be populated by only the very poor, leading the housing authority to ignore maintenance. Elevators did not work. Acts of vandalism were not repaired. Crime soared, a course of events that parallels public housing's history in Chicago.

In New York, in contrast, high-rises have long had a mix of working families and welfare families, stemming from a tight rental market that has made public housing attractive to the working poor. That mix has provided an economic and social stability that permits New York's high-rises to be more like middle-income developments in Chicago.

In addition, management procedures in New York have been more rigorous and resident-friendly than in Chicago. At the seven-story Brevoort Houses in Brooklyn, manager Richard Schultz publishes a quarterly newsletter in which he urges residents to report vandals to a graffiti hot

line, reminds them that dogs and cats are not allowed in the development, and warns against using stoves for heating. "It uses up the available oxygen in your apartment and creates a situation where small children might burn themselves," said one issue of the quarterly *Brevoort Dutch Dispatch*.

Even Jane Jacobs, who vilified high-rise public housing in her 1961 book *The Death and Life of Great American Cities*, was enough of a realist to admit that the huge investment made in public housing could not be written off. A little-cited chapter of her book carries the title "Salvaging Projects."

To those who wish to wipe the slate clean of high-rises, however, renovation promises only a high cost and a short life.

In a 1993 report, the City Club of Chicago asserted that housing authority plans to spend $1 billion to rehab projects including the Robert Taylor Homes, Henry Horner Homes, Stateway Gardens, and Cabrini-Green would be a waste of tax dollars. In addition, the club said, renovation would circumvent the agency's policy of limiting replacement housing to fewer than four stories.

Many high-rises undoubtedly should come down. But in Chicago, where about half of the 30,000 units of family public housing are in high-rises, the dream of demolishing and replacing every one of them with low-rises is unrealizable, despite two programs that disperse public-housing families throughout the city and suburbs.

Because of widespread neighborhood opposition, a scattered-site program that builds low-rise apartments in Chicago has constructed or rehabilitated only about 1,000 apartments over eight years. At that rate, it would take more than 200 years to replace all the CHA's high-rise family housing.

Similarly, a voucher program has relocated at least 5,500 public-housing families to more than 100 suburbs, but prospects for expanding it are limited because private landlords often are reluctant to rent apartments to CHA families.

Planners who support replacing high-rises with low-rises acknowledge that it will be difficult to tear down all the towers immediately. In the interim, they say, it is essential to renovate selected high-rises to improve living conditions for thousands of CHA residents. "We need to do something to fix up the high-rises," said Deborah Stone, executive director of the nonprofit Metropolitan Planning Council.

Where and How

A 16-story government-subsidized Uptown tower provides a conceptual model for renovation. With its boxy red and white facade, the tower at 850 West Eastwood Avenue is a Cabrini-Green look-alike. Constructed in 1969 under a HUD program that spurred private investment in affordable

A WALL MURAL AT 850 WEST EASTWOOD: Confounding the conventional wisdom about high-rise housing for the poor.

housing, the high-rise is a step up from public housing. But before a renovation completed in 1992, its problems were similar to those at the projects, including drug dealing, prostitution, and shoddy maintenance.

Today there are 500 people on the waiting list—five years' worth of turnover. The building is so safe that, in wintertime, residents leave their cars warming in the garage. "They go up and get their kids. It might take 5, 10 minutes, especially with slow elevators," said Regina White, the manager. "That's how secure they are. And the car is their most expensive possession."

Chicago architect Peter Landon, who designed the $4 million renovation, is among those who think that some high-rises can be made livable. He proved it here by creating a design with defensible space, attractive hallways that relieve monotony, upgraded apartments, and common areas that help build bonds among residents.

A wall mural in the community room symbolizes the transformation. In the mural, red balloons float in the sky, a girl swooshes down a slide, boys shoot baskets, and the flat-topped high-rise is pictured in the Chicago skyline, with Sears Tower and the John Hancock Center. This art leaps off the wall because it confounds the typical image of high-rise

housing, wrapping a style of architecture usually portrayed as drab and lifeless into a scene that is bright and life-affirming.

Still, much differentiates the Uptown building from CHA high-rises. Just 15 percent of its residents get some form of public aid, in contrast to 90 percent at the CHA. And it's in a reviving neighborhood, across the street from a school, near a hospital, and on a cul-de-sac. Moreover, there's just one tower—not an entire project. "If you took Eastwood and put five of them next to each other, you'd have problems," said Anthony Fusco, head of the for-profit development firm that owns the building and a former CHA deputy general counsel.

Successful Renovation

Yet the same ideas that transformed 850 West Eastwood Avenue have worked in public housing. They helped hammer out a new environment in six buildings at the Ida B. Wells Extension, part of the public-housing development of the same name.

About a mile and a half east of Comiskey Park, the 40-year-old Wells Extension is removed from the troubled State Street corridor and sits near middle-income developments such as Lake Meadows. In a departure from the high-rise stereotype, its boxy brick and concrete buildings are seven stories tall, a mid-rise height that is at once manageable for maintenance crews and small-scale enough to allow residents to recognize each other.

The CHA has comparably sized elevator buildings at Ickes Homes, Dearborn Homes, Cabrini-Green, and the Henry Horner Homes. Those at Ickes, Dearborn, and Wells have interior corridors, unlike the open-air galleries at other CHA high-rises.

Before the 1993 renovation by the Chicago firm of Dubin, Dubin and Moutoussamy, tenants at Wells Extension had many of the same problems as at the Eastwood building, only worse. Residents became tired of waiting for maintenance workers to change burnt-out lightbulbs, so they unscrewed incandescent bulbs from ceiling-mounted hallway fixtures. That plunged the corridors into darkness. Condensation formed on cement-block interior walls, building into rivulets that ran down the walls and shorted light sockets. "You could go ice skating on some of these floors," said tenant Velma Owens.

The difference between "before" and "after" in the six renovated Wells Extension buildings is startling. In one building, a first-floor children's room brims with positive images, including a tank with brilliantly colored fish and an aquarium for turtles. On the wall is a poster of Ida B. Wells, the antilynching crusader and the project's namesake. The building's nonprofit managers, the Woodlawn Organization, say

that such rooms are important for keeping children engaged in constructive activity.

Framing the entrance to each building, tough glass-block windows allow light to penetrate into lobbies. Corridor floors are furnished in a pleasant blue tile. Ceiling-mounted lighting fixtures in the hallways protect long fluorescent bulbs that cannot be used in individual apartments. Upgraded apartments include new kitchen cabinets and range hoods. Back entrances have been sealed off, so there is only one way in and one way out—the front door, which is patrolled by security guards.

Outside are new entrance canopies, brown paint that softens the harsh demeanor of the exposed concrete frames, plus tuckpointed brickwork. The latter has vastly improved insulation, so in wintertime, the cinder block walls don't sweat with moisture.

Residents say the physical changes, along with improved tenant screening and the introduction of private management, have had a dramatic impact. Drug dealers no longer operate in the renovated buildings. The six rehabbed buildings are practically free of graffiti, while the four that are awaiting renovation are covered with it.

In the refurbished structures, managers say they have little difficulty enforcing rules, such as a $50 fine for children playing in elevators. "Most people are so happy to be in a setting such as this—believe me, they're not breaking the rules," said Deborah Mallory of the Woodlawn Organzation.

The renovation cost $40,000 per unit, less than half the per-unit price of scattered-site town houses in Chicago. It was cheaper, said Richard Rucks, the project architect for Dubin, Dubin and Moutoussamy, because it did not require some of the most costly items of new construction, including a foundation, internal structure, and exterior walls. In addition, he said, it is easier to secure building materials within a renovated structure than a fenced scattered-site property.

Still another dramatic turnaround has occurred at the CHA high-rise complex known as Lake Parc Place, two towers in the 3900 block of South Lake Park Avenue where half of the 282 apartments are reserved for very low-income families and half for the working poor. Lake Parc, which has indoor hallways instead of outdoor breezeways, illustrates how architecture and landscape design convey signals that do nearly as much as the cost of rent and location to determine whether people are willing to live somewhere.

The complex had been occupied by members of the Rukin street gang before the CHA decided to transform it into mixed-income housing. Its Y-shaped high-rises, originally designed in the 1950s, carried the additional stigma of following the same tower-in-the-park model of public housing used at Robert Taylor and Cabrini-Green. By the mid-1980s, there was no

CHICAGO'S LAKE PARC PLACE: Jumping for joy in a middle-class version of tower-in-the-park planning.

park around the towers, just a field with old broken trees, weeds, and garbage.

The Chicago designers who reshaped the property—architects Thomas Hickey & Associates and Johnson & Lee and landscape architect Daniel Weinbach—cleverly turned it into a middle-class version of tower-in-the-park urban design comparable to nearby private complexes such as Lake Meadows.

A six-foot-high wrought-iron fence lines the perimeter of Lake Parc, preventing outsiders from entering at will or trampling its lawn and flowerbeds. Additional fencing surrounds the park between the towers, preventing children from gathering there late at night. Masonry gateposts, capped by tough-to-shatter glass-block walls, stand guard at each entrance. To get past them, residents and visitors must be buzzed in by a security guard in the lobby or have a key.

This design not only is safe but also communicates the impression of safety. The lush lawn and the park act like a symbolic moat that separates the towers from the danger of the rubble-strewn neighborhood around them.

Along with a rent break for working families at Lake Parc Place and the presence of indoor hallways, which provide a measure of comfort and security that outdoor breezeways do not, such design changes have played an instrumental role in breaking down the development's previous cluster of poverty. While it remains to be seen whether the mix of the working poor and the very poor will help those at the bottom of the socioeconomic ladder to climb upward, some upbeat changes already are apparent. In contrast to other CHA developments, for example, there is hardly any graffiti at Lake Parc Place. Maintenance costs are down. In a brightly lit Lake Parc Place lobby, meanwhile, drug dealing is unheard of and teenagers address adults politely.

"Hi, Miss McKinney," they say to Gladys McKinney, the building president at 3983 South Lake Park Avenue.

"Hey, Mr. Cook," they say to the building's manager, James Cook.

These snapshots of everyday life and snippets of conversation represent the triumph of normalcy—or, at the very least, a battle in which normalcy has gained the upper hand.

In many cases, of course, it will be cheaper to demolish public-housing towers than to renovate them. Yet there is a range of workable alternatives for renovating certain kinds of high-rises. With a mix of income groups, defensible space, good management, and location, rehabbed high-rises can save money for the very taxpayers who insist on destroying them.

An enlightened architectural plan is clearly more constructive than a stick of dynamite.

Postscript

By the spring of 2001, the CHA had demolished 22 of its 51 family high-rises as part of its $1.6 billion public-housing overhaul, but other high-rises were spared, including Lake Parc Place. The CHA also was planning to renovate several mid-rise buildings and to rebuild one architecturally significant high-rise complex—the Raymond Hilliard Center by Marina City architect Bertrand Goldberg, which opened in 1966.

The Hilliard Center, two pairs of crescent- and corncob-shaped high-rises in the 2000 block of South State Street, was to be transformed into a mixed-income complex under an $80 million, CHA-approved plan. The agency also received a $35 million grant to revitalize three South Side public-housing developments with mid-rise buildings—the Darrow Homes, the Ida B. Wells Homes, and Madden Park—starting in 2001.

Even as they welcomed the infusion of capital into long-neglected areas, some CHA residents and community leaders expressed concern about a critical shortage of affordable housing. Numbers bore them out, even though CHA officials insisted that no public-housing residents would be made homeless by the agency's massive redevelopment program.

The officials stressed that the CHA had 24,490 occupied public-housing units in 1999. Under the redevelopment plan, they said, 25,000 units would be rebuilt or renovated. But that figure represented a drop of more than 13,000 units from 1999, when there were a total of 38,776 units, both occupied and unoccupied. A similar picture emerged nationwide, where, between 1992 and 1999, about 20,000 public-housing units were demolished while just 5,600 homes were built or renovated. All the numbers added up to the same conclusion: The CHA and HUD weren't coming close to meeting the needs of the poor, either in Chicago or around the nation.

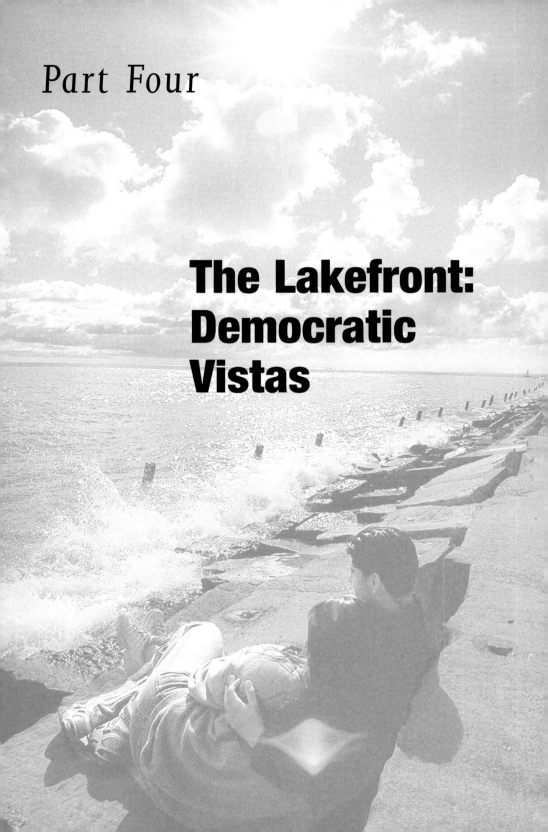

Part Four

The Lakefront:
Democratic
Vistas

A city's greatest public space speaks volumes about its character. Chicago's is quintessentially Midwestern, its wide-open vistas and watery pastures marking the meeting of the Great Plains and the Great Lakes. Yet this intersection of green parkland and aqua blue water is deceptively serene. For all the lakefront offers an escape from urban tensions, it is, just as often, a battleground for conflicting visions of what the city should be.

In the early years of the twentieth century, Daniel Burnham foresaw a populist playground of teeming parks. But after World War II, traffic engineers and others who believed in "progress" took over—with devastating consequences for the shoreline. Expresswaylike roads cut off city residents and visitors from the lake. Huge parking lots pockmarked the parks' green spaces. As the author Lois Wille wrote in her history of the lakefront, *Forever Open, Clear, and Free*, it was "the age of cement and convenience."

In the 1990s, a new land-use ethic sought to reclaim the lakefront from such incursions and to restore the shoreline to its original purpose: a sanctuary for recreation and culture. Its proponents, led by the nonprofit group Friends of the Parks,

won impressive gains, including the city's heroic effort to move the northbound lanes of Lake Shore Drive off the shoreline to create the Museum Campus. In the same spirit, a parking lot in front of the Museum of Science and Industry (just west of Lake Michigan) became a park. There also were smaller victories, including the lakefront's beguiling new variety of beach houses, which showed how new parkland could be built to a human scale.

PUTTING THE CAR IN ITS PLACE

Gem in the Making

The New Museum Campus Is Chicago's Latest Lakefront Jewel, but It Still Needs a Little Polishing

JUNE 4, 1998

A highway seems inevitable, cast in concrete, an act of God. It isn't. A highway exists because someone drew a line on a map and decreed its route. If we want to move highways to improve our quality of life, turning strictly utilitarian alleys of asphalt into grand urban pleasure grounds, then we possess both the ability and the artistry to do so.

That is the humanistic lesson offered by Chicago's new Museum Campus, which realizes the long-delayed dream of bringing together three natural science museums on a greensward uninterrupted by high-speed expressway traffic. The campus became possible in 1996 when the city repositioned Lake Shore Drive's northbound lanes to the west of Soldier Field—and thus off the lakefront.

Now, after the two years needed to green the Drive's former northbound lanes and to link the Field Museum of Natural History, the John G. Shedd Aquarium, and the Adler Planetarium and Astronomy Museum, it is possible to grasp what a boon the $110 million relocation project has turned out to be for Daniel Burnham's vision of a waterfront devoted to recreation and culture.

In all, 36 acres of usable parkland have been added to the lakefront. And in that sense, assessing the Museum Campus is as easy as cheering another three-pointer by the Bulls: when it comes to urban parkland, addition beats subtraction every time. More green space is better than less.

But the issue is more complicated than that. It's a matter of quality, not

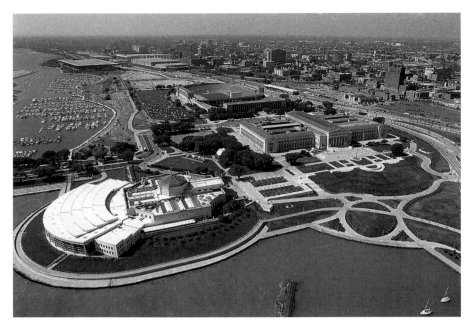

THE MUSEUM CAMPUS: Heroically moving a highway to enhance the lakefront.

just quantity. What kind of parkland? Is it easy to get to? What do we do once we get there? Seen in that light, the Museum Campus emerges as both a great leap forward and an imperfect first step. For all that it represents a major plus for the shoreline, its landscape, parking, and other features require considerable improvement before it deserves to be called a magnificent park.

Any realistic appraisal of this space must begin with the fact that it takes years, even decades, for freshly planted trees and shrubs to mature. Anyone who has moved into a new suburban subdivision, with skinny saplings lining the street, knows that.

Moreover, parking and other planning issues at the campus cannot be separated from the unresolved future of the two major lakefront facilities next door—Soldier Field, where the Chicago Bears are pushing for a multimillion-dollar stadium renovation, and Meigs Field, which Mayor Richard M. Daley wants to convert into a park in 2002.

Still, the broad outlines and many details of the campus can be glimpsed now, and they reveal why cities from Washington, D.C., to San Francisco are questioning the existence of roadways in a way that was unimaginable during the national highway construction binge of the 1950s and 1960s.

What municipalities have found is that these paragons of "progress" are, as often as not, disruptive eyesores, blocking the movement of people to treasured natural assets and hampering efforts to promote tourism and economic growth. With many highways coming to the end of their useful life in the next 20 years, urban planners are debating whether to rebuild them in place or relocate them, as Chicago has done.

As it has been rebuilt between Roosevelt Road and 23rd Street, however, Lake Shore Drive hardly qualifies as a typical highway. It offers spectacular views of the downtown skyline as the driver approaches from the south. And it resembles a boulevard, with handsome median plantings and unobtrusive street-level intersections instead of bare steel and concrete surfaces or ugly expressway ramps.

Equally important, city planners took advantage of the relocation to breach the barriers that historically have separated the Near South Side and the lakefront. A bridge at Roosevelt Road spans the Illinois Central and Metra tracks. An underpass at Roosevelt and Columbus Drive dips beneath Lake Shore Drive, forming the main pedestrian entrance to the campus from Grant Park.

This underpass is but one example of the ingenious mix of practicality and aesthetics contained throughout the Museum Campus, which was designed by Chicago architects and engineers Teng & Associates for the Chicago Department of Transportation.

Because the city's project manager, Richard Kinczyk, did not want pedestrians to cross the Drive at street level and risk injury or death, a way had to be found to get them beneath the road. The solution is as sexy as urban planning gets: the earth moved.

More than 120,000 cubic yards of dirt were displaced in order to create the gently sloping hill that leads down to the underpass as well as the tiered lawn that rises on the other side. The ground was lowered by as much as 22 feet. In the event of a massive rainstorm, water will simply flow through the underpass, to be sponged up by grass on the other side.

A Grand Gateway

As shaped by Teng and the lead consultant on the Drive relocation, the San Francisco urban designer Lawrence Halprin, the underpass is a grand gateway that befits a campus with some of the most impressive Beaux-Arts buildings in Chicago. Once we pass through it, the sounds of seagulls teasing us along, another advantage of lowering the landscape becomes clear: we are gazing at that rarity in Chicago, a hill. Riding the crest of it, in a way that evokes the sun-washed white marble monuments of the Acropolis, are the mighty temples of the Field and Shedd.

From this point, we can see how Teng's chief designer, John MacManus, arranged the north side of the campus: the great lawn, with its three cascading tiers, extends the monumental symmetry of the Field Museum into the landscape. Rising behind the lawn are white walls of precast concrete; they frame terraces in front of the Field and the Shedd where outdoor programs will be held. The terraces, which are reached by ramps accessible to those in wheelchairs as well as by grand flights of stairs, include a miniterrace, appropriately shaped like a ship's prow, that juts out from the sea-themed Shedd.

To the south of the three museums, directly atop the former north-bound lanes of the Drive, is a meandering pathway for cyclists and Rollerbladers, undisturbed by the revving of automobile engines and screech of tires. Burnham Harbor also has been reconfigured, with a new pedestrian promenade that makes it less of a country club for boaters and more of a public space.

A first impression, based on a number of treks around the campus as well as random interviews with a dozen visitors, is that it is likely to become a destination in its own right, much as people come to the grounds of the Getty Center in Los Angeles to see the stunning views of the Pacific Ocean and the craggy mountains—and never set foot inside the Getty Museum. Here, of course, our "mountains" are the skyscrapers of the Loop and our "ocean" is the lake.

With the encouragement of his enlightened clients from the city, MacManus has designed the campus as a journey that gives us both sweeping grandeur and human scale, as exemplified by the many corners that break up the monolithic profile of the white, precast concrete walls. There, just as MacManus hoped they would, people feel protected and lean their elbows on top of the wall, gazing out at the lake.

Yet there are problem areas, especially the terrace in front of the Field, which has been stripped of the trees and shrubs that MacManus planned. Why? Perhaps because the Field once coveted an extension of Roosevelt Road across Lake Shore Drive to make it easier for drivers to get to its front door—an outrageously selfish step that would have trampled the very principle, liberating the lakefront from cars, that brought the campus into being. Whatever the reason for the absence of the trees and shrubs, the Field's terrace, unlike its counterpart at the Shedd, is bereft of intimacy and intricacy. Simply put, it resembles a big billiard table.

More Trees Needed

The lack of foliage means there is nothing to soften the presence of the white concrete walls between the great lawn and the terraces, as Mac-

Manus intended. True, the walls possess a toughness that prevents them from looking flimsy in such a vast, monumental setting. But without greenery, they seem fortresslike; you almost can envision soldiers hiding behind them, guarding the hilltop.

The tiered lawn in front of Field seems oddly scaleless, bare, and unfinished, a characterization that also applies to the new swath of grass between the Shedd and the Field where the Drive's northbound lanes used to run. Because this parkland is at the foot of Solidarity Drive, the land bridge that links the two museums to the Adler Planetarium, it has the potential to be the campus's symbolic heart. In its present state, however, it is simply leftover space, a void that hasn't been thought through.

Things get worse at Solidarity. While the northern part of the campus is in effect a great front porch from which to watch the skyline and the lake, the segment that starts at Solidarity is the equivalent of a back-door service road, often crammed with cars and tour buses. Here, at least, the campus is not really a campus at all, and the Adler seems left on its own—reachable on foot from the other museums, but hardly connected to them through the landscape's design.

All this, at root, is a problem of parking and access, and nothing is likely to get solved until Soldier Field's future is determined. Even the leaders of the museums acknowledge that the trolleys they are running between the inconveniently located south and east parking lots of Soldier Field and their institutions merely represent a stopgap measure until a better parking solution is found.

In looking at how visitors navigate the campus, the museums also might address its lack of informative signs, which the Chicago Park District's plan to install conventional park signs will not rectify. Some of the visitors I encountered wanted to know such basic things as what the museums display, their hours, and the price of admission. Surely there is a way to answer these questions while avoiding sign clutter, perhaps with information kiosks at key entrances to the campus.

Now that the big move—relocating Lake Shore Drive—has been accomplished, there are lots of smaller moves that the museums need to make. Moving the Drive has broken down barriers to the lakefront as well as barriers between the museums, which, after years of competing, are finally cooperating. Their agenda should be simple: to create a campus that is more than the sum of its parts, a kind of permanent world's fair that celebrates the cosmic subject matter of the three museums—the earth, sea, and sky—while offering the everyday pleasure of communing with the lake.

Amazing what can happen when you move a highway.

Postscript

The Chicago Park District tinkered with several of the Museum Campus's problems in 1999 and 2000—with mixed results. At Daley's behest, the once-blank area in front of the Field Museum was filled with formal, rectangle-shaped groupings of lindens, yews, and ground cover. While the lindens blocked views of the Field's classical facade, the plantings filled the gap in scale between the massive museum and the comparatively tiny pedestrian. Meanwhile, a food concession and restroom pavilion was placed on the swath of grass between the Field and the Shedd Aquarium.

But a whole new set of Museum Campus concerns arose after a $580 million Soldier Field renovation plan was passed by the Illinois General Assembly in 2000 and by the Chicago Plan Commission and the Chicago City Council in 2001. The chief feature of the design, by Lohan Associates of Chicago and Wood-Zapata of Boston, called for an enormous new seating bowl within Soldier Field's historic colonnades. The bowl's western grandstand was to loom 45 feet above the stadium's rows of Doric columns, making them resemble matchsticks. The plan thus threatened to bring the gargantuan modernism of the nearby McCormick Place convention center into the heart of the Museum Campus, trashing the classical ensemble formed by Soldier Field, the Field, and the Shedd.

Still, the plan addressed several shortcomings of the campus, especially its lack of close-in parking. The architects proposed demolishing the Park District's headquarters building, located across McFetridge Drive from the Field, and replacing it with a 2,500-space underground garage that will provide convenient parking for Museum Campus visitors. Barring a successful court challenge by lakefront advocates or a change of heart by Daley, the changes are expected to be finished in time for the 2003 football season.

Park Above, Parking Below

A Subterranean Garage Adds Excitement to a Museum and Green Space to the Lakefront

JULY 16, 1998

A review of an underground parking garage? My editor thought my glasses had fogged up.

But if a garage turns out to be as visually enticing and as significant to the cityscape as the one that's about to be dedicated at the Museum of Science and Industry, then there is every reason to take it seriously.

Look closely and you realize that this is much more than a 1,500-

THE MUSEUM OF SCIENCE AND INDUSTRY (Before and after): Not getting rid of the car, but putting it in its place.

space, three-level hole in the ground where you plunk your car or minivan while enjoying such perennial crowd pleasers as the Coal Mine and the U-505 Submarine. It is a work of urban design and historic preservation, replacing an eyesore, the sprawling, 1,300-space surface parking lot that used to be in front of the grand Beaux-Arts museum, with a big green

carpet—six acres of parkland at the northern edge of Jackson Park. It also houses exhibition space, with a silvery, 197-foot-long train, the restored Burlington Pioneer Zephyr, set like a jewel in its center.

And it has prompted what is, in effect, an expansion of the museum, a towering underground entry hall just south of the garage that leads, via staggeringly long escalators, toward the museum's domed center. From the hall's wavy white ceiling hangs a dazzling piece of sculpture, a full-scale replica of the Cassini space probe now zooming toward Saturn. Once you arrive upstairs, it is much easier to orient yourself, a welcome change from the maze that used to confront you (and still does elsewhere in the building).

In other words, much more than a garage story has been unfolding at 57th Street and Lake Shore Drive.

The $57.6 million project is in many ways a cousin of the new Museum Campus at Roosevelt Road and the Drive. The big idea that unites both efforts is putting the car in its place—not banishing it from the lakefront, but diminishing its presence and thereby freeing precious land along Lake Michigan for strolling, picnicking, Frisbee-playing, or whatever else people choose to do.

Credit for the Museum of Science and Industry addition goes to Boston architects E. Verner Johnson and Associates, who conceived the museum's master plan; Chicago landscape architects Jacobs/Ryan Associates, who shaped the parkland; and Chicago architects A. Epstein & Sons International, who designed the garage, the space enclosing the Zephyr, and the entry hall.

Epstein also did the structural engineering for the project, no small thing because the equivalent of a bathtub had to be built in concrete around the garage to keep groundwater from seeping in.

Although the garage is underground, one of main design issues was the impact it would have above ground—specifically, how it would affect views of the 105-year-old museum, an official Chicago landmark built as the Palace of Fine Arts for the World's Columbian Exposition of 1893 and rehabilitated in the 1930s after a $5 million gift from Julius Rosenwald, president of Sears, Roebuck & Co.

Ionic colonnades, domed roofs, and porches supported by columnlike figures of women called caryatids make the museum a prime example of the classicism that predominated at the fair. Yet the museum's beauty has been concealed behind parking lots as well as additions such as the Henry Crown Space Center and outdoor exhibits such as the U-boat. The last thing it needed was to be liberated from the main parking lot, which had grown gradually over the years, only to have views of it marred by air vents and other aboveground protrusions of an underground parking garage.

The solution reached by the designers is appropriately respectful,

deferring to the building rather than straining to make a statement of its own. Only underground, where they were less constrained by history, did they let loose with a dynamic contemporary design that still manages to be in keeping with the museum's Depression Moderne interior.

At street level, the grand symmetry of the Beaux-Arts exterior is echoed in a pair of rectangular, classically inspired pavilions. Designed by Epstein, they allow those who park in the garage to ascend to ground level and to enter the museum via its grand stair. Although the pavilions are somewhat boxy and their roofs are crudely designed, their low-slung proportions, Indiana limestone cladding, and classical details don't get in the way as you eyeball the museum from 57th Street.

In the same modest spirit, Jacobs/Ryan has restored the landscape to the post-1893 world's fair look created by the Olmsted brothers, the successors to the great landscape architect Frederick Law Olmsted. A slightly sloping lawn without trees or shrubs ensures uninterrupted views from 57th Street. When they get a little fuller, lining both sides of the sidewalk along 57th, sugar maple trees should provide a well-defined sense of enclosure for those taking a stroll.

As part of the project, 57th has been dressed up with replicas of the eclectic streetlights used at the fair. Far from looking as though they belong in a theme park, they are, like the historic streetlights on State Street and Michigan Avenue, handsome and human-scaled, with a ring of authenticity because they are based on what was there before.

The big question is whether people are going to use the parkland. Right now, it almost looks as if it were meant to be seen, not touched. But give it time.

Not only does the museum's president, David Mosena, realize the need for programs that will make this very formal parkland a more active space, but also South Siders need awhile to make it their own. More benches would help, particularly in the roomlike outdoor spaces that flank the grand stair and offer splendid views of the caryatid porches.

Mainly, there is reason for optimism because that hideous parking lot, which acted like a moat that cut off passersby from the museum, is gone. Now, at least, the place seems more approachable. So pedestrians should start to wander in.

As for the garage, it's top-of-the-line—clean, brightly lit, with playful transportation-themed signs ("planes," "submarines" and "trains") to help you remember which level you stowed your vehicle on. And you don't have to go outside or travel far, as you do in the inconveniently located lots of the Museum Campus.

Mostly, the garage benefits from the presence of the Zephyr, which is set

atop specially built railroad tracks in a setting that resembles a train station. Its still-elegant streamlined shape is visible from all three levels of the garage. Epstein has put the train, which in 1934 set a land speed record by traveling nonstop from Denver to Chicago in 13 hours, to excellent use.

Because it bisects the garage, the train breaks up what otherwise would have been huge floors into manageably sized chunks. That surely helps to orient visitors, a key part of the museumgoing experience. The train also elevates the garage into something more than utilitarian. The fun of scientific discovery, it says to kids and their parents (in a way that the imposing classical exterior does not), starts at the front door. With the overhead lighting that turns the train into a gleaming object, that message is even more powerfully reinforced.

The Zephyr exhibition and the entry hall that begins at the train's gleaming nose are both things to be thankful for. If the museum and the Chicago Park District had not come up with $14.9 million beyond the $42.7 million in garage funds allocated by the federal, state, and city governments, there would have been no Zephyr space, and the entry hall would have been a visual disaster: a mean-spirited tunnel leading to the museum proper. Certainly no one would have called it the Great Hall, the name it now bears, without feeling foolish.

As built, however, the Great Hall conveys precisely the opposite impression. It is grandly scaled but not grandiose. Even though there's not a hint of natural light in the three-story subterranean space, the atmosphere couldn't be sunnier. You see the curvy, space-age ceiling and you're tempted to say, "Roger, Houston, ready for liftoff!"

The architects have worked a neat fusion in this exuberant space. They have taken some visual cues from the sleek curves of the train (stainless steel–clad columns, admissions desks, and the room itself are all oval shaped). Yet they have melded these Depression Moderne motifs with a dynamic series of forms, like that ceiling, that are strongly contemporary, if somewhat derivative of interiors such as the International Terminal at O'Hare.

But who's complaining? To ride up that long escalator is the late twentieth-century equivalent of ascending the steps of a classical temple, and when you get to the dome on the ground floor, the building's cross-shaped floor plan is easily grasped. All that's missing are views through some now-closed south doors of the museum to the Jackson Park lagoon, which would bring natural light into the cavernous interior and further help to orient visitors.

Still, there's only so much you can reasonably expect from an underground parking garage, even one this good. Here, digging down has raised our sights, scientific and aesthetic.

Beauty and the Beach

Three New Castles in the Sand Suit the Lakefront Perfectly

AUGUST 17, 1999

A beach house isn't simply a shed where we change out of our workaday clothes and into bathing suits. It is, ideally, a doorway between the land and the water, a picture window that frames views of sea and sky. It catches the cool air that flows off the water, soothing hot skin as well as frazzled nerves. It entices us to the water's edge while evoking sun-bleached memories of summers past.

For all these reasons, there is much to celebrate in three beach houses on Chicago's lakefront—new ones at North Avenue and Rainbow Park, and another that's been renovated at 63rd Street. Each is wonderfully distinctive, at once endowing its surroundings with a sense of place and ennobling the commonplace act of digging one's toes in the sand.

An updated version of the Depression-era building it replaced, the North Avenue Beach House resembles a steamship run aground with its faux red funnels. Nearly 10 miles down the lake, at Lake Shore Drive and 63rd Street, the Jackson Park Beach House spreads out along the waterfront like a palace, its green tile roofs floating majestically above the sand. Another two miles away, near 79th Street and South Shore Drive, the Rainbow Park Beach House brings a fresh, modern look to the lakefront, with silvery steel beams and circular sunshades that evoke wide-open umbrellas.

Beyond the glistening white museums for which it is best known, Chicago's shoreline now offers a colorful array of beach houses.

Come see them one by one.

The North Avenue "Boat"

Given its profusion of portholes, prows, smokestacks, and other nautical details, some passersby may think North Avenue's new beach house is a replica of the old one, once jokingly described as an example of the "early ocean liner" style.

But for all it appears to be a retro echo of the blue-and-white original—built in 1939, when streamlined trains and even buildings reflected America's infatuation with machines—the new beach house is anything but a slavish copy. It's new and improved—"neo–ocean liner," if you will.

The enhancements go beyond the beach house's oval shape, which is more fetchingly sculptural than its mostly straight-lined predecessor. By shifting the location of the beach house slightly to the south and east from

THE NORTH AVENUE BEACH HOUSE: Nautical like its 1939 predecessor, but improved in location and design.

its original spot at the end of North Avenue, the design team for the $7.1 million project—G.E.C. Design Group, with Wheeler Kearns Architects and the urban designer John MacManus—accomplished three big things.

The new site opens a vista of the lake, blocked by the old building, as one looks eastward on North Avenue. It creates a spectacular view of the beach house—Hey, is that the Queen Mary?—as drivers round the Oak

Street Beach curve on Lake Shore Drive. And it eliminates a dangerous "pinch point" where bicyclists, pedestrians, and cars crammed together just west of the beach house.

Now this stretch of the lakefront—the most heavily used beach in Chicago, drawing an estimated 7.1 million visitors a year—doesn't feel like the Kennedy Expressway at rush hour.

As skillful as these urban design moves are, it is architecture that stars at the North Avenue Beach House. In this facility, which includes public bathrooms, a lifeguard training center, and a new rooftop restaurant, Wheeler Kearns has done a superb job mixing the visual and the practical.

The key is that the architects have conceived of the building as something other than a one-liner. There are things to delight you all the way through, like handsome black Art Deco lettering on the outside and sea-blue wave patterns on the restroom walls.

But there's more to the building's appeal than imagery. The beach house has an intriguing sequence of spaces, beginning with its breezy central passageway and culminating as the visitor climbs stairs enclosed by the smokestacks and looks up to glimpse stunning oval-shaped views of the sky.

In Chicago, which tends to be oh-so-serious about its architecture, there's nothing wrong with a building that makes us smile. This playful beach house reminds us that innovation isn't only about inventing brand-new forms; sometimes, it means updating and improving upon those that already exist. The result at North Avenue is utterly captivating.

Old Glory in Jackson Park

At the Jackson Park Beach House, the task was to restore a people's palace to its former glory.

Built in 1917, the building is one of the most ceremonial on the lakefront. Its green tile roof was designed to arrest the eye of the passerby while its enclosed upper-level promenade provided the perfect place for ladies with parasols to gaze out upon the lake and sky.

Whereas the North Avenue Beach House is sleek and light, its counterpart at 63rd Street is rough-edged and heavy, emulating a mansion rather than a machine. Yet the building is permeable as well as powerful, its massive walls punctuated by airy arches. The beach house's beauty is enhanced by its concrete exterior, an unusual mix of cement and stone that has a texture comparable to old-fashioned peanut brittle.

When renovation began in 1997, however, the trouble was that the concrete was crumbling after decades of deferred maintenance and the ravages of the wind off the lake. "It essentially had been sandblasted for

THE RESTORED JACKSON PARK BEACH HOUSE: Bringing back the luster of a people's palace.

80 years," says one of the architects on the job, Peter Dubin of Mann, Gin, Dubin & Frazier (MGDF).

Steel reinforcing bars jutted out from the battered concrete. Weeds grew in the breezeways. Charcoal-gray asphalt shingles had replaced the green tiles on the roof. The once-grand building had essentially become a Chicago Park District storage locker—and, for South Siders, it was a bitter symbol of the way their lakefront was a poor cousin to Lincoln Park to the north.

Now, the Jackson Park Beach House is again a proud gateway, after a sensitive $6.2 million restoration carried out by Consoer Townsend Envirodyne Engineers, the MGDF firm, and DLK Architecture. Another $900,000 from the Chicago Department of Transportation paid for a traffic light and other road improvements.

What is so alluring about the design team's work is that you can't readily see it; they have worked with contractors to insert new concrete amid the old so that the building's surface is an almost seamless whole rather than a patchwork. (It took 30 samples of the concrete to get the job right.)

The green tile roofs and their broad eaves are back, making the building a commanding presence when seen from Lake Shore Drive. It's a knock-out up close, too, with restored details like floral scrolls beneath projecting balconies.

Step inside and there's more to like, especially in two courtyards where

THE RAINBOW PARK BEACH HOUSE: A striking adaptation of the Chicago Park District's typical beach house.

men and women once changed in the open air. With a $2 million grant from the Max Schiff Trust, the courtyards have been handsomely refurbished by the landscape architects Wolff Clements. One is a formal space with lush plantings. The other is informal, with a circular, computer-controlled fountain that invites children and adults to run through its dancing waters.

For all this building has come forward, though, it still has a way to go, especially when it comes to being people-friendly. The restored upper-level promenade, a beautifully proportioned enclosed space that frames stunning lake views, was padlocked shut on two recent occasions. Park District officials promise to correct that problem immediately, but they can do more to bring this space to life. A food cart would be nice. So would tables and chairs. The challenge is to bring the quaint promenade into the age of outdoor in-line skating rinks and beach volleyball courts.

Umbrellas in Rainbow Park

That era already has arrived at the Rainbow Park Beach House, by far the most modern of the lakefront's new facilities.

Part of a $4.6 million project that includes a new but old-fashioned-looking field house (a design dud, unfortunately), the beach house is a creative adaptation of the generic Park District beach houses that have been built at 57th Street and other lakefront locations. In essence, it con-

sists of a bathroom building and a concessions-and-lifeguard building, which flank a covered passageway that leads to the shoreline.

Unlike the generic beach houses, however, which are small and look like it, this is a big little building, its civic presence enhanced by an updated pergola—an arbor made of horizontal trellis work supported on columns.

Once, the pergola would have been made of wood. Now, as designed by David Woodhouse Architects, the columns are concrete-filled steel tubes and the trellislike beams are steel; together, they recall the marine derricks used in the Port of Chicago just to the south. Affixed to them are circular fiberglass panels that turn the sun's brightness down a notch. Their corrugated surfaces suggest the stripes of beach towels while their shapes evoke open umbrellas.

There's more that ties this building to its setting. The concrete block, for example, looks sandy rather than gray. Whereas some of the generic beach houses have gabled roofs that make them seem more of the land than the lake, this one is purposely low-slung, much like the beach house at North Avenue. "An artifact of the beach—heaped-up sand," says Woodhouse, who also designed the adjacent fieldhouse.

His beach house is perfectly laid out, its wings splaying diagonally to take advantage of the dramatically curving site at Rainbow Park, which has spectacular across-the-water views of the downtown skyline. Indeed, the circular fiberglass panels seem to open like a lifeguard's flip-up sunglasses, beckoning the visitor to enjoy the scene.

Happily, there are picnic tables where people can sit and, as at North Avenue and 63rd Street, outdoor showers where kids can get the sand off their feet before getting back in the car. But restroom and restaurant signs have yet to be installed, so the building looks a bit sloppy. And the Park District needs better road signs directing people in from South Shore Drive.

Still, faults like these are easily corrected. With a little buffing and burnishing, the beach house at Rainbow Park—and the lakefront's other new gems—can really sparkle.

REINVENTING THE LAKEFRONT

Nature didn't give Chicago its glorious shoreline. Good planning did. But late in the 1990s, flush with prosperity and fawning over Mayor Richard M. Daley's bevy of beautification projects, Chicagoans seemed to have forgotten that essential lesson.

While isolated improvements to the lakefront created the impression that all was well, a look beneath the surface revealed a very different story: a public space that was failing to live up to its vast potential. Worse, more than half a billion dollars in public and private funds were to be spent on the lakefront in the first years of the twenty-first century. Yet Chicago faced the prospect of squandering the money because it lacked a comprehensive blueprint for its most precious civic asset.

The need for one inspired the publication of the six-part series "Reinventing the Lakefront." The series documented what was wrong with the lakefront and presented a vision to make things right. It began with an overview that punctured the myth of the picture-perfect lakefront.

A Flawed Jewel

The Lakefront Needs Help, and the City of Chicago Has a Rare Chance to Remold It for the Twenty-first Century—but Where's the Vision?

OCTOBER 26, 1998

The lakefront is Chicago's undisputed crown jewel, a timeless treasure that brings dazzling images to mind: of fireworks and band shells, sailboats dotting blue waters, museums rising like wedding cakes from a sweeping expanse of green, skyscraper cliffs winking in the night sky. Our front yard, the lakeshore is the face Chicago presents to the world.

But zoom in on the 30-mile stretch of beaches, harbors, and parkland between Indiana and Evanston and troubling blemishes appear. What you see is a resource that is in serious imbalance, alternately overwhelmed and underachieving, a carelessly treated beauty that has lost much of its sheen.

The lakefront and its parks represent a legacy of incalculable value, a testament to visionaries such as Daniel Burnham, who, more than a hundred years ago, recognized that public spaces made better democracies, better citizens, and better lives. It is remarkable that what Burnham and others conceived so long ago still serves us in so many ways.

Yet, inexplicably, we have done little to build upon that legacy. The lakefront is at once a victim of our poverty of imagination and the crippling consequences of its own success.

As good as it is, the lakefront could be so much more. It could realize its vast potential if we just had a vision—and the will to act on it.

Here is what new or revamped public space along Lake Michigan could do:

It could help bridge the racial chasm that has long split Chicago.

It could begin to lift entire neighborhoods out of oblivion.

It could heal us physically, especially as the population ages, and could be an ever-renewable source of peace and fulfillment.

It could be a democratizing influence, allowing people from diverse backgrounds to mix and come to appreciate one another.

It could celebrate not only dead presidents and generals, but also the so-called ordinary men and women who endured extraordinary hardships to build this nation.

All this, which would enrich our lives immeasurably, is within our grasp. Yet we are missing our chance.

The lakefront, whose 3,000 acres of parkland, 29 beaches, and eight harbors attract an estimated 65 million visits a year, is off the public pol-

THE 49TH STREET "BEACH": A symbol of the decrepit south lakefront, where swimmers must descend a broken seawall to get to water.

icy radar screen. The city has been lulled by a booming economy and the illusion that Mayor Richard M. Daley, well-known for beautifying the city, has everything in hand when, in reality, he doesn't.

"The people and the powers that be in Chicago came to take the lakefront for granted," says Lee Botts, former director of the Lake Michigan Federation, a not-for-profit group devoted to the lake. "They have continued to brag about it, tout its virtues and its values to the city while they continue to let it fall apart."

The lakefront needs more than the mayor's Martha Stewart-izing. It deserves city planning as well as civic decorating.

It requires a forceful hand to bring together the Balkanized multitude of federal, state, and local agencies that have split the people's shoreline into fiefdoms—someone who can either coax or bully their leaders into pursuing a common vision.

Consider the state of the lakefront now, 25 years after the October 24, 1973, passage of the city's Lakefront Protection Ordinance, a historic piece of legislation that stopped huge commercial projects such as McCormick Place from desecrating any more public land along Lake Michigan:

- If someone from a foreign land were to traverse the lakefront for the

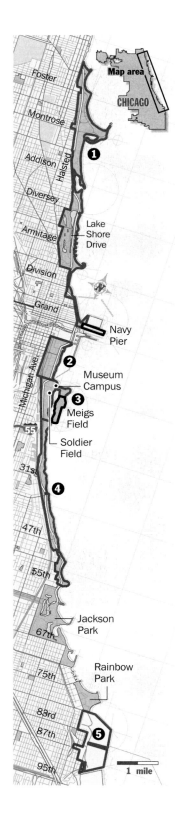

Key issues, key areas

Easing congestion

❶ Lincoln Park: Chicago's biggest park is crammed with cars and people. Will it help to spread Lincoln Park's wealth of activities to the rest of the lakefront?

Creating common ground

❷ Grant Park: During summer festivals, the centerpiece of the lakefront is jammed. Otherwise, it's practically empty. Can the city knit together several big projects into a park that is inviting year-round?

Three hot spots

❸ Navy Pier, Soldier Field, and Meigs Field: These three sites symbolize the fragmentation of lakefront decision-making. Is there a way to coordinate their futures?

Ending separate and unequal

❹ Burnham Park: The park named for Daniel Burnham reflects how Chicago has shunted aside its minority poor. With millions of dollars about to be spent on the south lakefront, is there a vision to address the city's racial divide?

Forging the postindustrial future

❺ South Works plant: Bigger than the Loop, the former U.S. Steel plant presents a huge canvas on which to paint new parkland. Will planners approach that prospect creatively?

NORTH AVENUE BEACH: An example of overcrowding on the north lakefront, packed during August's Air and Water Show.

first time, that visitor would see two Chicagos. One north, the other south. One mostly affluent and white, the other largely poor and black.

The very park named for Burnham, which sits on the stretch of the south lakefront lined with high-rise public housing, is a monument to neglect and inequality, a rubble-strewn landscape that lacks the basic facilities, from restaurants to restrooms, that most parkgoers take for granted.

A few miles north, where luxury high-rises overlook Lake Shore Drive, Lincoln Park has everything one could ask for: a zoo, harbors, cafes, and lagoons. Yet it is so overused and crowded that one sometimes risks life and limb by going there. The 1999 opening of the $30 million Peggy Notebaert Nature Museum at the already jammed intersection of Fullerton Parkway and Cannon Drive can only make things worse.

• Go to Grant Park and you find a lonely place with a world-famous fountain trapped behind a fence. When the city needs room for a million festival revelers, Grant Park fills the bill. But during the rest of the year, it is almost desolate because its spaces are not designed to a human scale.

• Go to the shoreline, where the revetments—the blocks of stone that are supposed to guard the parks from the lake's pounding—are partially in ruins. The great rocks also are intended to allow parkgoers to stroll or sit on their stairlike tiers. But in many spots they lie upended or splintered, recalling a landscape that has been bombed.

More than a third of Chicago's 30-mile shoreline—11 miles of beaches,

breakwaters, and revetments—has been devastated by the lake and must be rebuilt by the U.S. Army Corps of Engineers at a cost of $269 million. Yet the job's planned timetable is so leisurely as to be absurd. It is not scheduled to be completed until 2010. As a result, temporary concrete barriers, already being put in place along South Lake Shore Drive, are needed to stop winter storms from flooding the vital traffic artery.

Meanwhile, two beaches listed on the supposedly definitive Rand McNally map of Chicago, beaches that the mapmaker says are available for sunbathing at 49th and 67th Streets, simply do not exist. They were allowed to vanish beneath the waters long ago. At 49th Street, there is even the bizarre sight of a beach house but no beach. To go swimming, adventurous teenagers must climb down a series of slippery, jagged rocks.

• Go down to 87th Street and peer behind a chain-link fence where an enormous chunk of land, bigger than the Loop, lies fallow. Once it was home to a huge U.S. Steel mill, the celebrated South Works, which forged the metal that undergirds Sears Tower and other Loop skyscrapers. Here, the potential to make a public space that preserves the history of working people and their contributions to the nation is as yet unrealized.

• Go to any part of the lakefront and you will run into a concrete curtain—consisting of highways, ramps, the largest convention center in the United States, and mall-sized parking lots—that makes getting to the shoreline on foot either difficult or next to impossible. An egregious example: the sea of nearly 5,000 parking spaces, operated by the Chicago Park District, that surrounds Soldier Field.

"Is the Park District in the parking business or the parks business?" asks Erma Tranter, executive director of Friends of the Parks, a not-for-profit civic group.

Lincoln Park's crammed bicycle path, where cyclists, joggers, walkers, Rollerbladers, and mothers with baby strollers jostle for space on a strip of asphalt just eight feet wide, is a classic example of how changing trends in recreation have caught the Chicago Park District flat-footed.

As recently as the 1930s, bicycles weren't even allowed in Chicago's parks. When the lakefront bike path opened in 1963, no one foresaw the explosion of biking, running, and in-line skating that has rendered the path more crowded—and dangerous—than many city streets.

New trends threaten to make the lakefront equally out of sync with the people using it. Some examples:

• With the first of the Baby Boomers due to hit 60 in 2006, the lakefront will soon undergo a huge influx of elderly people. What sort of activities, tailored to their needs, will be available for them at shoreline parks?

• By 2010, Chicago is expected to have fewer whites and more

OAK STREET BEACH: Forcing the myriad agencies that control the lakefront to work together may be as hard as getting these teens to obey signs.

Hispanics, Asians, and blacks. That trend matters because, surveys show, different ethnic groups use parkland differently. Whites typically come alone or in small groups while those from other cultures tend to arrive in larger contingents and prefer communal activities such as picnicking. How do we accommodate everyone?

• When Chicago was a city of tightly knit neighborhoods, and the pendulum of people's activities often swung between the local church and saloon, a trip to a major park was a special event. People dressed up and took stately promenades. Grant Park, which was modeled on the formal gardens of Versailles, was designed for such a society. But it is ill-suited to the casual, fitness-oriented, Frisbee-throwing lifestyle.

Treated creatively, such challenges represent a chance to make a better lakefront. Yet Chicago lacks the vision and tools to respond to them.

While the city, the Park District, and the Cook County Forest Preserve District this year unveiled a citywide open-space plan covering everything from the Chicago River to neighborhood parks, its chapter on the lakefront is a laundry list of vaguely worded policy goals. One of them calls for "coordinating all lakefront planning and development," but doesn't say who will do the coordinating. Nor have any meaningful steps been taken in the 10 months since the plan was published. In fact, control over

the lakefront is fragmented among a Byzantine collection of agencies that jealously guard their turf. Worse, they often work at cross-purposes:

• Lake Shore Drive comes under the purview of the Illinois Department of Transportation, whose top priority is moving vehicles safely and speedily. But the expresswaylike character of the drive frustrates Park District planners, who want to make it easier for people to walk from the city to the lake.

• The giant McCormick Place convention center and popular Navy Pier are controlled by the Metropolitan Pier and Exposition Authority, a quasi-public, city-state agency that seeks to maximize attendance at both facilities. Yet the convention center and pier, which are poorly served by public transit, cause huge traffic jams on the Drive.

• The revetments are the province of the U.S. Army Corps of Engineers, the primary construction agency of the federal government, which is charged with preventing flooding at the least possible cost to American taxpayers. Yet that mission sometimes puts the corps at odds with the Park District, as when the corps proposed replacing the shattered revetments with mounds of stone—a configuration that would prevent parkgoers from walking or sitting on them.

The plan eventually was dropped, but endless delays in the rebuilding have frustrated Daley, who sent senior aides to lobby Vice President Al Gore to speed things up. City officials are now negotiating with the corps to shift the target date from its original 2010 to 2005.

The list of agencies that control a piece of the lakefront goes on and on. There is the Chicago Transit Authority, which transports people to and from the shoreline. The Chicago Police Department, which patrols the lakefront. The Chicago Department of Transportation, which controls key lakefront roads. The Chicago Plan Commission, which monitors the Lakefront Protection Ordinance. The Chicago Department of Planning and Development, which is supposed to sketch out the future of big lakefront sites such as the former U.S. Steel mill. The Mayor's Office of Special Events, which choreographs city festivals. Commuter railroads, such as Metra, whose trains slice through the lakefront. Even the Federal Aviation Administration, which regulates the airspace around Meigs Field.

Granted, cooperation among some of these entities is possible, as shown by the $110 million rerouting of Lake Shore Drive's northbound lanes and the creation of the Museum Campus, the new cultural complex south of Grant Park. The project was chiefly funded by the Metropolitan Pier and Exposition Authority and carried out by both the city and the state.

But such efforts are the exception rather than the rule. And that has major implications for the shoreline.

During the next 12 years, more than $500 million in public and pri-

vate funds will be spent on the lakefront, mostly to repair what is already there. Without a coordinated vision that pulls together the disparate efforts of the various players, the lakefront will continue to fall far short of its enormous potential.

Some changes could be made that would cost virtually nothing, such as moving the Chicago Air and Water Show from North Avenue Beach to 31st Street Beach. It would ease congestion in overcrowded Lincoln Park and add vitality to moribund Burnham Park. Granted, the boon would last just one weekend, but the germ of the idea could, to cite a noted planner, let a thousand flowers bloom if other attractions now in Lincoln Park are shifted to the south lakefront.

Other changes can be made by looking holistically at now-isolated projects, such as the $150 million Lakefront Millennium Park at the northwest corner of Grant Park. While the new park will cover an ugly railyard, it will do little to address one of the main reasons Grant Park is underused: giant roads, such as Columbus Drive, with eight lanes that ram through the park, frightening anyone on foot.

The fate of the lakefront transcends Chicago; this is a time when public space is under attack in America as never before. You see it at sporting events, where the wealthy and powerful sit apart from everyone else in their skyboxes, or in the new gated subdivisions. Terrorist attacks at home and abroad, meanwhile, have turned federal buildings into fortresses rather than symbols of government's openness to the people.

But the lakefront is common ground, a ribbon of green that beckons to a rainbow of humanity. It is what architects call an "edge," a dramatic meeting of two very different things, in this case the fluidity of the water and the solidity of the city.

We are lured to this edge for the same reasons that human beings have always beaten a path to oceans, rivers, and lakes: at the shoreline, we drink in some of the best of life.

The lakefront is where we enact our secular rituals—the social rites of summer festivals, tailgating at Bears games, smelt fishing, and toasting Bulls championships. Yet for all that it brings us together, it is also a place where we go in search of solitude. As Herman Melville, the author of *Moby Dick*, wrote, "Meditation and water are wedded forever."

The Chicago lakefront's importance to the region will only grow because there will be few chances in coming years to add large chunks of waterfront open to all—even though by 2020 the population of the six-county area is expected to rise to 9.1 million from the current 7.6 million. At the former U.S. Army base of Ft. Sheridan, surrounded by the North Shore towns of Highland Park, Highwood, and Lake Forest, just one mile of publicly acces-

SMELT FISHING AT NORTH AVENUE BEACH: One of the many secular rituals Chicagoans cele-
brate in the lakefront's cathedral of public space.

sible beachfront will be created as the base is transformed into housing.
That's a mere token because North Shore towns from Evanston to Lake Bluff,
which control 20 miles of shoreline, discourage outsiders from using their
waterfronts by charging fees that are at least double—and sometimes far
higher—than what their own residents pay.

In contrast to those suburbs, which have privatized their lakefronts, or
other American cities, which have industrialized their waterfronts,
Chicago has set aside 24 of 30 miles along Lake Michigan as public land.

In other words, Chicago has taken to heart Burnham's ringing declara-
tion, "The lakefront by right belongs to the people."

While the lakefront looks utterly natural, as if a divine hand had
reached down and drawn the softly undulating curves that provide a
respite from the city's ramrod-straight street grid, the vast majority of the
shoreline is, in fact, man-made. Nearly all the parks along Lake Michigan
were hewn from landfill dumped into the lake, beginning with debris
from the Great Fire of 1871 and continuing through the creation of the
northernmost extension of Lincoln Park in 1957 at Hollywood Avenue. In
a grand illusion, the fill was planted with trees, grass, and shrubs, then
armored with rocks against the fury of the lake.

Yet precisely because the lakefront is not a work of nature, we should not
hesitate to reshape it to serve our needs, physical, emotional, and social.

The question is how.

Granted, the Lakefront Protection Ordinance has delivered the shoreline from further incursions of the kind represented by Outer Drive East, the T-shaped apartment complex built east of the old Lake Shore Drive S-curve in 1962 and Lake Point Tower, the undulating glass high-rise constructed east of the Drive in 1968. But the ordinance's companion document, the 1972 Lakefront Plan, is as outdated as granny glasses and love beads.

Though not without merit, especially in the way it sought to curb pollution of the lake, the plan mostly remains trapped in the assumptions of its time, when Americans still believed traffic engineers held the keys to progress. "It was a status quo plan, not a visionary plan," says Ald. Mary Ann Smith (48th), chairman of the City Council's committee on parks and recreation.

Without a map of the future, we're lost, as shown by the potential mishandling of two huge projects that offer a chance to remake dramatically the southern half of our front yard. No master plan has been drafted to coordinate, in a larger context, the $122 million rebuilding of the revetments from 25th Street to 56th Street and the renovation of South Lake Shore Drive between 25th Street and 67th Street—a job expected to cost about $50 million.

Such projects offer an extraordinary opportunity. The city could use the occasion of the revetment work to bulk up, with landfill, what is now a pencil-thin Burnham Park, making room for a host of new attractions. A practical side benefit: a bigger Burnham Park would enhance flood control, sopping up the waters of the lake before they reach Lake Shore Drive.

The roadwork, meanwhile, could be combined with construction of a series of underpasses and overpasses that would allow safer, easier pedestrian access to the newly enlarged park.

But this chance to correct the historic imbalance between the north and south lakefronts will pass, perhaps forever, unless the powers that be come up with a detailed plan to coordinate the two projects.

The prospect of such planning gaffes and the overwhelming success of the Museum Campus, which happened because public agencies worked together, argue for the creation of a permanent lakefront commission, much like the now-dissolved entity that brought the campus into being.

Appointed by the mayor, the commission could be headed by a powerful civic figure, capable of pulling the levers of power in Chicago, Springfield, and Washington—someone on the order of former governor James Thompson, who has a keen interest in architecture and urban planning. Its leader would be charged with getting all the key players in the same room and on the same page. Such a commission could supervise as well the rewriting of the outdated 1972 Lakefront Plan, drafting a new

version for the entire lakefront while overseeing the creation of subplans for key areas such as the south lakefront.

The commission might even raise funds from the business community to underwrite those plans, a role the Commercial Club of Chicago played in the Burnham Plan. At the same time, it could lobby state and national legislators to provide financial support for what is no longer merely a regional attraction, but an international one.

Clearly, the costs of reinventing the lakefront will be huge. The tab for projects in the works alone exceeds $500 million—in addition to the $260 million rebuilding of the revetments, the $150 million Lakefront Millennium Park, and the $50 million reconstruction of South Lake Shore Drive—when projects such as a $30 million dedicated bus lane in Grant Park, the $30 million Nature Museum, a $7.5 million parking garage in Lincoln Park, $6 million in federal funds to improve roads leading to the U.S. Steel plant, and Daley's $27 million proposal to turn Meigs Field into a park are toted up.

Dollars and cents aside, though, the coin of the realm is vision. We need a new way of looking at the water's edge, one that represents a maturing of the emerging ecological consciousness that colored the 1972 lakefront plan.

Just as in an ecosystem, the fate of one part of the lakefront cannot be separated from that of another. Both the parts and the whole of Chicago's man-made shoreline must be designed to serve different users at different times of day and in different seasons. Based on that idea, the lakefront can grow out of the needs of our time, adapting to new expressions of our most enduring impulses.

"Our bodies and spirits need the fresh breezes that flow from the water," the architecture critic Wolf Von Eckhardt once said. "We need both its calm and its stimulus. We need the sense of community, the opportunities for festivity, for artistic expression, recreation and commercial bustle that urban waterfront offers. . . . In these often desperate times of anxiety and confusion, we need all this desperately."

Postscript

The need for good lakefront planning became even more pressing as the costs associated with the redevelopment of the shoreline rose higher and higher and the timeline for improvements accelerated sharply. In 1999, the U.S. Army Corps of Engineers and the City of Chicago reached an agreement which mandates that the reconstruction of lakefront revetments, floodwalls, and breakwaters must be completed in 2005—five years earlier than the corps' original deadline of 2010.

Even as the revetment work got underway, it was clear that the total price tag for lakefront improvements, estimated at $500 million in 1998,

had grown dramatically. It now exceeds $1.5 billion. By far the biggest new item was the $580 million Soldier Field renovation, approved by the Illinois General Assembly in 2000 and by the Chicago City Council and the Chicago Plan Commission in 2001. Meanwhile, the tab for Lakefront Millennium Park, a 24-acre greensward being built atop a parking garage in Grant Park, doubled to $300 million from $150 million, with additions like two performance theaters and the underlying structure needed to support them. Concentrating even more spending in Grant Park, the Art Institute of Chicago in 2001 unveiled plans for a $200 million addition across Monroe Street from Millennium Park. On the south lakefront, the cost of the planned rebuilding of South Lake Shore Drive shot to $90 million from $50 million after pedestrian underpasses and other improvements were included. The bill for the revetment project also rose, to $300 million from the 1998 estimate of $269 million. The total is sure to go even higher if other planned improvements to the shoreline, such as those now envisioned for Burnham Park, are carried out.

The Great Divide

Carved by Racism, the Chasm between North and South Side Amenities Can Be Bridged, but It Will Take More than a Few Flowers

OCTOBER 27, 1998

Nothing is more shameful about the Chicago lakefront than the fact that it is really two lakefronts—one for those who are black and poor, and another for everybody else.

Nothing is more important to the lakefront's future—and perhaps the city's—than redressing this historic imbalance.

Now, there's a chance to do just that, using two massive public works projects to transform the thin strip of bedraggled parkland south of the Stevenson Expressway into a broad expanse of grass and beach. It could be dotted by windswept dunes, sparkling lagoons, sculpture gardens, and serene peninsulas with spectacular views of the downtown skyline.

The impact of such a park would reverberate far beyond the South Side. By serving up a menu of attractions not available on the North Side and drawing people from throughout the region, the new south lakefront would not only spread the wealth—it would ease the crush of cars and people that makes Navy Pier and Lincoln Park victims of their own success. In the bargain, it could accelerate the revival of once-battered, mid-South neighborhoods such as Oakland and Kenwood, and in so doing increase the city's tax base.

BURNHAM PARK: Miles of stone blocks have been pounded into rubble, creating a shoreline that is unsightly and unusable.

Given that all this is within our reach, and notwithstanding the 44 years that have passed since the U.S. Supreme Court struck down separate-but-equal facilities, there is, incredibly, no detailed blueprint for the development of the south lakefront and an end to separate-and-unequal on the lake.

So Shirley Newsome is likely to remain angry at the yawning gap between the city's north and south shorelines.

Twenty years ago, Newsome moved from a high-rise condominium at 3950 North Lake Shore Drive to a single-family house in the 4100 block of South Lake Park Avenue. The Lincoln Park she remembers, across Lake Shore Drive from her old condominium, was a thriving, well-maintained place, with people of all ages and ethnicities strolling and playing. But Burnham Park, just east of where she now lives, is, in her view, empty, ugly, repulsive.

"Each time I went over, I found something disgusting," Newsome, chairman of a North Kenwood/Oakland community group, recalls, an edge in her voice. There was trash on the ground, broken bottles, and so few bathrooms, she said, that people used trees to relieve themselves.

A close look at the four-mile strip between McCormick Place and the Museum of Science and Industry backs up her denunciations, especially

when that parkland is compared with an equally long chunk of terrain in Lincoln Park between Fullerton Parkway and Hollywood Avenue. Chicago Park District statistics, assembled at the Tribune's request, show that these two stretches—one from 2400 South to 5700 South, the other from 2400 North to 5700 North—are anything but mirror images:

- The northern stretch has twice as many acres of parkland (924 to 440), drinking fountains (58 to 26), playlots (9 to 4), and rest-rooms (10 to 5).
- It has three times as many food stands (20 to 6) and bird sanctuaries (3 to 1).
- It has five times as many umbrella stands (5 to 1); and eight times as many outdoor sculptures (8 to 1).

Granted, some who venture to Burnham Park have devised ingenious ways to get around the paucity of facilities, like the young black man who said that when he's hungry, he simply takes out his cellular phone and orders a pizza hand-delivered to the park.

To many observers, however, the gap between Burnham Park and Lincoln Park is infuriating, and offers fresh evidence of how Chicago remains a city divided along the fault line of race. "I'm positive that race made a difference in the decline in services [on the south lakefront]," says Christopher Reed, director of the St. Clair Drake Center for African and African-American Studies at Roosevelt University.

While the park district has taken some baby steps toward correcting this imbalance, adding a popular new playlot at 31st Street Beach, for example, and while Burnham Park's southerly neighbor, Jackson Park, has some extraordinary features, like the serene Wooded Island and its Japanese garden, a huge gap remains.

It is not just about the quantity of acreage and amenities, but the quality of the parks—and how that impacts people's lives.

Go to Lincoln Park on any summer weekend and you will see sand beaches teeming with volleyball players, sunbathers, and swimmers. Go to Burnham Park and it essentially looks as if someone has detonated a neutron bomb.

The condition of the south lakefront is all the more appalling when one realizes that Daniel Burnham sketched a dazzling vision for it in his 1909 Plan of Chicago: a five-mile necklace of island parks stretching from 12th to 56th Streets. Between this outer shoreline and an inner shoreline of landscaped parkland was to be a picturesque lagoon plied by boats, encircled by restaurants, and decorated with such features as colorful aquatic plants bobbing on the water's surface. "This possible paradise," Burnham called it.

Burnham Park

A historic chance

While the northern part of Burnham Park has such world-class facilities as the Field Museum of Natural History, the park's bedraggled southern stretch symbolizes the way Chicago has mistreated its minority poor. Two major rebuilding projects, one of the shoreline protection system and the other of South Lake Shore Drive, offer an opportunity to help close the lakefront's racial divide.

A dream unrealized

Most of Burnham Park is a narrow strip of green pressed against Lake Shore Drive—literally half the park proposed in Daniel Burnham's 1909 Plan of Chicago. Because of funding shortages caused by the Depression and World War II, only one of the islands that Burnham envisioned was built. In 1946, it became Meigs Field.

KEY:

⬚ **Present Burnham Park boundaries**

⬚ **Burnham Park boundaries in 1909 Plan of Chicago**

Sources: U.S. Army Corps of Engineers; Illinois Department of Transportation; *Chicago Tribune*

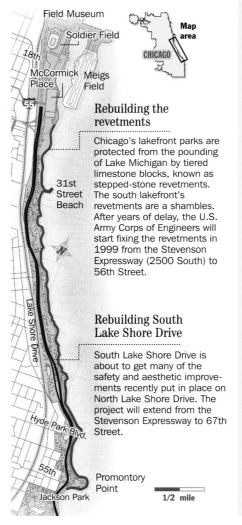

Rebuilding the revetments

Chicago's lakefront parks are protected from the pounding of Lake Michigan by tiered limestone blocks, known as stepped-stone revetments. The south lakefront's revetments are a shambles. After years of delay, the U.S. Army Corps of Engineers will start fixing the revetments in 1999 from the Stevenson Expressway (2500 South) to 56th Street.

Rebuilding South Lake Shore Drive

South Lake Shore Drive is about to get many of the safety and aesthetic improvements recently put in place on North Lake Shore Drive. The project will extend from the Stevenson Expressway to 67th Street.

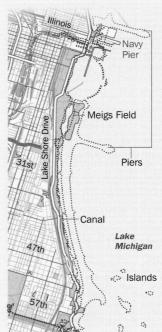

Promontory Point

1/2 mile

So alluring was his design, and so masterful was the public relations campaign waged on its behalf by Chicago businessman Charles Wacker, that voters in 1920 approved a $20 million bond issue (the equivalent of $163 million in 1998 dollars) to do precisely what Burnham had proposed—and build Soldier Field in the bargain.

Work began with the dumping of landfill into Lake Michigan, creating the inner shoreline of Burnham Park and the first of the islands, which was located off Roosevelt Road. But then the Depression struck. And World War II. By 1946, when the lone island was turned into a downtown airport and christened Meigs Field, no one cared any longer about living up to a bond issue passed in 1920. So in contrast to the thick swath of parkland that Burnham had foreseen, the park that bears his name remains an anemic sliver of green.

Parts of Burnham Park, in fact, are less than 10 yards wide, measured between Lake Shore Drive and the water's edge. And even at its widest point, Burnham Park remains skimpy compared with Lincoln Park, which, at its widest point at Montrose Avenue, is nearly a mile wide. Even the narrower stretches of Lincoln Park, like those between North Avenue and Diversey Parkway, are blessed by the presence of parkland along Lake Michigan and, to the west of Lake Shore Drive, by the spacious inner park, with its playing fields, zoo, and lagoon.

Together, this greenery subordinates the Drive, giving it the feel of a boulevard within a park. To the south, however, Burnham Park often seems like nothing more than a shoulder along the roadway.

"Benign Neglect"

Still, older South Side residents retain fond memories of Burnham Park, recalling picnics, softball games, and walks on the beach in the years after World War II.

Separate and unequal

The great divide between public space for the affluent and for the minority poor is shown by the difference between two comparable stretches in Lincoln Park and Burnham Park.

KEY:

2400-5700 North

2400-5700 South

Acres

924

440

Food concession stands

20

6

Restrooms

10

5

Playgrounds

9

4

Drinking fountains

58

26

Bird sanctuaries

3

1

Marinas

3

0

Trees/shrubs planted*

2,840

3,340

*Planted in the last 5 years.

Sources: Chicago Park District; *Chicago Tribune*

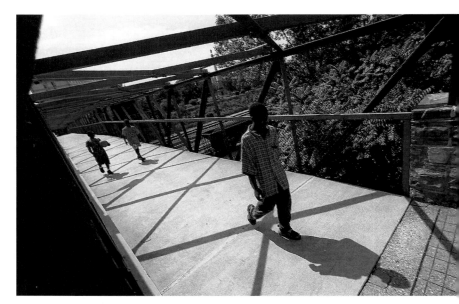

FOOTBRIDGES AT 35TH STREET: Walkers intent on reaching the lakefront face a daunting obstacle—crossing railroad tracks and Lake Shore Drive.

But things changed markedly in the 1950s and 1960s when working-class black families moved farther south along the lakefront and such massive public-housing projects as the Robert Taylor Homes were built in the old "Black Belt" along South State Street and farther east. "People would stop going [to the beach] because there was so much debris," says Timuel D. Black, a professor emeritus at the City Colleges of Chicago.

Eventually, the Chicago Park District under Supt. Edmund Kelly was hit with a federal lawsuit that charged a policy of "benign neglect" in minority parks. A 1983 consent decree forced the park district to spend more of its money in minority neighborhoods throughout Chicago.

Yet the legacy of benign neglect still defines Burnham Park. The net effect is to make the sparkling new Museum Campus at the park's northern end seem like a Potemkin Village hiding something less than noble.

Whereas Lincoln Park and its wealth of people-pleasing attractions and intricately designed landscape are a delightful piece of urban theater, Burnham Park represents a depressing theater of the absurd, a hall of urban planning horrors in which one problem compounds another.

From the Stevenson Expressway to 55th Street, the shoreline revetments—originally a series of tiered limestone blocks that, in addition to protecting the shoreline, allowed people to stroll or sit, gazing out on the blue waters of Lake Michigan—are an utterly unusable mess of rocks.

Meanwhile, the raging waters of Lake Michigan have tossed loose rocks back into Burnham Park, rendering whole fields of grass the equivalent of those colonial New England farms that had to be cleared of stone before they could be plowed. The rocks make the park, already pinched by Lake Shore Drive, even narrower—and more uninviting.

And while Lincoln Park is easily reached on foot, with streets feeding directly into it, Burnham Park is separated from the city by both Lake Shore Drive and the gash of commuter railroad tracks to its west. Would-be parkgoers traveling on foot must cross this formidable barrier by means of overpasses and immensely long bridges set at intervals of between a half-mile and a mile. That departure from the 1973 Lakefront Protection Ordinance, which calls for bridges and underpasses to be placed at intervals of one-quarter mile, has never been corrected.

Worse, Burnham Park's bridges are blocky-looking, with daunting flights of stairs that are inaccessible to the disabled. Nothing could differ more from Lincoln Park's elegant North Avenue Bridge, which has graceful, curving arches—as well as ramps—that beckon one to the lakefront. "You want to go up there and see the view," observes landscape historian Victoria Ranney. In contrast, the Burnham Park bridges "look like an ordeal to get up and over."

As a result of these obstacles, most people drive to Burnham Park, a practice that has dictated the construction of an inordinate number of parking lots set right along the shoreline, eating up already scant parkland.

Charles Reynolds, the director of the local advisory council at the Stateway Gardens public-housing project, simply drives elsewhere—

PROMONTORY POINT: A rare bright spot on the south lakefront, where couples like Cynthia Battle and Andre Muhammed Clark say their wedding vows.

North Avenue Beach in Lincoln Park. "I go there because it gives my children exposure to different ethnic groups, and they can go to the Lincoln Park Zoo," he says. "I have choices."

Yet it would be misleading, as well as unfair, to portray Burnham Park as a totally dismal landscape. For there is an important exception to the rule of the park's barren, boring landscape—Promontory Point at 55th Street.

Designed by the landscape architect Alfred Caldwell, created by landfill in the 1920s and completed in 1937, Promontory Point is a big bulge in the otherwise meager shoreline of Burnham Park. It consists of a meadow ringed by trees that break to reveal magnificent views of the downtown skyline and the steel mills to the south. Its focal point is a picturesque field house that suggests a castle or a lighthouse.

On a given day, the Point teems with people who sunbathe on its revetments, act out a play on its meadow, or take wedding vows in or outside the gracefully renovated field house.

That's the ultimate test of a public space, isn't it? Would you want to get married there?

Perhaps the Point's success can be attributed to the fact that it is located just east of affluent Hyde Park. But it still teaches a broader lesson: the extraordinary impact we can have by literally resculpting the shoreline—beefing up skinny Burnham Park to make possible a whole range of landscape features and activities that would distinguish this stretch of the lakefront from the North Side.

Pink Roses

For years, the question was whether Chicago would pour money into the south lakefront. Now, the issue is how the city will use that money and whether it intends to create a new Burnham Park or a cosmetically improved version of the old one.

Right now, cosmetics appears to have the upper hand.

Pink roses have been planted in the median of South Lake Shore Drive. They look nice, but in light of the massive infrastructure problems facing Burnham Park, they inevitably have a "let them eat cake" aspect, as if a few crumbs could satisfy a decades-old hunger for better parkland.

How about planting, instead, the seeds of urban revitalization?

Two big upcoming projects are handing Mayor Richard M. Daley that historic opportunity—if the mayor and the Chicago Park District can come up with a detailed plan for the park and a way to coordinate the various agencies that must carry out such a plan.

The U.S. Army Corps of Engineers is scheduled to repair the battered revetments from the Stevenson Expressway to 56th Street at a cost of $122 million; the project is to start next year, with completion scheduled for 2010.

Meanwhile, the Illinois Department of Transportation will overhaul South Lake Shore Drive from the Stevenson to the southern end of Jackson Park at 67th Street. The project is expected to cost about $50 million, and the target date for finishing is 2004.

Money like that is the urban planning equivalent of manna from heaven. Projects of this scope and cost present a once-in-a-century chance literally to reshape a park. So the challenge is to look at them holistically—as an exercise in city planning rather than as two isolated works of infrastructure.

Fixing the revetments should entail more than just rebuilding the stone walls in order to protect Lake Shore Drive from flooding. Similarly, the road renovation should concern itself with more than promoting smoother, safer motoring. Conceived as an interconnected whole, the two projects could transform what is now a third-rate park into a showcase of recreation and culture.

Resculpting the Shoreline

By following, for example, the model of Promontory Point and dramatically resculpting the shoreline as a series of broad peninsulas, the revetments project could make room for features that finally would give Burnham Park the dazzle envisioned for it by the man for whom it was named.

There could be dune grasses that would remind us of what the lakefront

looked like in 1673 when the explorers Louis Joliet and Jacques Marquette paddled their canoe to Chicago from the French outpost at Mackinac.

There could be lagoons that would relieve the now-bland landscape of the park and provide a place for parkgoers to fish, as they do at the beautifully restored Harlem Meer in New York City's Central Park.

And there could be public art that recognizes the contributions of African Americans to Chicago's history—perhaps even a grand sculpture garden that would extend all the way from McCormick Place to the Museum of Science and Industry.

Burnham Park could also become the new home of the Chicago Air and Water Show, a step that Lincoln Park activists are urging on the Mayor's Office of Special Events to relieve the massive overcrowding that annually occurs on the north lakefront.

Still, there's no point in creating a more enticing Burnham Park if people can't get to the park more easily on foot or by public transportation. That underscores why it is so urgent for transportation planners to design in concert with park planners. Collaboration could bestow on Burnham Park an inviting array of underpasses and graceful bridges (set at quarter-mile intervals, as called for in the Lakefront Protection Ordinance).

Similarly, planners working in concert could design a number of turn-around areas for Chicago Transit Authority buses to give parkgoers alternatives to driving to the lakefront—relieving the need for so many parking lots.

Finally, the collaborators could spruce up the neighborhoods to the west of Burnham Park, and turn the major east-west streets into boulevards that will complement existing north-south boulevards, such as the handsome Dr. Martin Luther King Drive. (One such project is already under way on Pershing Road.)

For all that to happen, however, there has to be a vision for Burnham Park and a way to transform it into reality. That hasn't happened yet—though to her credit, Park District Gen. Supt. Carolyn Williams Meza has signaled that she will ask the district's board to approve a $140,000 "framework plan" for Burnham in December.

The prospect of a park district plan is heartening because it means the agency would take the lead in reshaping Burnham Park, a role it so far has ceded to the state Department of Transportation, which in June began convening meetings of various agencies, community organizations, and consultants.

Yet "a framework plan" may not be the prescription Burnham Park needs. Such a plan typically takes a long view, listing proposed improvements that may take many years. It doesn't say what they will look like or how much they will cost, based on the sensible premise that conditions

can change over the long haul. But Burnham Park will be shaped in the near future, not the distant future; the rebuilding of the revetments, for example, is set to begin next year at 31st Street.

So instead of a framework plan that airs general goals, the south lakefront deserves a plan that spells out precisely what the landscape will look like—how all of its different parts (recreation facilities, roads, revetments, pedestrian access, and amenities) will work in sync. It would specify how different projects being carried out by different agencies will work toward the same end—and, most important, who will coordinate the work.

Ideally, a lakefront supercommission should be established to ensure that the rebuilding proceeds cooperatively. In the absence of such a commission, the mayor should consider reconstituting the group that helped bring the Museum Campus into being: a committee known as the Burnham Park Task Force, which was led by the chairman of the Chicago Plan Commission and the chairman of the Chicago Park District.

The task force worked because it got all the key players in one room— business leaders, civic groups, city agencies—to forge a coherent strategy for the Museum Campus. More important, it secured funding, pressing the Metropolitan Pier and Exposition Authority to foot the cost of relocating Lake Shore Drive's northbound lanes, clearing valuable lakefront land for the 57-acre campus.

Now we're all enjoying the results—a stunning greensward at the northern end of Burnham Park, where children can roll down a hill or lovers can snuggle on a bench overlooking a harbor.

The rest of Burnham Park deserves no less.

After all, when Daniel Burnham said the lakefront belongs to the people, he meant all the people, not just some of them.

In Burnham Park, city planning can resound with a millennial mission: to make the lakefront not just an edge between water and city, but a seam that joins black and white.

Postscript

The Chicago Park District commissioned a Burnham Park framework plan in early 1999. Shaped by the Bauer Latoza Studio of Chicago and completed at the end of 1999, it called for beefing up Burnham Park's skinny shoreline with the first major addition of landfill to the lakefront in more than 40 years.

The landfill would create at least 35 acres of parkland, providing room for new beaches, fishing piers, wetlands with dune grasses, displays of outdoor sculpture, food concession stands, and restrooms. These features would be placed in a naturalistic setting that mixes centers of activity with quieter areas

for sitting, strolling, and jogging. To make it easier for pedestrians to reach the lakefront, seven bridges would be built across Lake Shore Drive.

The Chicago Park District is supposed to carry out the plan by 2005 in conjunction with the U.S. Army Corps of Engineers' rebuilding of Burnham Park's revetments. By 2001 some improvements were underway; they added modest amounts of parkland as the revetments were rebuilt south of 31st Street and north of Promontory Point. In addition, a planned in-line skating rink was opened at 31st Street and proved an instant hit, drawing scores of daredevil skateboarders. But prospects for the rest of the plan were uncertain because there was no overall price tag and no lakefront supercommission to coordinate the park improvements with those being made on South Lake Shore Drive. It was far from a sure thing, for example, whether any of the proposed bridges actually would be constructed. The new revetments, meanwhile, drew jeers from parkgoers who faulted their institutional-looking concrete.

For its part, the Illinois Department of Transportation in 2000 unveiled a $90 million South Lake Shore Drive plan that called for 14 acres of additional parkland in Burnham and Jackson Parks, median planters comparable to those on North Lake Shore Drive, and pedestrian underpasses to improve access to the shoreline from the Museum of Science and Industry. Construction was scheduled to begin in 2002.

Further seeking to close the gap between Chicago's north and south lakefronts, the Park District in 2000 released plans for Jackson Park, the South Shore Cultural Center, and the Midway Plaisance, the grassy median that cuts through the University of Chicago campus. A Washington Park plan was expected to be completed by the end of 2001.

Grant Park's Double Life

Jammed and Raucous during Summer Festivals, Empty and Sleepy the Rest of the Year, Our Central Park Needs a Single, Vibrant Personality

OCTOBER 29, 1998

Every park, like every person, has its own personality. Unfortunately, Grant Park's is schizophrenic.

This was all too apparent one June evening as Bob O'Neill pedaled his green 21-speed bicycle through the most central of the city's parks, covering the same turf where, in just two weeks, millions of people would gather during the Taste of Chicago.

What confronted him was a scene of solitary grandeur, including a statue

GRANT PARK DURING TASTE OF CHICAGO: From the vantage point of a Ferris wheel, an example of how pedestrians flood into the park when roads are closed.

of Abraham Lincoln gazing out upon empty grass. Indeed, as O'Neill rode past a formal garden of hydrangeas near Buckingham Fountain, the lone living creature he encountered was not a human being but a duck.

O'Neill has a word for Grant Park when it isn't hosting hordes of visitors at the city's giant summer festivals. The word is "lonely." His cure? Simple. "More everyday traffic."

The man making these pronouncements has a passion for this park. A 34-year-old educational consultant, O'Neill heads the Grant Park Advisory Council, a citizens' board that reports to the Chicago Park District. As an activist, he helped spur Mayor Richard M. Daley and the Park District into sprucing up Grant Park for the 1996 Democratic Convention by giving Daley and city officials his photographs of such unsightly park scenes as birds roosting in broken light posts.

His characterization of the park is right on. During festivals and other special events, Grant Park becomes the pulsing heart of Chicago's lakefront. It's where popes and queens and other world-renowned figures, including a certain basketball player who wears number 23, greet the adoring masses—a spectacular setting for public spectacles.

But for much of the rest of the year, Grant Park just about drops dead. In contrast to the joyful noise the festival crowds make, it's eerily quiet. If the great American naturalist Henry David Thoreau were alive today, he

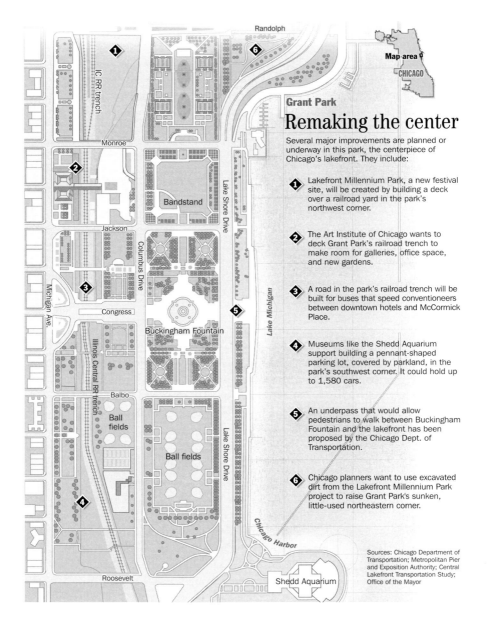

Randolph

Map area

CHICAGO

Grant Park

Remaking the center

Several major improvements are planned or underway in this park, the centerpiece of Chicago's lakefront. They include:

1 Lakefront Millennium Park, a new festival site, will be created by building a deck over a railroad yard in the park's northwest corner.

2 The Art Institute of Chicago wants to deck Grant Park's railroad trench to make room for galleries, office space, and new gardens.

3 A road in the park's railroad trench will be built for buses that speed conventioneers between downtown hotels and McCormick Place.

4 Museums like the Shedd Aquarium support building a pennant-shaped parking lot, covered by parkland, in the park's southwest corner. It could hold up to 1,580 cars.

5 An underpass that would allow pedestrians to walk between Buckingham Fountain and the lakefront has been proposed by the Chicago Dept. of Transportation.

6 Chicago planners want to use excavated dirt from the Lakefront Millennium Park project to raise Grant Park's sunken, little-used northeastern corner.

Sources: Chicago Department of Transportation; Metropolitan Pier and Exposition Authority; Central Lakefront Transportation Study; Office of the Mayor

IC RR trench

Monroe

Bandstand

Lake Shore Drive

Jackson

Columbus Drive

Michigan Ave.

Congress

Illinois Central RR trench

Buckingham Fountain

Lake Michigan

Balbo

Ball fields

Ball fields

Lake Shore Drive

Chicago Harbor

Roosevelt

Shedd Aquarium

wouldn't need to venture to Walden Pond for solitude. He could simply stroll through Grant Park's 323 silent acres.

This is the riddle of Grant Park: how can the same place that rocks and rolls during fests also be the perfect setting for "Brahms' Lullaby"? Unraveling the answer means coming to grips with forces that have made

entire stretches of the lakefront inaccessible and uninviting—although facing up to such forces is something those in charge of the lakefront and Grant Park have been reluctant to do.

It is a tale of traffic engineers who tore up a public space with roads that make walking through it an intimidating ordeal. It is a tale of architects who created a landscape of stunning visual power that lacks human scale. And it is a tale of public officials, including Daley, who have been content to improve parts of the park instead of figuring out how to make all of it come alive.

Now, however, Chicagoans have a chance to resuscitate the heart of their lakefront.

Millions of dollars in public funds are about to be spent on the park for such improvements as Lakefront Millennium Park, a $150 million, 16-acre festival site that will be built on a deck over a railroad yard in the park's northwest corner, and a $30 million road in the park's railroad trench that will speed conventioneers between downtown hotels and McCormick Place.

If these unrelated projects become the impetus for a broader effort that looks at Grant Park as a single, integrated whole, then the park can become as alluring to the everyday visitor as it is to the festival reveler. But that won't happen by adhering to the ideals of the turn of the century, when the park was conceived as a promenade ground for ladies carrying parasols and men in straw boaters. That won't do anymore, not in the age of Rollerblades and Spandex.

It will take looking to the future and imagining this very formal park with a lot less starch in its collar.

It will necessitate a new attitude in a city where bigger always has been synonymous with better: small is beautiful too. "When you look at a great park, it has lots of little spaces," says Fred Kent, president of the Project for Public Spaces, a New York City group that monitors parks nationwide. "It has a large community and small communities."

And it will require citizen activism, building on the efforts of past visionaries, namely the settlers who in 1836 decreed that what is now Grant Park should be "Public Ground—A Common to Remain Forever Open, Clear, and Free" and businessman Aaron Montgomery Ward, who in 1890 began 20 years of court battles that kept everything from stables to squatters' shacks from desecrating the people's park.

Modeled on Versailles

Grant Park is a populist symbol of Chicago, adorning postcards, book covers, and tourist posters. Its place in our mind, says Walter Netsch, former president of the Chicago Park District board, "is as strong as Michael Jordan's."

Take away Grant Park, and downtown Chicago might as well be Cleveland or some other second-tier city along the Great Lakes. The park is simultaneously a grand forecourt for the wall of skyscrapers along Michigan Avenue and the equivalent of a royal estate, its lineage tracing back to the gardens of Versailles.

Built atop landfill dumped into the lake, the park consists of a series of rectangle-shaped outdoor "rooms" that increase progressively in size as they move east toward the lake: small along Michigan Avenue, bigger along Columbus Drive, and biggest of all along Lake Shore Drive. During the summer festivals, these formal, French-inspired rooms are incongruously filled with the wail of electric blues, the smoky scent of outdoor grills, and thousands of casually dressed people chomping on ribs and every other kind of food imaginable.

From the vantage point offered by a helicopter, the scene is extraordinary: an ever-shifting, amoebalike mass—a people's army—floods into the closed-off streets that divide the rooms and takes over the park, making the aristocratic pleasure ground its own. In such moments—or when it is host to dignitaries like Pope John Paul II, who celebrated mass in the park in 1979—Grant Park becomes a powerful example of creating common ground amid a sprawling, diverse culture. People of different races and classes meet. They share turf. They experience the same event. And though they may not become friends, at least they get along, if only for a few hours. Here, public space plays a significant social role, acting as the glue that helps to hold an often fractious metropolitan area together.

The trouble is, the special qualities that cause the park to become so vibrant—the food, the musical acts, and the presence of lots of people, which in turn attracts more people—aren't present the rest of the year. But there's more to it than that.

Think about those closed-off streets and how they turn the park into the equivalent of a car-free zone. Then contemplate what happens when the streets are reopened to vehicular traffic. Pedestrians going from the Loop to the lake must negotiate Columbus Drive, an eight-lane road where drivers routinely ignore the 30 mph speed limit, and then Lake Shore Drive, a 10-lane road whose 45 mph speed limit is just as regularly flouted.

Not exactly a walk in the park.

Along Lake Shore Drive, just east of Buckingham Fountain, people on foot are allowed just four seconds before a flashing red hand indicates that traffic will be resuming momentarily. Seeing multiple lanes of vehicles speeding toward them, tourists such as Terry Greiner, a 53-year-old farmer from Keota, Iowa, scamper across the Drive, arms pumping, legs driving. "It doesn't last very long, does it?" gasps Greiner, referring to the "walk" light.

Ironically, this is the very spot where a red carpet was rolled across Lake Shore Drive in 1959 to enable a visiting Queen Elizabeth II to cross decorously from her yacht to Buckingham Fountain. Ever since, the lakefront promenade across from the fountain has been known as "Queen's Landing."

But with the exception of festival weekends, when police operate the traffic lights between Queens Landing and Buckingham Fountain, pedestrians hardly ever get "Queen for a Day" treatment. "If we weren't out here, a lot of these people would be dead," says one police officer. "I've seen so many close calls it's scary."

A Lack of Human Scale

It's as if Grant Park's rooms were patches of green floating on a sea of asphalt. And those rooms aren't furnished to welcome you, either, as a comparison between New York City's Central Park and Grant Park shows. Central Park has 4,486 park benches in its 843 acres, or 5.3 benches per acre. Grant Park has only 482 benches on its 323 acres, or 1.5 per acre.

This isn't just nit-picking. A park bench is like a sofa that your host directs you to sit upon; it sets a tone of hospitality. Grant Park's lack of benches doesn't beckon people. It repulses them, negating Daley's efforts to clean up the park's rooms along Michigan Avenue and adorn them with brightly colored flowers. "It's a trying experience, not a comfortable experience, to eat lunch here," says Steve Sobczak, a 35-year-old commodities trader, sitting on a concrete step near the corner of Jackson Boulevard and Michigan.

Even a superlong gray picnic table placed on the grass between Randolph and Washington Streets across from the Chicago Cultural Center—it's actually a piece of public art—draws as much criticism as praise, with some brown baggers complaining that its rows of contiguous seats make it impossible to have a private conversation.

True, the Park District has made some positive moves, such as creating the handsome new restaurant pavilions around Buckingham Fountain, where parkgoers can sit and watch the fountain's geyserlike water jets spout skyward. But that sort of people-friendly gesture is all too rare, as exemplified by the fence around the frilly fountain.

The fun of a fountain is getting close to the water, feeling its coolness warding off the summer heat. That's what happens at the modern fountain at Navy Pier, where kids run through columns of water that shoot up from the ground, or at Central Park's Bethesda Fountain, where one can sit along the fountain's bluestone ledge. In contrast, the curving metal fence around Buckingham Fountain, which has surrounded the fountain for at least 60 years, actually pushes people back.

It's a landscape seemingly designed in a mood of fear—needlessly, ac-

BUCKINGHAM FOUNTAIN: Sparking waters delight the eye, but a fence and the Chicago police keep visitors like Chelsea Home, 3, of Denville, N.J., from getting close.

cording to James Reilly, chief executive officer of the Metropolitan Pier and Exposition Authority (and a lawyer), who says, when asked about legal liability and the Navy Pier fountain, "We've never worried about that."

Similarly, Douglas Blonsky, the administrator of Central Park, reports that no one has ever drowned at Bethesda Fountain, although one fellow temporarily lost his pet boa constrictor when the snake decided to go for a swim.

Park District Gen. Supt. Carolyn Williams Meza has promised to look into removing the fence around Buckingham Fountain. She denied that the lack of benches in Grant Park is meant to prevent homeless people from sleeping in the park—a charge made by some—saying that it's not a high-priority issue because people aren't grousing about it.

Yet why not just fix the problem instead of waiting for complaints? Indeed, looking at Grant Park proactively rather than passively is precisely what's needed to cope not only with small problems like fences and benches, but also with the larger ones that make the park an underachieving public space.

That's because several big projects that are underway or on the drawing board open a window of opportunity to reshape the park dramatically. In addition to Lakefront Millennium Park, which will feature a 2,500-space parking garage and a terminal for buses bound for Navy Pier beneath its surface-level parkland, they include:

• The $30 million busway in the park's sunken railroad trench, due for completion in late 2000;

• A $1.5 million plan that calls for using the dirt excavated to create Millennium Park to raise the level of Grant Park's sunken and little-used northeastern corner, alongside easternmost Randolph Street and the Lake Shore Drive "S" curve (no completion date set yet);

• Decks that will cover the railroad trench immediately north and south of the Art Institute, allowing the museum to create more office and gallery space, as well as gardens open to the public (no cost or timetable yet);

• Construction of a parking lot with space for 850 to 1,580 cars in a pennant-shaped parcel of land at the level of the railroad tracks in the southwest corner of the park, with an estimated cost of $14 million to $27 million (not funded yet).

By coordinating these and other projects, as well as the agencies involved with them—the Art Institute; the Metropolitan Pier and Exposition Authority, which is the force behind the busway; the Chicago Department of Transportation, which is responsible for Millennium Park; and the Museum Campus authorities, who are pushing the pennant-shaped lot to create some much-needed close-in parking—the Park District can heal what ails Grant Park.

Yet that will take a master plan, which the district doesn't have—though Ed Uhlir, the project director for Millennium Park, says the mayor is "very interested" in putting one together.

The sooner the better. If no thought is given to making Grant Park more pedestrian-friendly, then the new underground parking decks will simply turn the park into a glorified stopover point for getting to Navy Pier and the Museum Campus.

"Sunday in the Park"

To excel at the care and feeding of the pedestrian, Daley can take some simple, inexpensive steps that fall under the rubric of "traffic calming," a philosophy he already has practiced in Chicago's neighborhoods, putting trees and shrubs in the middle of intersections to slow down cars.

Emulating what Milwaukee has done on its lakefront, Chicago could create variable speed limits on the portion of Columbus Drive that cuts through Grant Park. One speed limit, set at 35 mph, would be for the morning and evening rush hours, as well as nighttime hours when the parks are closed. The other, 25 mph, would be for midday and weekends, when the needs of pedestrians rather than drivers should predominate. With proper enforce-

ment, the limits would turn Columbus from the equivalent of an expressway into a park drive, so pedestrians won't have to sprint across it.

Signs for drivers might help (perhaps something like "Welcome to Grant Park, Richard M. Daley, Mayor. SLOW DOWN!"), as would strips of cobblestones at key intersections.

Netsch broadens that idea with a valuable proposal of his own that he calls "Sunday in the Park," an allusion to the Art Institute's famous Georges Seurat painting, *Sunday Afternoon on the Island of La Grande Jatte*. The painting is itself a celebration of public space, portraying a crowd of Parisians—middle-class people, working-class folks, even prostitutes—mingling on an island in the Seine.

To allow the heart of the park to beat again, Netsch suggests closing Congress Parkway between Michigan Avenue and Columbus Drive on Sundays, while also shutting down a portion of Columbus.

It's a wonderful idea, and it can be furthered, as Netsch proposes, with median planters in Columbus Drive—if they can be made as graceful as those on Lake Shore Drive. Care also should be taken to ensure that the planters don't squeeze out metered parking now along Columbus, inconveniencing those attending Buckingham Fountain's nightly show and softball players who use Grant Park's ball fields.

Imagine Columbus Drive on Sundays "as a pedestrian mall without cars, a shady walkway with roving street vendors. It would even act as our shopping street for Taste of Chicago," Netsch writes in his plan, which he made public at a June symposium on the future of Grant Park. "Imagine horse and buggy rides around the park," he continues. "Imagine a walkway without cars from Michigan Avenue to the lake."

Also deserving a hearing are city proposals that would enable pedestrians to traverse the park's roads more easily, including a Monroe Drive underpass to link Millennium Park and the Art Institute, a bridge that would join Millennium Park to the parkland to its east, and a 50-foot-wide underpass at Queen's Landing.

Admittedly, the $11 million price tag for the Queens Landing underpass is not small. Yet when you look at how a comparable underpass—bright, spacious, and inviting—has enabled people to walk to the Museum Campus in serenity rather than fear, the benefit justifies the cost.

Grant Park's rooms can be humanized, too, following models that exist right in the park.

One can be found in the north and south gardens of the Art Institute, which offer an astounding variety of places to sit—benches, ledges, steps—as well as shade trees and sculptures like Alexander Calder's red-painted steel sculpture, *Flying Dragon*. As a result, people tend to linger there

A MUSEUM CAMPUS UNDERPASS: A model for improving the lot of the pedestrian that draws walkers in with its delightful squares of light.

and come in groups more than they do in the park's other rooms along Michigan Avenue.

The other example is the popular outdoor dance program put on the past two summers by the city's Department of Cultural Affairs across Michigan Avenue from the Cultural Center.

At one of these events, dancers, mostly older folks, kicked up their heels as a chorus of strings played tunes like "In the Mood." Thought was given to providing places for them to sit; to get a chair, people turn in their driver's license or some other form of ID. "People are writing me letters and saying,

'Thank you for the free chairs,'" says the city's Commissioner of Cultural Affairs, Lois Weisberg. "People are so grateful for any little amenities you can provide them."

Much more can be done to add to the appeal of Grant Park. The Park District can:

- Build playgrounds and tot lots, like those at the edge of New York's Central Park, to serve families living in nearby developments such as Central Station;
- Create a "cultural mile" between Congress Parkway and Randolph Street that would extend the intimate, intricate landscapes of the Art Institute's gardens east and west;
- Promote the park's existing attractions, like Grant Park's formal gardens, or create new ones, such as a Halloween festival.

There's talk, too, about beautifying the new busway in the railroad trench. But why put some silly-looking murals there when the money would be better spent improving Grant Park's existing parkland? What's more important is to heed Netsch's environmentally responsible call that the buses in the busway be as technologically advanced as possible, so as not to befoul Grant Park's air with clouds of dust and fumes.

Paying for these improvements won't be hard, not if the mayor builds on the effort to get Millennium Park created with the help of corporate contributions and marshals the support of downtown business leaders. After all, it's their employees who are using Grant Park.

The little human details that make such a big difference pale in comparison to the cost of major infrastructure projects. Besides, some of them can be paid for privately, following Central Park's lead of offering commemorative plaques on park benches in exchange for donations. It all comes down to having a vision and the will to get it done—and to citizens, like O'Neill, who push public officials to keep on improving the public realm.

Without a plan, Grant Park will get marginal, cosmetic improvements. With a plan, the park with a split personality can become happy and whole, the centerpiece of the reinvention of the lakefront.

Postscript

In 2000, the Chicago Park District hired San Francisco landscape architects Hargreaves Associates and Harza Engineering Co. of Chicago to prepare a plan for Grant Park. The plan is expected to be completed in 2001. Even before the Park District commissioned the effort, however, city officials embraced the concept of breathing life into Grant Park year-round.

In 1999, the City Council approved construction of a $34.9 million,

1,478-seat theater in Lakefront Millennium Park. The privately funded facility, known as the Music and Dance Theater, will be home to a dozen long-itinerant arts organizations, including Hubbard Street Dance Chicago. Many perform in the fall and winter months, when activity in Grant Park typically ebbs. Another addition to Millennium Park, Frank Gehry's $15 million band shell, seemed likely to bring people to the park at times other than the summer festivals. So did an ice skating rink planned for Millennium Park along Michigan Avenue. Along with Millennium Park's expansion to 24 acres from 16 acres, however, such additions made Millennium Park a focus of controversy, pushing its cost to $300 million from $150 million.

Prospects for improving the lot of the pedestrian in Grant Park also brightened. City and state officials reached a deal in 1999 to build a bridge or wide underpass linking Buckingham Fountain to the lakefront. The job went to a team consisting of Spanish-born architect and engineer Santiago Calatrava and Chicago architects A. Epstein & Sons International. The timetable for the $19 million underpass, priced $8 million higher than the 1998 estimate, is not set. To accompany his Millennium Park band shell, meanwhile, California architect Frank Gehry designed a snaking pedestrian bridge that will cross Columbus Drive, linking Millennium Park with Daley Bicentennial Plaza to its east. The bridge is scheduled to be finished in 2003 or 2004.

A Landmark of Labor

As a Celebration of Industry, the Idled South Works Steel Plant Could Forge a New Link in the Chain of Waterfront Parks and Museums

NOVEMBER 2, 1998

Once it was a cathedral of Smokestack America, turning the night sky orange as molten ore was poured from huge ladles and, by day, making the air brown with smoke and dirt. That was fine with the men and women who worked there. Clean air meant layoffs.

Now, six years after Pittsburgh-based USX Corporation shut down the massive South Works steel mill, the sprawling lakefront property has been cleared of everything but a working power plant, some little-used railroad lines, and massive, half-mile-long walls that loom along a vast slip like the ruins of Stonehenge.

This is the ultimate postindustrial landscape; at 573 acres, the South Works site is bigger in area than the Loop. It presents a unique chance to accomplish two goals at once. Not only is it a vast canvas on which to paint a masterly vision of public space, it also could power the recovery of Chicago's battered Southeast Side.

Former U.S. Steel site

Big plot needs big plans

The largest stretch of undeveloped lakefront land in Chicago, the former U.S. Steel mill, known as South Works, represents the most significant chance in years to enhance the shoreline. At 573 acres, it is bigger than the Loop. In September, 1998, the Chicago Department of Planning and Development released a plan for the nearly vacant site. Among its key provisions:

1 An extension of South Lake Shore Drive, which would go through the western edge of the site.

2 New lakefront parkland, including landfill, which would create an almost continuous link between Rainbow Park to the north and Calumet Park to the south.

3 New housing on the northern half of the site, and an industrial park on the southern half.

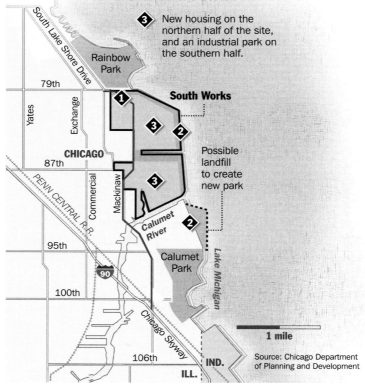

CHICAGO

Chicago Loop

Map area

South Works

South Lake Shore Drive

Rainbow Park

79th

Yates

Exchange

South Works

CHICAGO

87th

PENN CENTRAL R.R.

Commercial

Mackinaw

Possible landfill to create new park

95th

90

Calumet River

Calumet Park

Lake Michigan

100th

Chicago Skyway

1 mile

106th

IND.

ILL.

Source: Chicago Department of Planning and Development

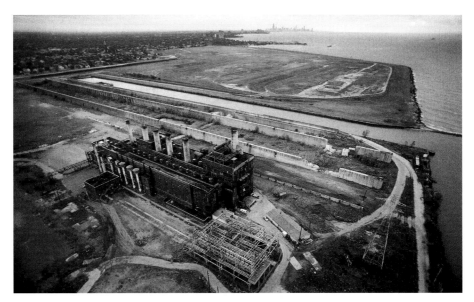

SOUTH WORKS: The ultimate postindustrial landscape, dominated by a still-functioning power plant and walls that once held iron ore unloaded from ships.

Unfortunately, the brushstrokes of city planners, who have sketched out some tepid possibilities for South Works, are hardly worthy of the Art Institute. After months of meetings with community leaders, they have produced a solid but unremarkable plan that calls for an industrial park, a housing development, and a strip of parkland along the lake. A first-year graduate student in urban planning could come up with something more scintillating than that.

Around the world, enlightened leaders are coming to recognize that there is another way to retool the Rust Belt: the new economic engine of cities is culture. In the industrial Spanish city of Bilbao, the ship-shaped art museum designed for New York City's Solomon R. Guggenheim Museum by California architect Frank Gehry is the emblem of this idea, which holds that cities can create wealth by importing tourists as well as exporting widgets. It has drawn nearly 1.4 million visitors since opening last October—three times as many as expected.

At South Works, though, there's no need to fly in crates of Kandinskys and Picassos, as the Guggenheim did to lure the world to its futuristic outpost in Bilbao. Etched in the slag piles that cover the site is a heroic tale of men like Frank Stanley, men who built the steel that undergirds the Loop's skyscraper behemoths, the rocket assembly structures at Cape Canaveral, Iowa's farm plows, and the railroads that crisscross a continent.

"Why were the foremen big and burly?" Stanley asks rhetorically of preunion days, when workers didn't have many rights. "To keep you in line. They'd tell you to do something. If you didn't, you got punched."

The South Works story speaks, literally and figuratively, to the great American myth of the melting pot. As the journalist John Maclean put it in a 1992 *Chicago Tribune Magazine* article about the closing of South Works, the plant's roaring melting pots turned iron ore, limestone, and coke into prime steel, and Scots, Irish, Poles, Czechs, Ukrainians, Mexicans, and others into generations of Americans.

Could Hollywood come up with a better plot line than that?

So why not mine the raw material of South Works for all it's worth and extend the lakefront's great string of museums a little farther south? A museum that would focus on the story of the steelworkers—work, leisure, unions, strikes, camaraderie, community—while exploring the grander theme of work in America is a natural for the City That Works.

True, its prospective location, 10 miles south of the Loop between 79th and 91st Streets, may seem remote. But consider that the proposed museum would be just four miles south of the Museum of Science and Industry, which attracted almost 1.7 million people last year—and that city transportation planners are talking about extending South Lake Shore Drive through the western edge of the South Works site.

And think how the museum would jog our memories. "We're suffering from national Alzheimer's disease," says Studs Terkel, Chicago's poet of the common folk. "Much of what [organized] labor has accomplished has been forgotten." He cites such revolutionary innovations spawned by the union movement as Social Security and the eight-hour day.

A museum based on the story of the steelworkers could be the gateway to a new National Heritage Area that would sweep around the curve of Lake Michigan, reaching all the way to the towering sand dunes of northern Indiana. It's the brainchild of U.S. Rep. Jerry Weller (R-Ill.), whose district includes Chicago's Southeast Side.

In 1999, Weller plans to introduce legislation to create the Heritage Area, a series of related sites including South Works and Pullman, the model industrial town built by railroad magnate George Pullman, as well as Lake Calumet, where, amid working steel mills, one finds prized wetlands.

The Heritage Area would capitalize on a new trend in leisure time, as Americans make pilgrimages to shrines of everyday history, like the banks of the 150-year-old Illinois and Michigan Canal that transformed Chicago into one of the world's great cities.

Yet in a classic instance of one hand not knowing what the other is doing, there is not a word about Weller's proposed Heritage Area in the city's plan

for South Works. That's too bad, and not just because it ignores the prospect of all those Hoosiers, Iowans, Michiganders, and the like coming to the Heritage Area—and dropping thousands of dollars into Chicago's coffers.

A Value beyond Tourism

Seemingly ordinary urban landscapes—union halls, produce markets, textile mills, steel mills—have a value beyond tourism. They have the power "to nurture citizens' public memory, to encompass shared time in the form of shared territory," as Dolores Hayden, professor of American studies at Yale University, writes in her 1995 book, *The Power of Place: Urban Landscapes as Public History*.

So, to dig up the riches that lie hidden like buried treasure at South Works, we have to adjust our sights—upward.

First, the city should come up with a farsighted plan for South Works that lays out the case for devoting prime lakefront land not to luxury high-rises, which developers must be salivating to build, but instead to parkland and cultural facilities open to everyone.

Second, we need to take a leap of mind comparable to the one Daniel Burnham made in the first decade of this century, when, in the Plan of Chicago, he envisioned that the lakefront, then mostly lined with railroads and freight cars, could instead be devoted to beaches, parks, and museums. Yet today, rather than banish industry from the lakefront, the task is to enfold it, at least in our memories, so it can tell the story of working Americans. "There's been an ever-expanding definition of what is history," says Perry Duis, a historian at the University of Illinois at Chicago. "It's moved beyond presidents and national events to a broader appreciation of everyday life experience."

To North Siders and maybe even to some South Siders—certainly to many who live in the suburbs—Chicago's Far Southeast Side needs an introduction. It's not unlike a foreign country, cut off from the rest of the city by its location far south of the Loop, a lack of good road connections, and a way of life alternately described as villagelike or insular.

Driving across the Chicago Skyway, the toll road that slices across the Far Southeast Side and connects the Dan Ryan Expressway with the Indiana Toll Road, you see a skyline dotted by church steeples and steel plants, some working, some closed. It's a place that the rest of the world tends to drive over rather than stop at to do business. Even Lynne Cunningham, president of the Southeast Chicago Development Commission, a nonprofit community development group, refers to it as "the land under the Skyway."

When USX shuttered South Works in 1992, the impact reverberated far beyond the mill. Suppliers, like those that provided alloys that went into the

SUSAN AND TEODULO VEGA: A daughter and her father, a South Works employee for 32 years—people like them tell the story of the old steel mill and its neighborhood.

steelmaking process, closed. So did industries that served the plant, like those that repaired ladles. Dry cleaners, grocers, department stores—all went out of business or saw the ink on their profit statements go from black to red.

The number of crimes and other social problems rose as churches and other institutions had less money to deal with them. Property values stagnated. Today, neighbors say, you can buy a single-family house in the area just across the street from the mill for as little as $50,000, far below the Chicago median price of $122,500.

All the while, people like Susan Vega, 43, an organizer for the Illinois Campaign for Better Health Care, didn't pull up stakes and leave. They kept the backbones of their neighborhoods from breaking.

Walking toward the plant one warm June morning from her green two-flat in the 8400 block of South Mackinaw Avenue, a block west of South Works, Vega remembers the constant hum emanating from the mill, the trains running over its narrow-gauge railroad tracks, and how her father, Teodulo Vega, a crane operator at the mill, would cooperate with others on his shift to make sure no one got killed.

She looks through a chain-link fence at those long walls along the slip, where the three essential materials for steelmaking (iron ore, limestone, and coal) were stored before making their way into the blast furnaces and refining mills. But instead of seeing an eyesore, she sees a landmark. "It's a constant reminder of what used to be here. Where 10,000 jobs used to be," she says. "It was part of the fabric of our lives, part of who we were."

Buried Chemical Agents

Seen strictly as a real-estate development, South Works is at once dazzling and daunting. "Its biggest advantage is its location and its size. And its biggest disadvantage is its location and its size," acknowledges Thomas R. Ferrall, director of public affairs for the U.S. Steel Group.

There are other disadvantages to the parcel, which USX wants to sell—to a single developer, it hopes—for $85 million. For example, the foundations of more than 100 South Works buildings remain embedded in the pile of slag on the site. Part of the foundations must be removed if water mains, sewer lines, and other utilities are to be built, according to Eileen Figel, Mayor Richard M. Daley's South Works project manager.

And while the Illinois Environmental Protection Agency has approved the site for residential construction and city consultants play down the chance of pollution-related problems, some environmental engineers say that buried heavy metals and chemical agents could mean polluted groundwater—as well as contamination at nearby beaches and the lake. "There are some very real constraints to development," agrees Peter Skosey, the urban development director of the Metropolitan Planning Council.

Still, if these obstacles can be overcome, Chicago can seize upon an incredible chance. In 1909, when Burnham unveiled his Chicago Plan, South Works had been in business for 29 years and wasn't about to move. So Burnham simply left a big gap at the site in his proposed chain of lakefront parks.

As recently as 1972, when Chicago published its last lakefront plan, South Works was spewing pollution into Lake Michigan. Park District employees still remember the lake water on the Far South Side turning red. Yet now that the plant is history, the city can instantly add two miles of parkland to its 24 existing miles of publicly accessible lakefront.

But what kind of public space does Chicago want to create here? How will it relate to the rest of the lakefront? How will it link up with Weller's proposed National Heritage Area? Why would somebody who doesn't live on the Far Southeast Side want to come here?

The city's South Works plan, prepared by the Chicago architectural firm of Skidmore, Owings & Merrill and released in September, does little to address these questions. Nor does it explore in depth the idea of a steel museum, which Southeast Side residents had suggested in early planning sessions. However, it deals thoughtfully with other issues:

- To help reduce the area's isolation, the plan calls for rebuilding four existing Metra stations to the west of South Works, between 79th and 92nd Streets.

• To prevent new housing from turning South Works into enclaves of cul-de-sacs, it recommends continuing the major east-west city street grid through the site.

• To keep a southward extension of Lake Shore Drive from walling off the lakefront, it foresees extending Lake Shore Drive through the western edge of South Works, not as an expressway, but as a boulevard.

• To create a continuous strip of parkland running from Rainbow Park (7500 to 7900 South) to Calumet Park (9500 to 10200 South), it suggests new shoreline parkland at the South Works site and raises the prospect of adding landfill to state-owned land across the mouth of the Calumet River from the site.

Granted, there's a public vision percolating here, one that offers a solid base on which to build a community. Yet the plan fails to soar. An injection of culture would enliven its prosaic mix of uses. And planners need to ponder the future of South Works not just from a bird's-eye perspective, but from the ground, where the people will be, so new parkland doesn't turn out to be an anemic, unexciting strip like the one in Burnham Park.

How about an outdoor concert stage that would provide an air of festivity? Or a small maritime museum, which would be appropriate because a lot of big ships pass by, going to and from the Calumet River? Maybe even a remote site of the Adler Planetarium, which would take advantage of the fact that South Works is so far from the bright lights of the Loop?

Whatever goes at South Works, the inherent toughness of the site should be allowed to speak. You can hear its grit in the voices of men like Stanley, a 77-year-old former steelworker who now is the cocurator of the Southeast Historical Society museum.

It's a tiny operation, located in the field house at Calumet Park and open just two days a week, but it has a rich collection of photographs and objects, such as a 20-foot-long, glassed-in model of what Commercial Avenue, the Southeast Side's commercial hub, looked like in 1940.

Back then, Commercial had major department stores, clothing stores, ice cream parlors, movie houses, and bakeries rather than the dollar stores it has now. The mill ran 24 hours a day, and when shifts changed, steelworkers would hit the bars and other places along Commercial. "You could go to Commercial at 2 A.M. and it would be like noon," says Stanley.

Stanley offers a different version of the slogan coined by U.S. Steel—"Safety First"—which remains written on the massive walls at South Works. Over the years, safety features at the plant improved, but in the early years of the century, he says, "Safety First" was a hoax. "People were crushed by trains," he says. "They fell into molten metal. People's hands got maimed."

It's a tale that ought to be heard by a broader public.

THE SLIP AT SOUTH WORKS: Once a docking site for ore boats that delivered raw materials to the plant, now a site that could be a museum celebrating steelworkers' history.

A Feel for Heavy Lifting

Think of how one could go to a museum and, as part of a series of exhibits about work in America, watch a video of the steelworkers recounting their experiences, hear about pivotal strikes, see historical footage of the plant, learn about its contributions to the nation, and touch heavy objects—melting pots, for example—that would give one a sense of what heavy lifting really is.

On emerging from the museum, one could gaze north across the lake to the skyline, where South Works steel holds up Sears Tower, McCormick Place, the Amoco Building, the John Hancock Center, and the Wrigley Building. One might see the skyline with new eyes—not just as a parade of skyscrapers, but as a symbol of the dignity of work.

Such a museum could be endowed by private philanthropy and by labor unions, as well as by a donation of land from the Park District. Yet rather than being narrowly conceived as a "labor museum," it could have the broader mandate of documenting and vividly conveying the ongoing importance of work to Chicago and the nation.

The museum also could grow from the idea that South Works once was a virtual city within a city, with its own hospital, restaurants, stores, railroads, police, and firefighters, even circuses.

If the proposed museum were to be located along the great boat slip where ore ships once docked, it could form the centerpiece of the new South Works, gathering a range of smaller buildings—shops, restaurants,

beer gardens—around it like a cathedral. They would lend a human scale to this vast waterfront site, turning it into an inviting city street.

While at first glance, the idea of commemorating a hulking steel mill along a lakefront chiefly noted for its green meadows and sandy beaches may seem implausible, the lakefront itself shows that industry and ecology aren't incompatible. In the area around the mill, industry already has stamped its presence on parkland, and the parkland seems no worse for it.

At the northern edge of Calumet Park, just south of South Works, there is a street called Foreman Drive, an allusion to the men who ran the work gangs. Along the Chicago Skyway, there is Bessemer Park, named for the Bessemer furnaces used in the steelmaking process.

That industrial flavor doesn't have to stop at South Works. It can extend through the National Heritage Area that Weller wants to create, emulating the Illinois and Michigan Canal National Heritage Corridor, which stretches 100 miles from Chicago to LaSalle-Peru. The corridor was designated the country's first National Heritage Area in 1984.

When the Illinois and Michigan Canal was completed 150 years ago in 1848, it helped turn Chicago from a frontier settlement into the metropolis of the Midwest by creating what historian Duis calls "the golden funnel," an enormously profitable connection, via the Great Lakes, between the commodity-based economy of the Midwest and the voracious markets of the East.

Yet 40 years ago, driven to irrelevance by railroads and interstate highways, the canal was decrepit and almost forgotten. Many of the cities and towns that grew up along it were dying. Today, because of the cooperation that the National Heritage Corridor has spurred among different bodies of government, the canal is once again a spine of economic prosperity. Paths from which mules used to tow canal boats are now bike trails. Picturesque towns along the canal, such as southwest suburban Lockport, have recovered, their handsome Joliet limestone buildings sparkling. In Joliet a former steel plant site, with ruins of blast furnaces and other industrial buildings, now has a 1.5-mile concrete walkway with interpretive signs.

There were an estimated 1.5 million visits to former industrial sites in the canal corridor in 1997, according to Ana B. Koval, the executive director of the Canal Corridor Association. The broader import of the corridor couldn't be clearer: the industrial past is a cornerstone on which to build the postindustrial future.

Just as at the Guggenheim Museum in Bilbao, where Gehry has inverted the conventional way of making museums with a flight of stairs that leads down rather than up to the main entrance, this new way of looking at pub-

lic space turns conventional thinking on its head, seeing beauty in what seems ugly, and extraordinary meaning in what appears merely ordinary.

There's no reason we shouldn't apply that vision to the lakefront, using a range of mechanisms like the tax-increment financing district, or TIF, which earmarks increases in property taxes generated by rising property values to pay for public works.

Means aside, the ultimate issue is our creativity and how we use it to seize upon the biggest chance in years to expand and enhance the lakefront. As the industrial era is supplanted by the Information Age, as smokestacks give way to microprocessors, we can transform the story of South Works into a new kind of lakefront story—one that celebrates industry as well as nature, the heroism of the common man and woman as well as the general on horseback.

That's the way to manufacture the revival of South Works.

Postscript

In a major boost for long-dormant South Works, the Solo Cup Co. in 1999 acquired 107 acres of the sprawling lakefront parcel for a new factory. The facility, which will make paper cups after its scheduled completion opening in early 2003, will fill the southernmost portion of South Works. Twenty acres of shoreline parkland will be built near the factory. A $78 million state plan to construct roads, ramps, and bridges leading to the former U.S. Steel site also was moving closer to reality.

The future of the rest of South Works is less certain in part because local political squabbles in northwest Indiana have prevented Weller from introducing legislation to create the proposed National Heritage Area. But at least South Works now has a blueprint worthy of its vast size. In 1999, city officials and Skidmore, Owings & Merrill unveiled a new South Works plan that brims with good ideas. Among them: creating a new beach, as wide as two city blocks, at 79th Street and turning the 2,000-foot-long slip into a recreation and cultural hub. It would be anchored by a museum devoted to labor history and steelmaking.

Striking a Balance

Lincoln Park Is about to Add the Nature Museum to Its Already Full Plate, While the South Lakefront Hungers for Improvements

NOVEMBER 3, 1998

A park is supposed to provide relief from the city, but on most summer weekends Lincoln Park seems indistinguishable from Times Square. Its roads are jammed with cars. Its bike path is crammed with cyclists, joggers, walk-

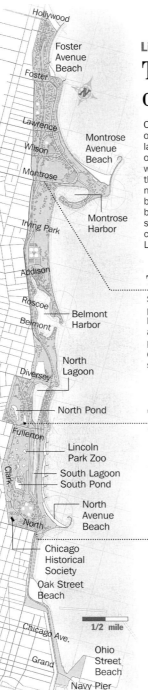

Lincoln Park

The downside of popularity

Chicago's biggest park is a victim of its own success, its roads and lakefront bicycle path jammed on summer weekends. And that congestion may get worse before it gets better. Below are some of the most congested areas in Lincoln Park.

Map area

CHICAGO

Too many cars

So many people drive to popular parts of Lincoln Park, like the beaches and parkland at Montrose Avenue, that the police place barricades in front of park entrances on some summer weekends.

The epicenter of congestion

The $30 million Peggy Notebaert Nature Museum threatens to make traffic jams worse at the already packed intersection of Fullerton Parkway and Cannon Drive.

Bike path "pinch points"

Tight spots in the lakefront bicycle path at Belmont Harbor, Diversey Parkway, Fullerton Parkway, and North Avenue are notoriously dangerous for cyclists, in-line skaters and pedestrians.

Source: Chicago Police Department

1/2 mile

THE LAKEFRONT BIKE PATH: Overcrowded and dangerous, an example of how changing recreation trends have caught the Chicago Park District off guard.

ers, in-line skaters, and mothers pushing baby strollers. All that's missing are the pulsating neon signs and sharpies dealing three-card monte.

With this sort of Manhattan-style congestion staring them in the face, you'd think that Mayor Richard M. Daley's planners would have refrained from placing any more major attractions in the lakefront's biggest and most populous park.

Guess again. Opening its doors in 1999 will be the $30 million Peggy Notebaert Nature Museum, right at the epicenter of Lincoln Park's mind-numbing traffic jams, the intersection of Fullerton Parkway and Cannon Drive. It seems almost perverse that someone would locate a front-line museum directly across from the Lincoln Park Zoo, which pulls in an estimated 3 million visitors a year, and the Lincoln Park Conservatory, which draws another 300,000.

But there's a lesson that can be extracted from the impending gridlock. If we can't move the Nature Museum—formerly the Chicago Academy of Sciences, a longtime Lincoln Park fixture—somewhere else, then at least we could redistribute other park features to points along the shore where the problem is too few people rather than too many.

Leaders of a number of Lincoln Park attractions, such as the Chicago Historical Society and the zoo, are taking this lesson seriously, undoubtedly recognizing that they stand to lose attendance—and revenue—if congestion

LINCOLN PARK'S "ELVIS IS ALIVE AND RUNNING A 5K" RACE: A park where the landscape—
and the people—are extraordinarily diverse.

worsens. The theme has also been adopted by Lincoln Park activists who, to
paraphrase the late comedian Henny Youngman, want somebody to take the
Air and Water Show—please!

Tired of the way the two-day August event chokes their already packed
park, the advocates are urging the Mayor's Office of Special Events to move
the entire show—lock, stock and B-1 bomber—to the 31st Street Beach,
which is about to undergo renovation and expansion. "We don't need it,"
says Betsy Altman, immediate past president of the Lincoln Park Advisory
Council, a citizens group that makes recommendations to the Park District.
"The park is overused."

Of course, many details need to be worked out if the event, which draws
hundreds of thousands of spectators, is to be shifted. And the Air and Water
Show lasts but one weekend, limiting any contribution the move would
make to Lincoln Park's overall population problem. Still, there's a big-picture
idea here, and it challenges the myopic vision with which the city typically
views the lakefront.

You wouldn't eat, sleep, shower, entertain, and do laundry in just one
room of your house, would you? So why should the Park District, with 24
miles of lakefront to choose from when locating attractions, concentrate so
much in one small area?

Within blocks of Fullerton and Cannon, in addition to the aforemen-

tioned draws, are a yacht harbor, a double-decked driving range, tennis courts, a summer theater, a two-story in-the-park restaurant, nearly half a mile of beach volleyball courts, and a fishing lagoon stocked with salmon, to name just a few.

The lakefront "needs to be more balanced," says Kimberly Trice, 28, who was sitting one August afternoon on Burnham Park's crumbling seawall amid discarded beer cans and broken glass. Trice, who recently moved from the North Side to the South Side, says she misses Lincoln Park's wealth of activities.

Her sentiments were echoed by Joel Duran, 27, who on a similar August weekday was relaxing with his cocker spaniel in the new "contemplative garden" at Lincoln Park's northern end near Hollywood Avenue. Lincoln Park is "crazy" on weekends, he said, noting that he studiously avoids it on those days.

They're both saying the same thing: the lakefront is in serious disequilibrium, with much of it lying fallow while other parts teem. While there's no "magic bullet" to fix the problem, a little spreading of the wealth would help.

A Diverse Landscape

More than any other lakefront park, Lincoln Park exemplifies how the lakefront is shaped as much by human action as by the forces of nature. With the exception of a small chunk of land near the Farm in the Zoo, the 1,212-acre park between Ohio Street on the south and Hollywood on the north consists entirely of landfill dumped into the lake over nine decades. In other words, most of the land where thousands of people now stroll, play soccer, picnic, and get caught in traffic jams was under water as recently as 70 years ago.

Everybody comes to Lincoln Park, from Gold Coast executives to homeless men and women who sleep next to their shopping carts, from slackers to suburbanites, from old bluebloods to a veritable United Nations of first-generation immigrants. This extraordinary human diversity is matched by the diversity of the park itself. It's a living history of American landscape design, ranging from the tightly controlled Victorian spaces near the park's southern end to the sprawling, wide-open spaces at its northern edge, their extrawide roads reflecting postwar America's infatuation with the automobile.

Given the way cars so dominate Lincoln Park today, it is stunning to see old black-and-white photographs that show horse-drawn carriages sharing a narrow Lake Shore Drive with early autos. And with bicycles now such a pervasive presence in the park, it is just as surprising to learn that, as recently as the 1930s, they were prohibited from nearly all Chicago parks, including Lincoln.

It was only when President Dwight Eisenhower suffered a heart attack

in the 1950s, and Americans suddenly exhibited a heightened concern about physical fitness, that park administrators began to recognize the value of cycling.

But when the late Mayor Richard J. Daley and Eisenhower's cardiologist (and cycling evangelist) Dr. Paul Dudley White went for a much-photographed ride on a tandem bike in Chicago in 1956, no one foresaw the health craze that would send millions of Americans into the streets for aerobic exercise.

Today, the bike path is a microcosm of Lincoln Park's congestion problem, a classic example of how changing lifestyle and recreation trends have outstripped the Park District's ability to keep up—and why the district needs to do a better job of planning ahead.

On a typical summer day, hordes of cyclists, walkers, joggers, and Rollerbladers jockey for space on a strip of asphalt that is only eight feet wide in some places. The national standard for the width of bike paths is 12 feet.

Most of the time, the conflicts that erupt amount to nothing more than heated words or obscene gestures. Occasionally the results are tragic, as when a 34-year-old Far North Side man, Wlodzimirerz Kowalski, died after colliding with an in-line skater at North Avenue Beach in 1998.

With all sorts of sporting trends foreshadowing even more traffic on the bike path—Navy Pier, for example, has started renting out "quad cycles," bicycles for four that resemble golf carts—things can only get worse. "We have to take pressure off the lakefront bike path," says Ald. Mary Ann Smith (48th), chairman of the City Council's Committee on Parks and Recreation. "It cannot be all things to all people."

Maybe it's time to pry apart the warring factions on the bike path and follow the precedent of New York City's Central Park, where Frederick Law Olmsted created sunken paths to separate pedestrians in search of serenity from the clip-clop (and smells) of horse-drawn carriages.

That precedent will be especially handy in accommodating all the aging Baby Boomers who in coming years will be taking long walks to keep trim. To do that, the Park District can construct two or three distinct paths—one for people on foot, another for those on wheels, and a third for high-speed cyclists who use the path to get to work or for activities like triathlon training. As Randy Neufeld, the executive director of the Chicagoland Bicycle Federation says, the best way to ease congestion on the path is "to separate wheels and heels."

But there are other solutions. By creating and promoting venues for skating, running, and cycling in the city's inland parks, the Park District can ease bike path congestion in Lincoln Park. More programs of all varieties in other city parks will further this goal because many bikers aren't long-distance cy-

clists riding along the entire lakefront. They're intrapark riders who use their bikes to get from one park activity to another. "It's very difficult to declare martial law and force everyone to do what you want to do," Neufeld says. "The idea is to design so people will want to do what is safest and best."

If only solving the rest of Lincoln Park's problems were so simple.

Seeing Red over Greening

The very demographic trends that threaten to make the entire lakefront out of sync with the people who use it already are making themselves felt in the park. Witness the tension the Park District has aroused with its seemingly innocuous campaign to rid the shoreline of surface parking lots. This greening of the lakefront has plenty of parkgoers—especially the growing number of people who like to load up the family minivan with kids, grill, cooler, playpen, and stroller—seeing red.

Many senior citizens, who also prize drive-up convenience, don't like it, and neither do some people who are disabled. "The only people that are going to be able to use [the lakefront] are the privileged few that live within three blocks—the wine and cheese crowd," complains Bill Kehoe, 46, a paraplegic cabdriver.

The conflicts caused by too many people fighting over too little space in Lincoln Park go on and on. Boat owners can't stand dog owners, whose pesky pooches swim at Belmont Harbor and block the paths of craft going to and from the lake. Fishermen turned hostile to bird lovers when the Park District took a step that inconvenienced them in favor of a bird sanctuary. Nature buffs get all steamed up when clueless barbequers dump still-glowing coals at the foot of trees, which can cause trees to die.

Perhaps it would help to bring in Henry Kissinger for a few rounds of shuttle diplomacy between these ever-quarrelsome interest groups.

But it's possible to resolve these problems ourselves, as revealed by the almost happy ending to the saga of the fishermen and the bird-watchers.

Four years ago, the Park District infuriated fisherfolk by closing an access road that allowed them to park near a fishing pier at Montrose Point and minimize the distance they had to haul their gear. By closing the road, which ran alongside the "Magic Hedge" bird sanctuary, whose dense thicket of foliage attracts migrating birds, butterflies, and wildlife, the district hoped to create more green space around the sanctuary. Responding to concerns that disabled fishermen would be cut off from the lakefront, the Park District then set aside parking spaces elsewhere near the pier while improving other Montrose fishing areas, notably the peninsula known as Montrose Hook.

Is everybody happy? Well, not really. But they can live with the outcome.

FULLERTON PARKWAY: For man and beast alike, Lincoln Park's notorious traffic jams make it anything but a pleasant getaway.

Fisherman Bill Diaz, 54, hasn't gone to Montrose Point since the Park District removed the road. On the other hand, he can't find much fault with his new fishing spot at the end of the Hook, where there's a stunning, across-the-water view of the downtown skyline. "I would say this is fine if you can't go out to the other one," proclaimed Diaz at the Hook one recent morning.

The idea, says the Lincoln Park Advisory Council's Altman, is that you can't plan the parks around just one user. There have to be compromises where everybody wins. But such compromises don't address the root cause of Lincoln Park's traffic congestion: the lakefront's imbalance of activities, which places an extraordinary burden on even so sizable a park.

On summer weekends, Lake Shore Drive's off-ramps at the avenues of North, Fullerton, and Belmont typically back up, as do roads like Fullerton that carry traffic between the Kennedy Expressway and the lakefront. Parking lots, like the one at North Avenue Beach, are jammed. Even at Montrose, with its vast network of roads and parking lots, traffic slows to a crawl. Three times this year, police had to block off entrances to the park at Montrose.

"Lincoln Park is horrendous," contends Michelle Silas, 48, a Chicago Transit Authority bus driver who says that the park's north-south roads are so jammed on summer weekends that it can take her 45 minutes to drive the mile-and-a-half stretch of Stockton Drive between Diversey Parkway and North Avenue.

A Planning Bible

Lincoln Park supposedly has a tool for fixing this problem—a 1995 plan crafted by the Park District and the Lincoln Park Steering Committee, a now-dissolved coalition of 21 citizens groups. The plan specifies a series of steps designed to improve the park. As one planner puts it, perhaps immodestly, "It's like a little Bible" for the community to follow.

Yet just as people stray from the Ten Commandments, those who are supposed to follow plans don't always do so, as the example of the Nature Museum illustrates.

True, the Lincoln Park plan opened the door for the Academy of Sciences to relocate from its previous home at the east end of Armitage Avenue to its new one at Fullerton and Cannon. But the plan did so in the context of calling for a parking structure for 400 cars on the site of the museum, and of using a hillside to hide the structure.

A high water table nixed that idea. "Darling, we'd be parking in the lake if we tried to dig down," says museum spokeswoman Kathleen Berg. She and community leader Allan Mellis downplay the prospect of huge backups, citing traffic control measures that have been put into place, such as a left-turn lane on eastbound Fullerton at Cannon and a new trolley system serving Lincoln Park.

"The jury's out" on the Nature Museum's impact on traffic, Mellis says. But Alderman Smith flatly condemns the move. "I personally believe it was a mistake to let [the Nature Museum] expand there," she says. "Knowing what we know now about congestion and watching neighborhoods throughout the city come back, it's really time for museums along the lakefront to carry their activities into the inland regional parks."

She adds, "If we really want these world-class institutions to provide world-class programs, they ought to have some of it in the neighborhoods, closer to children. . . . Now this may not bring people to an institution's restaurant or gift shops. But it does fulfill the mission of the institutions without exacerbating the traffic crush and the demand for more parking."

Despite the planning gaffe involving the Nature Museum, the Lincoln Park plan has, in general, proved an effective guide, as illustrated by some impressive work now under way at the park's southern end. There, in a move called for in the plan (and recalling in miniature the rerouting of Lake Shore Drive's northbound lanes to create the Museum Campus), city workers have shifted the southbound lanes of Stockton Drive to create 155,000 square feet of new parkland along Clark Street, nearly as much as three football fields.

In a related project, the Chicago Historical Society has begun construction on a $7.5 million parking garage just east of Clark. "The Historical So-

ciety did not just want to build a parking garage. It wanted to try to work with the community to solve some of the different traffic congestion problems in the area," says Robert Nauert, vice president for finance at the Historical Society. "We approached this in a holistic manner," he adds, sounding like a planner rather than a finance guy.

The next step, Nauert says, must be to improve other attractions along the lakefront, particularly the south shoreline. He points to how the Park District's renovation of beaches at 12th, 31st, and 57th Streets has lessened the crunch somewhat at North Avenue and Oak Street beaches. "The bottom line is that, in the middle of the summer, this is one of more desirable areas of the city. If you move some of the demand generators to other areas of the city, then it's going to lessen the congestion," Nauert says.

Clearly, though, only a multipronged attack will do away with Lincoln Park's traffic jams:

• More people ought to be able to get to the lakefront by bus. Currently, many CTA east-west routes, like the North Avenue line that stops near the Historical Society, barely penetrate the park, leaving parkgoers to walk vast distances—with picnic baskets, blankets, and more—to their destinations. How about altering the routes so they're more convenient and even giving families a discount on weekends?

• In 1998, the Lincoln Park Zoo and Chicago Historical Society sponsored a trolley route that connected Lincoln Park with three Mid-North parking garages (at Piper's Alley, Grant Hospital, and Children's Memorial Hospital) that had room on weekends. More than 18,000 people rode the trolley, making a dent in park congestion. The institutions plan to continue the trolley program if they can figure out how to pay for it.

• City planners wisely want to do away with a 41-year-old provision in the Chicago zoning code that allows developers to construct 15 percent more floor space if they build next to a public open space of at least five acres and at least 200 feet in depth. Intended to create a city of skyscrapers surrounded by parks, the provision gave Chicago an unanticipated byproduct: the dreary row of high-rises packed alongside North Sheridan Road—and the traffic tie-ups that inevitably came with them.

• A so-called "pay and display" program now getting a trial run in the park at Waveland Avenue is designed to unclog park roads, discouraging residents from parking their cars there indefinitely. It works like this: you feed money into a machine, which gives you a sticker that you display on your dashboard.

Not surprisingly, "pay and display" does not please people who live nearby. Yet Altman would like to see it expanded to Stockton and Cannon Drives and offers assurances that the plan can be fine-tuned, suggesting

that it be suspended from September through May, when Lincoln Park is not so crowded. "If we don't do something to manage the cars that are in the park, then we will have no alternative but to pave over the park or prevent people from using it," she says.

But that leaves unanswered the question of where else Lincoln Park residents would park during the summer (surely not in the already crowded neighborhoods to the west) and how they'd pay for it. This one needs more thought.

So does the prospect of moving the Air and Water Show to 31st Street Beach. On its face, it's a wonderful idea because it would give underused Burnham Park what overused Lincoln Park doesn't want: an event that regularly draws hundreds of thousands of spectators. Yet upon closer inspection, the switch won't fly, at least not yet.

Burnham Park, of which the 31st Street Beach is a part, needs new shoreline revetments, the tiered blocks of stone that protect the parks from the pounding of the lake while giving parkgoers a place to stroll, sit, or sunbathe. The revetments in Burnham Park now look as if they've been bombed.

Who in their right mind would sit there, amid piles of trash and broken glass, and watch planes go by? What's the point of introducing people to the south lakefront unless it makes a good showing and encourages them to come back?

Clearly, the solution to Lincoln Park's problems rests not just inside Lincoln Park, but outside of it—in a new balance of activities and programs along the entire lakefront. By redistributing them, particularly to the underachieving south lakefront, the city and Park District could make the overwhelmed north lakefront less crowded and more sane. At the same time, they can redress the division by race and income that splits both the shoreline and the city.

It's all about turning the lakefront into a great populist smorgasbord, with a variety of people-pleasing activities lined up like so many enticing buffet dishes from Evanston to Indiana. But if the lakefront is to become the equivalent of a smorgasbord, with more offerings on the South Side and less congestion on the North Side, the menu items had better not leave visitors with a bad taste in their mouths.

The South Side should take the Air and Water Show—when it's good and ready.

Postscript

Despite the Nature Museum planning gaffe, city officials still seemed intent on pouring resources into a park that already had more than its share of them. In 1999 a $24 million plan to turn the most heavily

trafficked part of Lincoln Park into a "Museum Campus North" drew the ire of South Side community leaders, who decried it as unfair, especially because many South Side parks remained in need of basic services. Designed for the Park District and Lincoln Park museums by Thompson Dyke & Associates of Northbrook, the plan calls for a four-season theme garden, a steel pedestrian bridge over Fullerton Parkway, and a renovation and expansion of the Lincoln Park Conservatory. According to Park District officials, it still lacks financial backing.

Big Canvas, Little Plans

Mayor Daley Could Be an Architect for the Shoreline, Not Just a Groundskeeper—and Now Is the Time to Act

NOVEMBER 5, 1998

A city looks different from the air than from the ground, as anyone who has ridden the Ferris wheel at Navy Pier knows.

Climb into one of those gondola cars on a warm summer night and you are transported to an aerie from which the lakefront unfolds in majestic splendor, a sweeping intersection of land and water that stretches from the smoke-belching steel mills in the south to the range of high-rises in the north.

But back on terra firma, the prospect is decidedly less inspiring.

Visitors to Navy Pier not only have to fight their way through formidable traffic jams, but must either shell out a small fortune for nearby parking—or walk as far as a mile if they choose the cheaper alternative of a meter.

Two miles down the shoreline, those driving to the new Museum Campus also struggle to find close-in parking on summer weekends despite the nearly 5,000 spaces that sprawl alongside Soldier Field. Now that it's fall and park attendance has dropped dramatically, those spaces are empty and ugly—a sea of asphalt where there ought to be parkland by the lake.

There's only one person who can shape up the downtown lakefront. Yet that person, Richard M. Daley—mayor of the nation's third largest city, former president of the U.S. Conference of Mayors, a leader who has so solidified his grasp on power that he is virtually assured of reelection next year—seems to be shying away from the bold moves necessary to get the job done.

Whereas the great lakefront visionary Daniel Burnham urged Chicagoans to "make no little plans," little plans are practically all this mayor makes. He's got a thing for flowers, trees, and wrought-iron fences. Indeed, aides say Daley can't stand the idea of big-picture, comprehensive planning—which they have come to call "the 'C' word."

To be sure, Daley presided over the relocation of Lake Shore Drive and

NAVY PIER: Where the Dock Street pedestrian promenade is jammed—as are Lake Shore Drive and other roads leading to the pier.

the creation of the Museum Campus. But it was Mayor Jane Byrne who proposed moving the Drive in 1982 as part of a package of infrastructure improvements for the proposed 1992 World's Fair.

In addition, while aides for the mayor said in a recent interview that he would support a master plan for Grant Park, to date nothing has come of that vow, underscoring the sporadic nature of planning efforts at City Hall. "He views [long-range planning] as holding things up instead of getting things done," says one person familiar with the mayor's thinking.

Perhaps Daley's reticence can be attributed to what happened early in his tenure, when he sought to be a visionary like his late, legendary father, Richard J. Daley, unveiling such grandiose designs as a third airport at Lake Calumet and casinos on the Chicago River.

After those initiatives suffered humiliating defeats and he was perceived as an impotent figure whose days in office were numbered, Daley quickly recast himself as an apostle of "small is beautiful," tending to the kind of tiny details that his predecessors delegated to subordinates. In his view, say those who work for him, sweeping plans raise the public's expectations—and, in politics, you should never promise things you can't deliver.

While undoubtedly a certain security—job security—attaches to the act of keeping expectations low, leaders are supposed to raise, not lower, our sights, aren't they? Isn't that what Burnham and his generation of politicians and business leaders did in executing their vision of a better shoreline?

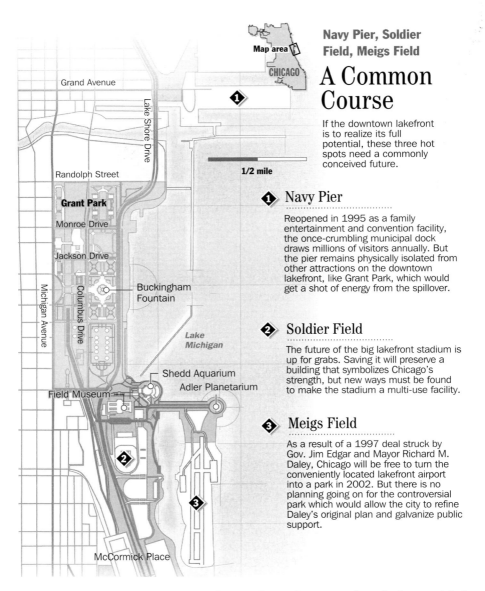

Navy Pier, Soldier
Field, Meigs Field

A Common Course

If the downtown lakefront is to realize its full potential, these three hot spots need a commonly conceived future.

1/2 mile

❶ Navy Pier

Reopened in 1995 as a family entertainment and convention facility, the once-crumbling municipal dock draws millions of visitors annually. But the pier remains physically isolated from other attractions on the downtown lakefront, like Grant Park, which would get a shot of energy from the spillover.

❷ Soldier Field

The future of the big lakefront stadium is up for grabs. Saving it will preserve a building that symbolizes Chicago's strength, but new ways must be found to make the stadium a multi-use facility.

❸ Meigs Field

As a result of a 1997 deal struck by Gov. Jim Edgar and Mayor Richard M. Daley, Chicago will be free to turn the conveniently located lakefront airport into a park in 2002. But there is no planning going on for the controversial park which would allow the city to refine Daley's original plan and galvanize public support.

That no one at City Hall is emulating their example and taking a global view of the lakefront is more than too bad. It's downright alarming when one considers that two major planning decisions will soon be staring Chicago in the face: whether or not to raze Soldier Field if the Chicago Bears decide to leave when their lease expires in 14 months, and whether or not to turn Meigs Field into a park when the moratorium Gov. Jim Edgar worked out with Daley runs out in 2002.

The lack of foresight with which the downtown lakefront is being treated is emblematic of the way Chicago is fumbling the future of its entire shoreline.

In the view of veteran lakefront watchers, that's how things have operated since 1972, when the Daley in the mayor's office was Richard J., not Richard M., and the city last issued a detailed plan for its most precious civic asset. "They got a pretty report and that was the end of it," said Lee Botts, the former director of the Lake Michigan Federation, a nonprofit group devoted to the lake. "Since then, it's really been a piecemeal approach."

Changes now in the pipeline that threaten to worsen lakefront gridlock, such as the expansions of the Adler Planetarium and the Shedd Aquarium, promise to put new pressure on the mayor to coordinate the downtown lakefront or watch it become overwhelmed, as Lincoln Park is. "We cannot be creating a scenario where we're going to be choking the lakefront with more automobiles," says Ald. Mary Ann Smith (48th), chairman of the City Council Committee on Parks and Recreation. "There has to be a plan."

The need for planning—big-picture planning, not microplanning—comes sharply into focus when one looks closely at the cases of Meigs and Soldier Field, as well as a third hotspot, Navy Pier.

Mall on the Lake

All can play a wider role in the life of the lakefront than they do now.

For example, while Navy Pier is incredibly popular—it is expected to draw more than 7 million visitors this year—it also is extraordinarily isolated, stuck at the end of Grand Avenue. It is Chicago's very own mall on the lake. With a little planning, though, the pier could become a powerful magnet that draws people and then distributes them to nearby attractions. The overflow from Navy Pier would surely be a boon to Grant Park, which is shoulder-to-shoulder with people during city festivals but nearly devoid of humanity otherwise.

At present, the pier enables us to sample the carnival midway pleasures of urban life, yet it causes suburban-style pain, particularly through the traffic jams that inevitably result from funneling thousands of cars through already busy Lake Shore Drive and narrow feeder streets. The latter seem destined to become even more overburdened as massive commercial developments, such as the planned River East project, rise just west of the pier.

The impending mess symbolizes how City Hall is reacting to the present rather than planning the future. In essence, city transportation planners still are trying to catch up with the dramatic shifts created by 1995's reopening of the pier and the 1998 debut of the Museum Campus.

Once, transit on the lakefront simply meant getting people to and from Grant Park—essentially, a series of movements between downtown and

neighborhoods that was facilitated by the buses and trains that serve the Loop. Now, the city has too late awakened to the fact that, because of piecemeal planning, a new string of attractions up and down the shoreline are without suitable public transit to accommodate them.

The proposed $775 million light-rail "circulator," which would have linked the pier, McCormick Place, and other key spots downtown, was the ideal response to this change. But the circulator, a pet project of Daley's, died in 1995, a victim of insurmountable financing obstacles, yet another big plan of the mayor's that went bust, further conditioning him to reject grand designs. The mishmash of privately sponsored rubber-tire trolley lines that replaced the circulator is a classic example of how the public is ill-served by uncoordinated planning.

There is one trolley line for Navy Pier, another for the Museum Campus, another that serves the Museum of Science and Industry, and still another for the Lincoln Park Zoo and Chicago Historical Society. But why not unify the lines, nearly all of which are operated by the same private company, the Chicago Trolley Co., into a single lakefront loop that would have branch lines extending to Chicago Transit Authority stops and other pick-up points?

It sounds simple enough. Indeed, the Chicago Trolley Co. already has a downtown loop that ties together tourist attractions such as Sears Tower, the Art Institute, Navy Pier, and the Museum Campus. The problem is that it costs a family of four (two adults and two children) $46 for all-day passes, putting the service out of reach for many and gentrifying the lakefront.

Benefits of a Lakefront Loop

Were the city to do more than let the private sector fill the vacuum it has created and subsidize the line, it would (1) get people out of their cars, reducing congestion; (2) make the lakefront less expensive for visitors who now pay exorbitant parking fees; and (3) create arteries that would link now-disparate attractions such as Navy Pier, the Museum Campus, the Art Institute, and Buckingham Fountain into one consolidated whole.

Better yet, the trolley could run through the railroad trench in Grant Park, where, at a cost of $30 million, the Metropolitan Pier and Exposition Authority is building a two-lane road intended to speed buses between downtown hotels and McCormick Place. Surely such a road should be put to a broader public use than just moving around out-of-towners on expense accounts.

The need to go beyond tunnel vision is just as apparent at Soldier Field, where nearly 5,000 parking spaces have been a lakefront eyesore for decades. They seem uglier than ever now that they are flanked by the greensward of the Museum Campus and the handsomely redesigned Lake Shore Drive.

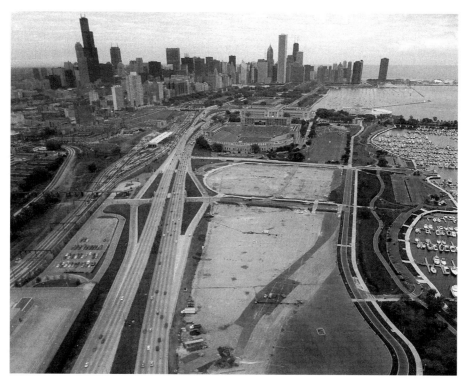

SOLDIER FIELD: Surrounded by nearly 5,000 parking spaces, an example of how the greening of the lakefront begun at the nearby Museum Campus is far from complete.

Here is a grand opportunity to green the downtown lakefront, yet as the negotiations between the Bears and the city drag on, the only "green" on the agenda is how much the city is going to kick in for improvements, such as a new scoreboard. Wouldn't it be wiser to look at what Soldier Field and its environs could do for the lakefront 365 days a year, not just during the 10 regular season and exhibition games that the Bears play?

Granted, there's a certain logic in preserving Soldier Field, even though Burnham himself wanted the site to be public playing fields. After all, the 74-year-old stadium is a National Historic Landmark and, as a monument to America's war dead, its future should not be taken lightly. Besides, it's one of Chicago's iconic images, its row of classical columns evoking the city's urban power as few other buildings do.

Soldier Field should stay. But the Bears, ideally, should leave. Their fans swamp the parking lots on game days, inconveniencing or driving away those who want to attend the neighboring Museum Campus.

If the Bears do find another lair, city planners ought to dust off a 1988

plan by Chicago architects Lohan Associates which suggests how to create a Soldier Field that does not conflict with its surroundings. Under this plan, Soldier Field's classical outer facade and upper-level colonnades would be preserved but its interior seating would be "peeled back" so the stadium could be reshaped to host city festivals, while better accommodating events such as concerts and pro soccer games that already are there.

Whether the Bears leave or stay, Soldier Field can be transformed from a stadium in a parking lot to a stadium in a park, a concept that already has worked in Charlotte, N.C., home of the NFL expansion Carolina Panthers. Instead of pavement, the two-year-old stadium is surrounded by large expanses of grass where fans can tailgate, picnic, or play touch football. As people do at Wrigley Field, the Panther faithful park on city streets or in nearby lots and walk to the game. "We wanted to make it a destination rather than a place where you just walk in and walk out," says the designer, Chicago landscape architect Peter Schaudt.

While Schaudt's model won't translate directly to Chicago, given the need to provide parking for the Museum Campus as well as the stadium, there are other ways to green some or all of the parking lots—for example, installing an underground parking deck at the north end of the Soldier Field lots, as John McCarter, president of the Field Museum, suggests. Such a facility could be financed by bonds or a federal grant similar to the one that backed the Museum of Science and Industry's new $57.6 million underground lot, a park-above-parking-garage arrangement that has freed the great, neoclassical museum from the blight of cars.

More of that farsighted thinking can be applied to the lakefront's single most controversial piece of ground, and one in which Daley has a huge political stake—Meigs Field. As a result of the 1997 agreement between Daley, who wanted to turn the airfield into a park, and Edgar, who wanted to keep the airport, it now seems likely, barring a citywide revolt, that the mayor will get his wish sometime after 2002.

Whatever the timing is, Meigs must go. To stand on this peninsula—to be removed from the clamor of the city and glimpse the stunning views it affords of the skyline and the south shoreline—is to realize that Meigs is an anachronism.

Not a Single Plane

Currently, city officials say, only about 200 people—business executives, politicians, and others—use the airfield on a typical summer day. "In the winter," says one official, "we have days where we won't see a single plane come or go."

With three years until Meigs can be closed, there's an opportunity to refine Daley's original plan for an "outdoor museum" that would complement

MEIGS FIELD: Where planes take up space that otherwise could be devoted to parkland.

the natural science institutions of the Museum Campus—the Field Museum, the Shedd Aquarium, and the Adler Planetarium—with features such as wetlands, a bird sanctuary, and a hill serving as an outdoor planetarium.

While the plan basically has merit, it nonetheless could use improvement, especially by the addition of a flagship attraction that cannot be found elsewhere on the lakefront. Yet there's no planning going on for the park; the mayor said so himself in an interview early this year, claiming, "All the ideas that were presented before—they were well received."

Even his Meigs supporters think that attitude is ill-advised. "It's an opportunity for a world-class facility that no one else has got," says Reuben Hedlund, the former chairman of the Chicago Plan Commission. "You can't do it in 60 days."

Planning would accomplish two related aims: it would juice up the original plan and—if there is substantial public input—help galvanize public support in favor of converting Meigs into a park.

Two possibilities for injecting drama into Daley's plan come to mind. Aerial trams could carry visitors to the peninsula, or, if the trams would eat up too much ground, water taxis. Meanwhile, a maritime museum could be nestled into one of the existing buildings at the airport, such as the firehouse—a perfect match for nearby Burnham Harbor.

A maritime museum would recall, as no facility now does, how essential Lake Michigan has been to Chicago's history and commerce: how, in 1848, the link between the lake and the Illinois and Michigan Canal led to Chicago becoming a major trading center; how, by the turn of the century, the city was one of the busiest ports in the world; and how scores of immigrants—Irish, Swedes, Germans—completed their journey to the New World on the Great Lakes.

Building on the collection of the Chicago Maritime Society, which operated a museum at North Pier between 1988 and 1991 before encountering organizational problems, such a facility could play on the theme of discovery, celebrating such figures as Marquette and Joliet, the first European explorers to venture here in 1673.

Indeed, Daley might want to drop his plan to dub Meigs "Northerly Island," a name based on Burnham's long-ago idea to create a necklace of islands along the waterfront. It would be more appropriate to rename Meigs "Discovery Park," an allusion to the great discoverer Christopher Columbus, who is represented in a statue at Lake Shore and Columbus Drives, his outstretched left hand pointing the way to uncharted territory. Indeed, as Chicago markets itself as a global tourist destination, "Discovery" can be the grand theme for the downtown lakefront.

Before all that can happen, though, Chicago has to discover the hidden potential of its shoreline, not just the downtown lakefront, but the entire 30 miles between Indiana and Evanston.

The first step is to look past the civic myth of the perfect lakefront and confront the not-so-glamorous reality—the shattered shoreline revetments, the beaches that have been allowed to be swept under the waves, the grand central park that lies empty most of the year, the bedraggled parkland south of McCormick Place, the traffic jams that make the north lakefront a hassle rather than a respite.

Too much of the lakefront is designed to be seen rather than used, a problem epitomized by the spectacular new flower beds along South Michigan Avenue in Grant Park. They look wonderful from a passing car, yet why not put some park benches nearby so parkgoers could sit, relax, and enjoy them? While park users questioned for this series consistently praised Daley's efforts at maintenance and beautification, they just as routinely faulted the mayor for facilities that are not user-friendly.

But the trouble runs deeper: if the lakefront remains trapped in the straitjacket of a prosaic aesthetic, then it can neither respond to new trends in recreation and demographics—the aging of the population, for example—nor can it reach its potential as a work of civic art that expresses the full spectrum of America's increasingly diverse society.

A New Architecture

What the lakefront needs is a new architecture: of both landscape and public policy.

Should the mayor decide to deal with the less-than-perfect condition of the shoreline, he needs to address one of its fundamental causes: the fragmented decision-making that afflicts both the downtown lakefront and the rest of the waterfront. Daley can do so by appointing a powerful commission that would coordinate the efforts of the dizzying array of agencies that control the lakefront, seeing to it that the more than $500 million in projects planned for the next 12 years—roads, buildings, and revetments—turn into an ensemble that is more than the sum of its parts.

Could such a commission have halted planning gaffes like putting the Nature Museum at the already jammed intersection of Fullerton Parkway and Cannon Drive in Lincoln Park? Probably not, given that the museum is a longtime Lincoln Park institution. But the commission surely could emulate the success that a now-dissolved planning task force had in the creation of the Museum Campus, ensuring cooperation, for example, among federal and local authorities in the redevelopment of the former U.S. Steel mill, the biggest chance in years to add new parkland to the shoreline. Ideally, such a commission also would supervise the rewriting of the outdated 1972 lakefront plan, as well as mastermind subplans for areas like Burnham Park.

If City Hall can neither acknowledge that there is something wrong with the lakefront, nor provide the leadership to make things right, then perhaps the citizenry will have to force it to do so, using Daley's upcoming reelection campaign as its forum. The city's architects can meanwhile emulate the model of predecessors such as the late Harry Weese; they can become consciences of the lakefront, drafting pro bono plans that will provide a planning foundation. Leaders of major institutions, particularly those on the South Side, such as the University of Chicago, can quietly press the mayor to shape up the lakefront, especially since it is their front yard. The city's business executives might even underwrite planning efforts themselves, following the noble civic tradition set by the Commercial Club of Chicago and its support for Burnham's Chicago Plan.

Who knows? If a movement for better planning comes from the ground up, then City Hall may be forced to recognize the inevitable: reinventing the

lakefront requires more than a patchwork of initiatives. The task is huge and complex, and can be accomplished only by integrating all the pieces into a seamless entity that is at once global and local, emphasizing the grand sweep of the waterfront while never neglecting the individual parkgoer.

There is no better place to glimpse what can be done than the Ferris wheel at Navy Pier. As your gondola rises slowly, it is possible, even on a blustery fall day, to be borne back to a warm August night and feel the rush of exuberance that comes from witnessing the vast, undulating arc of the shoreline. As the gondola nears its apex and the cars on Lake Shore Drive begin to look like toys and the skyscrapers line up like pieces on a chess board, you understand that the city is not a machine—cool, efficient, rational—but a vessel of human possibility.

You see not just what is, but what could be.

You see the heart of the lakefront, Grant Park, beating vibrantly, not just during festivals but all year round.

You see Navy Pier and the land bridge of the Museum Campus reaching out into the lake like great arms, no longer isolated from each other, but part of a greater whole—resembling a world's fair that never stops.

You see a north lakefront that is still rife with people, but is less crowded and more sane. And you see a south lakefront that no longer is a stepchild, but is instead a glorious counterpoint to the north.

What you see is the future of a great American city, and the dazzling prospect—if we seize this fleeting moment—of transforming Chicago and the lives of its people.

Postscript

Since the publication of "Reinventing the Lakefront," Chicago has taken some key first steps toward making its shoreline a more vibrant public space. But there are still miles to go if the reality of the lakefront is to be as good as its reputation.

Nothing is quite as important as the Chicago Park District's decision to commission plans for four of its seven lakefront parks—Grant, Burnham, Jackson, and Washington. Those parks comprise nearly 2,000 acres and more than 10 miles of the city's 24 miles of publicly accessible shoreline. While park advocates and others are right to question a range of details, no one can deny that the plans represent an essential road map, one that promises to ready the lakefront for a new century and the needs of a new generation of park users.

But when the political and financial stakes are high, as in the proposed $580 million renovation of Soldier Field, planning goes off the radar screen. At the end of 2000, for example, Governor George Ryan and Mayor Richard M. Daley rammed the Soldier Field deal through the Illinois General Assem-

bly in just two weeks. Once state legislators assured its funding, the stadium revamp was a fait accompli and city public hearings on it were a sham. Too bad. For this is one bold plan the lakefront can do without.

Unless lakefront advocates succeed with a court challenge to the plan or Daley changes his mind, the Soldier Field renovation is due to be complete in 2003. True, the renovation promises to address lingering problems around Soldier Field, turning the ugly surface parking lots into 17 acres of parkland while building a 2,500-space underground garage for Museum Campus visitors. But these improvements will come at a very high cost—the transformation of Soldier Field, a public monument to American war heroes, into a corporate sports place designed, first and foremost, to benefit the Chicago Bears, a privately owned football team. Not only will the new Soldier Field's western grandstand tower over the stadium's historic colonnades like a flying saucer. But also, under an agreement between the Bears and the Chicago Park District that was expected to be approved in 2001, the stadium's name itself will be up for grabs. The Bears will be allowed to reap millions of dollars by selling so-called "naming rights" to a corporation that will get to attach its name to the arena. Does "Fat Cat Stadium at Soldier Field" have a nice ring to it? Even a revised design that the Bears released in 2001, which called for covering the lower portion of the controversial western grandstand with a tilting wall of glass, failed to correct the fundamental problem: This was too much building for too little site. It would have been far wiser to move the Bears off the lakefront, where a giant football stadium would have caused far less havoc.

While the Soldier Field deal represents a triumph of expedience over visionary planning, there still is a chance to better the rest of the lakefront. The big question is whether Daley and David Doig, the new general superintendent of the Chicago Park District, can come up with the money to pay for their plans—and whether the park district's plans, in particular, will be coordinated with those of other agencies that wield enormous power over the shoreline.

Given the vacuum of leadership and Daley's unwillingness to fill the void with a powerful lakefront commission, the future of the shoreline hangs in the balance—teetering between vision and reality, dreams and the dollars needed to make them come true. It is impossible to predict the outcome, but it can be said that a change in outlook has occurred and that, in spite of the planning gaffe at Soldier Field, the city has adopted a new and more humanistic vision for its lakefront. Experience shows that such visions can take years, if not decades, to realize. But there is no denying their power to shape our thinking—and eventually, our actions. In the long run, one can only hope, these visions will reinvent the lakefront for those who really count—the swimmer, the bird-watcher, the family going to the beach, the man with the fishing pole.

ACKNOWLEDGMENTS

J
ust as a work of architecture is the result of a collaborative effort, so a book about architecture involves the contributions of innumerable talented people—enough, it would seem, to populate a small skyscraper.

It goes without saying that I am indebted to Chicago's architects and urban planners, both past and present. Without their efforts and erudition—I learn something in each and every interview—this book would have been impossible.

As the first city of American architecture, Chicago has provided extraordinary subject matter for observers of the built environment. My own observations about the city and its architecture build upon a foundation laid by generations of authors, columnists, critics, editors, and historians, among them: Ira Bach and Susan Wolfson, Devereux Bowly Jr., Robert Bruegmann, Carl Condit, Perry Duis, Paul Gapp, Arnold Hirsch, John McCarron, Harold Mayer and Richard Wade, Martin Meyerson and Edward Banfield, Ross Miller, M. W. Newman, Tim Samuelson, Franz Schulze, Alice Sinkevitch, John Stamper, Robert Twombly, Lois Wille, Carol Willis, and John Zukowsky. I also have gained insight about Chicago from Richard Solomon, the director of the Graham Foundation for Advanced Studies in the Fine Arts, and from my fellow architecture critics—Lee Bey, Edward Keegan, and Cheryl Kent.

The late Paul Gapp, who was my predecessor at the *Chicago Tribune*, deserves special thanks. Paul was a true gentleman, generous with his time and wisdom; I will never forget his broad "Gapp grin" or the computer message he once sent me after reading one of my garbled first drafts. "Clarity is everything," he wrote, advice I remember to this day. I also want to thank Paul's widow, M. J. Gapp, who remains a good friend and a constant source of encouragement.

I owe my involvement in the field of architecture to an inspiring professor, Joel Upton of Amherst College, whose 1977 course in French Gothic cathedrals opened the door to much more than Chartres and Notre Dame. Over the years, that interest was nurtured by the art historian Stanley Meltzoff of Fair Haven, New Jersey; the writer and critic Lois Wagner Green of Berkeley, California; and by my teachers at Yale University from 1982 to 1984, including the architectural historian Vincent Scully; Donald Watson, who headed the Master of Environmental Design program, and the architecture critic Paul Goldberger, who taught a seminar in criticism.

In addition to Goldberger and Gapp, I have been privileged to learn from other colleagues, such as Robert Campbell of the *Boston Globe*, David Dillon of the *Dallas Morning News*, Benjamin Forgey of the *Washington Post*, Ada Louise Huxtable of the *Wall Street Journal* (formerly with the *New York Times*), and Allan Temko (formerly with the *San Francisco Chronicle*). My hope is that this collection of essays will offer something of value to the next generation of architecture critics, much in the same way that I have benefited from reading and talking to my distinguished forerunners in the field.

Everyone has to start somewhere; I am particularly grateful to those who helped me to take key early steps: Bud Whisler and Piero Patri, who hired me in 1980 as an office clerk for their San Francisco design firm; Darryl Roberson and Chuck Bowman, who needed a public relations writer at their San Francisco design firm in 1981; the late Don Pickels and Ann Holmes of the *Houston Chronicle*, who provided a 1983 summer internship that allowed me to research a master's thesis on Houston architecture; Henry McNulty and Henry Scott, formerly features editors at the *Hartford Courant*, who in 1983 and 1984 allowed a mere graduate student to write architecture critiques for their newspaper; and James P. Gannon and Arnold Garson, formerly editors at the *Des Moines Register*, who in 1984 gave me my first full-time job as a reporter and sometime architecture critic.

While at the *Register*, I was fortunate to receive firsthand lessons in the craft of journalism from fellow reporters Ken Fuson, Larry Fruhling, and Dale Kasler. Iowa's wizard of words, former *Register* editor Michael Gartner, generously offered piercing critiques of my prosaic prose and reminded me, as he does all journalists, "The easiest thing for the reader is to quit reading." *USA Today* executive editor Bob Dubill, an old family friend from my native New Jersey, also has been extraordinarily giving on my behalf.

At the *Chicago Tribune*—where former editor Jim Squires, former managing editor F. Richard Ciccone, and former metro editor Ellen Soeteber brought me on as a reporter in 1987—my work has been inspired by and improved upon by a legion of editors, photographers, graphic designers,

reporters, and fellow critics. Certainly, I am most grateful to Jack Fuller, the president of Tribune Publishing, and Howard Tyner, vice president for editorial at Tribune Publishing, who in 1992 gave me the chance to continue the tradition started by Gapp. I also owe thanks to former associate editor Joe Leonard, who handled the contract for this book, and to his successor, operations editor Dale Cohen.

There are many others to acknowledge. Douglas Balz, then editor of the section known as "The Arts," spurred my interest in public housing when he proposed the Tribune's 1993 Architecture Competition for Public Housing. Owen Youngman, then the Tribune's features editor, invited me to delve deeper into the issue of housing the poorest of the poor by conceiving the 1995 series "Sheltered by Design." Veteran projects editor Barbara Sutton shepherded that enormous undertaking into the newspaper and taught me lessons that would bear fruit three years later in the 1998 series "Reinventing the Lakefront."

Special thanks for the lakefront series go to R. Gerould Kern, the Tribune's deputy managing editor for features, who had both the vision to pursue the series and the courage to back his writer every step of the way. Tempo associate editor Jeff Lyon's contribution was equally important; he not only provided sharp analysis but also elegant wordsmithing that made my drafts immeasurably better. Former Tempo editor Tim McNulty brought to the endeavor his keen understanding of politics, asking me to ponder the lakefront from this perspective: "What do you want done? And who do you want to do it?" The series also drew heavily on the work of Lois Wille, former Tribune editorial page editor and author of Forever Open, Clear, and Free: The Struggle for Chicago's Lakefront. Lois has been a great friend, generous with both her time and wisdom.

In addition to those who supervised the big projects, I have been blessed to work with skilled colleagues who edited shorter, but no less important, stories. Two of them, in particular, have pushed me to write with lucidity and verve: Nancy Watkins and Kaarin Tisue. I also want to thank entertainment editor Tim Bannon and Arts & Entertainment editor Linda Bergstrom for being flexible with my deadlines as I worked to complete this book.

There are many other fine Tribune editors to cite: Robert Blau, Marcia Borucki, Geoff Brown, Rebecca Brown, Margaret Carroll, Bob Condor, Nadia Cowen, Marjorie David, Gary Dretzka, Mary Elson, Tim Franklin, the late Jim Gallagher, Peter Gorner, Denis Gosselin, Andrew Gottesman, Al Gray, David Jones, Rick Kogan, Lilah Lohr, Richard Lorenz, Jim Musser, Jim O'Shea, Bill Parker, Scott Powers, Chris Rauser, John Schmeltzer, Patricia Tennison, Joanne Trestrail, John Twohey, Jim Warren, Paul Weingarten, and David Young. Thanks

also to Brian Downes, Mary Ellen Hendricks, and Denise Pondel for preparing contest entries; and to longtime features department secretary, Nanette Smith, for her many contributions.

All architecture critics look better when they are teamed with great photographers; I have been fortunate to work with the *Tribune*'s superb photo staff, especially Bill Hogan on the housing series and former *Tribune* photographer Wes Pope on the lakefront series. Their images were so powerful that I had no choice but to write well. Former director of photography Mark Hinojosa provided key concepts on the public-housing series; picture editor Torry Bruno played the same role on the lakefront series. Photo editor Marsha Peters made vital contributions day to day. Former assistant picture editor Eric Chu and assistant picture editor Laura Husar organized the photos for this book. Assistant picture editor Wendy White provided further assistance.

Graphic design is equally important in explaining complex urban issues, as is evident by the graphics that accompany the lakefront series in this book. For them, I wish to thank associate managing editor for design and graphics Stacey Sweat, former *Tribune* graphic artist Kevin Hand, former associate graphics editor Celeste Bernard, former associate design editor Therese Shechter, Tempo art director Tom Heinz, and former Tempo designer Joey Santos. Tom Heinz has provided consistently excellent layouts for my stories in Tempo. Associate graphics Steve Layton has skillfully supervised the alteration of the lakefront graphics to the format of this book; that work was done by graphic artist Phil Geib.

In preparing this book, I have been given essential support by the staff of the Tribune Information Center. Editor of information systems John F. Jansson has kindly allowed his staff to take the time to help me. I particularly want to thank manager of photos Mary Wilson and *Tribune* information associate Kemper Kirkpatrick, who assembled the pictures that appear on these pages, as well as *Tribune* information associate David Turim, who put nearly all of the essays in this collection on computer discs. Thanks also to information researchers Brenda Kilianski, Judy Marriott, Steve Marino, Joe Pete, Alan Peters, and Larry Underwood, and information associate Colleen Vanderhye, all of whom dug up much-needed material.

I would like to pay tribute to my fellow critics for their support as I labored over the two multipart series in this book. Thank you, Alan Artner, Richard Christiansen, Julia Keller, Steve Johnson, Greg Kot, Howard Reich, Sid Smith, John von Rhein, Phil Vettel, and Michael Wilmington. I have benefited, too, from my interactions with numerous *Tribune* reporters and columnists, including Bob Davis, John Kass, John McCormick, George Pappajohn, Patrick Reardon, Bill Recktenwald, and Ellen Warren.

Also deserving thanks are John Madigan, the chief executive officer of Tribune Company, parent company of the *Chicago Tribune; Chicago Tribune* publisher Scott Smith; Jack Fuller, Howard Tyner, and *Tribune* editor Ann Marie Lipinski, a treasured friend and colleague who is a champion of journalistic values. Citing these high-ranking people is no mere formality. In evaluating buildings and urban spaces, architecture critics invariably upset those who are wealthy and powerful. Over the years, critics at other newspapers have been muzzled because their bosses didn't want to take the heat. To the great credit of the *Chicago Tribune*, I have never—ever—had that problem.

There is further reason to thank Fuller because he indirectly set this book in motion, acting in his capacity as a member of the board of trustees at the University of Chicago. Fuller encouraged my participation in a 1999 fellowship program for journalists and scholars at the university's Franke Institute for the Humanities. During the fellowship, J. Paul Hunter, then direcctor of the Franke Institute, brought my idea for a collection of essays to the Press's associate director, Penelope Kaiserlian. She has skillfully steered this project from conception to execution, always with unruffled grace. I have been fortunate to work with her assistant, Mary Laur, who has been a model of thoroughness and thoughtfulness in editing my essays. I also wish to thank senior manuscript editor Carol Saller for fine-tuning the text with admirable precision; senior manuscript editor Erin DeWitt for her careful copyediting in the final phase; Susan Danzi Hernandez for her meticulous index; senior designer Mike Brehm for his handsome, highly readable design; as well as those who read and commented on the book proposal, University of Chicago faculty member W. J. T. Mitchell and Franz Schulze. The University of Chicago Press's publicity manager, Erin Hogan, has brought her creative spirit to this venture. The Press's director, Paula Duffy, has been an equally enthusiastic backer, eager to talk about architecture in the city to which she has returned.

As much as all the professional help has made a difference, the kinship of friends and family has meant just as much. In that regard, I want to thank many longtime friends: from Chicago, Chuck Berman, Barbara Brotman, Robert Blau and Leah Eskin, Steve Kagan and Ann Marie Lipinski, Joel Kaplan and Susan Miller Kaplan, Gary Marx and Cecilia Vaisman, Elizabeth Taylor and Jim Kaplan; from Amherst College, Daniel Cohen, David Glasser, Vern Harrington, John Lawlor, and the late Owen Kupferschmid; and from my hometown of Fair Haven, N.J., Mark Lynch and Robert Drugan, with whom I bodysurfed at Sandy Hook and grew to love the water's edge. Joel Kaplan and Gary Marx deserve special thanks. They are always there, trusted friends both professionally and personally.

Finally, I want to express my deepest gratitude to my family, whose un-wavering support over many decades has made this undertaking possible.

My sister, Brooke Kamin Rapaport, a contemporary art curator at the Brooklyn Museum of Art, and her husband Richard Rapaport have been unfailingly generous in every way. It is a special treat to have a sister who works in an allied field of the fine arts.

My grandmother, Sylvia Palew, has fed me in more ways than she will ever know; her example of social activism undoubtedly influenced my decision to be an activist critic.

I also wish to thank the family of my wife, Barbara Ann Mahany—her brothers John, Michael, David and Brian Mahany, as well as her mother, Barbara G. Mahany, who has opened both her home and her heart to me.

Most of all, I would like to thank those to whom this book is dedi-cated—my parents, Arthur and Virginia Kamin, as well as my wife and our son, William Maxwell Mahany Kamin.

My parents are great parents; they have taught me innumerable, life-shaping lessons. My father, the newspaper editor, instilled in me a love of the printed word and showed by example that it was possible to be a con-science for your community. My mother, the schoolteacher, taught me the art of teaching, which is a critical part of a critic's job. I simply cannot thank them enough.

The same goes for my wife Barbara Ann, who is easily the most tal-ented writer in our family and who forms its emotional core. Barbara, a former pediatric oncology nurse who is now a writer for the *Chicago Tribune*, remains a powerful healer; she has helped put me back together on more than one occasion. I love her deeply and I owe her everything; she is my passion and my partner. Our son, Willie, who loves baseball and hockey and his cat Turkey Baby, is the joy of our lives—our double byline.

Will—the book's over now. Let's go out and play with your baby brother Teddy, the latest double byline.

CREDITS

Photos are by *Chicago Tribune* staff photographers unless otherwise noted.

Title Page and Introduction

Daley Plaza, pp. ii–iii, Cathy Bazzoni, City of Chicago.
Chicago lakefront and skyline, p. xii, Frank Hanes.

The Evolving Metropolis

Sears Tower, p. xxii, Frank Hanes.
Michigan Avenue pylon, p. 4, Bruce Bondy/courtesy of DLK Architecture Inc.
Marriott Hotel, p. 7, Milbert Orlando Brown.
Disney Store, p. 11, photo for the *Tribune* by Kevin Tanaka.
State Street, p. 16, Phil Greer.
Roosevelt Road/State Street subway station, p. 22, courtesy of Daniel P. Coffey & Associates.
Block 37, p. 27, Vladislav Yeliseyev Architectural Illustration.
Traffic circle, p. 33, Charles Cherney.
Congress Plaza, p. 37, Steve Hall/Hedrich Blessing.
Sculptures at the Roosevelt Road Bridge, p. 39, David Klobucar.
Roosevelt Road Bridge, p. 40, David Klobucar.
Damen Avenue Bridge, p. 44, Gary Taber/Copelin.
Chicago Stock Exchange Building, p. 49, *Tribune* file photo.
Reliance Building, p. 55, Carl Wagner.
Fallingwater, p. 59, Sarah Beyer/courtesy of Western Pennsylvania Conservancy.
Robie House, p. 60, Milbert Orlando Brown.
Unity Temple, p. 63, Milbert Orlando Brown.

Capone's Chicago, p. 67, Blair Kamin.

Planet Hollywood, p. 70, Blair Kamin.

Michael Jordan's, p. 71, Blair Kamin.

Navy Pier, p. 73, photo for the *Tribune* by Erik Unger.

Grand Avenue in North Bridge, p. 78, photo for the *Tribune* by Erik Unger.

Nordstrom store, p. 81, Phil Greer.

Old Orchard Shopping Center, p. 87, Steinkamp Ballogg, Chicago.

Hinsdale houses, p. 90, Patrick Witty.

Downtown Arlington Heights, p. 94, George Thompson.

The Art of Architecture

Monadnock Building, p. 98, Charles Osgood.

John Hancock Center, p. 102, John Kringas.

Sears Tower, p. 106, Frank Hanes.

7 S. Dearborn, p. 111, Steinkamp Ballogg, Chicago.

300 E. Randolph, p. 115, Chris Walker.

Commerzbank Building, p. 119, Ian Lambot/Ian Lambot Studio.

Peoples Gas Building, p. 125, *Tribune* file photo.

Inland Steel Building, p. 129, Nick Merrick/Hedrich Blessing.

Washington, D.C., subway, p. 134, *Tribune* file photo.

Arts Club of Chicago, p. 139, Blair Kamin.

Museum of Contemporary Art, p. 143, Steve Hall/Hedrich Blessing.

Harold Washington Library Center, p. 146, Judith Bromley Photography.

Adler Planetarium and Astronomy Museum, p. 151, Terry Harris.

Holocaust Memorial Museum, p. 157, Max Reid/courtesy of USHMM Photo Archives.

Rose Center for Earth and Space, p. 161, Sara Krulwich/NYT Pictures.

Guggenheim Museum Bilbao, p. 166, Erika Barahona Ede/© FMGB Guggenheim Bilbao.

Sony Center, p. 171, O. Reuter/Sony Berlin.

IIT Campus Center, p. 177, Rem Koolhaas/OMA.

Millennium Park band shell and trellis, p. 182, Terry Harris.

Aronoff Center for Design and Art, p. 186, © Jeff Goldberg/Esto.

Architecture as a Social Art

New Seward Elementary School, pp. 188 and 222, Steve Hall/Hedrich Blessing.

Daley Plaza, p. 190, Peter L. Schaudt/Peter Lindsay Schaudt Landscape Architecture, Inc.

Old Town School of Folk Music, p. 195, Steve Hall/Hedrich Blessing.

Cows on Parade, p. 199, Phil Velasquez.

Comiskey Park, p. 205, George Thompson.

Chicago Stadium, p. 209, Carl Wagner.

United Center, p. 213, Jim Prisching.

Old St. Patrick's Church, p. 218, Nick Merrick/Hedrich Blessing.

Educare Center, p. 226, Nick Merrick/Hedrich Blessing.

Red-brick condominiums, p. 232, Terry Harris.

One Superior Place, p. 236, Chris Walker.

Renaissance Village, p. 241, Bill Hogan.

Willow Court, p. 243, Bill Hogan.

850 W. Eastwood Ave., p. 245, Bill Hogan.

Marcus Garvey Commons, p. 248, Bill Hogan.

Touch football at Harbor Point, p. 251, Bill Hogan.

Harbor Point and Boston skyline, p. 255, George Riley/courtesy of
 Goody, Clancy & Associates.

Robert Pitts Plaza, p. 257, Bill Hogan.

Renaissance Village front porch, p. 260, Bill Hogan.

Renaissance Village, p. 263, Bill Hogan.

Robert Taylor Homes, p. 265, Paul Zakoian/courtesy of Thomas Hickey
 & Associates.

Ida B. Wells Homes, p. 268, Bill Hogan.

Wall mural at 850 W. Eastwood Ave., p. 272, Bill Hogan.

Lake Parc Place, p. 275, Bill Hogan.

The Lakefront: Democratic Vistas

Chicagoans beside Lake Michigan, p. 278, Nancy Stone.

Museum Campus, p. 282, José More.

Parking lot at Museum of Science and Industry, p. 287, Walter Kale.

Parkland at Museum of Science and Industry, p. 287, Bill Hogan.

North Avenue Beach House, p. 292, Charles Osgood.

Jackson Park Beach House, p. 294, Charles Osgood.

Rainbow Park Beach House, p. 295, Charles Osgood.

All photos for "Reinventing the Lakefront," pp. 299–359, Wes Pope.

All graphics for "Reinventing the Lakefront," pp. 300–354, Kevin Hand.

INDEX

Burnham Park, 310; benign neglect results, 314–16; Burnham's vision for lakefront, 311–12; condition of facilities, 310–11, 312; district plan prospect, 318–20; plans for rebuilding, 300, 313; Promontory Point, 316; resculpting opportunities, 317–18; upcoming projects, 317

Byar, James Lee, 144

C. F. Murphy Associates, 132, 152
Cabrini-Green, 258–59, 269
Calatrava, Santiago, 41, 167, 331
Caldwell, Alfred, 316
Callaway, John, 150
Callison Architecture: Nordstrom, 81
Camden Yards ballpark (Baltimore), 204, 208
Campbell, Robert, xx, 75
Capitol Hill, xvii
Capone's Chicago, 67; closure of, 72; fake appearance of, 67; historical misrepresentations, 68–69
Carbide & Carbon Building, 50
Carlins, Joel, 235
Carson Pirie Scott store, 10, 13
Cartier Foundation for Contemporary Art (Paris), 140
Caruso, Susan, 56
Cassity, Patrick, 43
Central Michigan Avenue Association, 6
CHA. See Chicago Housing Authority
Cheesecake Factory, 104
Chicago Building, 50
Chicago Department of Transportation, 37, 42
Chicago Folk Center. See Old Town School of Folk Music
Chicago Historical Society, 134
Chicago Housing Authority (CHA): HUD takeover, 240, 251–52, 260; public-housing authority, 240, 246, 249
Chicago Maritime Society, 360
Chicago Park District, 42, 319–20, 362
Chicago Stadium, 209; demolition, 211–12; design description, 210; history and legacy, 209–10, 211
Chicago State University, 136
Chicago Stock Exchange Building, 47, 49
Chicago Sun-Times, 29
Chicago Theological Seminary, 62
Chicago Title & Trust Tower, 115
Chicago Transit Authority (CTA): Arlington

Heights Metra station, 94, 95; State Street/Roosevelt Road subway stop, 21, 23
Chicago Trolley Co., 356
Cisneros, Henry, 245, 249, 251, 260
City Council, Chicago: landmarks law, 48; limits to design approval jurisdiction, 66; 7 South Dearborn approval, 110, 113; Soldier Field approval, 309, 362
"City-Escape," 66–72
Class L tax classification, 52
Clay, Jon, 75
Clements, Wolff, 295
Clinton, Bill, xvii
Clinton, Hillary Rodham, 63, 64
Clybourn corridor, 68
CNA Center, 132
Columbia Point. See Boston Harbor housing
"Comiskey Park," 204–8
Comiskey Park, 205; bungling of, 146; constrictions of budget and site, 206–7; cost, 205; history of old park, 204–5; lack of risk taking in, 148; trend toward incoherency, 68; upper-deck shortcomings, 207–8
Commerzbank, Germany, 119; atrium design shortcomings, 121; ecological design, 120–21; green building idea importance, 119–20
Commission on Chicago Landmarks, 139
computers: detail possibilities using, 220; endurance of buildings and, 187; freedom of design using, xix, 153, 167
condominium buildings, 232; described, 232; design shortcomings, 233; missing sense of place, 231, 233, 234; zoning laws and, 234
Congress Plaza, 36, 42
Congress Plaza bridge: architectural history, 37–38; design highlights, 37, 38–41
Conlon, Sean, 232, 234
Conrad Sulzer Regional Library, 196
Consoer Townsend Envirodyne Engineers: Jackson Park Beach House, 294
Cook County bridges: architects' role in design, 36, 42; Congress Plaza, 37–41; Damen Avenue, 43–46; design contribution to city, 46; renovation plans, 37, 42; Roosevelt Road, 40, 41–42
Cook, James, 276
Corcoran, Mullins, Jennison, 254
Council on Tall Buildings and Urban Habitat, 109